THE COMPLETE MANUAL OF
NATURE PHOTOGRAPHY

The
NATURE

Guglielmo Izzi
Francesco Mezzatesta

TRANSLATED FROM THE ITALIAN BY
Adrian Anthony Bertoluzzi

HARPER & ROW, PUBLISHERS, New York
Cambridge, Hagerstown, Philadelphia, San Francisco,
London, Mexico City, São Paulo, Sydney

1817

Complete Manual of
PHOTOGRAPHY

AUTHORS' NOTE

Books on photographic technique traditionally have given shooting data for each photograph reproduced. Before the advent of the automatic reflex, the choice of shutter speed and diaphragm aperture was direct, carefully thought out, and hence memorized with greater facility. At present, precision in exposure is no longer a problem: automation determines one parameter on the basis of the other chosen by the photographer. It is therefore unusual to keep a record of how one exposed, and in this book it has not been considered necessary to give data, often unreliable and of little interest. It is, on the other hand, useful to indicate those photographic factors which characterize and exemplify the technique used in the case of individual photographs.

This work was first published in Italy under the title *I Manuali del Fotografo la Natura*. © 1979 Arnoldo Mondadori Editore S.p.A., Milano.

FIRST EDITION

Library of Congress Cataloging in Publication Data

Izzi, Gulielmo.
 The complete manual of nature photography.
 Translation of: La natura.
 Includes index.
 1. Nature photography—Handbooks, manuals, etc.
I. Mezzatesta, Francesco. II. Title.
TR721.I9913 778.9'3 80-7891
ISBN 0-06-014868-3 AACR2

81 82 83 84 85 10 9 8 7 6 5 4 3 2 1

CONTENTS

NATURAL LIGHT

Natural light changes continuously in intensity and quality with the alternation of day and night and under the variable influence of atmospheric factors. Knowing how to recognize characteristics of light is very important for the nature photographer as it is the raw material of photography. To what extent does light vary on the surface of our planet? How high is the level of light in the sunlit desert compared to the darkness of a moonless night? If we translate these levels of light into the unit of measure used in optics, the foot-candle (or its metric equivalent, the lux), we shall find a difference of hundreds of thousands of times. If, on the other hand, we adopt the unit of measure of light used in photography, the exposure value (EV), we get a difference of only about twenty gradations. While values expressed in lux double when the intensity doubles, the corresponding EV increases by one unit.

Lux may only be related to the exposure value if a standard of sensitivity is fixed, which is normally considered equal to ASA 100. The EV measures exposure, that is, quantity of light, while lux measures a level of illumination. The graph below shows the average variation of luminous intensity on the earth in the temperate belt. From the exposure value obtained, one can extract all possible corresponding combinations of shutter speed and diaphragm aperture.

Our eyes, adjusting themselves automatically to changes in light, cannot judge the level of luminosity with sufficient precision. In emergency cases EV proves to be very useful because, by assisting the memorizing of conditions of light, it allows one to arrive at an approximate exposure. The high luminosity of daytime has a range of about five EV: from the lev-

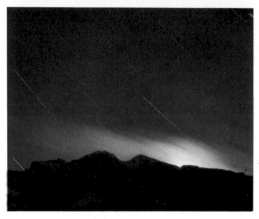

Above: The light at sunrise. Right: At night the stars trace circular paths in the sky around the North Star. Diagram below: How luminosity on earth varies.

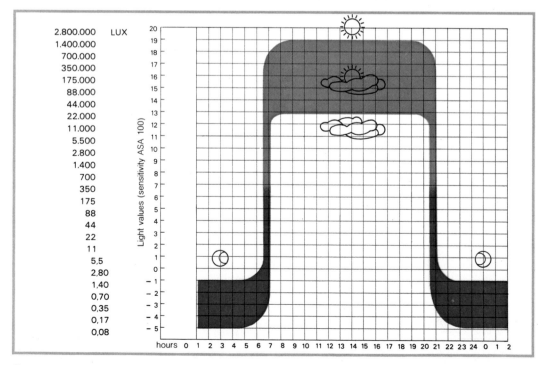

el of 17 to 18 in bright summer sunlight, EV can drop to 12 to 13 on cloudy days. At sunrise and sunset, in a short space of time, exposure moves to values between 5 and 9, and at the same time the kind of light changes both in color and direction of source. In these moments the light takes on new and interesting angles particularly suited to panoramic photography. At night luminosity is usually very low; the presence of the full moon can however cause the exposure value to rise from -5 to -1.

The Color of Natural Light

At midday sunlight is white by definition, and most photographic color film is calibrated for this kind of light. While the eye tends to compensate automatically for color variations, film faithfully registers every chromatic difference. For this reason pictures taken at sunset normally reveal warm, or red, tonality; on the contrary, on days when the sky is overcast one gets cold, or blue, tonality. Photographs taken in any type of daylight are generally acceptable to our eyes, but common types of artificial light, which maintain different balances between the intensities of the primary component colors, may show a vivid coloration on film which has an unpleasant effect. To measure these differences in color, the Kelvin scale is used, which allows comparison of light coming from any source on the basis of color temperature (the color of light given off by a heated body passes from deep red to blue as its temperature rises).

In practice, nature photography uses mainly daylight; however, when artificial light is required, electronic flash is used, which, having the same color balance as natural light, can easily be mixed with it.

Table: Color temperatures of natural light and of some of the main sources of artificial light.

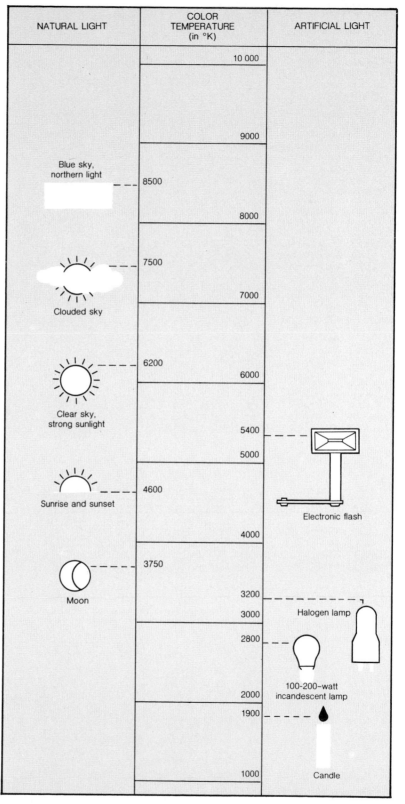

NATURAL LIGHT	COLOR TEMPERATURE (in °K)	ARTIFICIAL LIGHT
	10 000	
	9000	
Blue sky, northern light	8500	
	8000	
	7500	
Clouded sky	7000	
	6200	
	6000	
Clear sky, strong sunlight	5400	
	5000	Electronic flash
Sunrise and sunset	4600	
	4000	
Moon	3750	
	3200	Halogen lamp
	3000	
	2800	100-200-watt incandescent lamp
	2000	
	1900	Candle
	1000	

9

HOW LIGHT IS MEASURED

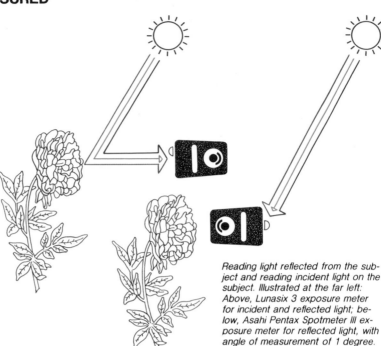

Reading light reflected from the subject and reading incident light on the subject. Illustrated at the far left: Above, Lunasix 3 exposure meter for incident and reflected light; below, Asahi Pentax Spotmeter III exposure meter for reflected light, with angle of measurement of 1 degree.

Natural light is very changeable, from hour to hour and from place to place. To determine the correct exposure simply means locating the right degree on the scale of luminosity: with color material, a mistake of even one degree is often inadmissible and so the light must be measured with precision to obtain consistent results.

There are two methods for measuring exposure: with a separate hand-held exposure meter and with an exposure meter incorporated in the camera.

The Separate Exposure Meter

Exposure meters are instruments that measure light by indicating the exposure value to be used with a given sensitized material. From the EV reading one can extract combinations of shutter speeds and apertures which are equally correct.

Characteristics of the Exposure Meter

Angle of measurement: around 20° to 30° in the normal kind of exposure

meter. Special exposure meters known as spot meters measure the light at a very narrow angle, around 1°· they are very useful for subjects which one cannot get close to and in macrophotography. They are also used to measure contrast, that is, varying degrees of luminosity in the same picture.

Types of cells: The first kind used, the selenium cell, has been abandoned because of poor sensitivity. The most popular exposure meters now use CdS cells (cadmium sulphide). The latest ones, like Profisix, use silicon cells, which have certain advantages compared to CdS cells: greater sensitivity, greater reading speed, insensitivity to glare with strong lights.

How to Use Exposure Meters

There are two methods for measuring light with hand-held exposure meters.

Measuring light reflected from the subject: The cell of the exposure meter is pointed toward the subject, sufficiently close to exclude anything of unimportance to the picture, carefully

avoiding stray light that would distort the reading. The spot exposure meters, with their narrow angle of measurement, allow more accurate readings.

Measuring incident light falling on the subject: The exposure meter cell covered by the diffuser is placed near the subject and pointed toward the camera. In fact, the subject can be at some distance from the exposure meter, if the light and its angle are the same in relation to the camera. The measurement of incident light is more reliable and precise in some cases because it is not influenced by the subject itself.

Sensitivity: Sensitivity to light is commonly measured by means of the ASA or the DIN scale. Starting from the common value of 12, one can calculate any sensitivity, bearing in mind that with each doubling of sensitivity, the ASA value doubles while the value in DIN increases by three units. The newly introduced international scale, ISO, combines these two scales into one—for example, ISO 100/21.

The Exposure Meter Behind the Lens

Most reflex cameras incorporate one or more exposure meter photocells which read light through the lens. The cells are connected to the camera controls to ensure that measuring and setting the exposure are done in the simplest and quickest way. Two exposure meter systems, based on different concepts, are used in the reflex:

Table of equivalents for sensitivity values

DIN	ASA
12	12
15	25
18	50
21	100
24	200
27	400
30	800
33	1600
36	3200
39	6400

The measurement of reflected light is calculated on the basis of the tonality of the subject, and good results are obtainable for subjects that are neither too bright nor too dark.

1. Cells that measure light through the lens before release: During exposure they remain inactive because the mirror, in rising, interrupts the passage of light. This is the traditional exposure meter system, widely used, which on most occasions functions very well. Alternative positions of the cells adopted in different cameras conse- quently read different areas of the framed image. Three types of cell are now in use: the most common is cadmium sulphide, and more recent are the silicon cell and the Ga-As-P (gal- lium-arsenic-phosphorus) cell.

2. Cells that measure the light reflected from the fo- cal plane: A method intro- duced by Olympus in the OM-2 camera, which re- cently has also been adopted by Contax 137 IMS and Nikon F3. This system possesses the spe- cial and very useful feature of setting the exposure to the light of a special flash, connected to the camera, thanks to the extremely rapid response of silicon cells, which function as through-the-lens sensors. Exposure with the flash be- comes completely automat- ic with any aperture; in the chapter on macrophotog- raphy, details concerning its practical application will be given.

Sensitivity of cells: The sensitivity of cells is mea- sured by the lowest EV number which can still be read using ASA 100 as the film sensitivity reference point and with the standard lens open to the largest aperture. The smallest beam of light still measur- able by the cell depends on the largest aperture, while the EV for the correct exposure depends on the sensitivity of the film.

Right: Two different through-the-lens exposure meter systems (the cells are shown in red).

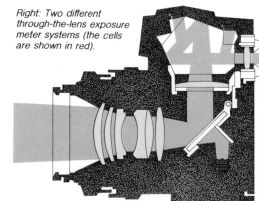

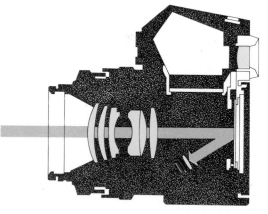

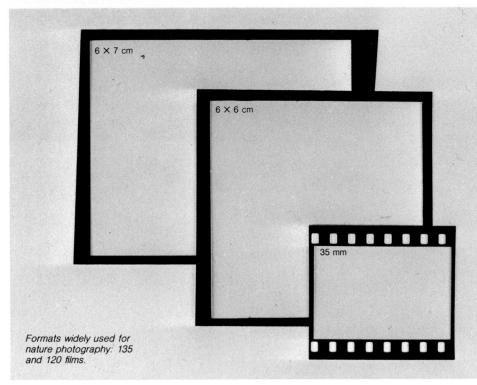

6 × 7 cm

6 × 6 cm

35 mm

Formats widely used for nature photography: 135 and 120 films.

Basically there are four distinct categories of sensitive material for amateur photographers:

- Black-and-white negative film
- Color negative film
- Slide film for color transparencies
- Material for instant development

One should bear in mind that there are other kinds of film for more specialized use. Among these the only one that might be of some interest to the amateur photographer is infrared film, which is available only in the 35 mm size. It is used mainly for scientific purposes.

General Characteristics of Film

Film is identified by a commercial name and by numbers, which need some explanation.

The format is indicated by a code number, for example, 110, 120, 126, 127, 135, 220.

For the 135 format, corresponding to perforated 35 mm film, the number of frames is also given immediately following the format code. For nature photography the choice of format is reduced basically to two: the 135 and the 120, as all reflex cameras take one of these two sizes of film. The 135 format uses magazines of 12, 20, 24, and 36 frames. Thirty-five mm film in bulk lengths is also available, and economical.

The 120 format uses a paper-backed film strip 6 cm (2¼ inches) wide, for fifteen pictures 4.5 × 6 cm (1¾ × 2¼ inches) or twelve of 6 × 6 cm (2¼ × 2¼ inches) or ten of 6 × 7 cm (2¼ × 2¾ inches). The 220 format has features similar to the 120 but with a film twice as long.

Sensitivity, or film speed, an indication of the amount of light which the film should receive for correct exposure, is measured normally in ASA and DIN.

The expiration date is always shown on the package, and it is good practice to check this when purchasing. If the film is kept in a cool, dry place, the photographic quality is well preserved even beyond the date indicated. Subject to checking a sample from the same batch, rolls of film nearing the expiration date may be used without risk, and even sometimes after the date, as long as they have been kept under good conditions.

The emulsion number identifies a uniform production batch. Different batches of the same film can in fact give rise to slight chromatic variations. If film is purchased for a major photographic expedition, it is advisable that it should all have the same emulsion number, and should be checked in advance so as to avoid unpleasant surprises.

Storage of film. In general it is advisable to purchase small batches of film, and keep it in a cool, dry place without opening the airtight package. For greater stability over a length of time, it is advisable to keep film in plastic bags at a temperature of around 10°C, in the lower part of the refrigerator. For longer storage, film may be placed in the deepfreeze at −20°C. But before being used, film must be warmed to the temperature of the surroundings for a number of hours. Only for some kinds of professional color film is constant storage at a temperature below 13°C required to assure the complete stability of the color characteristics.

Color balance. Color films belong to two distinct categories: one is designed to give balanced colors with daylight, the other to give balanced colors with tungsten artificial light. For daylight a color temperature of 5000°K to 6000°K is usual, while for artificial light the range is between 3200°K and 3400°K, depending on the kind of light source.

PHOTOGRAPHIC SYSTEMS

The Negative-Positive
System in Black-and-White

This system is suggested when the photographer intends to develop and print his own photographs, creating pictures in which the tonal rendering is carefully controlled. Subjects with strong contrast and modeling are suitable— for example, an arid and rocky natural environment, or subjects which require the use of high-sensitivity film. In macrophotography and underwater photography, where color plays an important part, black-and-white often gives a pale, unnatural result.

The Color Negative-Positive System

The high cost of printing as well as variable results and dependence on laboratory quality have limited the use of color negatives in nature photography. Their use is recommended when varying end products are needed, such as black-and-white prints, color prints, and transparencies, or when prints are required to accompany reports or scientific documents in limited numbers, or again when enlargements for interior decoration are needed.

The Color Slide System

This is the system used in all fields of nature photography on account of the high quality of the photographic image, combined with modest cost and reliable results.

The Instant System

With the arrival of the SX camera, instant photography has reached simplicity of operation and high quality. Instant photography is essential when each shot is used by the photographer to modify the composition, lighting, and exposure of the next shot, and when an instant document is required in scientific work. At present it is only of marginal interest in nature photography.

THE NEGATIVE-POSITIVE SYSTEM IN BLACK-AND-WHITE

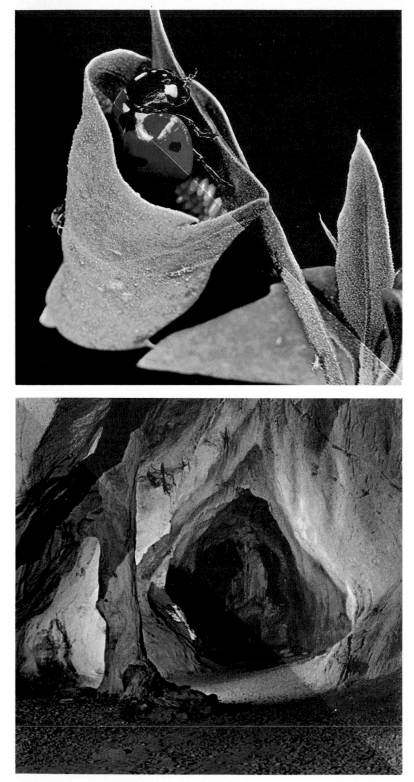

Choosing a black-and-white system indicates an interest in developing and printmaking and a preference for subjects in which light and shadow play the main role. The image in black-and-white is a graphic abstraction that transforms the colors of the real world into gray tones. While the color image is perceived instinctively, improving the nearer it approaches to reality, even to the extent of deceiving the eye, black-and-white is always a translation into a different, monochromatic language. On the one hand, one forgoes a whole range of data linked with color, while on the other hand one achieves reality through a series of grays in a more creative and independent way. When the quality and reliability of color photography were still questionable, and failed to give a sufficiently accurate reproduction of the color spectrum to satisfy the eye, translating the image into the language of grays was commonly preferred; but now that the quality of color has greatly improved, black-and-white has been almost totally abandoned in documenting nature. It still remains valid, however, in the strictly creative field. By comparing the two pictures shown on the left, the importance of color is immediately evident in the upper, while the lower is valid, even in black-and-white, with its play of light and shadow.

The intrinsic creativeness of black-and-white and its practical simplicity and flexibility encourage the processing of the negative oneself and, if possible, the printing. Whoever chooses

In the picture of the ladybug, the importance of color is immediately apparent—a further dimension in natural history documentation.

In the picture of the grotto (Toirano), on the other hand, the importance of contrast is evident, as well as the expressive quality of black-and-white.

black-and-white as a tool of photographic research in the study of nature must have the principles of the system clear in his mind if he wants to get good results for his trouble.

The Choice of Film

The variety of black-and-white films available on the market is very wide, in spite of the reduction in recent years owing to the enormous advance of color. Film quality today tends to be uniform, and the choice is based essentially on the sensitivity of the film. The higher it is, the more graininess there will be in the structure of the image, with less contrast and definition.

Low-sensitivity film, up to ASA 50: These are used for static pictures, for example, panoramas and environments which are rich in detail, in which modeling in the shapes and a high degree of definition is sought.

Medium-sensitivity film, from ASA 100 to 200: Widely used, may replace the slower ones when larger formats are being used to obtain equally high quality photographs.

High-Sensitivity Film, around ASA 400: Among the most widely used on account of their distinctive tonal richness and softness in contrast, with graininess still limited. The better known are Tri-X and FP5, which, if handled carefully, give excellent results. These films are adapted to be stretched to ASA 1600 with adequate processing, and the photographic quality remains acceptable.

Ultrarapid film, beyond ASA 400: They should only be used when their full speed really is necessary, the last resort when the subject must be shot in dim light.

Processing the Negative

Developing the black-and-white negative oneself is a necessary step in guaranteeing consistent results and reliable quality. It requires only a little precision and attention, as the technical side is simple and within everyone's grasp.

Find the method that best suits you, starting with the classical formulations of film and developer.

For quick, easy processing, the Paterson-type developing tank is best. Liquid developers and fixing agents, diluted when about to be used, are convenient. Acquiring first-hand experience on the basis of the tables relating to time and temperature, one can then tackle more specialized processes, making full use of the film, as regards both photographic quality and sensitivity.

The Print

If finding a processing laboratory that prints sufficiently well in black-and-white becomes a problem, it may be necessary to do it oneself. Printing requires a minimum of time and space; in fact, modern printing equipment is both easy to use and reasonable in price. Furthermore, with resin-coated paper, processing time has been significantly reduced, making the process even quicker than with fiber-based paper. If you devel-

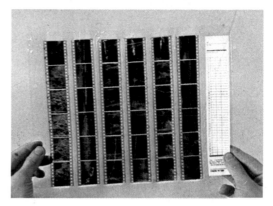

op and print yourself, you have the double advantage of being able to correct both the composition and the image contrast. Furthermore it is easier to find which steps need improving. In fact, only if all three stages—exposing the film, developing the negative, and printing—are properly carried out, can good results always be assured.

How to Store Negatives

The best method of preserving negatives is to cut them into strips and place them in transparent

sleeves, as shown in the photograph above. This protects them from dust and fingerprints, while allowing them to be seen clearly. The entire transparent envelope containing the six frames in six strips may be placed on a sheet of photographic paper, then pressed down with a glass sheet and exposed to the light of an enlarger for a suitable length of time. Then the sheet of negatives with its contact print can be stored systematically and easily identified on retrieval.

BLACK-AND-WHITE FILM				
	SENSITIVITY		TYPE	MAKE
	ASA	DIN		
LOW	25	15	Agfapan 25	Agfa
	32	16	Panatomic-X	Kodak
	50	18	Pan-F	Ilford
MEDIUM	80	20	3 M 80	3 M
	100	21	Agfapan 100	Agfa
	125	22	Plus-X	Kodak
	125	22	FP-4	Ilford
HIGH	200	24	3 M 200	3 M
	200	24	Agfapan 200	Agfa
	400	27	Agfapan 400	Agfa
	400	27	Neopan	Fuji
	400	27	HP-4	Ilford
	400	27	HP-5	Ilford
	400	27	Tri-X	Kodak
ULTRA	1000	31	Recording 2475	Kodak
	4000	37		
	1250	32	Royal-X	Kodak

THE LANGUAGE OF BLACK-AND-WHITE

Nature photography is essentially research and documentation of the extraordinary, ever-changing, and continually amazing world of nature. It might seem superfluous to refer, however briefly, to the aesthetic criteria of photography, but just as the rules of grammar and syntax apply to a written document, so in the case of picture documentation the rules of composition and visual communication must be respected; both sets of rules point to the same end, to render the communication more readable and the inherent message in every image easier to assimilate. The rules of pictorial composition simply show how to bring order into the photograph so that our eyes may read easily and fully all the information that the photographer wishes to communicate.

From a given subject one can extract an infinite diversity of pictures by simply changing the three main parameters of the photograph: (1) the placement of the camera relative to the subject; (2) the focal length of the lens; and (3) the quality of light—type and direction.

Composing means appropriately framing and attentively checking all that appears on the ground glass of the reflex, eliminating anything which could create distraction or confusion, combining the essential elements so as to obtain a picture which is naturally pleasing and capable of communicating the photographer's impressions or feelings on each discovery.

The photograph in black-and-white fundamentally lacks three qualities of the real world: color; depth, or third dimension; and movement. Only with graphic and compositional contrivances is it possible to create the visual impression of these missing elements by the skilled use of contrast, perspective, and blurred movement.

Contrast is the essence of black-and-white. It may be defined as the measure of the variations in luminosity. Subjects naturally suited to black-and-white are those with sufficiently strong contrast, where the color element is of minor importance. For flat, gray subjects, one should play with the light to create light and shade where there is none, by using backlighting, for example, or emphasize structure and surfaces, accentuating the differences in tone. In black-and-white one should think of reality as being a play of light and shade, of chiaroscuro.

In looking on the ground-glass screen at the picture which you are taking, try and observe the subject while varying the photographic parameters available, eliminating all that is not strictly necessary to the picture, until you feel that your picture is immediate, pleasing, and well-proportioned. Take good care to keep the background in mind; the more uniform it is and the more tonal contrast to the subject, the more the subject will stand out. Nothing spoils a picture more than a confusing background.

Symmetry is a means of drawing the attention to the subject, which usually improves the legibility of the picture. It can also suggest immobility, which must be suitable to the subject.

Shooting with backlighting is useful to increase contrast, emphasizing the essential shapes of the subject. If backlighting is combined with strong front illumination, it helps to give a sense of depth with modeling; if, on the other hand, backlighting is strong and sharp, it tends to form a silhouette, a pure graphic effect.

Ansel Adams, a master of black-and-white. The photograph is a personal interpretation of nature—a search for a musicality of tone gradations, images of composed and solemn beauty, the fruits of great feeling and masterly technique.

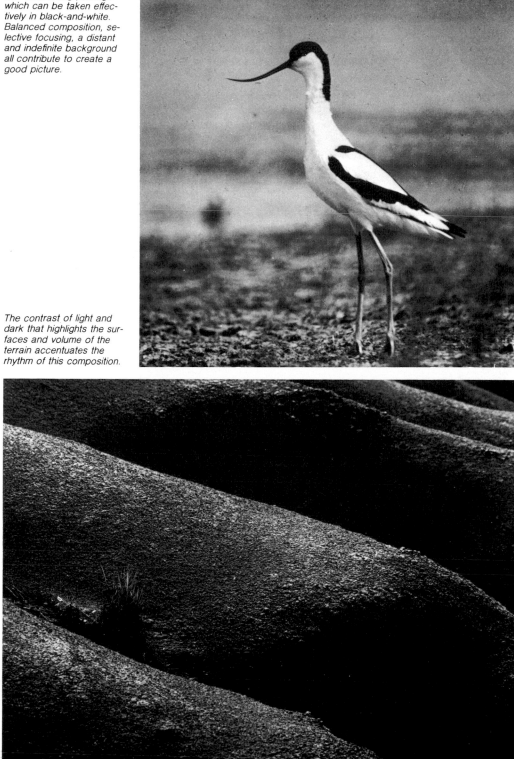

Avocet—a typical subject with contrasting plumage which can be taken effectively in black-and-white. Balanced composition, selective focusing, a distant and indefinite background all contribute to create a good picture.

The contrast of light and dark that highlights the surfaces and volume of the terrain accentuates the rhythm of this composition.

17

The disturbed reflection and the uniform background with no break in continuity give the picture of this heron the appearance of a symbol of isolation and silence.

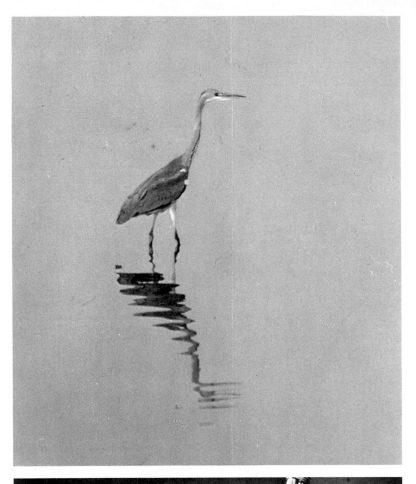

The uniform background is the compositional element governing a harmonious photographic rendering in pictures of this kind. The precarious position of the shrike clinging to the cable effectively contributes a sense of dynamism and transience.

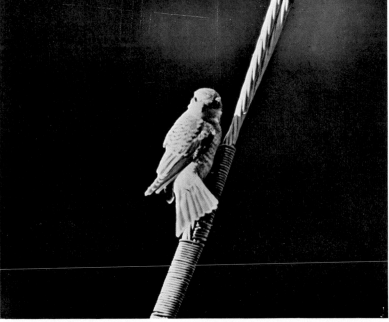

Flowers in backlighting. A typical example of how one can obtain an excellent picture in black-and-white by increasing the contrast and making full use of illumination from the back which outlines shapes, detaching them from the background.

Cheetah family. Few elements, interplay of light and shadow, diagonal composition, clean background: these are the merits of this pleasing and well-composed picture.

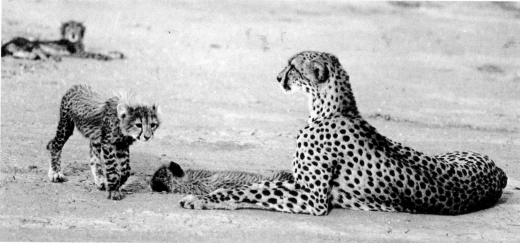

THE NEGATIVE-POSITIVE SYSTEM IN COLOR

	SENSITIVITY		TYPE	MAKE	DEVELOPMENT
COLOR NEGATIVE FILM					
	ASA	DIN			
MEDIUM	80	20	Agfacolor CNS	Agfa	Agfa PN
	100	21	3 M Color Print	3 M	C-41
	100	21	Fujicolor F-II	Fuji	C-41 or CN-16
	100	21	Kodacolor II	Kodak	C-41
	100	21	Vericolor II prof.	Kodak	C-41
	100	21	Sakuracolor II N 100	Konishiroku	C-41
HIGH	400	27	3 M Color Print 400	3 M	C-41
	400	27	Fujicolor 400	Fuji	C-41
	400	27	Kodacolor 400	Kodak	C-41
	400	27	Sakuracolor 400	Konishiroku	C-41
	400	27	Agfacolor 400	Agfa	C-41

The negative-positive process in color can be very simple or very complex: in the former case, the negative, once exposed, is sent to a laboratory for developing and printing. This will give a 9 × 13 cm (3½ × 5 inch) print at a price somewhat higher than that of the transparency and normally inferior in quality to it.

Less simply, the negative can be sent to the laboratory for developing while the print is made by the photographer, who must however have available the necessary darkroom equipment and possess the skill needed to achieve results of a consistently high quality.

Most camera users follow the first alternative for family and album-type photographs. Neither alternative is much used in nature photography for a few obvious reasons: the first one is economic—the high cost of enlarging pictures suitable for public exhibition; the second is the fact that one relies wholly on the laboratory for the quality of the prints, as it is still not so common for nature photographers to possess suitable equipment and sufficient time and experience to develop good color prints themselves.

Characteristics of Color Negative Film

Film of this kind available on the market has reached a good quality which, under different labels, is all about the same. The most critical stage is the printing, which determines the final quality of the image. On balance one can say that the average quality of prints today is satisfactory for general-purpose photography but does not permit the use of the more sophisticated equipment and techniques, the fruit of personal investment and considerable commitment which characterize the serious nature photographer. Negative films constitute a sufficiently homogeneous group. They are all color balanced for daylight, and can be developed in the same manner (except Agfacolor CNS); after developing they show the same characteristic orange color. This background tonality in negatives, known as a mask, is used to improve the purity of colors in printing. These films can be used to take pictures in artificial light without filters, as it is possible to correct the balance afterward with filters during printing. They are divided into two distinct categories: medium- and high-sensitivity film. The high-sensitivity film was made available only a few years ago, and it has inaugurated the epoch of available-light color prints. A useful characteristic to keep in mind is the possibility of printing directly from the negative in black-and-white or color, and on positive material for projection or for viewing panels.

Color prints make attractive wall decorations. One should, however, avoid exposing the prints to direct sunlight, which can affect the not very permanent dyes in the photographic paper.

THE REVERSAL SYSTEM FOR COLOR TRANSPARENCIES

The positive image is formed during the processing, directly on color-slide film used in the camera: each transparency is an original which can be seen in a viewer, but in order to be enjoyed, should be projected on a screen. This limitation on the use of transparencies has for many years restricted their circulation. Transparencies have always been preferred by the professional, as they are the most suitable material for separation, plate-making, and printing. Since automatic projectors became available, which greatly simplify the projection of transparencies, making it a straightforward and pleasant operation, they have acquired a greater and well-deserved popularity. Furthermore, reflex cameras, with their exposure precision, have made it easier to obtain satisfactorily consistent results with these materials.

The extraordinary color quality, combined with modest price, have ensured the supremacy of transparencies in all nature photography. For years Kodachrome has been the material most used in the field of nature photography on account of its high definition and good color quality. Its disadvantages include limited sensitivity, or speed (two kinds are available, ASA 25 and ASA 64), and the need to have the processing carried out exclusively in professional laboratories, as it is highly complex. Other reversal materials can be home-developed. The quality of all reversal material is usually very good: choice depends on personal taste for color quality, balance, and contrast. The most common development process is the Kodak Ektachrome line, identified by code number E-6. This process is also used for 3M, Fuji, and Sakura films. The relative simplicity of the Agfa line makes feasible its use by the amateur photographer for home development with satisfying results.

One characteristic of the reversal system is that developing must be as even as possible so that the color balance and the quality of reproduction do not suffer. The only variation permitted is increasing the development time, which allows one to push the speed of the film beyond its nominal value: in many cases one can ask professional laboratories for a lengthened development, simply indicating the actual sensitivity at which the film was exposed, obviously within the limits set by the manufacturer. Altering the development time is useful when justified by critical shooting conditions, but it must be understood that it involves a deterioration in photographic quality. Developing slide films oneself may only be of advantage where laboratories are difficult to find or if rapid processing of the shots taken is required. Precision in the operations is needed to ensure consistent results, and only regular use of the process justifies the purchase of the developing kit and allows it to be put to optimum use.

In projection transparencies display the whole of their wide tonal gradation and have the capacity to convey the reality captured through the lens.

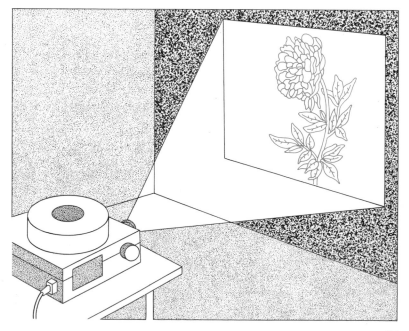

Characteristics of Color Slide Films

There are two well-defined types of color slide film: those for daylight, balanced for color temperatures of 5000°K to 6000°K; and those for artificial light, 3200°K (type B) and 3400°K (type A). As the positive image cannot be corrected after development, one must purchase film suited to the kind of light being used. However, a daylight film can be used with artificial light, and vice versa, using suitable conversion filters.

Color slide films are the ones most used by nature photographers on account of their capacity to render effectively the whole range of color tones, as the picture below of the scarlet ibis illustrates. Some of the reversal films most widely used are listed in the table below.

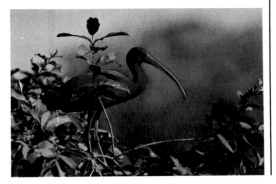

COLOR FILTERS

Reversal material requires the use of filters, which can be glass, mounted to be screwed onto the lens barrel, or gelatine, used with appropriate universal attachments. A through-the-lens exposure meter system compensates automatically during exposure for the subtraction of light due to filter absorption. We shall now look at the kinds of filters which interest the nature photographer.

Neutral Protection Filters

There are two neutral filters: skylight and UV (ultraviolet). Both kinds can be securely mounted to the lens to protect both the front surface of the lens and the screw thread from dust, spray, and abrasion. The skylight filter has a very soft amber color, which warms the image a little. It is advisable when the illumination from a sunless sky would tend to give a cold tonality. The UV filter cuts out only ultraviolet radiation, eliminating the faint haze in panoramas. On account of its absolutely neutral quality, it is preferable to the skylight filter as a permanent protection.

Conversion Filters

The 85B filter is used to allow a film balanced for exposure with tungsten artificial light to be used with natural light. This filter is orange and it restrains the effect of excessive blue. The 80A filter is sky-blue in tone and is used with normal daylight film exposed in artificial light, which is richer in yellow light. If we use the two filters together, we obtain a gray density, that is, a neutral density, since the two complement one another. In nature photography, however, the use of these filters is limited.

COLOR SLIDE FILM					
	SENSITIVITY	TYPE	MAKE	COLOR BALANCE	DEVELOPMENT
	ASA DIN				
LOW	25 15	Kodachrome 25	Kodak	daylight	special Kodak K-14
	64 19	Kodachrome 64	Kodak	daylight	special Kodak K-14
	40 17	Kodachrome 40 A	Kodak	artificial light (3200 °K)	special Kodak K-14
	64 19	Ektachrome 64	Kodak	daylight	E-6
	50 18	Agfacolor CT 18	Agfa	daylight	Agfa
	50 18	Agfachrome 50 S	Agfa	daylight	Agfa P-41
	50 18	Agfachrome 50 L	Agfa	artificial light	Agfa P-41
MEDIUM	100 21	Agfacolor CT 21	Agfa	daylight	Agfa
	100 21	3 M Color Slide 100	3 M	daylight	E-6
	100 21	Fujichrome R-100	Fuji	daylight	E-6
	100 21	Sakuracolor R-100	Konishiroku	daylight	E-6
HIGH	160 23	Ektachrome 160	Kodak	artificial light	E-6
	200 24	Ektachrome 200	Kodak	daylight	E-6
	400 27	3 M Color Slide 400	3 M	daylight	E-6
	400 27	Fujichrome 400	Fuji	daylight	E-6
	400 27	Ektachrome 400	Kodak	daylight	E-6

THE POLARIZING FILTER

This photograph was taken with a polarizing filter attached to the lens in the position of minimum absorption. The resulting image is the same as if the shot had been taken without the filter.

By rotating the filter one finds the angle of maximum absorption. In this image the reflections on the sea have diminished and the tonality of the water has turned to green.

Photograph in which the polarized effect is absent. Note the abundance of reflections from the water of the stream.

Here the polarizing filter has been used. The reflections have almost completely vanished. The longer length of time required has produced a more blurred image of the water.

This filter consists of a gray polarizing screen in a rotating mount. By turning the filter, it is possible to find the position of maximum absorption of the light which is already polarized by natural effects. The extent of the filter's effect depends also on the shooting angle and the amount of polarized light present.

In sunlight there is always an area of the sky in which polarized light is present. This belt forms a right angle with the direction of the sun's rays and can be identified by observing the sky through the viewfinder of the reflex and turning the filter until the best effect is obtained.

Polarized light is also produced when light falls onto a nonmetallic reflecting surface. If reflected at an angle around 30° to 45°, the maximum effect is produced. The surface of still water gives a strong mirror-like reflection, but even reflection from disturbed water has a noticeable polarizing effect. Ice in a sheet reflects polarized light.

The best angle for the filter should be found by directly observing the image on the focusing screen, and the exposure measured by means of the meter when the filter is properly positioned, because absorption by the filter depends on the effective fraction of light blocked. For example, when a filter is used to block very bright reflections, the exposure can be affected to a very large extent.

In environment photography in sunlight, the polarizing filter proves a very useful instrument for increasing color saturation, reducing haze, and enhancing the blue sky, which takes on deeper, more contrasted tones.

When a wide expanse of water is present, the best effect between the two extremes can be selected, that is, the complete presence or complete absence of reflections. The latter sometimes appears unnatural, because it drastically alters the normal appearance of a sheet of water.

23

PROJECTORS

The need to project transparencies is of itself a considerable limitation on the enjoyment of photos on slide film, especially if the method of projection is inconvenient. With the advent of the automatic magazine projector, the process has been simplified by avoiding the continuous interruptions and tiresome movements characteristic of single-frame projectors. The modern projector has achieved a measure of reliability and simplicity which permits easy and frequent use. Automated ones for 35 mm formats are quite popular: the feed and projection of the transparencies are effected by an electric control on the projector or by cable. Transparencies mounted in frames 5 × 5 cm (2 × 2 inches) are placed in plastic or metal magazines which allow rapid sequence projection and are also useful for storing them.

Projectors can also possess other characteristics, depending on the purpose for which they are to be used. Automatic focusing proves very useful when mounts without glass are used; transparencies move about in the magazines on account of their thinness, and would otherwise require frequent adjustment to the focus. A zoom projector lens avoids the need to adjust the distance between the projector and the screen and can be handy in projecting in rooms of varying sizes; however, it normally has an optical quality inferior to that of ordinary lenses. A good projector will possess the following characteristics: mechanical reliability, simple and easy operation, compactness, and portability, which turn it into a really efficient and serviceable domestic appliance.

For transparencies of a 6 × 6 cm (2¼ × 2¼ inch) format (in frames 7 × 7 cm) the range of projectors with characteristics similar to the 35 mm format is somewhat reduced. The prototype of these is the classical Rollei P.11 twin-format projector, which for many years was the only one with a high standard of performance, an automatic magazine, and feed-through. The Rollei magazine is the only one which takes the 6 × 6 format and it holds 36 slides. But it has the disadvantage of letting the frames slip out if the magazine is tilted, and this can spoil the image if the glass on the frame breaks.

Mounts for Slides

The 35 mm slides are normally returned by the laboratory in plastic or cardboard mounts: the latter are less satisfactory as they are very light and easily bent. The usefulness of glass mounts is questionable. The advantage of greater protection from dust and fingerprints must be weighed against high cost, greater fragility, and a tendency for mold to form on the emulsion. In any event, it is better to use ordinary plastic mounts without glass when slides have to be sent by mail, taking the added precaution of protecting them in transparent plastic envelopes.

Mounts for 6 × 6 cm (2¼ × 2¼ inch) slides are only available in glass as a rule. They are fairly expensive and may only be used on a few projectors, by means of the Rollei magazine for 36 slides.

Magazines for 5 × 5 cm (2 × 2 inch) Transparencies

Linear magazines. They have the great advantage of possessing a larger stor-

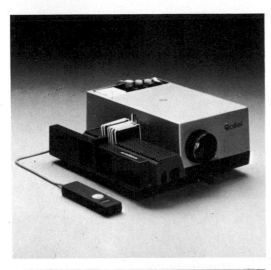

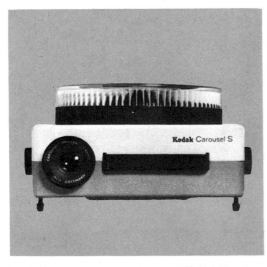

Various kinds of automatic projectors for slides. From top down: Rollei P.350 AF, GAF 201, Kodak Carousel S.

age capacity for slides and are fairly reasonable in price. The standard Rollei-Leitz magazine is linear, holding 36 or 50 slides. Low in price and easy to operate, it is widely used. It has the disadvantage of allowing the slides to drop if the magazine is tilted slightly to one side. On the other hand, the slides are easy to handle even during projection.

The Paximat-GAF magazine is linear, also holding 36 or 50 slides. As it is enclosed on three sides, it gives a greater degree of security in use and avoids the accidental dropping of the slides. For the same reason slides cannot be handled during projection.

Rotary magazines. These allow continuous uninterrupted projection of at least eighty slides in 5 × 5 cm frames. On the other hand their storage capacity in relation to volume is low, and price is rather high. The most widely used ones are of three kinds: rotary magazines of the Prestinox type, which is compatible with the Leitz linear system, holding 100 slides, and which is mounted vertically on an appropriate rail; the Paximat magazines, to go with the Paximat linear system, which carries 100 slides and is also mounted vertically but enclosed on three sides, which avoids the risk of letting the slides slip out; the Kodak magazine, which holds 80 slides and possesses the professional features of being solidly built and reliable. It is used in a horizontal position and the slides slip into the projector through a slot in the magazine, which prevents accidental exit of frames.

Lap Dissolve

The quality of a slide show is considerably enhanced by means of a device synchronizing two projectors operating alternately with uninterrupted continuity, eliminating dead points, dark breaks or, worse, glare breaks on the screen. Eyesight is less strained, and there is a much more pleasing effect due to the sequence of images that merge into one another.

The sequence must be programmed with precision because the two magazines contain alternating images of the same sequence. A number of different devices have been developed for this kind of projection, for example from Kodak, Prestinox, GAF, and Zeiss. The Kodak system, which is the most fully developed, can also be extended to several pairs of projectors operating simultaneously to achieve the so-called multivision; the screen is divided into compartments, on each one of which a single pair of projectors is focused, operated by one control box. To produce these visual displays an onerous business of multiple mounting is needed, more akin to cinematography than to photography. A new horizon in this field has been opened by a revolutionary projector, the Rollei P-3800, which can produce a lap dissolve projection by means of a single linear magazine. The projector selects the slides and feeds them alternately to the two projection units. The simple process of operating an ordinary slide magazine makes this kind of projection, which is of a better quality, available to a much wider public. The only disadvantage is the more limited capacity of the

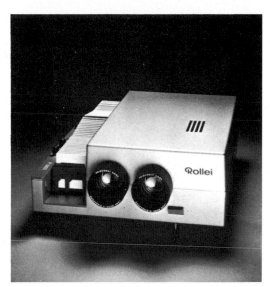

Rollei P 3800 projector with dual projection system to allow lap dissolve.

Rollei linear magazine, which can hold only 50 slides at the most, and the set distance between projector and screen due to the preset angle of the two lenses. Lap dissolve provides a new dimension, a smooth, pleasant projection with a quality which transforms and broadens the expressive potential of this instrument of communication; it is no longer pure still photography yet remains distinct from the cinema.

Kodak system for lap-dissolve projection which uses two Carousel projectors and a single control.

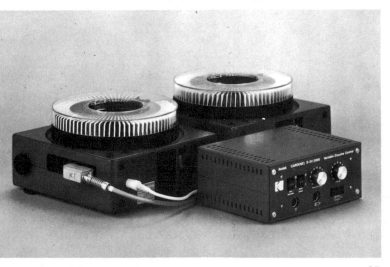

THE STORY IN PICTURES

A sequence of pictures, individually valid, yet in no special order, inevitably soon tires the viewer; to hold attention there should be an informative commentary, too. The model to approach is the movie, but compared with the amateur cinema, a sequence of slides presents different characteristics and some advantages: very high photographic quality compared to 8 mm or 16 mm formats; low cost; set-up which is easier and simpler to alter even at the last minute to suit a particular audience. For example, one can fill out a theme by adding slides in sequence and removing others to take account of the interest-level of the audience.

The essential elements that transform a sequence of slides into a practical and effective vehicle of communication, a real audiovisual device, are the following: the careful choice of pictures both as regards photographic quality and topical relevance; editing which is consistent and pleasing at the same time; a sound commentary, which is significant and thorough; and finally, quality in the projection, without jumps or interruptions, for example, through lap dissolve to create a fluid rhythm in the narration.

Rules for Creating Picture Narration

First one must be clear about what one wants to narrate, and one should possess a good selection of pictures on the topic. Then some basic editing must be done (to be submitted if possible to some qualified friends for their opinion). The same feelings and interests which affected us in the discovery of nature should also take hold of the viewer, but one must avoid showing him fruitless waiting or personal mistakes. The first rule for producing a picture narration: the more items of news or information which are condensed into the image, the slower and more difficult will be the reading. It can happen, for example, that a foreground subject needs only a short time to be accepted, while an environment or a panorama must be described and commented on at greater length. Second rule: if, from one frame to the next, everything stays constant save the position of a single object and this draws all attention, the sequence acquires a dynamic third dimension which lends meaning even to photographs that would have been insignificant on their own. Third rule: the viewer cannot follow different subjects which are moving or alternating in a disorderly fashion from one frame to the next. The thread of the narrative is lost, as in a novel with an overelaborate plot.

There are two kinds of sequence: simple sequences with continuous framing, a single subject which moves as in the example above; and complex sequences, which require a real cutting and editing operation, starting from hundreds of transparencies on a specific subject. Producing a valid sequence in this case demands special skills and an accurate knowledge of the subject under review. A sequence can, for example, describe the discoveries of a wildlife photography expedition or the life of an animal, or describe a natural environment.

For the practical creation of a sequence, one needs a slide-editing panel large enough to display about thirty mounted transparencies. The slides dealing with one topic are spread on the light box and then, as in a jigsaw puzzle, they are shifted about and rearranged in the order of the narrative. From the first sequence of images, remove all those which are not strictly necessary. Starting

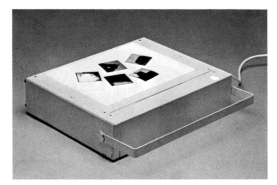

A light box is used to select slides.

with the same photographs, on the basis of ability and experience, one can create an interesting and effective sequence or a confused and tedious one. From a practical point of view, in producing a sequence, the following points should be kept in mind.

Photographic aspect of the picture. A preliminary selection should ensure that all technically unsatisfactory slides have been discarded at the outset. However, in some cases even pictures that are photographically poor in quality can be used if they are irreplaceable in the narrative. Skillful editing helps to make full use of the documentary content, minimizing photographic deficiencies. For example, a picture that is too bright, overexposed, will pass almost unnoticed if coherently inserted in a series of clear, sunlit pictures. An image which is slightly blurred can be inserted in a sequence of movement in rapid succession, achieving a wholly acceptable effect while preserving the photo's documentary function. With coherent editing one can use blur to great effect to convey a sense of both dimension and dynamics.

Natural History aspect. The validity of a nature picture depends on the way it records or highlights some natural phenomenon, for example, the description of a place or the image of a rare subject or one that is especially difficult to approach, or the documenting of animal behavior of an unusual or interesting kind. High photographic quality enhances its documentary value, but is something entirely separate. Thus one

On the right: Example of a simple sequence in which the framing is fixed and only the subject moves. During the projection the audience will be able to follow the snail through the various stages of its difficult crossing from one leaf to another.

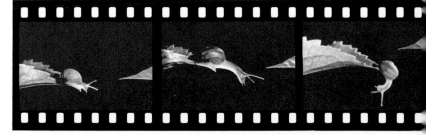

can have high quality pictures of little interest to the naturalist or, on the contrary, poor pictures possessing great documentary value. The purpose of this book is to provide the tools to improve the photographic quality of pictures which should possess a validity of their own owing to their focus on nature.

As regards sequence, in the choice of pictures we advise avoiding jumps in luminosity or color between one slide and the next where this is not meant to indicate an abrupt change in the narrative. The narrative must flow coherently and consistently also from a visual point of view, without tiring the eyes, which should be allowed to adjust to a sequence of images passing from very dark to very bright. If one particular tone predominates in a set of slides, owing, for instance, to the color of the light or to reflection off the surrounding vegetation, introducing pictures which markedly deviate in tonality from the usual will break the rhythm of the sequence, and these images will appear incongruous.

As a general rule the advice to discard all slides not strictly necessary to the narrative always holds good. A sequence should not be too long because the audience will tire after several dozen slides, and their attention tends to wander.

Sound

Once the slides have been selected and loaded into the magazine in a certain sequence, they are numbered appropriately so that they can always be identified. The commentary can now be drafted. (One should already have a

broad outline of this in mind when choosing the slides.) In essence there are two methods which may be followed in producing a sound commentary: The first method is to produce a commentary to be read out loud or, better to be used as an outline during projection—the outline is an easier and more flexi-

ble method, which allows one to adapt the commentary to the needs of the audience.

Care is required in synchronizing the commentary with the slides; the author should normally do this himself, being familiar with the pictures and the way in which they were produced. The second method makes use of tape recorders to produce a recorded commentary which is synchro-

nized with the slides. Cassette recorders are available on the market which greatly simplify the whole work of synchronization as well as the projection stage, like the Philips 2229, which can be connected by means of an attachment to all modern kinds of projectors and allows simultaneous recording of the

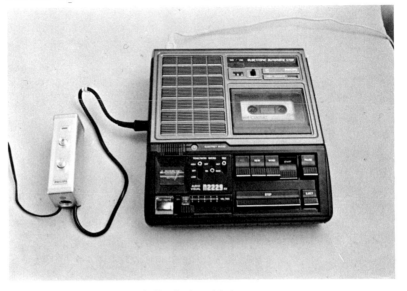

Philips 2229 recorder equipped with attachment to be connected to the projector to synchronize sound on slide sequences.

sound commentary on the first track of the magnetic tape and the slide change signal on the second track. In this way the sequence becomes a really independent audiovisual package which can be shown with or without the narrator.

Since cassette recorders like the 2229 are low-powered, on many occasions it is necessary to amplify the signal: one interesting and helpful

suggestion here is to use the "active" type Philips "Motional Feedback" acoustic box, which greatly simplifies the problem. In preparing the commentary, the first piece of advice is to let the image speak, avoid being verbose or generalizing and telling the obvious. Naturalist references should be given in

terms suited to the audience in question. It is well to quote the names of species being shown in addition to the location and time when the shots were taken. Information on photographic technique is often appreciated.

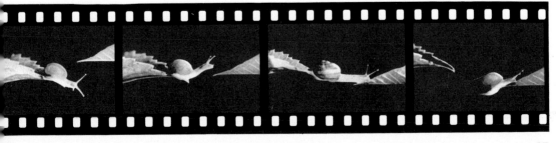

FROM ONE SYSTEM TO ANOTHER

The choice of an ideal process, which in the field of nature photography is normally the reversal process to produce transparencies, does not rule out the possibility of changing from one to another with satisfactory results. We need only remember that each additional process to which the original is subjected reduces the quality of the image to some extent. One can obtain good results, however, by using sufficiently accurate techniques of reproduction.

What are the necessary materials? The simplest instrument is the transparency copy holder, consisting of a tube to be fixed to the camera, equipped with lens and slide holder. It has the advantage of being inexpensive and practical. Results are fairly good. As a light source one can use sunlight directly, measuring the exposure with the normal through-the-lens meter of the camera, or flash may be used, which requires a calibrating test, however. The focusing

equipment consists of a stand with a built-in electronic flash in the base and a pilot light, allowing for duplication of transparencies with a fair degree of control of both composition and contrast.

The purchase of this equipment can be justified if one is interested in modifying or elaborating pictures rather than in straightforward and occasional duplication.

Types of Transfers

From black-and-white negatives two alternative possibilities exist: the ordinary print on paper and the black-and-white transparency. Such transparencies can be obtained by contact printing on positive material made for this purpose. The usual development processes are used. A special material is also available on the market from which transparencies in black-and-white can be directly obtained—the Diadirect from Agfa, sold with the processing kit, or Kodak 5246 Direct-Positive film. In

results are obtained with soft prints, as the contrast of the image tends to sharpen.

From color negatives all three types of reproduction can be directly obtained (color print, print in black-and-white, transparency) with a single step—an advantage to bear in mind in the choice of this material. The quality can be very good if each stage is given proper treatment in the darkroom.

A color transparency may be obtained from a color negative by printing on positive material, which needs special processing.

A black-and-white print with correct tonal rendering can only be obtained with panchromatic paper of the Kodak Panalure kind. Nevertheless, color negative

tion. The quality of the copy depends a great deal on the method used as well as the film: working with a professional copier, one can also improve the image, controlling both composition and contrast.

Color prints on paper are obtained with two different materials, both for direct printing: on Cibachrome paper, by means of a developing process simple enough to be done even with a minimum of darkroom experience; and on reversal paper of the Ektachrome 2203 type, which requires a less simple processing, best dealt with in a professional laboratory. Results are good if

Professional equipment for copying transparencies consisting of a stand and a system of flash illumination with a pilot lamp.

Common method for copying transparencies with geared bellows extension and slide-holder attachment.

needs particular attention. On the other hand, if you already possess a bellows for macrophotography, it is almost always equipped with an accessory for copying transparencies. Apply the normal techniques of macrophotography. Finally, the specialized, more expensive

many cases another simple and fairly practical alternative exists: taking a photograph of a black-and-white print, measuring at least 8×10 inches, with normal color slide material. Shooting must be done with special attention to the evenness of the lighting and the neutrality of color. The best

film has a sufficiently light mask to allow printing on ordinary black-and-white paper, with results that are often reasonably faithful to the color tonality in the negative.

From the color transparency, copies of the same format can be obtained with the methods already described, using a normal reversal material with high definition or special reversal material for reproduc-

the initial image is suitable and balanced in terms of color and contrast. Softness of tone helps the reproduction, which tends to accentuate contrast. The cost averages double that of prints obtained from a negative. Prints in black-and-white can be obtained by rephotographing the transparency with negative black-and-white film and then printing from this by the normal process.

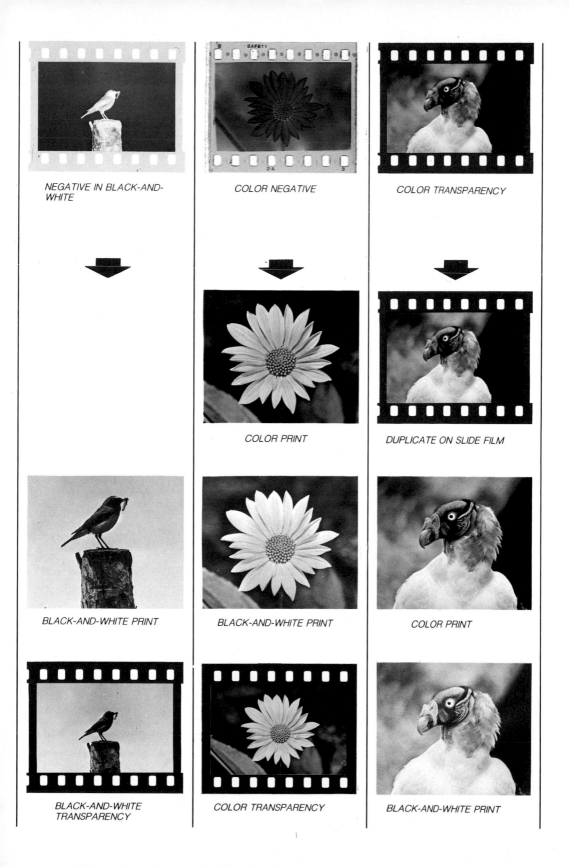

NEGATIVE IN BLACK-AND-WHITE

COLOR NEGATIVE

COLOR TRANSPARENCY

COLOR PRINT

DUPLICATE ON SLIDE FILM

BLACK-AND-WHITE PRINT

BLACK-AND-WHITE PRINT

COLOR PRINT

BLACK-AND-WHITE TRANSPARENCY

COLOR TRANSPARENCY

BLACK-AND-WHITE PRINT

THE REFLEX SYSTEM

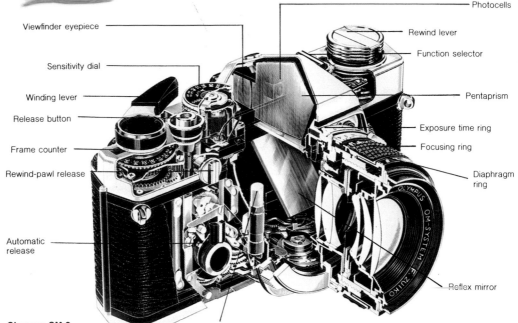

Viewfinder eyepiece

Sensitivity dial

Winding lever

Release button

Frame counter

Rewind-pawl release

Automatic release

Olympus OM-2

Photocells

Rewind lever

Function selector

Pentaprism

Exposure time ring

Focusing ring

Diaphragm ring

Reflex mirror

Pneumatic shock-absorber for reflex mirror

All branches of nature photography have expanded following the widespread introduction of the modern single-lens reflex camera (SLR). The remarkable versatility of these cameras is well suited to the requirements of both studio and nature documentation. The modern single-lens reflex possesses three fundamental characteristics: direct vision of the image; extreme adaptability of the system, which can use dozens of different pieces of equipment on the same camera body; and through-the-lens metering, which greatly simplifies the problem of exposure.

Direct Vision

Direct vision on the ground-glass focusing screen of the same image which is registered on the film is essential to rapid and sound choice of composition and focus, and to decide if the lens is the one most suited to the subject. There are two kinds of viewfinders:

1. The waist-level viewfinder, in which left-right reversal of the visible image occurs, so that shooting can be difficult, especially when the subject is moving.

2. The pentaprism viewfinder, in which the image appears exactly as we see it in reality. This is the most popular one because it constitutes the best compromise for convenience, perfect image vision, and focusing.

Vision in the reflex-camera viewfinder can be difficult if mechanically old-fashioned lenses, without automatic diaphragm, of small aperture are mounted, which must be stopped down before shooting.

The reflex camera is a precision instrument giving a remarkable performance: in or on the camera body, the heart of the system, are hundreds of component parts, providing for the whole field of photography as applied to the documenting of natural and scientific subjects.

Adaptability

The direct vision in the finder of the image that strikes the film is the key which has opened photography to the once impractical use of ultralong-focus, ultra-wide-angle, super telepho-

to, zoom, and macro lenses. The camera body is now an accessory which transforms traditional scientific equipment for direct vision into photographic instruments, for example, in photomicrography and astronomic photography.

Measuring Light Through the Lens

This technique has freed photography from uncertainty regarding exposure

and from the frequent errors that often in the past made each picture a matter of pure chance. Furthermore, it has helped to spread the use of color slide film, which on account of its narrow latitude, requires very accurate exposure.

On the opposite page: Lenses for the Nikon 35mm camera system (the table for telephoto lenses is on page 33).

The viewfinder of the reflex allows one to control both the exposure meter parameter and the focus.

22 • 16 • 11 • 8 • 56 • 4 • 28 • 2 • 14

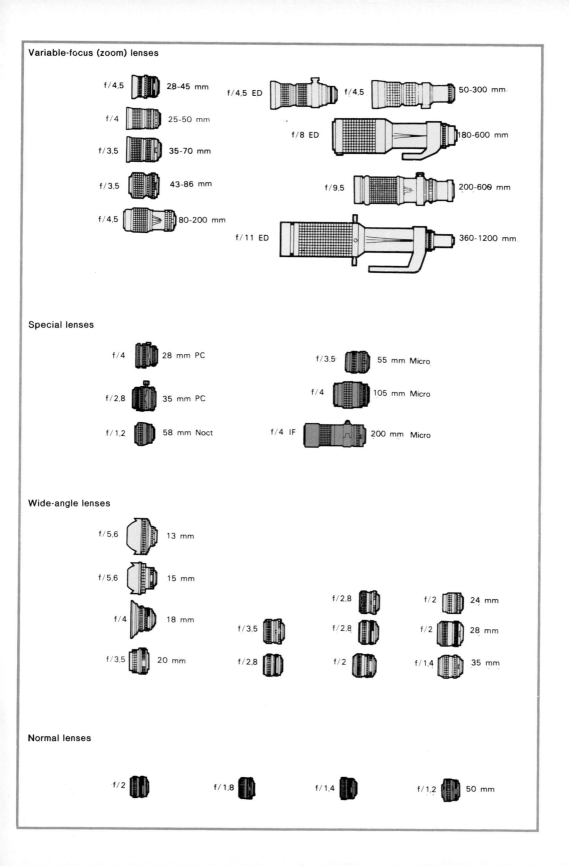

Variable-focus (zoom) lenses

f/4,5 — 28-45 mm
f/4,5 ED —
f/4,5 — 50-300 mm
f/4 — 25-50 mm
f/8 ED — 180-600 mm
f/3,5 — 35-70 mm
f/3,5 — 43-86 mm
f/9,5 — 200-600 mm
f/4,5 — 80-200 mm
f/11 ED — 360-1200 mm

Special lenses

f/4 — 28 mm PC
f/3,5 — 55 mm Micro
f/2,8 — 35 mm PC
f/4 — 105 mm Micro
f/1,2 — 58 mm Noct
f/4 IF — 200 mm Micro

Wide-angle lenses

f/5,6 — 13 mm
f/5,6 — 15 mm
f/4 — 18 mm
f/2,8 — 24 mm
f/3,5 — 20 mm
f/3,5 —
f/2,8 —
f/2 — 28 mm
f/2,8 —
f/2 —
f/1,4 — 35 mm
f/2 — 24 mm

Normal lenses

f/2 —
f/1,8 —
f/1,4 —
f/1,2 — 50 mm

CAMERA LENSES

The camera lens plays the leading role in the technique of photography. This is even more so in nature photography. Each lens has a personality, its own particular way of solving a given photographic problem. First one must get to know the characteristics which identify lenses and their functions, to be able later, on the basis of personal experience, to "feel" which one is the most suited to particular requirements.

Characteristics of Lenses

Focal length, expressed in millimeters, corresponds to the distance between the plane of the image and the center of the lens when it is focused on an object at infinity. The effective length does not always coincide with the optical one, insofar as the use of special optical or mirror systems allows the length to be con-veniently reduced for practical purposes. The normal focal length corresponds with the length of the diagonal of the format. All lenses of a given focal length, regardless of type, form images of the same size on the film.

Maximum aperture is expressed with a diaphragm number which is a fraction corresponding to the relation between the focal length and the effective maximum diameter of the lens. It is important to familiarize oneself with this concept because it is most useful for a speedy calculation of the diaphragm aperture of any lens or optical system. For example, if a lens of 300 mm focal length has an effective aperture of 37 mm, the diaphragm aperture is 300/37 = 8.

Denomination (for example, Telyt) follows the name of the manufacturer (for example, Leitz). This distin-guishes the optical structure of the lens.

Serial number identifies the lens and should be noted for the purpose of guarantees, customs registration, and insurance.

Type of mechanical attachment on the camera body shows what reflex system it belongs to. There are specific attachments for each particular reflex system and attachments common to cameras of different manufacturers. For example, the screw-on attachment 42 × 1, still in common use (for which a very large number of lenses are available at modest prices), and the K type attachment, introduced by Asahi to replace the 42 × 1, already being used by Mamiya, Ricoh, and Pentacon, which amounts to a praiseworthy attempt at standardizing optics.

Attachments differ in the following respects:

1. The type of mechanical coupling (of three kinds: screw-on, bayonet, stop ring).

2. The extension, corresponding to the distance between the plane of the film and the plane of contact of lens and camera body. This distance establishes whether a lens belonging to another system can be attached to a camera body, at least theoretically. Lenses with a longer extension than the original can be used, but only with special attachments which compensate for this difference. Rarely is there any advantage in this because automation is almost always lost. The extensions of some of the more widespread cameras (in millimeters) are: Konica, 40.5; Canon, 42.1; Minolta, 43.5; Topcon, 44.7; Pentax, 45.5; Yashica Contax, 45.5; Olympus, 46; Nikon, 46.5; Leicaflex, 47.

3. The diameter of the attachment ring in millimeters. The larger it is, the more viable it is, facilitating the coupling of even ultra-long-focus lenses.

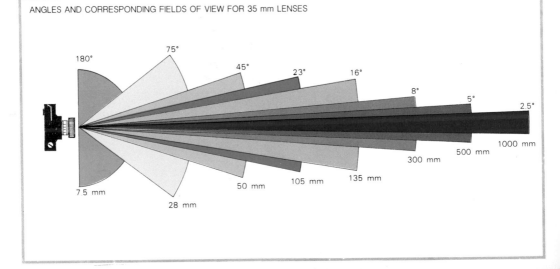

ANGLES AND CORRESPONDING FIELDS OF VIEW FOR 35 mm LENSES

180° 75° 45° 23° 16° 8° 5° 2.5°
7.5 mm 28 mm 50 mm 105 mm 135 mm 300 mm 500 mm 1000 mm

Above: Each focal length has a field of view angle. With the same format, when the focal length of the lens is doubled, the angle of view is approximately halved.

By changing the focal length of the lens, different pictures can be obtained from the same position.

4. The diameter of the front screw thread on filters and lenses. The advantage of having a single screw-thread size for many lenses of the same reflex system is very valuable, because it avoids cumbersome and expensive duplicates.

The Choice of Lens

The choice of lenses is based on two general principles:

1. To cover the greatest number of shooting requirements with the smallest number of pieces, for both economy and convenience.

2. To possess a wide aperture. This is generally an advantage, but since for every additional *f* number the optical surface is doubled, the average cost and weight are correspondingly increased in line with structural features. Therefore, the rule is not always followed. Anyhow, the widest aperture lens is not always the most advisable. For specific purposes, a working compromise must be found each time. For example, in wildlife photography, the aperture of the telephoto lens is often vital, while in macrophotography it is of secondary importance, as small diaphragm apertures are normally used to lengthen the depth of field sufficently.

Focal length should be chosen, for both wide-angle and telephoto lenses, on the basis of actual need, trying not to deviate too much from the normal length.

The focal length determines, depending on format, the angle of field. Each time that the focal length is doubled, the effective area of the subject framed is halved and the focusing screen will show linear dimensions doubled.

It is helpful to choose a set of lenses with the focal lengths sufficiently distant

On the right: Telephoto lenses and teleconverters of the Nikon 35 mm system.

Below: Mirror (catadioptric) lenses.

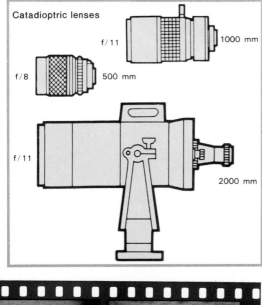

Catadioptric lenses

f/11 — 1000 mm

f/8 — 500 mm

f/11 — 2000 mm

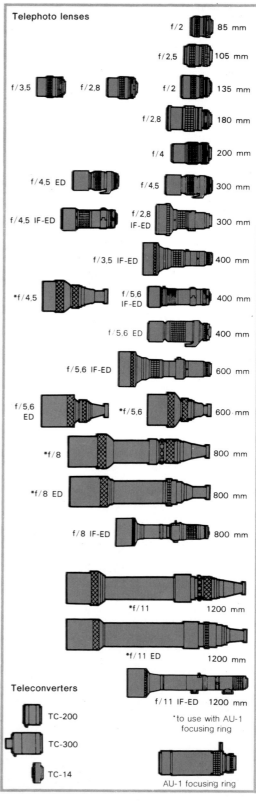

Telephoto lenses

f/2	85 mm
f/2,5	105 mm
f/3,5 f/2,8 f/2	135 mm
f/2,8	180 mm
f/4	200 mm
f/4,5 ED f/4,5	300 mm
f/4,5 IF-ED f/2,8 IF-ED	300 mm
f/3,5 IF-ED	400 mm
*f/4,5 f/5,6 IF-ED	400 mm
f/5,6 ED	400 mm
f/5,6 IF-ED	600 mm
f/5,6 ED *f/5,6	600 mm
*f/8	800 mm
*f/8 ED	800 mm
f/8 IF-ED	800 mm
*f/11	1200 mm
*f/11 ED	1200 mm
f/11 IF-ED	1200 mm

Teleconverters

TC-200

TC-300

TC-14

*to use with AU-1 focusing ring

AU-1 focusing ring

from one another, for example, each one half that of the next. To get some idea of the magnification a lens produces on a given format, divide its focal length by the focal length of the normal lens, which for a 35 mm format is generally 50 mm. Note the data on angle of field and focal length in the illustration, page 32. The lens equipment must be chosen to avoid duplicates or gaps that could inconvenience the photographer.

The normal lens is the one that comes closest to direct vision. Its greatest advantage lies in its usually wide aperture and its reasonable price. A possible alternative is a special normal-focal-length lens for macrophotography (the best known is the Micro Nikkor 55 mm *f*/3.5), which gives less aperture but has special optical features and is particularly useful in macrophotography, reaching the ratio 1:2 directly with the focusing helix, and the ratio 1:1 with an appropriate extension.

Lenses for the 35 mm format can be listed in categories, on the basis of their function:

1. *Short wide-angle lenses* from 24 to 18 mm focal length, are expensive, more creative, and demand careful handling but in some cases are irreplaceable.

2. *Medium wide-angle lenses* from 35 to 28 mm, practical and versatile, are better if used with medium aperture. They may be considered the normal lens for environment photography.

3. *Normal lenses,* very widely used, reach the maximum apertures (up to *f*/1.2) and are usually the least expensive, compared with wide-angles and telephotos.

4. *Short telephoto lenses* from 85 to 200 mm, with sufficient aperture and flexibility, are frequently used for near-distance subjects, for detail, and also in macrophotography.

5. *Medium telephoto lenses* from 300 to 600 mm, with smaller aperture, are heavier and more expensive. They are com-

monly used in wildlife photography.

6. *Super telephoto lenses* from 800 to 2000 mm, are heavy and large, high-priced, and with limited aperture. If used with due patience and care they can give great satisfaction in wildlife photography at medium and long range.

7. *Lens converters* are not lenses but optical components which, when placed between the camera body and the lens, increase the focal length by a constant factor, for example, 4, 2, or 3. They are useful in terms of flexibility and convenience.

MEASURING LIGHT

Measuring light by means of the through-the-lens exposure meter simplifies exposure to a remarkable degree. With any lens it is the image framed which determines the actual exposure, and also the meter automatically takes into account any accessory attachment, for example, bellows, filters, etc., which could subtract further light.

Methods used for measuring light in reflex cameras are of two kinds: (1) Effectively shutting the diaphragm (stopping down), and (2) full aperture, which is more functional. How they differ must be clearly understood, because one may have to use either method with lens-camera combinations, even with sophisticated equipment.

Methods of measuring with diaphragm change consist in measuring the light which will effectively fall on the film with the chosen aperture; by means of a pushbutton the exposure meter circuit is closed, the diaphragm shuts, and at this point one can center

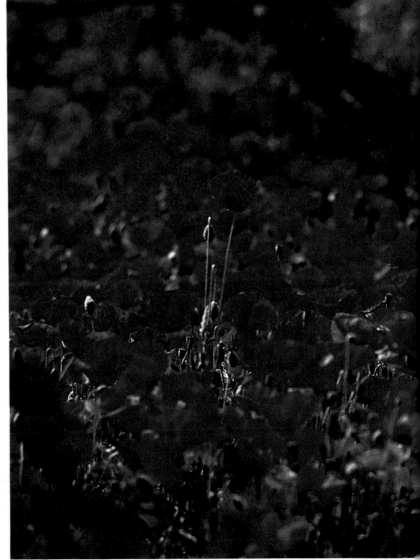

the index needle with the reading in the viewfinder to select the correct exposure, with shutter speed and diaphragm aperture coordinated. A recent innovation has brought a noteworthy simplification: electronic shutters and silicon cells give a very rapid reading, and the viewfinder is dimmed only for a few moments, sufficient to measure the light and to automatically set the correct exposure time for the electronic shutter. For the second method, light reading at full aperture, there must be a mechanical or electrical link between lens and

camera body, through which the exposure meter cell can be informed of the aperture selected. At full aperture the cell receives all the light possible and by means of calibrated resistances furnishes the right information to the galvanometer for movement of the index needle.

Together with obvious advantages of speed and practicality, there is also a greater utilization of the light sensors, which work with the full amount of available light, providing a wider scope of action in low light. The only drawback is one of construc-

tion. Lenses must be preset to transmit the diaphragm value to the camera body. For this reason bayonet attachments have now been adopted by

all manufacturers; these permit a perfect mechanical coupling, in contrast to the screw-on attachment, which does not provide so firm a connection.

In color photography especially, correct exposure is essential to obtain quality results. In this photograph the light was measured with the greatest precision and the chromatic result is excellent. Depth of field is shallow, hence the blurring in the immediate foreground and more distant background; here, however, this is not a fault; the picture is fascinating because of the skill of the photographer, who has placed all the emphasis on color.

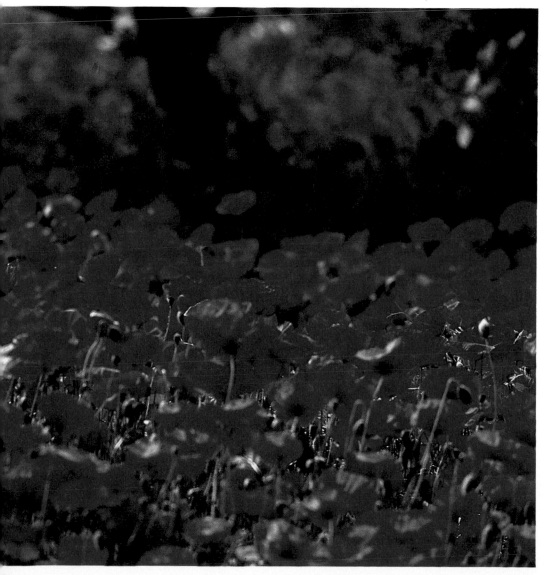

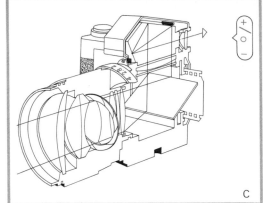

A,B: Measuring light by effectively reducing the aperture. There is no connection between the cell and the diaphragm. The measurement is made while stopping down the diaphragm, causing reduction of light in the viewfinder.

C,D: Measuring light with full aperture. The diaphragm remains open; the cell picks up the exposure value. No reduction of light in the viewfinder; the quickest method and compatible with automatic exposure systems.

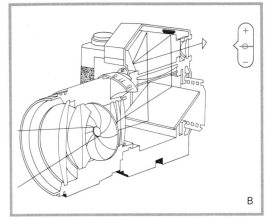

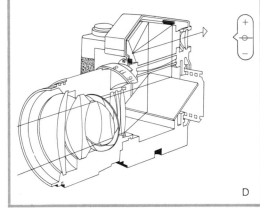

FIELDS OF MEASUREMENT FOR PHOTOCELLS

Exposure meter systems have adopted different methods of reading light in terms of the position of the cells and, hence, in terms of the wider or narrower area of the framed image read by the cells themselves. Diagrammatically these may be reduced to three methods:

Integration Reading Method

The photocells read the whole of the framed area, giving an average value for the light. This measure is useful when the total image has to be faithfully reproduced and, as can be seen from the photomicrographic example (top of page 37), when the image has no preferential part, although areas of greatly varying density are present.

In many cameras the semispot type of reading has replaced integration reading because the latter does not always give an accurate measure under general conditions of use, that is, outdoors where a limited area of great luminosity is present, such as the sky, which does not represent the center of interest and tends to distort the reading.

Center-Area Reading Method (Semispot)

This is the most practical method for most occasions and is widely used. The cells give a preference reading to the center of the framed image, excluding the upper part of the horizontal framing, normally occupied by the sky. In practice the exposure is more balanced because it is the reflected light from the subject which predominates in the reading; with the integration method in some cases one would get an underexposure.

If the subject is not central and areas of strong contrast are present, there may be a wrong reading; in this case it is best to center the subject, take a reading, and then compose the picture.

Spot Reading Method

The photocell reads only a small part of the image shown on the focusing screen. Only some cameras possess this feature, which is almost always associated with another one of more general use. This measurement is very useful when only a limited part of the image constitutes the real subject and it is not possible to get close or when strong contrasts are present. In these cases a semispot or total reading would give the wrong exposure because extremely dark or bright areas which are of no interest in the image would get in the way.

Integration reading method

Semispot reading method

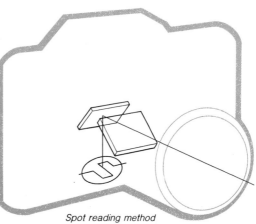

Spot reading method

AUTOMATIC REFLEX CAMERAS

All the most recent single-lens reflex cameras incorporate an exposure meter for through-the-lens reading coupled to the shutter speed and aperture controls.

To this traditional type of camera has been added a generation of reflex cameras even simpler and faster to use: the automatic exposure reflex cameras. With traditional reflex cameras, the exposure is manually controlled to act on the shutter speed or diaphragm aperture so as to center the needle of the indicator or the indicator lights (LED) in the viewfinder; cameras of the highest quality are found in this category that are particularly suitable where no great speed of operation is required or, for example, when the remote-controlled camera unit does not have to be completely automated, and also when the camera is used mainly with electronic flash. For the na-ture photographer they amount to a reliable and sometimes economical and convenient second camera body. But when speed and precision of exposure are needed, the automatic cameras are essential. We shall now look at their main functional characteristics.

There are substantially two kinds of exposure automation, shutter priority and aperture priority. They require different practical approaches with advantages and disadvantages to evaluate on the basis of individual preference.

Shutter Priority Systems

The exposure time is set by the photographer and the camera determines the right aperture. This is the method that comes closest to the one most commonly used with traditional cameras. Depending on the type of subject, one estimates the shutter speed needed to freeze the movement, and the aperture is adjusted in accordance with the meter reading, taking into account the depth of field needed. In practice, the drawbacks of this automatic method are two: From a structural point of view, only lenses made for a specific reflex system can operate on automatic within that system. Second drawback: From an operational point of view, we shall see that the field of exposure changes with different lenses; in the case of medium telephoto lenses automation is greatly reduced, and automation is lost with mirror lenses which have a fixed diaphragm. In the same way the area of automation is reduced with macro lenses (only well stopped-down diaphragms can be used).

On the other hand, shutter priority is very useful when shooting moving subjects at medium distance. This system has been incorporated into a number of cameras: the Konica TC and FS1, the Canon AE-1, and the Mamiya NC 1000 S.

Aperture Priority Systems

The aperture is set by the photographer and automation selects the correct exposure time. This is the most popular method (used by Asahi, Nikon, Contax, Olympus, Leitz, Minolta, Fuji, Rocoh, Praktica, Chinon) for some good reasons: It is completely compatible with reflex systems already in use, as no modifications are needed to lenses and attachments already functioning with the full-aperture method of reading; there is greater precision of exposure and ease in handling through electronically controlled shutters that can select any shutter speed within the automation interval, normally between 1/1000 of a second and a few seconds, without any break in continuity.

Above: 65–135 Hexanon zoom lens. On the diaphragm ring, note the AE (automatic exposure) position for operating on automatic reflex cameras.

On the right: How automation functions with shutter priority. The exposure time selected by the photographer reads across, while the camera automatically sets the aperture. By changing the lens, the area of automation is narrowed or enlarged depending on the possible range of the diaphragm aperture. With lenses which are not coupled or with a fixed diaphragm, automation is lost.

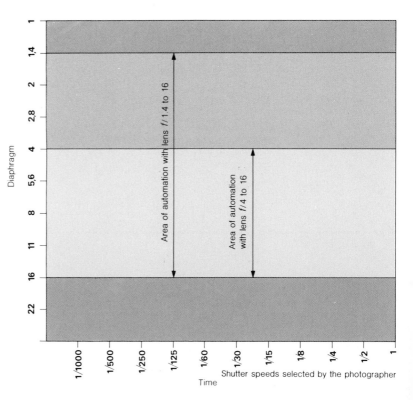

The automation operates independently of lenses or attachments coupled to the camera body. Automation functions even without the camera lens, on the microscope, with mirror lenses, with transparency copiers. It is a very versatile and accurate method, which presents some problem only in cases where there is a prime need to control and arrest movement.

Multi-Mode Systems

By coupling the two kinds of automation in the same reflex camera, the greatest freedom of operation has been achieved to suit the requirements of each individual occasion and subject. The three cameras of this kind, Canon A-1, Minolta XD7, and Fujica AX-5, offer further remarkable features by the addition of increasingly sophisticated kinds of electronic circuits.

Automatic Exposure Correcting Device

In automatic reflex cameras it may be desirable in certain cases to correct the exposure manually. The most accepted method is that of disconnecting the automatic parts. This is almost always possible (except in the case of wholly automated reflex cameras, such as the Asahi ME, which allow for only a single nonautomated shutter speed), but it is a slow and impractical method. Two other more practical methods have been adopted:

Memory device. By means of a pushbutton, the exposure meter reading can be recorded for a given framing, and the view can then be altered as required. The exposure will be the one recorded as long as the button is kept pressed down. In general it

is a quick and handy method for varying the exposure, and extremely useful for controlling backlighting.

Correction device. The correction can be recorded on an appropriate ring, up to two exposure values up or down. It is important to have a warning signal when the corrector is inserted to avoid forgetting it when shooting. These devices are particularly useful with strong contrasts and when bracketed exposures around the value indicated by the cell are required. Automation is immensely helpful not only in freeing the photographer from continually adjusting the exposure at every slight change in light, but also in allowing attention to focus on the image and making the camera, perhaps equipped with motor drive as well, a truly independent and remote-controlled unit.

Above: Exposure time selector. In the AUTO position the camera works with automatic shutter speed selection.

On the right: How automation functions with aperture priority. The diaphragm aperture selected by the photographer reads across, while the camera automatically sets the shutter speed. With all lenses the same extent of automation is preserved. Even lenses with a fixed aperture, like catadioptric ones, can be used with automatic exposure.

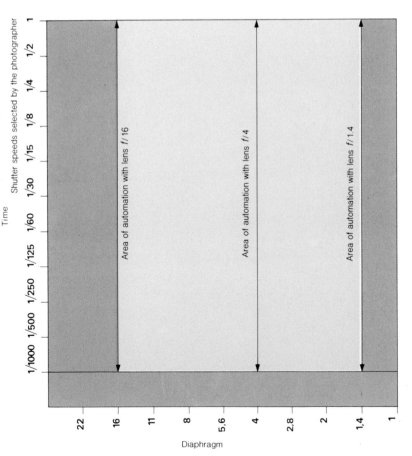

KNOWING ONE'S OWN CAMERA

The reflex camera market is huge and continuously growing. Buying a reflex means that its system of accessories then becomes available. Many manufacturers offer well-equipped reflex systems at reasonable prices; the alternative of purchasing universal accessories and lenses should be considered, since high-quality equipment can be bought at attractive prices.

First, as regards the camera body, an automatic one is undoubtedly advisable; and it is better if it is adaptable for motor drive. Familiarize yourself with cameras possessing characteristics that satisfy your own requirements, paying more attention to practical matters than to sophisticated features.

Rapid focusing requires readiness, quick responses, practice, and a perfect knowledge of how your equipment works.

You should have the greatest degree of confidence in your reflex camera. Learn to handle it with complete self-assurance so as not to risk missing rare opportunities. Initially you must learn how to hold the camera firmly in the most practical and comfortable way, experimenting with different techniques of aiming; you must always try to minimize body vibrations, supporting yourself with the elbows close to the side of the body, and hold your breath at the moment of release, always balancing the pressure of the forefinger with that of the thumb on the camera. You must also learn how to focus quickly, memorizing the feel of the ring turning: for this, practice centering the focus with the lens most in use, accustoming yourself to looking at the ground glass screen, moving the focus back and forth.

Precision and speed of focusing are almost always crucial in wildlife photography. One must also make the movements for selecting shutter speed and diaphragm setting automatic and instinctive: Try with eyes closed to increase the aperture by one stop, or to diminish shutter speed by one.

Getting to know all about one's own camera and being able to operate it swiftly without error are indispensable to using it accurately in front of the subject on location.

For the beginner, we suggest a few proven combinations of practical photographic equipment:

1. Camera body with a 35 mm lens and a 100 mm lens, to which should then be added a 50 mm macro lens and, according to preference, a more powerful wide-angle lens, such as a 24 mm and/or a 300 mm telephoto lens.
2. Camera body with 28 mm and 85 mm lenses, followed later by an ordinary macro lens, and for the medium telephoto, the 300 mm lens; a lens converter is useful. The 300 mm is the smallest practical telephoto lens for wildlife photography.

The medium fixed-focus lenses from 100 to 200 mm are less frequently used; a more useful and flexible choice would include a zoom from among the many kinds available designed to cover these particular focal lengths. The quality can be excellent (for example, the famous Nikkor 80-200) but it is still good to choose from among the best universal lenses: to mention one, the Vivitar 70-210, which can be used in macrophotography. Zoom lenses have the unquestionable merit of allowing a far freer control over composition, which is very important with transparencies as they cannot be modified after the shot. Among wide-angle lenses, the choice is limited to a few focal lengths, while the telephoto selection fortunately is much more extensive, since these lenses are the tools of wildlife photography.

ACCESSORIES

Accessory equipment for the reflex system is best acquired with care, in accordance with actual needs.

The Focusing Screen

With cameras that make provision for interchangeable parts, certain types of screens are available which adjust to different conditions of use. The most popular screens, normally attached to many reflex cameras, have split-image focusing or a microprism screen, which simplifies focusing by destroying the image once it goes out of focus. The two methods are usually combined in one viewfinder. These screens are suitable for all normal purposes; when the lens aperture is smaller than $f/4.5$ or 5.6, the center area tends to remain unnaturally dark because one of the focusing elements is inoperative and the subject stays partially hidden.

To solve the problem many kinds of screens have been suggested with varying combinations of optical systems to facilitate focusing in low light; Nikon offers at least 19 kinds. The simplest screen is only ground glass. (The Fresnel lens, recognized by its concentric rings, is always used, and its function is to secure even light on the screen.) Another type of screen, with a cross-graded axis, is suitable for photomicrography. The grid screen is useful with wide-angle lenses for checking perspective and the horizon line.

Cable Release

The cable release can be from 15 to 20 cm (6 to 8 inches) to a few meters in length. It has two functions: to avoid shaking the tripod-mounted camera at the moment of release; and to lock the shutter release by means of a ring nut and operate the camera (and the motor drive) by short-distance control (up to 5 to 10 meters) as an economical kind of remote control. The traditional long mechanical cable or pneumat-

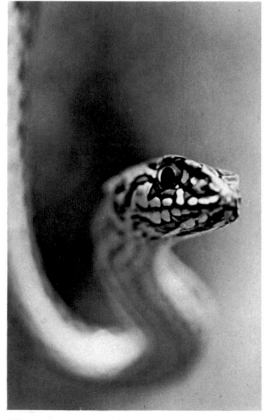

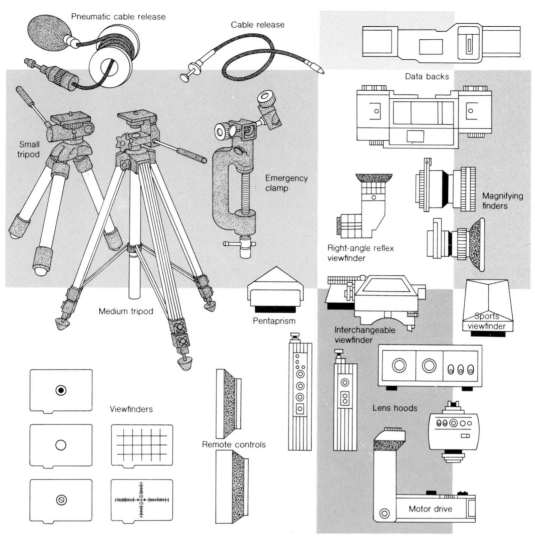

Pneumatic cable release

Cable release

Data backs

Small tripod

Magnifying finders

Emergency clamp

Right-angle reflex viewfinder

Medium tripod

Pentaprism

Interchangeable viewfinder

Sports viewfinder

Viewfinders

Remote controls

Lens hoods

Motor drive

ic release can be replaced with an electric one for some cameras and offers greater efficiency and speed of response.

Lens Hood

Marginally useful for wide-angle lenses, lens hoods are extremely useful for telephoto lenses, many of which already incorporate them.

Stands

The most injurious movement for the photograph is almost always that of the camera itself. The quality of the image is destroyed by camera movement; such muddy and disappointing pictures are especially noticeable in projection.

There are two ways of minimizing this constant danger:

(1) Use sufficiently fast exposure time.
(2) Utilize a suitable stand and a cable release when possible.

We shall now examine the main kinds of stands.

Mini-tripods. Small and light, these can be classed with all-purpose clamps. They are good for emergency use and to minimize moderate shake with wide-angle and short telephoto lenses and in photomicrography.

Medium tripods. Accessories of general application. A necessary part of every nature photogra-

pher's equipment. They should be solid and sufficiently light and compact to be carried without difficulty. In choosing among such a wide range of models, keep in mind the main purpose of use, e.g., waiting for a wildlife subject, environment, macro, etc. The best tripods are equipped with a center column and a locking handle to adjust height, plus a screw fitting on each end (the lower one, between the legs, being used for macrophotography). The clamp on the column should have distinct open and locked positions, as a sudden drop can cause serious damage. The swivel or panoramic head must be solid enough

to hold the camera firmly in all positions, and all the better if the design allows adjustment to a vertical position for the camera as well. Dual-purpose feet, flat and pointed, adapt more easily to any kind of terrain. For long telephotos, heavier, more solid tripods are necessary and are more cumbersome to carry.

Monopods eliminate only vertical shake. They are light and convenient, and offer a compromise where the tripod would take up too much luggage space.

Shoulder supports are helpful when stalking wildlife, and will be described when we come to that subject.

ELECTRONIC FLASH

Vivitar 283 flash. An adaptor for plastic lenses, which modify the angle of discharge, is fitted to the lamp.

The electronic flash is a device that produces light flashes lasting from 1/300 to 1/50,000 second. The luminous discharge is rapid, neutral, and cold. A light at 5500°K can easily be mixed with natural light. The practicality of the apparatus, its economy of use, and the consistency and speed of its light have established the superiority of this kind of artificial illumination over all others. Flash bulbs, which do have some special uses, have been almost abandoned.

In nature photography flash is often indispensable, as it allows pictures to be taken which could not otherwise be photographed,

for example, in macrophotography. Recently electronic flash has been developed to increase its efficiency and flexibility. The more advanced flash equipment is, the simpler the technique for handling it. Equipment may be classified under four headings according to function:

1. Traditional equipment, with fixed discharge time; small, as, for example, the Metz 302, or powerful, like the Multiblitz Report. In accordance with the guide number, the aperture should be adjusted for each change in subject distance.

2. Equipment with automatically controlled discharge; an example is the small Metz 303 or the professional Metz 402 with preselected aperture control; at intervals of distance the flash automatically adjusts the luminous discharge.

3. Equipment with automatically controlled discharge, but with the sensor separate from the flash (for example, the medium Vivitar 283 and the professional Vivitar 365); their operation is similar to that of the previous type of instrument, with the advantage, however, of being able to freely illuminate the subject with the flash, while the automatic adjustment is operated by the sensor attached to the camera hot shoe.

4. Equipment with discharge automatically controlled by the cells positioned behind the lens of the reflex; a system introduced with the Olympus Quick Auto 310 coupled to the Olympus OM-2. Recently the Contax 137 IMS and the Nikon F3 have introduced similar systems.

The Guide Number

Besides the operational characteristics, a fundamental factor is the maximum power expressed by means of a number called the guide number (GN). This number corresponds to the diaphragm stop required to photograph a medium subject placed at a distance of one meter from the flash, using a film of ASA 100. On this basis, one can obtain the guide number for any other sensitivity; for example, if GN = 16 for ASA 100, for ASA 400 it will be 32.

The choice of flash should be made bearing in mind that power, weight, and volume increase proportionately, depending on actual use; therefore, it is helpful to limit the maximum power and obtain the least weight.

If used properly, flash is a workable and effective instrument; the main problem is how to anticipate its effects as regards both quality and quantity of light, granted that these cannot be directly calculated on account of the extreme brevity of flash. Exposure meters exist, in fact, that

solve the problem of measuring flash, but apart from being rather expensive, in some cases they do not eliminate real difficulties in measuring—in macrophotography, for example, and in underwater photography.

The latest kinds of flash, using various devices, have achieved the desired result of automating the measurement of flash.

Criteria for the Better Use of Flash

One should regard the type of light as if it were coming from a continuous source. This means that the light may be concentrated or diffused, reflected or attenuated, obtaining varied photographic effects of hard or soft lighting. In visualizing this, it can be useful sometimes to have a flashlight, the light beam of which is directed like that of the flash to imitate the same effect. Only if you can really foresee the behavior of the light will you be able to obtain consistently good results.

It is important to bear in mind that the intensity of the flash depends purely on the power of discharge and on the distance of the subject from the lamp, in accordance with the diminution of luminous intensity as the inverse square of the distance. Looking at the diagram below, one can see that the beam of light which strikes the first square will be spread over an area four times greater

On the right: Light diminishes as the distance from the source increases in accordance with the inverse-square law. A beam of light illuminating a square surface at a distance of 1 meter (3 feet) at a given intensity spreads itself, at double the distance, over a surface four times larger, and hence the luminous intensity is equal to one-quarter, and so on.

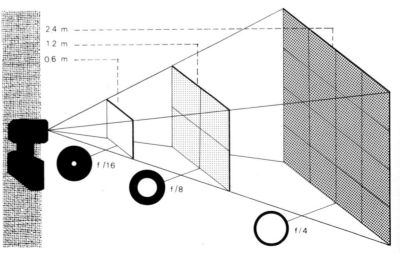

2.4 m

1.2 m

0.6 m

f/16

f/8

f/4

Above: Vivitar flash with zoom control of the angle of the beam of light, and separate sensor for the automatic adjustment of the luminous discharge, mounted on the camera hot shoe. The rewind warning light and the controls to adjust the angle of reading are visible.

Above, right: Metz 402 flash, with fixed sensor under the flash holder.

when the distance is doubled. In photographic language, this means that the aperture must be opened two stops each time that the distance between subject and flash lamp is doubled (the distance between camera and subject does not alter the quantity of light in any way).

From what has been said three facts emerge:

(1) The guide number divided by the distance between flash lamp and subject gives the correct aperture.

(2) If we place the flash at 25 cm (9 inches), for example, the intensity will be at least sixteen times greater than from 1 meter (3 feet). This explains why powerful flash is unnecessary in macrophotography. But be careful: equal changes of distance correspond with quite different effects as regards light intensity and therefore of exposure; for example, by bringing the subject 12 cm (5 inches) nearer to the lamp, the light changes little if the distance is 100 cm (12/100 = + 10%), but it changes by at least two diaphragm stops if the initial distance is 25 cm (12/25 = + 50%).

(3) If repeated flashes are used, the correct aperture may be calculated by bearing in mind that the second flash should logically double the total light on the subject, and hence one must first reduce the lens aperture by one stop before the two flashes. However, to reduce the aperture by two stops, four flashes would logically be needed. Having defined the traditional calculation of flash, it will be easier to appreciate the advantages of computer flash, where exposure is controlled automatically. The diagram below shows how a small photoelectric cell placed on the front part of the flash can measure light reflected from the subject; when the preset level is reached, the luminous discharge is automatically interrupted. In practice an aperture is set, based on film speed and the estimated distance. The speed at which the cells respond is extremely fast, fast enough to interrupt the discharge after 1/50,000 second. The range of action is equivalent to at least six or seven diaphragm stops.

In models with photoelectric cells separate from the flash unit, a greater flexibility in use and a higher degree of precision are possible because the subject is easier to center and isolate, as the photocell takes into account all light around it or in the background, like a normal exposure meter.

Some sensors, like the Vivitar 365, can also vary the angle of reading, facilitating the measuring of light from the subject and avoiding background interference. Having the sensor separate from the flash enormously increases the efficiency of the system: slanting, diffuse, or reflected illumination is possible, with wide or narrow angles, by means of lenses or diffusing filters.

An accessory with an interesting use is the variable transformer. Fitted in place of the sensor, it directly selects the length of the flash, from the entire flash down to 1/64 of it, a range of at least seven diaphragm stops.

How the automatic computerized flash works. A sensor turned toward the subject responds with ultrarapid speed. When the lamp is on, the sensor begins to measure the light reflected from the subject and as soon as this reaches the preset level, the discharge is interrupted. Thus the camera receives only the quantity of light required, which is compared in the drawing to the capacity of a tank of liquid whose delivery is cut off by a valve.

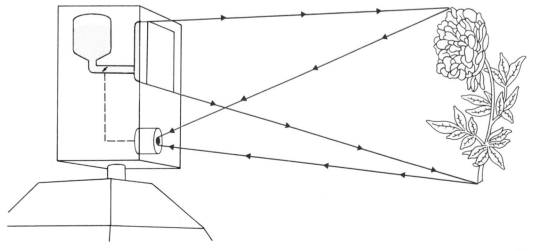

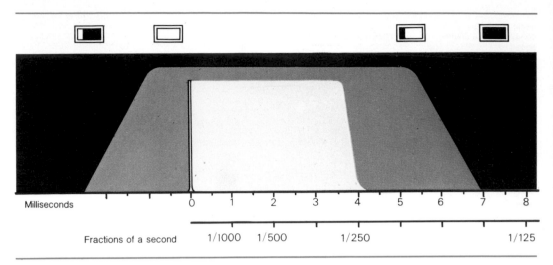

Milliseconds 0 1 2 3 4 5 6 7 8

Fractions of a second 1/1000 1/500 1/250 1/125

Exposure and flash. The 35 mm SLR camera is fitted with a focal-plane shutter which can be synchronized with flash at a maximum speed of 1/60 or 1/125 second. The diagram illustrates the exposure mechanism with the automatic flash: when the focal-plane shutter opens completely (as shown in the upper part of the diagram), the luminous discharge begins, which can last from a minimum of 1/50,000 up to a maximum of 1/300 second. If sufficient natural light is present, it may dominate the flash light, as it is effective all the time the shutter is open.

The correct exposure indicator lights up right after the luminous discharge to show whether the light controlled by the sensor was sufficient to give a correct exposure. This information is very useful as it allows one to check each time whether everything has functioned normally and, if not, to remedy it immediately.

Synchronization Between Flash and Shutter

All reflex cameras have two different kinds of flash connections. One is identified by the letter M (or by a sign depicting a bulb) and the other by X (or by a zigzag arrow). The M connec-

tion for flashbulbs is characterized by a delay between the opening of the shutter and the flash ignition of about 15 milliseconds; the X contact, with a delay of only 5 milliseconds, is suitable for electronic flash, which has an

inertia of almost zero. Skipping over the M contact to consider the use of the X contact, remember that focal-plane shutters, which are used on all reflex cameras (except in the special case of the Hasselblad, which has a between-the-lens shutter mounted on every lens), are subject to the limitation of a maximum shutter speed for synchronization, which varies from 1/60 to 1/125 second, according to the type of shutter. This speed is usually marked, sometimes with a different color, on the shutter speed ring; a slow shutter speed with synchronization gives greater freedom

to photograph with ambient light. In fact the shutter speed never interferes (this applies to focal-plane shutters) with the amount of flash light that determines exposure, because the duration of the discharge is always shorter (normally less than 1/300 second). It is obvious that the only device which limits the flash is the diaphragm.

When flash is used in the presence of natural light or ambient light, bear in mind that there are two independent light sources: one which is limited by both shutter speed and aperture, and the other, the flash, which is limited by

Right: African squirrel. The flash has brightened the shadows, emphasizing the subject, while the background lit by daylight provides a natural setting and gives modeling to the animal. This is a typical example of balanced exposure with a daylight effect.

the diaphragm aperture alone. With normal light any combination of shutter speed and diaphragm aperture with the same exposure value gives the same exposure, that is, the same image density; this no longer holds true here because flash exposure depends on the diaphragm alone. By changing combinations of shutter speed and diaphragm aperture (with the requirement of a maximum speed of, say, 1/125 second for focal-plane synchronization), we will obtain wholly different images, from the predominance of flash with open diaphragm to the predominance of ambient light with closed diaphragm.

Daytime Effect and Nighttime Effect

Daytime effect, as we have defined it, is obtained with flash in the presence of ambient light. The exposure is selected so as to balance the two kinds of illumination. The resulting image will be soft, and the subject more acclimatized and natural.

The nighttime effect is obtained when flash predominates. The background is dark and the subject is not harmonized with its setting, but isolated as in a nocturnal photograph, even if daylight is present when the shot is taken. The daytime effect is more effective and preferable whenever a sufficient amount of surrounding light is available. By using the Hasselblad reflex with between-the-lens shutter, the choice between daytime and nighttime effect is simplified, because one can use all speeds up to 1/5000.

Slave Flash

A slave unit is an extremely useful accessory which simplifies the link-up between synchronized flash units. Connected to a flash unit, it induces synchronized ignition when struck by the light of another flash. It makes each flash into one autonomous unit of illumination, which is released simultaneously with the master flash unit connected to the camera.

Through-the-Lens (TTL) Automatic Exposure Flash

The Olympus OM-2, the first camera system with direct measurement of light reflected from the film itself, has two silicon cells that scan the surface of the film during exposure. Owing to their high speed of response, they are able to act as automatic flash sen-

sors, controlling the discharge of light from the appropriately connected flash unit. The Quick Auto 310 flash unit, inserted onto the hot shoe by means of a special clamp, is then regulated by the silicon cells, which transmit to it the electronic signal to interrupt the luminous discharge when the light striking the film is sufficient.

In practice, direct flash control is simple because this method takes everything into account and is independent of diaphragm and lens. Once the discharge is over, a flashing pilot light indicates if this has been sufficient for correct exposure.

The advantages are considerable, for example, in macrophotography. At present the only disadvantage is the impossibility of using other kinds of flash.

Exposing with flash, one obtains a night effect (above) when the natural light is negligible, while one obtains a daytime effect (below) when the two light sources are at a similar level (picture above: 1/125 second, f/16; picture below: 1/15 second, f/16).

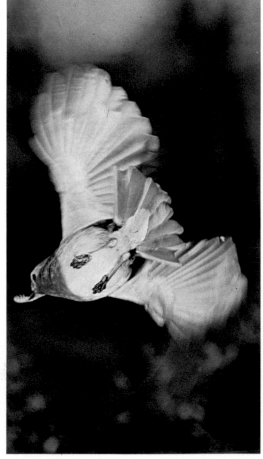

Above: Flash primed for synchronization, with the slave unit inserted into the hot shoe.
Below: The variable transformer fitted on the Vivitar 365 flash, called "Varipower."
Left: A robin. Flash has made it possible to freeze the bird in flight, but not the rapid movement of its wings.

45

ANALYZING PICTURES

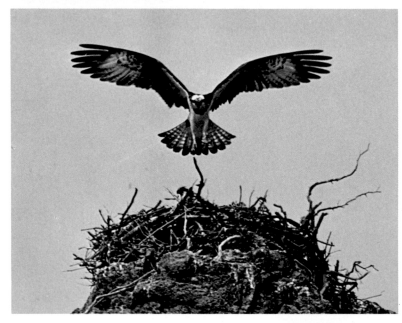

first, the frontal view, the outstretched ears emphasize that attention is turned toward the photographer; the outline is crisp and clear, the background does not interfere. In the second picture we have an example of how to frame two subjects sideways, playing on the rhythm produced by the two graceful heads, in different planes, and cropping the picture effectively so as to convey, with a balanced structure, a sense of immobility. Every picture must be sensed more than seen, carefully observed and built during the shooting. When one acquires a feeling for composition, the capacity to see photographically, it will be obvious immediately whether the image appearing on the focusing screen can be a good photograph, assuming that it is technically well executed.

To discover the elements of good composition, we must try to understand the mechanics of looking at a picture: instinctively the eye seeks out a center of interest. The clearer and the more immediate the impact of the composition, the more easily we shall grasp the significance of the information in a photograph.

One rule which is always valid is to omit from the composition everything that is not strictly necessary. In the photograph above, the symmetric composition, the clean background, and the central position of the subject give special emphasis to the bird returning to its nest. A complex, blurred background would have diminished the legibility of the image, thus weakening its graphic impact.

On the right and below are shown examples of how to frame correctly two subjects in the same picture in different ways. In the

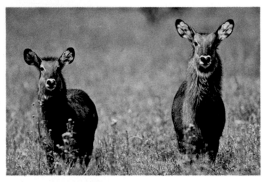

If the picture is flat and confused, it is advisable to change some compositional element—the angle of the shot or an outline, for example. Thus it should be possible gradually to improve the image.

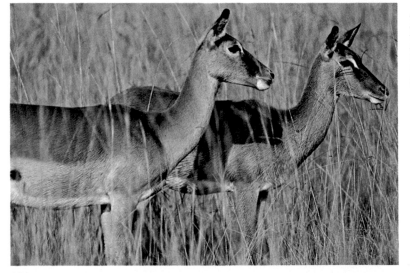

In this photograph the reflection on the water emphasizes the chromatic rhythm of the giraffes with an element of symmetry, which helps to render the image more incisive and interesting.

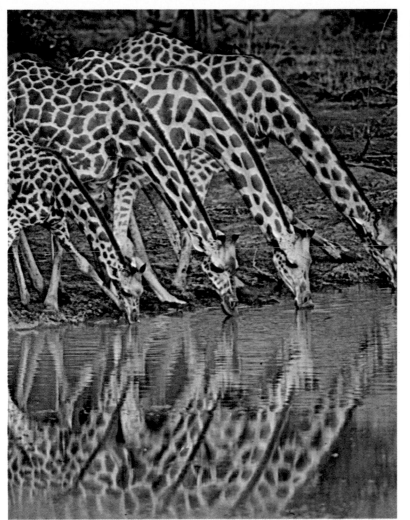

In this last photograph color plays a decisive role in detaching the subject from the blurred background dominated by vegetation. The composition is simple, the subject is centered; the "flat" position of the animal, in one plane, simplifies the problem of focusing and depth of field.

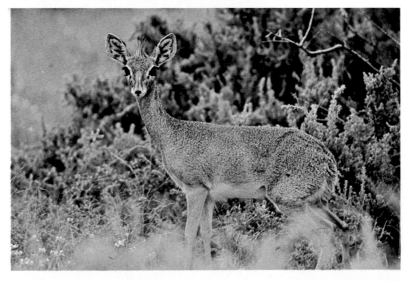

THE PHOTOGRAPHY OF NATURE

THE NATURAL ENVIRONMENT

There are still parts of the earth where living organisms live in balance with their surroundings. In these conditions no element exists in isolation from the rest—on the contrary, everything exists in a harmonious relationship, exchanging energy within the ecological system. In such cases one can truly speak of a natural environment.

The natural environment in the strict sense has been considerably reduced through the impact of the human population, which has greatly affected many geographical zones, altering their physical, chemical, and biological features, often beyond an acceptable limit. To live reasonably in harmony with our environment, we must regard ourselves as part of that environment and not contrary to it or above it. Indeed, the failure to make this elementary fact part of our awareness makes long-term coexistence with nature extremely difficult, if not impossible. In certain cases our inevitable impact on the environment can be acceptable, even with its resulting human-centered processes, provided that nature's own model of equilibrium is adopted in man-made models. Hence the need for greenery, open spaces, water and clean air, silence and natural sounds like the songs of birds is not simply a factor in regional planning but a biological necessity for the psychological and physical well-being of the human species.

Nature as Spontaneous Necessity

A concept of life which models itself on nature is not a novel philosophy or a desire to go back to the past but a spontaneous need of each human being. This need is sometimes conscious and sometimes buried within the subconscious. Its return to the surface and reacceptance by society represents a fascinating objective especially for the young.

Environmental Awareness

The ability to perceive the environment can be regained through experience. In the human organism this sixth sense really exists, suppressed and held back especially by traditional anthropocentric culture. This forgotten ability must be stimulated. Touch, sight, and hearing, faculties which are often underdeveloped in modern man, can recover again, accustoming the organism to the natural environment through contact.

Enjoying Nature

Walking in the midst of nature to observe it, or for recreation, seems to be coming into vogue again in the guise of sporting activities. Walking is good for one's health and averts many psychosomatic and cardiovascular disorders.

Physical inertia, stress, and tension can be overcome by a real enjoyment of the natural environment. The bicycle and the horse are also valid means for putting one's own muscles into use, while exploiting the wholeness of the surroundings.

Observing and photographing the enormous variety of species in the animal and vegetable kingdoms that make up the habitat are acceptable outlets for the utilization of one's spare time and the pursuit of health. Watching a flock of ducks in flight and photographing deer at dawn are activities which contribute not only to a knowledge of these species but also to a spontaneous and useful process of mental relaxation that accompanies the pleasure of being in a natural environment.

Natural environments. A picture suffices to express the idea. The photograph below shows penguins on the Palmer archipelago (Antarctica), looking almost like a village, so harmonious does the relationship between environment and animals appear. On the facing page, a completely different setting, on the border between northern and southern Zimbabwe. Here the Zambesi River forms Victoria Falls.

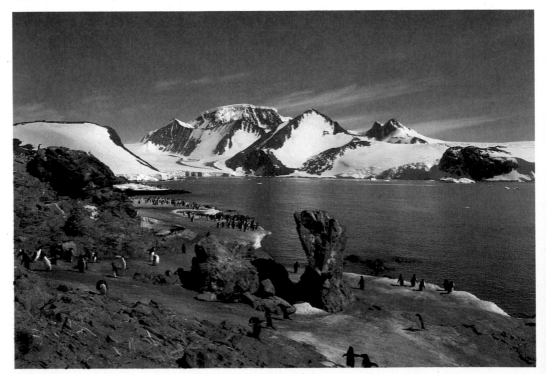

APPROACHING NATURE TO LEARN ABOUT IT

It is difficult to want to protect or respect something one knows nothing about. Many associations of naturalists have taken a large stride forward and changed from praiseworthy groups of zoophilists into experienced conservationist associations, substituting for a vague emotional defense of animals a knowledge of the mechanisms by which the natural environment works. With such knowledge a better defense of these same animal species is made possible.

Going into the Country to Learn about Nature

It becomes necessary to forsake the laboratory and theoretical study and go

Beginning to Recognize the Parts of Nature

Walking in the country, one must know how to see or at least begin to see even the simplest things. One will stop to look, and then identify pieces of egg broken by rats or crows, or further on, a molehill. Even in the most despoiled and unthinkable places lovely flowers can appear. On damp ground one might spot the tracks of wading birds or of pheasants, or elsewhere the droppings of a hare or perhaps the lost feather of a green woodpecker.

Thus one begins to compose visually the diverse parts of nature. The next

Birdwatching

This pastime is spreading everywhere. It consists of going into the country, marshland, rivers, lakes, woods, or mountains to observe birds that live there in the wild, learning to recognize them in flight, and following them in their natural behavior. All seasons are suitable for birdwatching, but those in which migration takes place are best. A sound choice would be spring and autumn, when the number of birds to be watched increases considerably. One myth to be discounted is the belief that birds are only to be found in certain places. In town or city, for example, we can watch many birds in the

public parks. Anyone can see robins, finches, blackbirds, or doves even in urban gardens, which may be safer for birds fleeing from destroyed woodlands and the effects of agricultural pesticides. Woods are more difficult places for birdwatching because birds are camouflaged and hide in an instant. It will not prove difficult, however, to recognize the shrill-sounding jay, or the green woodpecker with its undulating flight.

Along the coast different species of gulls are easily observed. In certain areas of the coast, where conservation is enforced, one can see large numbers of other birds such as the cormorant, the shearwater, and the peregrine falcon. But the ideal locations for

into the country to watch, listen, move about, and feel oneself to be part of the natural environment.

For the beginner outside his own accustomed surroundings, such as the city, for example, it is not easy to discover nature all at once. At each step there is a living world about us which, for the most part, passes unnoticed. For example, in a bush or a pool, myriads of tiny creatures exist hidden from sight. One finds the most varied species of insects in the water, snails and lizards on the ground, and small nest-building birds in the hedges.

step will be identifying the different animal and vegetable species. At this point you will discover the helpfulness of not only the more expert among your naturalist friends, but also different field guides on plants, flowers, animals, tracking, and geology. The guides must be sufficiently small and portable so as not to take up too much room in your knapsack or pocket but also comprehensive. They do not have to be encyclopedic, because once the unidentified details of nature have been singled out, a more detailed study can be undertaken at home.

Above: Hares at play. A picture among many which can help us to understand nature.

Right: Pelicans in the morning mist. This is not simply a photograph which creates atmosphere but an effective illustration of a natural environment.

birdwatching are the watery areas: marshes, rivers, and lakes. Here the presence of water creates the best conditions for the growth of a myriad of living creatures: insects, amphibians, and fish, and the luxuriant vegetation of the marshes. It is possible, therefore, to admire the most varied species of ducks, in flight and resting on the water in search of food, or wading birds probing mud or sand or herons in search of frogs or fish, or the marsh harrier scouting the area with its characteristic glide, or little reed warblers and dozens of other melodious birds hidden among the reeds and willows.

Binoculars

An important means of learning about nature,

practicing birdwatching, and preparing for subsequent nature photography is by observing through binoculars. This is the first step for learning to observe before progressing to the use of more complex photographic equipment. Learning how to aim binoculars rapidly is rather like aiming the telephoto lens. The ease with which the more expert naturalists frame their subjects through the camera lens, managing to sight animals immediately which to others seem extremely far distant or nonexistent, shows how useful it is to have some practice with binoculars before devoting oneself to nature photography. It is also useful to take a look at the environment to be shot, concentrating on the more

interesting geological, botanical, and wildlife details while seated in a comfortable position with a wide view.

To do this, very powerful binoculars are unnecessary, indeed they are less useful since they are more awkward when the subject has to be framed quickly, and they are harder to handle. The ideal binoculars for someone beginning this absorbing activity is the 8 X 30 model (the first figure indicates the magnification, the second the lens diameter, or luminosity). Bear in mind that a luminous lens allows one to "see" better than a more powerful one endowed with less luminosity. This can be verified at sunset, but especially at dawn when the birds are more active. Even

the 7 X 30 or 7 X 40 models are therefore quite suitable for the beginning ornithologist. With binoculars there are two main types of observation: stalking and stationary.

Stalking observation. This first kind involves walking quietly in places where birds pass. As soon as a bird is sighted, you should raise your binoculars and attempt to frame the subject in flight, focusing at the same time. You can practice with pigeons, sparrows, or urban-dwelling doves. At first, framing will be poor or focusing will be inexact. But don't be discouraged: by persisting, this sequence of "visual catching" will become natural and automatic.

Stationary observation. Another very useful exer-

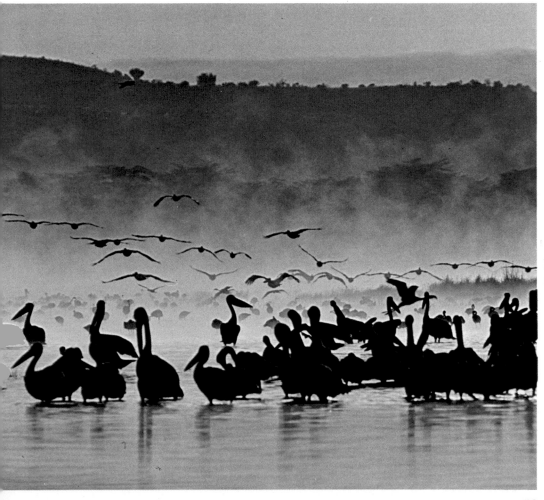

cise consists in stopping in a fairly natural place (with not too many houses or roads) and scanning the horizon through binoculars from a seated position. While one may see nothing with the naked eye, with the help of binoculars many birds will be rendered visible. Naturally an effort will be required to identify the different species, which in this case are usually far distant; it is just this effort that serves as an exercise, which is also useful because it accustoms one to patient observation.

Getting Started

For the first few searches for ornithological pictures it is advisable to have a guide—who, in a sense, can be regarded as basic equipment for the beginner. It is not easy to start entirely on your own, inasmuch as the beginner often has the false impression that there are no birds when in fact there are, but sighting is not easy for someone unaccustomed to this kind of observation. Things are much easier in a wildlife sanctuary provided with blinds. Here birdwatching is facilitated by the presence of these permanent places of concealment, from where one can safely observe with binoculars without disturbing the birds. Outside the sanctuary wild

birds appear fleetingly, and must be identified instantly. They have been made wary by hunters roaming the countryside.

Additional Birdwatching Equipment

A handbook for identifying birds is indispensable, and several good ones are available (such as *The Complete Field Guides to North American Wildlife* by Collins and Ransom (New York: Harper & Row) and *The Birds of Britain & Europe* by Heinzel, Fitter and Parslow (London: Collins). Suitable shoes or rubber boots complete the basic equipment of the birdwatcher. A notebook in which to record observations will also prove useful.

Rules to Follow in Spotting and Identifying Birds

When driving in a bird sanctuary or nature reserve and groups of birds are sighted in the fields bordering the road, one should not get straight out of the vehicle, but should remain inside, slow down, turn off the motor, and gradually lower the window. Animals in fact are very afraid of a standing human figure, which they immediately regard as an enemy, while they are not afraid of the outline of a car, which can

be considered as a blind.

Another useful piece of advice is, don't be in a hurry to see the birds. It may happen by chance that while traveling along in a vehicle, some rare species is spotted, but most times it pays to stop in a natural environment and wait patiently. If the place is well chosen, the animals themselves will approach the birdwatcher and not vice versa.

Characteristics by which to Identify Birds

Species of birds differ from one another in their mode of flight, their shape, form, color, habitat, sound, and behavior.

Flight. Some species fly

Associating with animals helps us love and respect them. Below: The boy is freeing a little owl.

Bottom photograph: With binoculars and telephoto lens one can capture unusual pictures, for example, the courtship of these two albatrosses.

with an undulating movement (for example, the woodpecker and the barn owl); that is, after a few beats the wings are closed and a distance is covered with a wavelike movement similar to the seal in water. Other birds, such as ducks, fly by beating or flapping their wings continuously. Birds of prey usually alternate their wing flapping with gliding with outstretched wings for a lengthy time. By checking in the handbook the individual characteristics of flight of the presumed species, you can verify your ornithological hypothesis.

Shape and color. A magpie, once seen, with its long, gaudy tail and unmistakable black and white plumage, cannot be confused with a hooded crow, which is squatter and darker. But be careful: Against the sky, colors appear different and almost always darker, especially with back light.

Size. Size is difficult to assess with birds in flight. One frequently hears descriptions of huge birds, which then have to be sized down after study. In flight the buzzard can appear enormous when compared with a sparrow, but it turns out to be small if an eagle appears close by. It is important, therefore, to frame other birds in the vicinity as a standard of comparison.

Behavior and habitat. Bird behavior plays a fundamental part in helping to identify them. What bird clings to the side of a tree in preference to any other position except the woodpecker? What bird of prey, by flapping its wings, can remain stationary in the air like a helicopter except the kestrel or other hawks? Habitat is also important for the purpose of identification. For example, it is unlikely that a marsh harrier would be seen circling above a highland wood.

Birdwatching. This is an activity that may be enjoyed while on a hike (right), or by watching passing birds from prepared blinds (above).

PHOTOGRAPHING NATURAL ENVIRONMENTS

A good picture of a river, marshes, a wood, a mountain range, or the seacoast is the basic ingredient for any subject in nature, as well as being an important photographic contribution. To succeed in graphically representing the environment in its wholeness is no less fascinating and important than a good photograph of a flower or an animal. The difference lies in the fact that animal photography depicts a detail, while the environment photograph renders all the details unified in the habitat. Moreover, in wildlife photography the difficulties are more obvious, insofar as the subject moves, takes flight, etc. In the case of environment photography, the task may appear easier: and so one sees thousands of pictures, even published ones, which, apart from being unacceptable photographically, are also totally inadequate as images depicting an environment.

The concept behind depicting an environment suggests that the photograph must bring out the essential elements of the habitat in question, the fundamental characteristics which make that environment a unique one of its kind. From the picture one should be able to gauge that in that place alone and only under those particular conditions could certain animal and plant species live, and that the geological processes over millennia of natural history have formed that environment. Pictures of the natural environment should be full of life, not only on account of artistic intervention incorporated into them, but also through having rendered the real life hidden within the environment. If one were to analyze a good environment photo by dividing the framed area into so many small squares, one should be able to say that each square possesses its own purpose and meaning for the naturalist. In projecting transparencies, environment illustrations might be accompanied by a luminous arrow to point out that every part of the photograph, from the sections of mountain to the branches in the foreground, the curves of the river, the forest where certain animal species are concealed, are like pieces of a visual mosaic which can be drawn together in a single whole with the help of a wide-angle lens.

Environment and Landscape

In most books on nature photography, the photography of the environment is referred to as "landscape photography." We would like to explain the main difference between landscape photography and environment photography. In the first case, the "pictorial" shot is meant, the traditional picturesque view, perhaps with church and village in the background. In this case human activity is the main theme sought, framed in a landscape setting. It should be made clear that in speaking of nature photography these pictures are out of place, while they may be perfectly suited to photographic expression of the human environment. The photography of the natural environment should be the result of the meeting between the naturalist who knows how to value and "feel" the nature which he sees and the photographer who knows the rules for making a good picture.

Cooper River in Alaska—a good example of a "natural environment" photograph. It is easy to see how this picture would differ from a landscape photograph—perhaps with a village church and bell tower in the background—which would express a pictorial rather than an ecological taste.

NATURAL VARIABLES IN ENVIRONMENT PHOTOGRAPHY

In environment photography the presence of certain physical elements is constant enough to make certain suggestions useful.

Rain and Water

Water in natural environments is one of the most photographed elements. If the distance between the camera and the environment is great, the water of a river or lake in the distance will not create serious technical problems. But these may exist when the water is closer. Reflections can normally be eliminated, as we have seen, with a polarizing filter, which makes it possible to penetrate photographically the glimmering surface of the water and to capture a clear image, for example, of fish moving on the bottom. When photographing in black-and-white, yellow-green filters can be used in the case of thick vegetation along the edges or seaweed or other flora in the water itself. To convey the movement of the water, it is helpful to take several shots in which the water is moving rapidly, moving slowly, and still. A choice can then be made of the most suitable picture and exposure, depending on the photographer's taste and the use to which the visual document is to be put. Characteristic of this genre of photography are waterfalls, in which the vaporous flow of water (exposed, for example, at 1/50 or 1/30 second) lends the image an evocative and almost magical appearance.

The same suggestion of movement is possible with rain. There is a choice between an image with small dots produced by the raindrops arrested with fast shutter speed, or raindrops appearing as streaks, using a longer exposure. With rain the chromatic effect tends to be gray because of the lack of light. Black-and-white photography may be preferable, since the contrast can be heightened in the printing stage.

Mist

Pictures of misty environments offer original opportunities in nature photography. Distant mist (for example, a shroud of mist over a valley or mist rising in the mountains) makes possible a unique characterization of the environment, seen from the outside. Early-morning mists just beginning to be dispelled by the sun make interesting pictures. Sunlight filtering through, the gleam of wet soil and rising mist, effectively typify, for example, the environment of the Central European landscape.

Conditions are different when taking a photograph inside mist. Apart from special effects, which some photographers desire and which are more suited to a civilized environment, one can do little to depict a natural environment which is visually distorted. In wildlife photography, on the other hand, an animal shot shrouded in mist or emerging from mist may take on a unique appearance in the context of nature photography.

A patch of vivid color in the foreground, a soft background: an effect produced by the morning mist dispersing.

57

THE HORIZON

The horizon line is the most important element in composition and must always be kept in mind in natural environment photography. When it is sharp and it cuts the image into two parts, its position in the photograph becomes a decisive factor in the balance of the composition. Above all, it must always be horizontal: this seems obvious, but a slanting horizon is an easily made error which can totally spoil a transparency. To avoid this you should form the habit of using the upper or lower edge of the viewfinder as a reference line. In framing the shot, the choice of the position of the horizon depends on what is regarded as the real subject of the picture, as well as on compositional factors. Schematically there are three possibilities.

The center horizon. This cuts the photograph into two equal sections and usually conveys a feeling of monotony and indecision, as if the main point of interest, the subject, were missing. It should almost always be avoided, except in cases where there are symmetrical elements in both sections of the picture.

The low horizon. This is used with sunsets where the sun is the main point of interest, the fulcrum of the composition. The sky becomes the predominant element in the panorama, and should be appropriate, therefore, with clouds, moon, or sun stimulating interest.

The high horizon. This is advisable each time the natural environment is the real subject of the picture and the horizon is in the right position for the shot. A horizon in the upper part completes the picture and gives it breadth. Its presence is valuable anyway because it is an instinctive visual reference; by excluding it completely, the picture tends to become closed and oppressive. Only if there is some specific reason, such as an aerial photo, is omitting the horizon justified.

Two typical examples which leave the photographer in no doubt as to the best position in which to place the horizon in framing the shot.

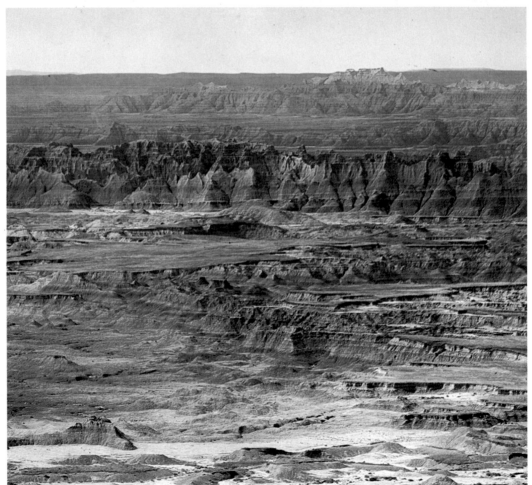

DEPTH OF FIELD

Depth of field describes the zone of sharp definition in front of and behind the plane of focus. Its extent depends only on the actual diameter of the diaphragm aperture, and on the distance from the subject, as will be explained in detail later. In natural environment photography this usually creates no problem if the shot is taken in daylight with sufficient light to use a medium-diaphragm aperture. The important thing is to know how to employ the whole depth available with the selected diaphragm. In practice this means selecting the focusing distance so that the sharp zone includes the entire field framed for the shot as well as possible. If infinity is included in the region rendered sharp, the most

ring the background intentionally.

In reflex cameras there are two ways of calculating depth of field. The first is to look at the notches symmetrically marked to the right and left of the pointer on the focusing ring. Each symmetric set of notches corresponds to a diaphragm value. In some cases calculation is facilitated by means of color coding. It should be noted that not all cameras carry these pointers, and that they are not exclusive to reflex cameras.

With a little practice one soon gets an idea of the effective area for a shot according to different diaphragm apertures and distances. It is advisable to become familiar with this simple and rapid method. Focusing is never separate from the choice of the

THE WIDE-ANGLE LENS

The wide-angle lens is the lens which extends the capacity to show subjects from a new and creative point of view and convey a feeling of space and perspective. Close approach to a subject, which is achieved by the use of a telephoto lens, can be simulated in the printing stage by enlarging part of the image; however, the effect produced by a wide-angle lens is irreplaceable. In certain cases, without a suitable wide-angle lens it will be almost impossible to get a shot which does not exclude important areas and does not break up the environment into many different images, when it should be depicted in its entirety to convey the impression

produces the geometric truth of things. If striking effects of perspective are required, one should use a short wide-angle lens, and in this case, the foreground will be stressed.

The first rule to remember is to hold the camera horizontal; if the lens is tilted even slightly, all the lines of the subject tend to fall, to slope in an unnatural way, giving a vertiginous effect.

The Choice of Focal Length

As a general rule with the wide-angle lens, one should always use the longest focal length capable of taking a complete picture of the environment. The shorter the focal length, the easier it is to obtain unusual images, but these are often badly composed and have displeasing effects of

Clever use of depth of field and of the wide-angle lens (on the right) to get a panorama.

suitable position for focusing with a given diaphragm aperture is called the hyperfocal distance. In practice, with a lens adjusted to the hyperfocal distance, the depth of the field of focus extends from about half the hyperfocal distance to infinity.

In photography of the natural environment, continuous attention must be paid to the depth of field because the subject of the picture is the environment in its entirety, and therefore it must all be included within the area of sharp focus.

A different approach is used in wildlife photography, for example, when the subject is an animal on its own, which is singled out and highlighted by means of selective focusing, blur-

depth of field. The use of small apertures is dictated by the need to extend the zone of sharp definition so that the eye can take in without difficulty the important elements of the picture.

The second method consists of a release button fitted to many cameras which closes the diaphragm to a set value, making it possible to see the actual image on the focusing screen directly. Some difficulties may arise in the case of smaller apertures, with considerable reduction in luminosity. However, by working with progressive diaphragm values, one can judge the extension of the sharp zone better and accustom the eye to less light.

and interest it arouses.

The use of the wide-angle lens to full advantage requires a certain appreciation of how the appearance of things is altered, how volume and distance acquire unusual dimensions: objects close by tend to dominate, the background becomes softer, depth of field increases, the perspective appears exaggerated, creating the impression of large spaces. It is worth noting that the wide-angle lens does not distort the perspective when it is of good quality, free from aberrations. Steep perspective effects are produced by the uncommon viewpoint, due to the short distance between lens and subject.

Perspective depends solely on this distance; the wide-angle lens faithfully re-

perspective.

For the 35 mm format, focal lengths of 35 mm and 28 mm are regarded as being normal because they expand the view without creating serious problems of perspective or composition. Lenses with these focal lengths are suitable for most requirements, and are also sufficiently fast. Lenses with focal lengths ranging from 24 to 20 mm can be regarded as the real, frequently used wide-angle lenses, but a degree of experience is needed to employ their full creative potential. They are a must for taking shots in close surroundings or for panoramas of wide areas. From 18 mm down, lenses are classed as ultra-wide angle, and are expensive and have a progressively narrower field of application.

THE SEASONS

The alternating seasons are like a biological clock directing the evolving of life. The photographic record which best conveys this idea consists of a set of pictures of the same environment taken in different seasons.

A useful piece of advice, one which always produces satisfying results, is to link photographs of some natural environment taken in different seasons with pictures of animals dwelling there. With a few images one can convey the idea of the harsh or favorable conditions linking the survival of the animals to their habitat.

The colors of the environment, visible chiefly in spring and autumn, also vary from year to year, and are directly connected with different atmospheric conditions.

Winter

In winter many mammals, reptiles, and amphibians reduce their activity, hibernate, and disappear from the external environment, taking refuge in caves or lairs. Plants lose vigor and reduce their physical dimensions to the tough, resilient ligneous parts. The natural environment presents itself to the photographer somewhat divested of its animal and vegetable presence.

Opportunities for taking pictures of other characteristics of the natural environment increase. The snowy blanket of winter covers the contours of the countryside, conferring unusual softness on it and mellowing its outlines. The snow-covered surfaces produce strong reflections of light which heighten the contrast. Trees and areas untouched by the snow naturally appear dark, which may offer a choice for certain kinds of harsh, realistic settings. In other cases a slight overexposure is called for to get a balance between intense light and dark shadows.

Ice on plants or rocks conveys the idea of a harsh wintry place very well. In winter colors are generally softer and monochrome tones prevail.

Spring

In spring the nature photographer can record the rapid changes which take place as a result of the profound phenomenon of life reawakening. During this period one can record the ice melting on streams, the first flowers sprouting in the meadows once the snow has cleared, or the green grass, initially light in color, gradually turning darker as it grows thicker. This awakening cannot be photographed with the same clarity in every setting. Woods and countryside, for example, change their appearance in a more spectacular fashion than the cold zones and the underwater world.

In spring there are more opportunities to capture rapid changes in atmospheric conditions. To photograph lightning during evening and night storms, the camera must be placed on a stand, keeping the shutter open and using a cable release to close it.

While framing the area of the sky where the lightning flashes appear, one may decide to take an impression of one flash only or keep the shutter open until several have been taken. But one should not exaggerate here because tiresome overexposure may result, rendering the lightning excessively bright, with halation rings around it. Further opportunities offered by spring are dark clouds threatening the landscape during storms, and the rainbow which follows. For a rainbow one should take a few extra pictures with the diaphragm aperture wider or narrower than that which is indicated by the exposure meter, as the rainbow can sometimes appear more or less luminous than the surroundings.

The same viewpoint and the same framing. These four pictures taken at different seasons of the year illustrate the changes in a natural environment.
On the right: The same tree in winter, spring, summer, and autumn.

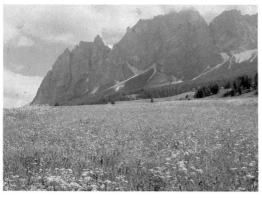

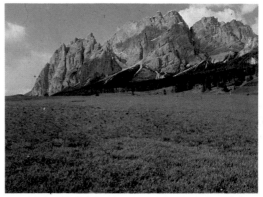

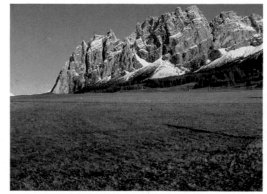

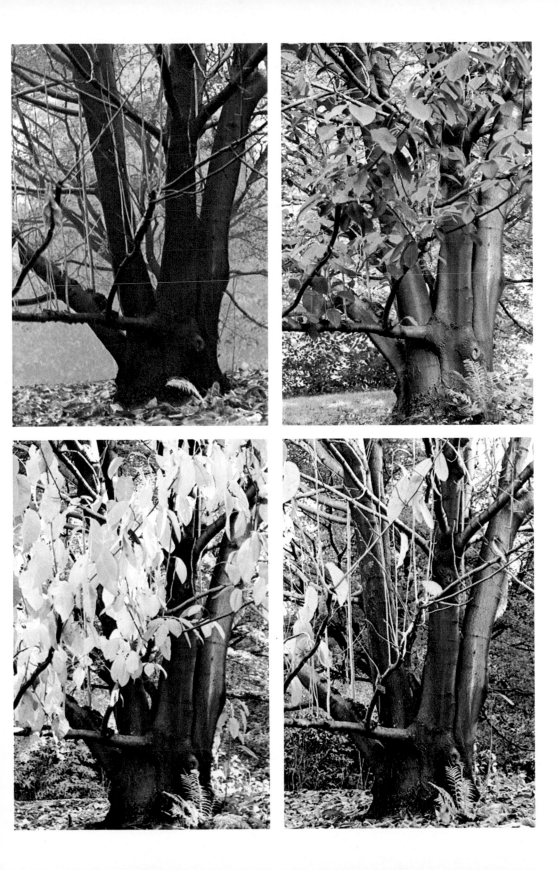

Summer

Vibrant colors with deep green vegetation, strong light, and possibly a haze in the air are all elements which the photographer encounters in summer.

In this season nature enjoys a period of relaxation. With the labors of propagation past, animals turn their attention to nourishing and strengthening themselves before the advent of another cold season. Opportunities for photographing animals in their natural settings are not lacking.

We are also more active during summer, and it often happens that while taking shots of the natural environment, one is interrupted by the presence of human elements in the picture. Passing cars, outing parties, and campers frequently disturb the picture: but it would not be very effective to show the puffin's habitat with tents visible in a clearing.

In shooting vegetation in black-and-white, it is not a bad idea to use green filters to reduce the preponderance of dark green characteristic of this season. With a sensitive film on an extremely bright day, it can happen that even with the diaphragm stopped down as far as it will go, the corresponding shutter speed will be beyond the thousandth mark. To reduce the luminous intensity, place a neutral gelatine filter in front of the lens.

The heat of summer often produces bands of mist, which render shots of surroundings less incisive, even though they may be wholly satisfactory as regards framing, focusing,

and exposure. Thus the habitat of the griffon vulture can be effectively depicted by sunny tones which characterize the barren stretches frequented by sheep or other tough, herbivorous creatures that are indispensable food for vultures. The same habitat photographed in spring during a storm would not convey the right meaning.

Autumn

Color harmony describes the environment. In this season natural environment photography gives excellent results: green, yellow, and chestnut hues mingle together, lending a mellow quality to images. Naturally a great deal depends also on the vegetation found in the environment being photographed. In the past trees were planted on the basis of the shades of color they took on in autumn. Wonderful combinations and permutations of color were thus obtained in these horticultural works of art: from amber to scarlet, from dark green to violet. Even without having recourse to these breathtaking artificial parks, which still exist, one can capture warm autumnal images. The right time, when the colors are changing, must be chosen, and one may have to wait for the low light of the afternoon to illuminate the leaves from behind and from the side, highlighting their thin, transparent quality. Photographs of autumn taken with the sky overcast and with just the right exposure ensure that a stronger relief is given to all those chromatic details of nature absent in other seasons.

THE DIRECTION OF LIGHT

In natural environment photography there is no optimum light. The sun at different times of the day highlights different aspects of the same setting, rendering details more or less visible, giving stronger or weaker contrasts of light, heightening colors. The lighting best suited to the aspects of nature which are to be documented can be selected. The bond which exists between the animals of the forest and the adjacent clearing where they emerge to feed can be rendered by a radiant frontal light which illuminates the meadow, highlighting it strongly, and which also penetrates between the trees, bringing out their pattern. If one waits for the sun to move across to the opposite side, the resulting semi-backlighting effect is that of a dark wood with an adjacent clearing. The highlighting of the habitat in the clearing has disappeared, but the image has taken on another shape suited, for example, to expressive meanings which are more striking, like depicting the world of predators emerging from the woods toward evening. The tying together of environment photography with the creatures of nature is of considerable use in a didactic context. If a photograph of the sun's rays filtering through branches to light some small shrubs on the ground deliberately accentuates the darkness of the wood and the bright luster of the shrubs with a slight underexposure, the resulting effect can show how precar-

ious the growth of life is without the sun's light.

The technique of selecting strong contrasts to bring isolated and sunlit subjects into greater relief is frequently used; for example, to convey the hard life of pioneer plants in the tundra or to illustrate the difficulties of contorted trees adapting to their environment and clinging to the rocky Mediterranean coast. Depending on the quality of light which he desires to use, the photographer must choose a suitable position before the sun lights up the part of the natural habitat to be photographed. Time will be needed to frame the picture, to choose the appropriate wide-angle lens, and to think and visualize the photographs to be taken. In a mountainous environment and one which is unfamiliar, it is a good idea to carry a small compass, especially when venturing forth in the early morning to shoot with the dawn light, or when making preliminary excursions on the day before shooting in order to choose the right locations, knowing the exact position where the sun will rise. For example, one can calculate whether it is possible to photograph a particular rock face with the radiant sunrise or whether one should wait a few hours, giving up that effect to make use of the very first light of day instead.

Each hour of the day has its own characteristic light, from dawn through morning, midday, afternoon, and sunset. The different angle of inclination of rays and the veil of the

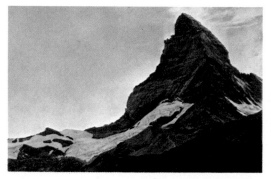
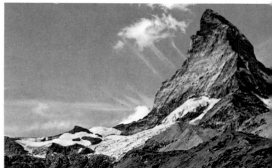

atmosphere greatly influence the rendering of forms and the predominance of certain colors. Blue light is reduced by the atmosphere, which allows red light to pass through. Dawn offers unique features for natural environment shots. The fine, radiant light picks out the contours of things and turns the landscape reddish, while reflecting the blue from the sky and giving shadows a bluish hue. In the morning, mists disperse and the sun rising ever higher increases the illumination. Photographs of natural environment taken in the morning are generally "cleaner," with prominent contours better defined.

At midday with the sun high there is less exclusion of sky-blue tones. The chromatic scale is better balanced and white light prevails. The contrast between illuminated bodies and shadows is greatly increased and shadows appear short and hard. In the afternoon the light reassumes its slanting angle, and while shadows are lengthened, warm tones prevail more and more. At this time the softness of the light and reduction in contrast permit natural details in areas not directly illuminated to be photographed. As a rule any subject will benefit from soft afternoon light on account of the added emphasis given to its contours and structure. Care must be taken, however, to avoid underexposure, by working out the right exposure for the shaded areas and taking several shots from the same position with diaphragm apertures bracketed around the value shown on the exposure meter. If necessary, one can rest the camera on a rock or something similar or use a tripod. Often it is the wish to take a hurried hand-held photograph before sunrise which produces an afternoon-type underexposure. Sunset always offers inspiring effects for the photographer. Certain natural settings such as the Grand Canyon take on a breathtaking appearance at this hour of the day, when the light of the sun appears to light up the mountains with varied shades of luminosity.

An overcast sky is a great natural filter for sun rays, eliminating strong contrasts and diluting colors. Some consider shots taken without direct sunlight to be dull, but the chromatic balance and clear rendering of the texture of natural environment, features which are present in this sort of photography, make it effective for taking pictures of certain cold regions or the European countryside and mountain areas.

The Matterhorn taken at different hours of the day. Making use of the changing angle of inclination of the sun's rays, one can accentuate or cut out different parts of an environment, as is also apparent from the two photographs at the top of the page.

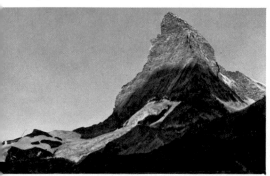

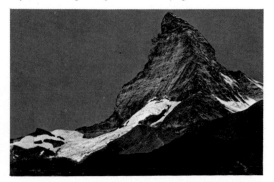

THE GEOLOGY OF PLACES

Photographing geological features is in a sense like photographing the earth's history: furrows formed through water erosion, desert rocks molded by wind and sand, moraines left by glaciers, little islands and rocky curves created by the force of the sea, the millennial evolution of canyons.

A typical subject for geological photography is stratification, which can be seen on the faces of many mountains. This is the result of sedimentation processes during thousands of years, and the formations furnish important data on the origin of a particular region. To photograph them one should wait for a good side light so as to bring the protruding parts into prominence and to highlight the differences between each layer of stratification. If the geological detail is to be emphasized, hard shadows and excessive contrasts of light should be avoided. For instance, when filming volcanic eruptions, strong contrasts are useful to express the harshness of the features.

Lenses

Lenses must naturally be chosen in accordance with what you intend to photograph and how close to the subject you will be. A normal or medium wide-angle lens is generally the most suitable, while a short telephoto lens or a zoom often suffices to solve the problem of detail. For areas to which access is difficult, a long-focus telephoto lens may be used.

Fossils

Precious treasures are hidden within sedimentary rocks. These fossils are sometimes extracted by people who don't appreciate their importance and are taken home to be used as ornaments, and often end up by being lost or broken. Fossils should be protected since they represent an exceptional palaeo-ecological guide to the life of a given environment later transformed into rock. The photography of the geological aspects of nature enables pictures to be taken of them set in their rocky surroundings, where they have remained for millions of years. There exist so-called "open-air museums," where the most varied fossils can be studied and photographed without removing anything.

If you do not have the patience to wait for the right angle of inclination of the sun, which will probably only last long enough to shoot a few pictures, take a medium flash with an adjustable meter which can give an exact reading of the exposure from close up.

Fish, seashells, water reptiles, seaweed, and other fossilized forms can be taken with macro and normal lenses, which should be carried along as well as the wide-angle lens.

Rocks

In photographing rocks a good deal will depend on the angle of the shot. By altering it, especially when shooting ovoid-shaped rock masses, a distortion of the curves will be produced causing intentional modeling effects. In this way one can accentuate a rock in the foreground, showing also the geological context of surrounding rock formations, or vice versa, emphasize only one particular agglomerate. More spectacular effects can be obtained by using a wide-angle lens with a very short focal length to underline the distortion effect.

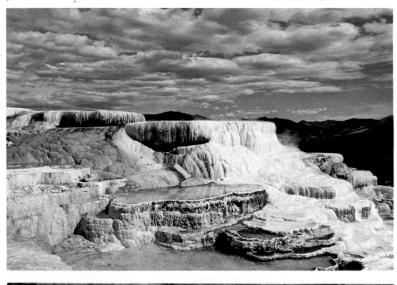

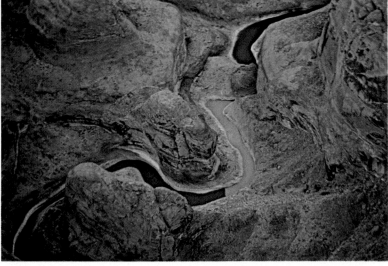

Three striking images which provide sound documents of the geology of their locales. Above: Yellowstone Park. Left: Glen Canyon, Colorado River. Opposite page: Columnar basalt in Ireland.

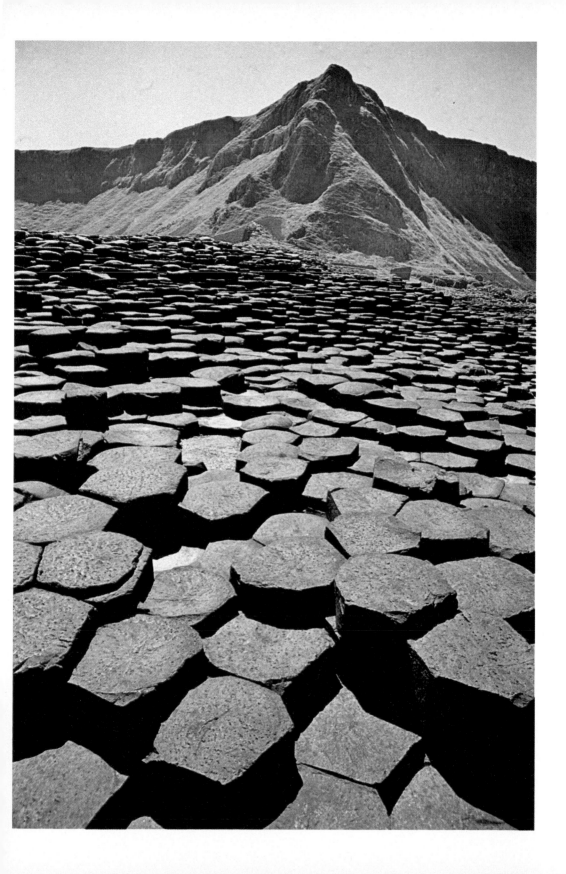

CAVE PHOTOGRAPHY

Photographic surveys of enclosed natural environments present us with particular problems in addition to the difficulties already part of exploration itself. To face the difficulties and dangers found in exploring natural caves, actual experience of speleology is necessary. Even the documenting of caves which are already known and accessible requires considerable care, since one has to face total darkness, humidity often of a high degree, the presence of water everywhere, and muddy and dangerous paths.

Subterranean environments, sealed off from the light of day and from human sight for millennia, present elements of interest whether they are of a scientific and naturalistic or scenic and spectacular nature. They are fascinating even to those who are not interested in speleography. The simple act of penetrat-

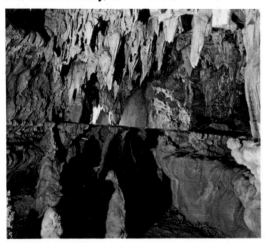

ing one of these caves requires organized preparation, suitable equipment, a guide, and planning of the route and length of the visit.

In practice, caves are explored and photographed by an organized expedition comprising at least four or five persons. The many problems which confront one all at once under these conditions can only be overcome by close collaboration among the various members of the group. If they are able to allocate tasks to face all the unforeseeable difficulties in moving about and taking shots, it will then be possible to proceed quickly and efficiently. In caves time is always precious.

The Techniques

Natural caverns, since they possess an extremely varied and complex structure

Grottoes of Toirano (Savona, Italy). The photograph on the left was taken with five synchronized flash units, a 6 × 6 cm camera with 50 mm lens at f/5.6; and the picture below with six flash units, a 35 mm camera with 24 mm lens at f/8.

and shape, demand organized effort to find suitable and feasible positions for the camera to shoot from and for the various flash units.

Flash can be used effectively in two ways: with synchronization by means of slave units; and with shutter open, firing the flash units manually. The first method is faster but requires careful arranging of the sensors to face the main flash linked to the camera; this is not always easy.

Having chosen the subject, one selects the position of the camera (or cameras), mounted on a tripod with cable release inserted. The camera will have a flash attached which will trigger all the others. If there are other cameras, their shutters are opened and closed manually on command; the lenses can be wide-angle ones of varying focal lengths so as to take shots of the same scene simultaneously from different angles. Flash units must be fitted with diffusion filters (transparent paper fixed with adhesive tape is sufficient) to obtain a soft and even light over the whole area to be framed. Each

flash mounted on a stand and connected by a lead to a slave unit constitutes an independent lighting unit, which should be placed carefully so as not to be visible from the shooting position, lighting its own section of the wall, its own sensor receiving the signal from the pilot flash. After these intricate preparations a set of exposures may be made, varying the diaphragm stop each time to ensure correct exposure. With this method satisfactory results can be obtained even in very spa-

cious chambers, providing a sufficient number of lighting units are used.

Flash is the only light which will guarantee a record of the authentic colors of the cave walls. The method becomes simpler when details are being photographed which require only one or two flash units: those with individual sensors are undoubtedly very handy.

Besides pictures of environments, caves provide subjects of great interest, ranging from fossil remains to nocturnal animals such

as bats. Cave photography has a documentary purpose which is easier to realize if the photographer has the guidance of an expert speleologist. For example, the upper photograph on page 66 appears to be cut into two halves by a horizontal line; this corresponds to an old water level, which has produced a clear, characteristic break in the stalactite growth. Only by placing the lens at exactly the same level was it possible to bring out this feature in the photograph.

The high degree of humidity can create problems especially with the wiring and flash circuits. A simple solution is to place the lighting units in plastic bags (providing they are transparent) sealed with tape.

Bats in a cave. Because they seek shelter high in places, they often have to be photographed with a telephoto lens.

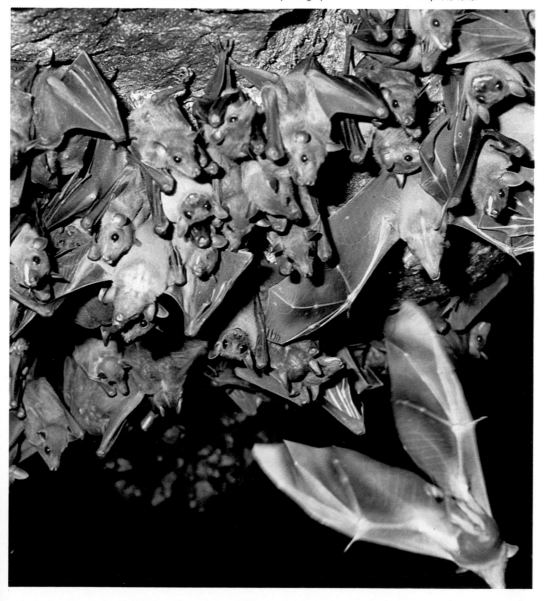

STRIKING PHOTOGRAPHS

Why does a picture capture the attention of the most distracted observer? What are the secrets for creating spectacular pictures? How do great nature photographers work? Sooner or later every nature photographer feels the need to improve his own technique and advance beyond the stage he has reached, in order not to restrict and repeat himself. Having exhausted the modest scope of documenting his own environment, he seeks to produce images which will possess some originality by comparing experiences and studying what has been published. Producing more striking pictures means knowing how to condense into the image a natural reality which is interesting in itself plus a pleasing composition; it also means making such images instantly readable without effort.

Certain photographs become symbolic of particular animals or environments. Creating pictures at this level demands professionalism in their conception. In fact, they never happen fortuitously, but are the result of a great deal of effort and experiment, carried out always holding in mind the thing one is searching for. If we see, for example, that a certain picture would benefit a great deal if it were taken with the sun rising in a given composition, a decision will have to be made to set out on as many early-morning treks as are necessary to get just the right light. A much exploited element, but one that is always effective if used properly, is in fact the sun. The luminous disk, which appears yellow in backlight, can give vitality to images which would otherwise be flat. Such is the case also with the moon, which adds a useful and evocative element to the composition in twilight pictures. Many famous photographs have in common the quality of simplicity: few compositional elements, one subject only, and color masses judiciously balanced.

Anything which is unusual or which calls to mind situations which are symbolical, that is, which have already been classified by popular culture, becomes an image easy to assimilate. For example, the picture of a shaded wood inhabited by tame and graceful animals conjures up an idyllic world of harmony and concord.

The sun-drenched and silent setting of the desert recalls the idea of the absence of life, while certain situations of unusual vigor in nature are effectively expressed by a plant growing isolated in the desert or clinging to the side of a rocky slope.

It should also be remembered that many pictures gain in expression by increasing the contrast. By means of transparency duplication one can modify both tone and composition. Apart from this it is a useful exercise in training the eye to create variations on a theme from one photograph.

Photographs of nature taken from the most inaccessible points and from original and fascinating angles often reveal surprising aspects, as the picture below shows. Lava Falls, Colorado River, by Ernst Haas.

Right: Another photograph by Ernst Haas, taken at night during a volcanic eruption.

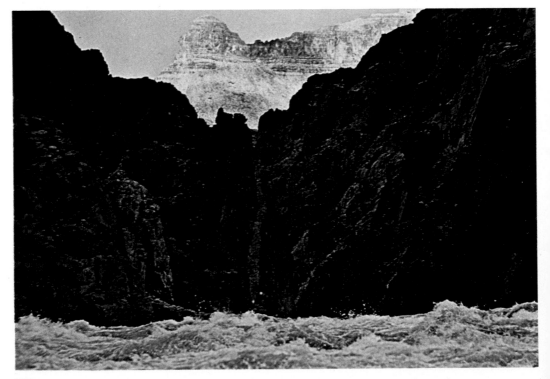

PHOTOGRAPHING TREES

Trees are extremely under-valued subjects from a photographic point of view and are often poorly used, although they are always within reach of the camera, not being able to flee from the nature photographer as animals can. In fact, what can be discouraging is the difficulty of separating the tree from its background so as to bring it into prominence. It is not easy to find trees completely isolated

• Photograph the tree from a distance with a medium telephoto lens, with diaphragm at full aperture to blur out the whole background scene.

Trees in Their Environment

A tree should also be photographed in its natural environment. The image should not come out looking fuzzy, like the usual photograph of woods. One

Further Problems in Framing

If possible it is often an advantage not to photograph the tree from below but to find an elevated position, perhaps provided by a slope or other unevenness of the ground. The more athletically disposed can also attempt, at their own risk and peril, to take a position on a neighboring tree, but they will have the

problem of branches and leaves, which normally hinder composition. It is better, however, to use a normal lens or a medium telephoto (if the subject is not too close) because with the wide-angle lens it is usually impossible to avoid distortions, which cannot be eliminated if the viewpoint is not ideal, and one is forced to tilt the camera in the wrong way with this type of lens.

Photographing individual trees can be easy, as in the case of the solitary baobab on the left, or very difficult, as with the great Norway spruce deep in the forest of conifers (on the opposite page).
Below: Conifer forest in winter.

from their environment, as happens in Africa, for example, with acacias or baobabs. More frequently the tree is found in the vicinity of other plants that disturb the framing. To remedy this drawback a number of possible solutions are offered:

• Search for a composition which isolates the tree, making a repeated effort to locate this from different side positions.

• Wait for lighting more suitable for stressing the outline: for example, side illumination and rear illumination are best for bringing out the tree, also emphasizing the transparency of the leaves; the opposite effect is produced by a level frontal light.

• Wait for the right season, in which the color of the leaves on the tree to be photographed contrasts with those on surrounding trees.

should be able to distinguish clearly the arboreal figure selected in the natural setting where it grows. This is also useful in understanding more about the life of the tree. For example, in the forest of Bialowieza, in Poland, the trees are centuries old, since no one is allowed to cut them; when they have aged considerably and fallen to the ground they are left to decompose in an equilibrium which has lasted for centuries. Now the diameter of these trees does not give any idea of their real age, since they grow and develop in a vertical direction in search of light. Environmental photographs of these trees with their slender trunks can only give an idea of their age if they show their height and tops, which seem to be competing with one another in search of the sun.

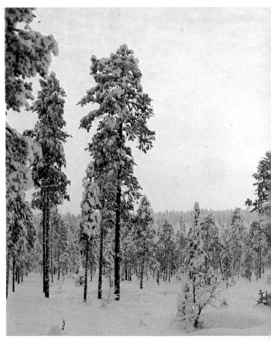

Documenting the Life of Trees

Trees vary a great deal. Think of the differences in color and appearance which they take on with the seasons or under the harsh and varying atmospheric conditions in which they frequently flourish, in snow or wind, for example. Even during and immediately following storms, trees appear different. The attentive nature photographer will not allow these moments to escape.

To photograph trees through the seasons, first look for the right position for a shot which will bring out the foliage. The miracle of changing colors should be emphasized. Then return every three months to the same spot to take a picture, using the very same frame. A work of patience indeed, but one which is amply repaid by a complete set of pictures of the life of the tree. Normally our idea of the world of plants and trees is based on their appearance at a given moment of the year; however, the real life of trees is observed by comparing their varying dress. This direct comparison can only be made, evidently, through pictures.

If you are not satisfied with documenting the annual biological cycle of the tree, illustrate its life by following its evolution over a period of years. For this type of long-term photographic description, use trees that are in easy reach of the lens, such as the plants in one's own garden or neighborhood.

To compare the differences which exist among the same arboreal species in the diverse environments where they grow, one can emphasize how variegated the plants are, owing not only to the intervention of man in pruning them or curtailing their growth but also to differences in climate, soil, and environment. In this way tree photography becomes a scientific documentation.

Large Trees and the World Linked to Them

When we speak of "large trees" we mean those hoary, grand specimens which have survived the felling of thick forests in bygone times. With their mighty shapes and resolute bearing, they provide ideal subjects of photography which are not difficult to shoot, because in the course of their long life

they have conquered space at the expense of the surrounding flora and hence find themselves well isolated. Around them lies concealed a whole world of flora and fauna of great interest to the nature photographer.

The nature of undergrowth and of plant forms closely linked with the tree, such as fungus and lichen, is the easiest to document photographically. The right illumination is the most important element for this kind of picture. One can wait for suitable sunlight

(sun low on the horizon) to bring out the silhouette of fungi or to show up the soft and homogeneous carpet of undergrowth. With the requisite patience and macro equipment, even lichen may be taken with natural light. It is advisable, however, to use a flash of small or medium power to photograph less illuminated details.

Large trees, on account of their age, have cavities and protuberances which serve as shelter for many animals; thus they attract insects and snakes, mam-

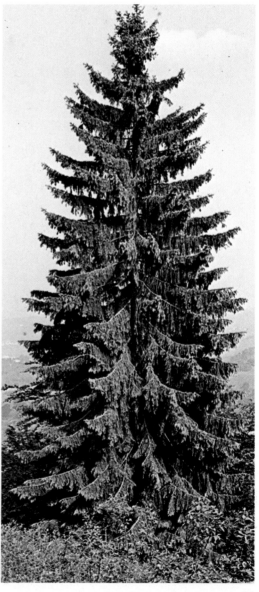

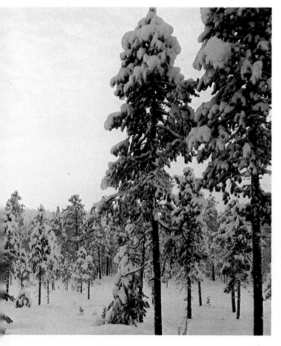

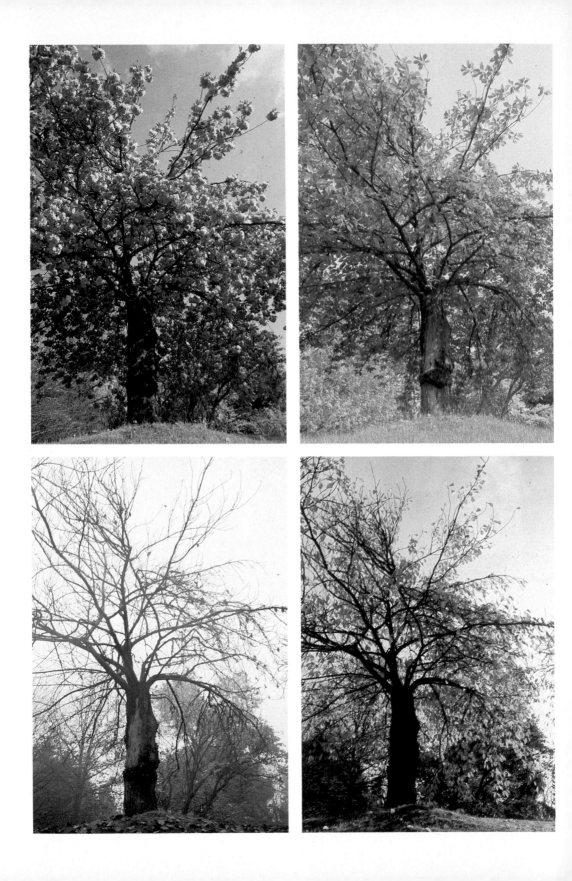

On the facing page: Another example of a tree photographed in each of the four seasons (see also page 61).
Below: Detail of a broadleaf woods in autumn.

mals and birds, more than do bare saplings. Along the trunk can be seen the green woodpecker hammering away in search of insects, the tawny owl hidden in a hole, the jay, magpie, or sparrow hawk absorbed in building a nest between the forks of branches, or wild bees that live in deep cavities. To photograph these animals one must have a great deal of patience.

Many beginners in photography mistakenly think it is enough to find places to which animals are attracted in order to be able to take pictures of them with relative ease. They soon discover to their disappointment how difficult it is not only to photograph these creatures but even to succeed in catching sight of

them (especially in the case of mammals and birds). One should put into practice what we have suggested above: Study nature in order to observe and photograph it. Keep well hidden and await the arrival of some companion of the tree. In any event, one should know beforehand which species attached to the great tree are likely to appear, so as to be ready to take the shot. For example, one must take into account the possibility of a marten appearing who will climb up the trunk, or a bird of prey who might alight on the dry branches higher up. To attempt a picture of the marten, some kind of photographic trip device must be prepared; and to catch the bird, the point at which it will probably come to rest must be capable of being framed from the photographer's chosen hiding place. Nothing is more frustrating for the nature photographer than having a golden opportunity slip from his grasp due to technical unpreparedness.

A Botanical Collection in Pictures

On each tree many details can be photographed. Some differences are peculiar to individual subjects, such as the twisted trunk, malformations, the effects of parasite action, the shape of the roots emerging from the ground due to the particular soil in which they have grown. On the other hand, some details are fixed characteristics of all trees, differing only in shape from species to species. Thus a botanical collection in photographs can be built up which is useful for learning how to recognize the different arboreal species. In place of twig and leaf samples once prepared by botanists, today the different species are illustrated in sets of photographs which highlight every detail. Each plant is described and illustrated with a sequence of pictures which show its structural features, such as leaves, flowers, fruit, seeds, appearance, bearing, age, shape, trunk, and bark.

The Leaves

It is useful to isolate a leaf or two on a branch. A picture of foliage confusedly crossing and muddling the subject with the foreground helps neither the photographic composition nor identification of the subject. One should search for the twig that stands out from the rest and, if possible, frame it against the sky, thus succeeding in sharply separating the leaves from the background. In such cases twine can be used to hold apart the bunch of leaves in question. Branches should not be broken. At the most one can detach one leaf for the purpose of recording its shape in close-up and under the right light. Pictures of this kind are a good way of making a photographic collection for educational purposes.

Another difficulty which may be encountered (as with flowers) is wind, which can prevent proper focusing. Using a clothespin to hold the supporting twig

still may help to solve the problem.

Photography of deciduous trees, with their seasonal changes in foliage, offers continually new subjects and compositions, in contrast to the evergreens. In spring, the soft shades of the tender young leaves can be captured. A similar mellow effect can be achieved by photographing leaves after rain or when they are heavy with dew. In all these cases the low light of morning helps to bring out the structural pattern of the leaves.

Flowers and Fruit

The inflorescence of trees, apart from the spectacular blossoming of fruit trees, is a fairly neglected subject in photography. At times one can observe amateur nature photographers, apparently not very knowledgeable in botany, striving to find the female inflorescence on trees which are exclusively male.

Some difficulty may be experienced in cases where flowers or fruit are too high to be reached.

One can capture many details in trees, taking shots which are satisfactory not only photographically but also from a naturalist's viewpoint.
Below: Moss on a conifer, and fungus on a trunk.

On the right: Characteristic pattern of the bark of the Prunus serrulata.
On the facing page, above: Leaves and flowers of the horse chestnut tree. Below: Acorns of the white oak.

The use of a medium, 105 mm telephoto lens or an 80-200 mm zoom can solve the problem, providing one is not in a hurry to find the right composition. Many fruits are excellent subjects to complete the photographic collection. Think of the photogenic nature of maple fruits, with their characteristic winged form, or ash tree fruits, which resemble insects' wings.

An opportunity not to be missed when taking shots of fruit is the occasional presence of insects and birds. The medium telepho-

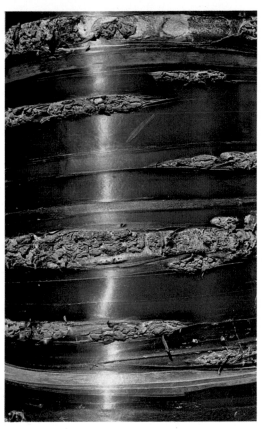

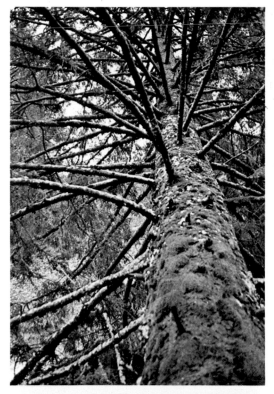

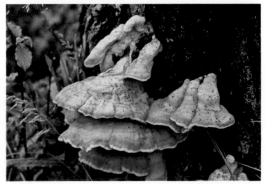

to, macro or normal, already mounted and ready for use, will make all the difference on these occasions.

To augment illumination it is useful to have a small flash, which will also make it possible to take the cones of the shaded conifers. With the help of a small stand or mini-tripod, in addition to the flash, one can also take pictures of fruit and seeds which have fallen to the ground. These pictures, if taken at the right angle, are far better than the artificial photographs prepared in a studio. Studio images in fact are more like the painter's still life than the photographs of a modern naturalist.

Outline, Trunk, and Bark

The appearance of trees in winter lends itself quite well to shots in black-and-white. The sharp contrast between the silhouette of the tree and the sky empha-

sizes the harshness of winter life for the plant. Pictures of bare trees also focus attention on species differences aside from leaves and fruit. In taking these shots one must pay attention to extraneous elements, such as specks of light or vapor trails of jets. These factors, considered to be of little account, in fact prove to be very damaging, disturbing both the composition and the meaning of the image.

Macrophotographs of bark, especially with side lighting, are important in describing the tree. Interesting photographic contrasts, for example, can be shown between the bark of plane trees and that of oaks, or between fir trees and pines. From the structure of the bark and from its fissures one can even calculate the plant's age. When the leaves fall, the bark is lit by a stronger light. This is the ideal moment to get a good photographic image.

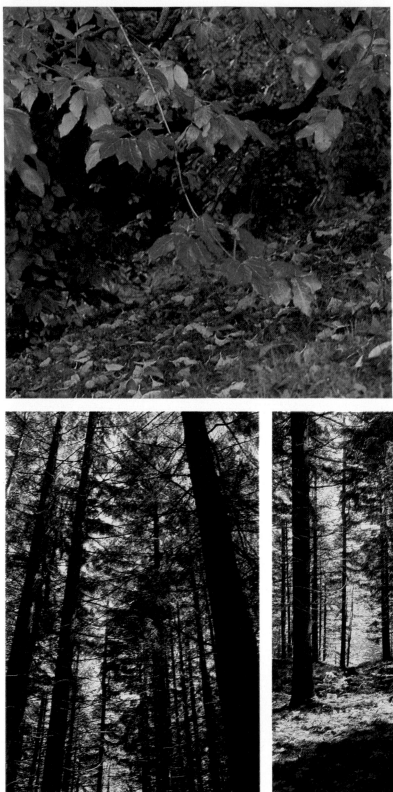

On the left: Autumn colors in the woods.

Below, left: A common mistake, especially with beginners—long-trunked trees taken from below produce a disagreeable effect of convergence toward the top. On the right: The same woodland taken with the camera tilted at the correct angle.

On the facing page: An effective and technically well-executed photo of trees.

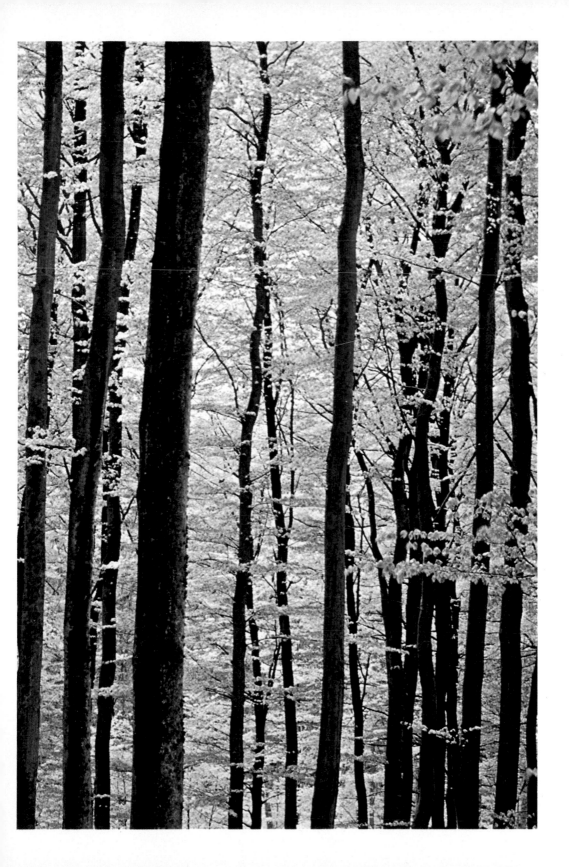

PHOTOGRAPHING ANIMALS

There are those who tend to see wildlife photography as similar to real game hunting. In fact, some parallels do exist, such as seeking out the animal or aiming the telephoto lens like the barrel of a rifle. But the difference between the two activities is much more substantial than might appear at first glance. To begin with, the nature photographer who takes pictures of animals is usually convinced of the need to preserve carefully this precious heritage of wildlife. For the picture hunter it would be absurd to destroy subjects which give so much joy in watching and filming. While the hunter with a gun seeks out his prey to kill it, the hunter with a camera seeks to capture a moment in the life of his prey without destroying it. Furthermore, the more one learns about animals and their world (and nature photography con-

tributes enormously to this), the harder it becomes to shoot them. Many hunters have already made this transformation, shelving the rifle and raising in its place a reflex camera with telephoto lens. It can be said that by widening his knowledge of nature, man has gained an ecological conscience which draws him away from the sanguinary pastime of hunting.

The Joys of Discovering the Animal World

The search for better pictures, besides satisfying purely technical criteria, produces in the wildlife photographer the desire to freeze the thrilling moment of encounter with animals in the most effective way possible and to be able to relive it afterwards in looking at the pictures. Wild animals are not motionless like flowers or rocks, nor

are they constrained in their flight as in a zoo. The contest of wits between animals in the wild and the nature photographer is a valid stimulus for obtaining good pictures. Hence the great fascination that wildlife photography holds.

A Healthy and Sporting Activity Within Everyone's Reach

There are two types of wildlife photography: stalking, actively searching for animals in their habitats; and ambush, from a concealed place such as a hut or blind, waiting for the animals to approach the camera. As with birdwatching, which is the almost indispensable prerequisite for learning how to move in nature and understand it, wildlife photography is a sports activity that requires its practitioners to spend many hours in the open air.

The urge to take good pictures induces even the laziest to accomplish ardu-

ous exploits. In stalking wildlife photographic subjects, you may find yourself walking for hours on the moor in search of partridge or snipe, or climbing up a steep rocky slope to take shots of chamois. The chance to photograph the animals from close quarters goads one to action. All this helps a great deal to get one engaged in a psychophysical activity which is extremely useful as a release from daily tensions and stress.

As for the long periods of waiting, which are unavoidable in ambush wildlife photography, these accustom one to self-control and patience. In fact, the desire to see the animals and photograph them makes having to wait much less tiresome.

The idea that wildlife photography can be confined to a few experts is a fallacy. There are nature photographers, among the leaders of this art, who maintain that an excessive

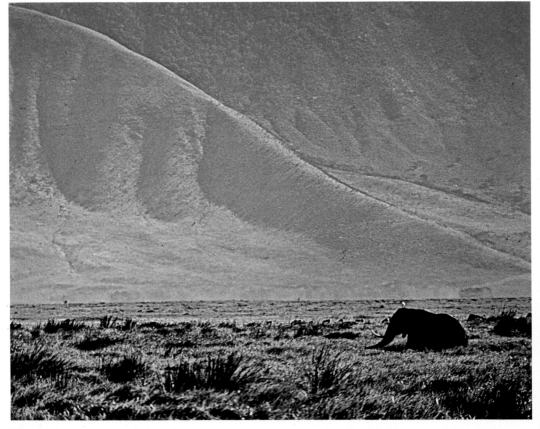

proliferation of amateurs practicing this kind of photography can only do harm to nature, and that therefore the circle of wildlife photographers should be limited (mainly to themselves). But notwithstanding these leaders, the number of people experiencing the desire to plunge into nature armed with a camera and telephoto lens seems bound to grow. Rather one might wish that this activity should become an effective alternative to more sanguinary practices and serve as an incentive for the preservation of the faunal heritage.

Anyone can practice wildlife photography. The technically expert photographer will be able, in approaching nature, to penetrate her secrets and pho-

tograph them. The naturalist, on the other hand, will not find the task of learning about the workings of the camera and its parts too difficult. Don't think that the equipment and the technical know-how are unduly complex: the important thing is to acquire a good knowledge both of the fundamental laws of nature and of photography.

The "Eye" of the Wildlife Photographer

With experience one acquires the eye of a wildlife photographer. Only through trial and error and the expenditure of a great deal of film can one train oneself to grasp the decisive moment, to take the most effective shot with the right illumination. After many in-

effective attempts comes the really successful shot, to make amends for all previous disappointments. Finally after a great deal of practice, the choice of the right moment to shoot becomes automatic.

At first, the photographed animals will appear very small, but these pictures, even if imperfect, will please their author, either because they remind him of his first experiences

or because they serve as a record, to add to the knowledge of a species encountered in a particular environment, and they will bear witness to the photographic "catch." You can build a collection containing all the species photographed, progressively substituting for pictures of species which you already possess later and better photographs as your experience grows.

The African elephant roaming in the savannah (opposite page) and two bison grazing in the grass, with the setting sun flushing the sky red (below). Looking at pictures of this kind suggests the magnificent results and the great satisfaction to be had from photographing wild animals and the fascination in searching for them.

BASIC EQUIPMENT FOR WILDLIFE PHOTOGRAPHY

The Reflex Camera

The field of the 35 mm reflex camera is in a continual state of growth and development. Manufacturers have put on the market equipment which is extremely diversified and sufficiently complete to meet most requirements. Some of these reflex systems can

be recommended with confidence on account of their traditional reliability. Among these are Nikon, Olympus, Asahi, Canon, Contax-Yashica, Konica, Leitz, Minolta. Some, like Nikon and Olympus, offer in their catalogues, highly specialized accessories for nature photography.

The choice of a reflex

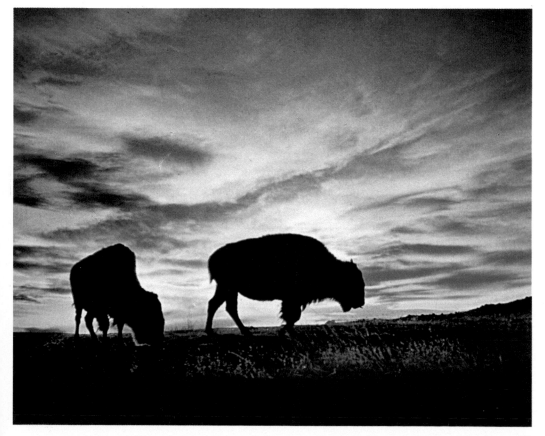

system must be carefully considered, bearing in mind that the aggregate equipment one intends to purchase should satisfy one's real needs as a whole, and at a suitable price.

The Choice of Format

The camera we shall be referring to throughout this book is the 35 mm reflex, which represents the best compromise in terms of performance, price, and overall size. Notwithstanding this, the larger-format reflex undeniably gives a better quality image and is especially useful for powerful enlargements and for more strictly professional needs. However, the 35 mm format, at its best, using a high-quality lens and fine-grain film, gives results which are very similar to the larger formats. This is confirmed by the fact that many professional photographers have adopted it for general use.

The 4.5 × 6 format has recently been made available again with the debuts of the Mamiya 456 and the Zenza Bronica ETR, which give similar performance to a 35 mm camera, with overall dimensions only slightly larger than the traditional reflex 135. This is a compromise which combines the advantages of a large format with bulk and cost still reasonable enough to make it potentially attractive and capable of being promoted.

The classic 6 × 6 cm format is inseparably linked with the name of Hasselblad, which, years ahead of its time, designed the most practical and complete modular reflex system. This camera is a bench mark for professional photography, a strong and versatile working tool whose only disadvantage is high cost, justified by its undisputed quality.

Other 6 × 6 cm format cameras available on the market at present are the Zenza Bronica EC/TL with automatic exposure, which uses Nikon lenses, as does the simpler S2A model; the Rolleiflex SLX, electronic automatic with extremely sophisticated features; and finally the two models of

Kowa SIX Professional. The 6 × 7 cm format is the largest available with the advantage of a reflex system. There are two cameras, the Asahi Pentax 6 × 7 and the Mamiya RB 67, in both of which weight and size are substantial. Where the quality of the image is of special importance and weight and size are not insuperable obstacles, this format can give results of a high standard suited to powerful enlargements. The 6 × 7 has some advantage over the 6 × 6 format, which, from a compositional point of view, adapts poorly to many subjects, including panoramas, in which realism and definition are decisive factors in conveying the grandeur which so impresses the viewer.

There are four common characteristics of the larger-format cameras, three of which would favor the 35 mm: greater bulk and weight, double the cost of film and processing, fewer and less wide-ranging accessories. On the other hand, there is the undeniable advantage of a better-quality image.

The Telephoto Lens

The basic characteristics of telephoto lenses as used in wildlife photography are their flexibility, ease of handling, enlarging power, and luminosity. Small-power telephoto lenses should be excluded; a 300 mm telephoto lens is a minimum requirement with which to begin wildlife photography.

The 300 rnm lenses are usually fairly light and luminous, not cumbersome, and easy to handle. Subject enlargement is quite good but limited, which means that in accustoming oneself to the use of a 300 mm lens, to take shots of animals one must learn how to get reasonably close to them. Some excellent 400 mm lenses also are available, which again present a compromise among the four positive features of the telephotolens for wildlife photography.

With the 500 mm, an excellent lens for taking animals at long distance which draws them within

photographic range, we turn to a different category of lens, the mirror, or catadioptric, lenses. These are lenses in which the light that enters is reflected off a mirror (which can be seen by looking into the lens) placed at the end of the lens barrel, onto another, smaller mirror positioned immediately behind the front lens. This smaller mirror in turn reflects the image onto the film. The purpose of these reflections is to reduce the cumbersome length of the telephoto lens while providing the desired focal length.

ject, especially when liquid surfaces like the sea or a lake are being taken. These circles are ignored by some, while others cannot tolerate them. Much will depend on the kind of picture and personal taste.

Telephoto with Ordinary Lens or Mirror Lens?

The wildlife photographer faces the dilemma of having to choose between the ordinary lens and the mirror lens. In the catadioptric system the fixed aperture has the disadvantage of being unable to get a

Basic equipment for a young wildlife photographer. A telephoto lens with a focal length of 300 mm mounted on a reflex camera and supported by a rifle grip allows him to enjoy his first taste of wildlife photography.

Catadioptric lenses are thus smaller than ordinary lenses of equal focal length. No ordinary camera lens is light and manageable enough to be carried and handled with ease and capture a bird in flight, for example, as the mirror telephoto lens. In ordinary lenses, the light passing through the front element makes a direct journey to form an image on the film; that journey is as long as the focal length, hence the reason for the excessive length, weight, and bulk of high-power telephoto lenses.

Catadioptric lenses, because of the reflection of luminous rays onto the mirrors, produce small circles or rings which are visible in the background of the sub-

group of animals into focus if they are on different focal planes, since the depth of field cannot be increased by stopping down the diaphragm. On the other hand, the fixed diaphragm in telephoto mirror lenses may not be a disadvantage: in coupling the mirror lens to a camera with aperture priority and automatic exposure, the routine required to take a photograph is reduced to framing the shot, focusing, and pressing the button. The electronic shutter sets the speed required for the fixed aperture, selecting without interruption any intermediate speed indicated on the selector ring between 1/1000 second and one second. However, a shot of a flock of animals,

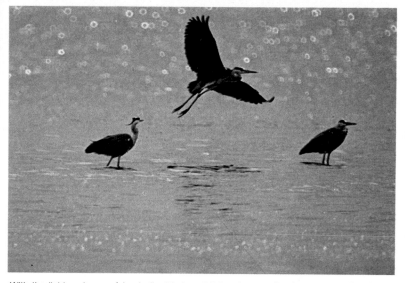

With the light and powerful catadioptric lens (pictured on the right), small luminous rings sometimes appear on the image, which may or may not be acceptable to the photographer, depending on personal taste.

only one or two of which are in focus with the telephoto mirror lens, and with small circles visible in the background, might make one think of the advantages of using a normal telephoto lens: greater depth of field and absence of background circles. The difficulties are carrying a heavy lens attachment over rough paths, and the time lost in aiming the lens at the animals plus the fact that they would probably have taken flight before the picture was shot. With plenty of time, telephoto lenses of equal focal length possess undeniable advantages, such as their luminosity. With a fast telephoto lens one can use a low-sensitivity film, which helps the sharpness of the image considerably as there is less graininess. On the other hand, moving from a telephoto with a normal lens system to one with a mirror lens system, one can appreciate the lightness and ease of handling, exceptional qualities for a lens of such great focal length. Catadioptric lenses are fine for getting as close as possible to individual subjects. For taking groups of animals as well as the surrounding environment,

one should use a normal telephoto lens, stopping down the diaphragm as much as possible to give the image depth.

High-power telephoto lenses require that the camera be kept steady by means of a stand. If the normal telephoto lens is very fast and not too heavy, it can also be used on a rifle grip.

The Rifle Grip

Different models of holders for telephoto cameras exist. They are called rifle grips. These are supports made of light metal which rest against the shoulder: in this way the weight of the photographic equipment is properly supported and the bulk steadied. They are used mainly in so-called stalking wildlife photography, where the shot is taken without the use of a tripod resting on the ground. The index finger of the right hand is placed on the trigger release, while the left hand holds the barrel of the lens for focusing.

A good rifle grip should not only be a carrying shaft for whatever is on top, but should be made in such a way that it can also be supported by the ground, tree branches, and so on,

to give even greater steadiness to the whole bulk, especially when one is having problems with exposure. For this purpose there are models with a folding foreleg which rests on the ground, and others made in a rectangular shape on the upper horizontal of which the camera and telephoto lens rest while the lower horizontal can be placed on the ground or on the car door. To appreciate in a practical way the advantages this accessory has to offer, you might make a number of trial shots both with the rifle grip and without it. The advantage will equal what you would get using a 50 or 100 percent faster exposure time. Sometimes this difference can be crucial to the success of a picture in wildlife photography. A shutter speed of 1/125 second with a 500 mm telephoto lens supported by a rifle grip will produce excellent wildlife shots. This will surprise many beginners, who mistakenly believe that only by using speeds of 1/1000 or 1/500 second can stills of animals be obtained. On the other hand, with shutter speeds of 1/60 second it is difficult to get good results unless a perfect panning technique is used, as we shall see further on.

Certain modifications to improve the rifle grip have been introduced, such as a

support which is fitted to the shoulders, or a belt more suited to a resting position, when rifle grip and equipment are allowed to hang by one's side ready to be raised at the first sighting.

The Tripod

The tripod used in wildlife photography should have a strong head, with a single or double grip to allow the photographic equipment to be swiveled easily horizontally and vertically. It is an advantage if the feet are fitted with small removable points which can be stuck in the ground for positioning on slopes.

Lightness, steadiness, and firmness are not easy requisites to unite in a single tripod; there are models, however, which possess all of them. The tripod must also withstand unavoidable knocks during carriage and be capable of immersion in water or mud without suffering damage.

MOTOR DRIVE

Nikon FE with MD 11 motor (above) and the same motor detached (below).

In its simplest form the motor is an accessory which, when coupled to the reflex, moves the film and resets the shutter after each shot, allowing greater speed of action. The photographic market clearly intends to make this accessory more available, and now all makers are offering motor

drives for their reflex cameras. Arguments in favor of motor drive are not lacking, especially for nature photography. Speed of action is in itself a sufficient advantage, but perhaps the decisive argument lies in the ability to operate the camera by remote control with no problems. The most obvious drawback has always been the increased weight and bulk, especially in professional models with sequence. The latest motor drives tend to be small and light, reasonably priced, and basically reliable. The most radical changes are found in the Konica FS-I and the Contax 137 IMS, which incorporate

motor drive in the camera body, eliminating the winding lever while maintaining normal weight and bulk. In respect to motor drive, there are three categories of 35 mm reflex:

• Cameras with no provision for motor drive. These are economy cameras or

ones not of recent design. The ambitious photographer is likely to replace them with later models.
• Cameras designed for motor drive. All quality cameras and even many more moderately priced cameras take this accessory.
• Cameras with motor drive incorporated. These are a recent innovation of interest for two reasons: weight reduced to normal, and price, which may be competitive on account of structure simplifications introduced into a lightened construction.

There are three kinds of power drives:

(1) The single-release automatic winder. Few models of these remain, having been replaced by more complex ones.
(2) Single- and continuous-release motor drives giving up to three frames per second. These are the most popular, fast enough for all normal needs.
(3) The single- and continuous-release motor drives giving up to five frames per second, made for leading cameras from different makers. In single-release motors one must press and let go of the release button every time, while with continuous release keeping the button pressed down permits a rapid sequence at the velocity allowed by the shutter.

An important feature is being able to operate the motor by means of electric controls, which can easily be connected to any remote-control apparatus or timing device.

When to Use Motor Drive

Its most useful application is with shot sequences which are remote-controlled or linked to electronic trip devices, but the motor can prove invaluable in other situations, as in capturing the culminating moment or when taking panoramic shots of subjects in movement or when the camera body is mounted on copying equipment and several copies have to be made or in macrophotography on location.

ZOOM LENSES

Zoom lenses are lenses which allow the focal length to be varied and hence the angle of view within a given space. Apart from their undeniable usefulness, zoom lenses are on average of inferior optical quality compared with corresponding fixed lenses and are heavier. However, the continuing technological development of these lenses, which enjoy enormous popularity, points to the likelihood that there will be an improvement in their quality, allowing them to compete with fixed lenses. Some of these lenses are already of a very high standard, in particular the Nikkor 80-200, which is considered superior to the ordinary telephoto lens in definition and efficiency.

Some markedly important features of zoom lenses are an evenness of focusing at any focal length and ease and flexibility in handling. The controls for altering the focal length are normally coupled with the focusing so as to be easily operated with one hand by two movements, piston and rotary, on the same ring.

The real advantage of using these lenses can be appreciated on the transparencies: zoom lenses

give better compositional clarity, obtained without difficulty. The facility to alter the angle of view prompts the photographer to check whether the framing will benefit by some change. Zoom lenses help us to use our eyes and search for the right balance in the image. With fixed focal length lenses, the need to shift forward or backward to vary the composition becomes a tiresome limitation, comparable to that of changing the lens.

Types of Zoom Lenses

On the basis of standard variations in focal length, zoom lenses are classified as follows:

• From wide-angle to normal lenses, for example, the 24-50 mm zoom, suitable for environment photography because they have a considerable depth of field and they allow correct adjustment of the composition of a shot in order to capture the various dimensions of the environment.
• From wide-angle to short telephoto lenses, for example, the 35-100 mm zoom. Sufficiently easy to handle, they are suitable

for general use in place of the normal lens.
- From short to medium telephoto lenses, for example, the 70-250 mm zoom. Sufficiently light, these are the most suitable zoom lenses for subjects that are relatively approachable or of average size. Some can focus to close-up by means of a special macro position.
- From medium to super telephoto lenses, for example, the 200-600 mm and

360-1200 mm lenses, heavy and expensive. These are not very common because of price. For wildlife photography they allow control and variety in framing, invaluable in the presence of subjects of widely differing dimensions, like birds and hippopotamuses, for example, because the passage from one framing to the other would certainly not be easy with a fixed focal length lens.

Top: Nikon FE camera with motor drive and 80-200 mm f/4.5 zoom lens.
Above: Two large telephoto lenses. On the left, the 600 mm Nikon with normal f/5.6 lens, which weighs 2.7 kilograms (6 pounds); on the right, the 1000 mm f/11 Nikon with mirror lenses, weighing only 1.8 kilograms (4 pounds).

SOPHISTICATED EQUIPMENT

The large and powerful telephoto lenses have always fascinated wildlife photography enthusiasts. Who hasn't dreamed of getting stunning results with an instrument of exceptional power like a telephoto lens of 1000, 1200, or even 2000 mm?

One belief which should be discarded is that the most unusual and difficult photographs are obtained by using a super telephoto. In fact, the greater the distance between photographer and subject, the denser the atmospheric barrier and hence the greater the chances of haze. In using the super

telephoto, every little movement can blur, so steady stands must be used and the subject brought into focus with great precision, since the slightest movement of the subject can produce a blurred picture, with subject out of focus or outside the field of view. In certain situations, however, a super telephoto lens can be essential, as, for instance, for a photograph of an osprey in its nest: the bird cannot be approached too closely for fear of endangering its brood. The 1000 mm catadioptric lenses and the normal 800 mm ones are the extremely long lenses used most frequently. And here the quality of the lens becomes

relevant. There are those who advise using superlative quality lenses. No doubt the capacity to penetrate the atmosphere, as they say, is possessed by certain really good telephoto lenses only. But this observation should not drive one to a frantic search for the best lens. It must be remembered that atmospheric conditions influence the result of a picture much more than special lenses do. After a night of rain which has cleansed the air of impurities and in the presence of a strong sun and clear sky, you can be certain that photographic results will be at their best even with a telephoto lens of average optical quality. Contrariwise, on a dull day with the best 800 or 1000 mm in the world, you may still fail to get a good image.

A further point to consider in this field of sophisticated equipment is the existence of 600 mm lenses with the dimensions of a 1000 mm lens but with remarkably good luminosity

and optical quality. With normal lenses of 600 mm and aperture of f/5.6 or 800 mm and f/8, satisfactory results can be obtained in ambush wildlife photography.

Usually one acquires sophisticated optical equipment after years of working with more modest lenses. Those who want to speed things up and move on to these lenses at once will usually get results similar or even more modest than what would be obtained using simpler equipment.

One should not forget the rule laid down by the experts among wildlife photographers, that is, never use a powerful lens for a shot that can be obtained using a shorter and lighter telephoto lens. The less atmosphere there is between camera and subject, the better. With the long focal length lens one must always calculate the minimum focusing distance. The most frustrating thing that can happen to a wildlife photographer is failing to get the animal into focus simply because it came too close to the camera.

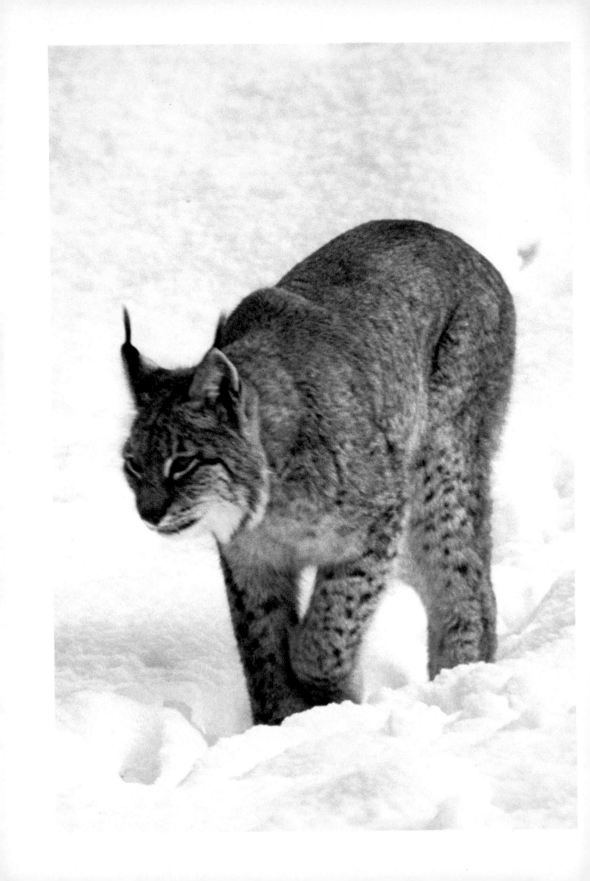

SPECIAL LENSES

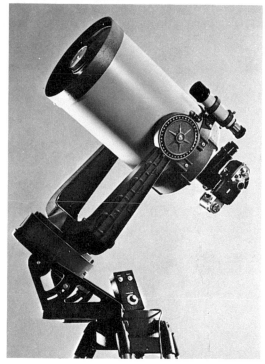

Where the field of operation for the nature photographer ends, that of the astronomer begins. In fact, the use of telephoto lenses with focal lengths over one meter is becoming more and more suited to astronomic exploration, where they are called telescopes. In daylight photography the drawbacks multiply progressively with the lens; weight, dimensions, and price increase somewhat; vibrations become unavoidable, making necessary the use of firm, heavy tripods; and the image loses definition and contrast.

In photography of the night sky, the situation is different. The position of shooting is fixed, and to eliminate vibrations tripods which are as heavy as nec-

Facing page: A lynx taken with a super-telephoto lens at a great distance, with the result that the definition is not very sharp in this considerable enlargement. The photograph is justified, however, considering both the rarity of the animal and the difficulties met with in getting the picture.

essary may be used. The image is strongly contrasted, made up as it is of light sources against a dark background.

Characteristics of Telescopes

Telescopes, like lenses, are divided into two classes: lens telescopes, which are called refracting telescopes, and mirror ones, known as reflecting telescopes. These last ones, classified as Schmidt-Cassegrain, are much more popular on account of the greater luminosity they give and the high quality of image. The main feature is the diameter of the mirror, which determines both the amount of light gathered as well as the size of the luminous point by which a star is reproduced on the film: with the same focal length, doubling the diameter of the mirror means that four times as much light is transmitted and, moreover, it is concentrated on a surface four times smaller. The resulting image is therefore sixteen times brighter. The other impor-

tant parameter is the focal length. Without going too deeply into technicalities, we will briefly examine the characteristic features of a number of reflecting telescopes which can be used in both terrestrial and astronomical photography. Three kinds made by Celestron give a clear idea of variations in use in relation to the increase in focal length.

The characteristics of the C90 model are the following: aperture, 90 mm; focal length, 1000 mm; diaphragm, *f*/11; weight, 1.35 kilograms (3 pounds). This is the smallest and lightest model, and it can be hand held, mainly for terrestrial use, as a telephoto lens or

Left: Equipment for astronomical photography, a 2000 mm Celestron C14 f/ 10, weighing 9.2 kilograms (23 pounds), with motor propulsion for stellar photography. Below: The moon taken with a 1000 mm telephoto and a X 2 lens converter.

telescope of 20X magnification.

The features of the C5 model are: aperture, 127 mm; focal length, 1270 mm; diaphragm, *f*/10; weight, 4.8 kilograms (13 pounds). A tripod must be used and it is suitable for astronomical as well as terrestrial use.

Finally, the features of the C8 model are: aperture, 200 mm; diaphragm, *f*/10; focal length, 2000 mm; weight 9.2 kilograms (23 pounds). It is a telescope mainly for astronomical use, for which specific attachments are available.

Astronomical Photography

With normal equipment one can only take pictures of the two extraterrestrial bodies near enough, that is, the sun and the moon, or the sky as a whole.

The sun. Bearing in mind that it is very dangerous to photograph or even to look at the sun directly through the camera, three methods are advised:

• Place a piece of black cardboard with a hole 2 to 3 mm in the center over the front lens of the telephoto lens. That will serve as a sufficiently small diaphragm aperture to reduce the concentration of heat.

• Use a neutral density filter in front of the lens of 4 or 6X with aperture kept stopped down to *f*/32 or even smaller.

• With a telescope, one can photograph the image projected by the eyepiece onto a sheet of paper suitably placed, the surest method of following sun spots.

The moon. Undoubtedly the easiest subject, the full

moon can be photographed with the camera hand-held, though it is safer to use a tripod, with medium and high-sensitivity film, exposing with aperture at *f*/8 or *f*/11 and shutter speeds from 1/30 to 1/250 second.

The heavens. With an exposure varying from a few minutes to half an hour or more, at full aperture, a photo will show the movement of rotation around the polar axis. To eliminate the luminous trails a tripod is needed with a special motorized apparatus which follows the earth's movement exactly.

FOCUSING AND DEPTH OF FIELD

Any picture can be irreparably spoilt by the wrong focus. If automatic exposure allows one to forget about diaphragm aperture and shutter speed, the focusing operation must still be taken care of, and it is achieved by moving the focusing ring smoothly backward and forward so as to keep the subject constantly within focus. This operation can sometimes be difficult on account of low luminosity or smallness of the field of focus. In any case it is useful to learn how to focus, practicing those automatic movements which transform the reflex camera into a true and obedient

extension of the eye. First of all, one must learn to turn the focusing ring the right way without hesitation, then succeed in rapidly reckoning how much it needs to be turned to keep a moving subject in focus or to switch from one subject to another.

Every lens has its own special characteristics of flexibility in movement and range. You must acquaint yourself with your own lens so as to be able to handle it with maximum speed and precision. In this way you will be able to seize every opportunity.

Even in this field, however, electronic technology

is now replacing manual operation. Systems of automatic focusing have already been developed. If they prove to be sufficiently reliable and light, they could become invaluable in those cases where keeping the subject in focus requires great speed.

Instruments for Focusing

One of the fundamental characteristics of the reflex camera is direct vision of the real image. The simple device which allows one to focus visually is the ground-glass screen. This is usually associated with Fresnel lenses, recognizable by the thin concentric circles on the image, which serve to render the luminosity of the image uniform. The ground-glass screen is admirably suited for focusing with medium and long telephoto lenses, which do not allow the use of optical devices normally employed, like the split-image rangefinder and microprism screen. These devices help greatly to determine the plane of focus; the image is destroyed or split as soon as the lens does not have the subject in sharp focus. But normally these devices cease to function when the luminosity of the lens falls below $f/4.5$ or 5.6, and also a clouded image right in the center of the screen may prevent vision of the subject itself. Interchangeable viewing screens may be useful.

With the simple ground-glass screen, exact focus is obtained by watching the sharpness of the image. The more luminous lenses make the operation easier, owing both to the clearer vision and to the reduced depth of field at full aperture.

Depth of Field

Depth of field is the extent of the region of sharp definition in front of and behind the plane of focus. This concept cannot be separated from that of focusing, because, except in copying a transparency or print, the subject is always three-dimensional itself or its surroundings are. In photography the ability to

control depth of field distinguishes the expert from the beginner. Depth of field depends on the following factors: focal length, aperture, focusing distance, and, finally, the largest permissible diameter of the circle of confusion (the diameter of those points imperceptible to the eye which make up the sharp image).

Depth of field is largely a matter of intuitive choice. If instead of apertures and focal lengths of lenses, we look at the actual measurement in millimeters of the diameter of the aperture through which light enters the camera, that is, the diameter of the diaphragm, we shall find that, at a given focusing distance, the depth of field depends solely on this measurement with any camera lens and any aperture.

How is this number found? Simply by dividing the focal length by the selected aperture, or by measuring the diameter of the diaphragm aperture with a caliper. For example, a 500 mm telephoto lens with a diaphragm aperture of $f/8$ will have an effective aperture of $500/8 = 62.5$ mm; while a 24 mm wide-angle lens at the same aperture of $f/8$ will give $24/8 = 3$ mm.

What does this number tell us? The diagram on page 87 shows how the depth of field changes with a change from 0.1 to 100 mm in the effective aperture of any lens; for example, at three points of focus: 1 meter, 5 meters, and 10 meters on the vertical axis.

In this way one has a compendium of all possible combinations of lenses and apertures. The upper limit of 100 mm for the diaphragm is rarely exceeded. In summary, the following conclusions can be drawn:

• Depth of field increases the smaller the aperture is and the greater the focusing distance; the depth of field depends only on the actual diameter of the diaphragm and not on the focal length. In the diagram the depth of field is the area delimited on the left side by the hyperbolas of the same color.

A gopher brought into focus with a 600 mm Nikon f/5.6. Notice the eye in perfect focus and the depth of field reduced to a minimum to include only the subject. In this kind of photograph any inaccuracy in focusing would be unforgivable.

- As the aperture is reduced beyond a certain value, depth of field rapidly becomes very long.
- When the depth of field in sharp focus extends to infinity, the hyperfocal distance for the particular aperture is the most convenient focus each time we want to have the background sharp as well as the subject.
- Telephoto lenses, because of their greater focal length, are clearly at a disadvantage compared to wide-angle lenses because,

with an equal diaphragm setting, the effective aperture is always greater.

To check the depth of field in practice, there are two methods: first, by using the notches usually marked on the focusing ring, to the right and the left of the distance index pointer; second, by means of the button (not always provided) which stops down the diaphragm to the selected value, giving a satisfactory view of the actual image to be photographed.

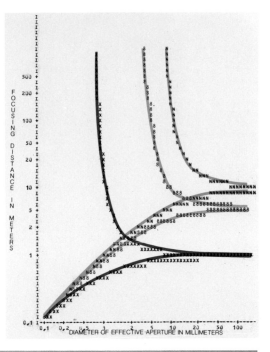

On the right: The graph, obtained by computer, shows the change of depth of field in terms of the effective aperture in millimeters of diaphragm diameter at three common focusing distances.
Below: This group of ibexes, taken with a 200 mm lens, is a model photograph as far as the precise and correct use of depth of field is concerned. When the subjects are numerous it often becomes a problem to keep them all in focus, as stopping down the diaphragm precludes adequate shutter speed.

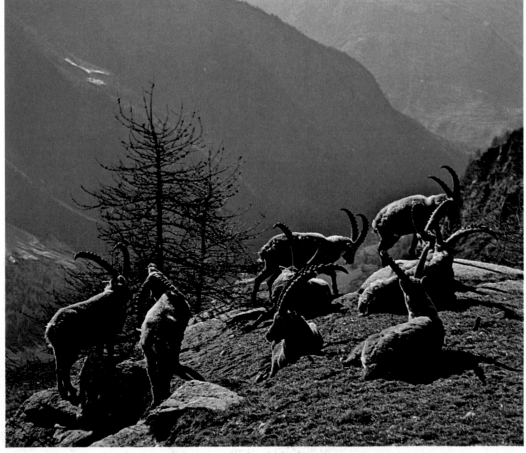

EXPOSURE IN WILDLIFE PHOTOGRAPHY

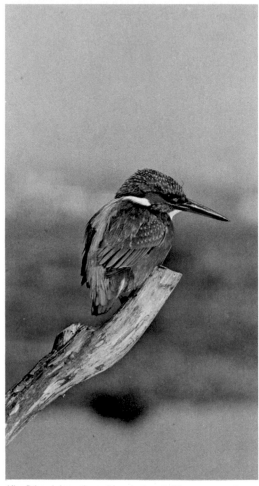

Kingfisher taken at a moment of rest. The exposure has been calculated for the subject, which the blurred background helps to emphasize.

Correct exposure means measuring the light so that the film receives the amount required for its sensitivity. The camera must therefore be set so that the right quantity of light enters for a given film. If there is a great deal of light in the surroundings, the required amount will enter in a short time through a small aperture; if, on the other hand, there is little light, a large aperture and a slow shutter speed will be needed to gather the same quantity of light.

The exposure values (EV) are numbers which indicate a measure of light, a degree in the scale of exposures possible, each one

half or double the value of the adjacent one. The adjustment of the instruments that control the amount of light, the diaphragm and the shutter, must be combined so as to allow just enough light to enter. The equivalent combinations correspond to one exposure value, one quantity of light. The subject of exposure may be summarized concisely.

The graph on page 89 shows all possible combinations of shutter speeds and apertures normally used. The diagonal lines unite all the points which correspond to the same quantity of light, and the same EV number. These

values give a correct exposure for a sensitivity reference equal to ASA 100. For each greater or lesser degree of sensitivity there will be a corresponding step in the exposure value. Starting from zero on the EV scale, corresponding to an exposure of 1 second at $f/1$, which is easy to remember, the whole graph can be reconstructed.

For each subject one must calculate the correct exposure out of all those possible, diagrammatically summarized in the graph. Giving the correct exposure simply means determining the level of luminosity by means of an exposure meter and reading the corresponding exposure value from this, taking into account the sensitivity of the film. Choices to be made at this stage are limited They arise mainly from the contrast of the image, that is, selecting the area to give most emphasis so as to isolate the subject for the most appropriate measure of light.

The second stage involves choosing, on the basis of the EV arrived at, from among all the equivalent combinations of shutter speeds and apertures the one considered the most suited to the subject. This is the creative moment in exposure. The photographer is free to give preference to the effect of the diaphragm on the depth of field, or to freezing movement by means of a fast shutter speed. All the photographs will have correct exposure. If we look at the graph we shall see that certain areas can be associated with a similar technique of shooting: for example, the area between the lines marking EV 20 and EV 10 groups together all the daylight conditions for taking pictures. This is the area of exposure most frequently in use and the one that concerns wildlife photography. The vertical area from 1/2000 to 1/60 includes practically all photographs of movement. In the intermediate area, from 1/60 to 1/8, the steadiness of the hand-held cam-

era becomes a critical factor, and it is related to the kind of lens. Long telephoto lenses require a fast shutter speed or a steady tripod. With this graph in mind, we shall be able to single out the area of exposure which interests us for each occasion. Corresponding to the zone on the lower left are the low exposures, used in the presence of strong levels of luminosity. In the area to the right of 1/2 second, owing to the particular properties of the film, the exposure time should be increased by one or two stops in order to compensate for slow film used at very low-intensity light. This loss of speed is called "reciprocity failure."

Selecting the Exposure

The exposure meter shows the correct value by means of luminosity reflected from the subject, based on the kind of reading chosen. The more an image is uniform and of average tonality, the closer it approaches to the ideal reference point, middle gray, for which exposure meters are calibrated, and the reading will be easy and precise. In the presence of strong contrasts, the exposure-meter reading must be corrected in order to capture the tonal rendering of the real subject.

Negative Film

When using negative film, it is usual to measure the light in the areas of shadow and expose according to this reading: so the tendency is to overexpose. This practice is justified by the fact that negative film material can accommodate a limited amount of overexposure, which can be controlled and corrected at the printing stage better than underexposure can. Moderately dense negatives always carry the image, which may be printed satisfactorily, compensating for the density; in thin negatives the part of the image in shadow is lacking and this information cannot be recovered in any way.

For reversal, or slide, material, on the other hand,

the inverse rule applies, to expose for the highlights. In the reversal process it is the highlights that lose the image and detail, becoming transparent and empty. In projection overexposed transparencies possess washed-out, vapid colors and an irritating luminosity which disturbs the rhythm of projection. Underexposed transparencies, on the other hand, give greater average density and darker tones, but the image is complete.

These two rules should be borne in mind to indicate which alternative to follow in determining the exposure to increase the chances of getting the right density and the best quality photograph.

Exposure Latitude

Exposure latitude is the degree of tolerance of film to exposures which are over or under the correct one. Negative material has good exposure latitude, and will produce satisfactory prints with up to two diaphragm stops up or down. Reversal materials will tolerate not more than one diaphragm stop larger or smaller on average. The quality of the image is adversely affected

most by overexposure, and the rigid nature of processing allows for no compensation.

Estimating Exposure Without an Exposure Meter

If deprived of the exposure meter, what can one do? First of all, it is a good idea to check whether your reflex camera still works without the batteries, and on what shutter speeds you can rely; but, generally speaking, it is useful to have some memorized references to turn to in case of necessity. The first way to acquire these emergency expedients consists in learning to use the exposure values. Although reflex cameras no longer note EV for valid structural reasons, if one accustoms oneself to thinking of exposures on the basis of levels of illumination, the references on which to base the exposure will be found easily.

In practice the EV numbers most often used with your own equipment would be few, and they are easy to remember because they are simple. You may be able to guess the approximate value which falls be-

tween two EV numbers; however, it is almost always necessary to make two or three different exposures to obtain the correct one. A rule of thumb which may be useful is this: In normal daylight conditions with the sun, the shutter speed corresponds approximately to the ASA number of the film being used, when aperture is set at f/ 16. If we can remember that in daytime the average range of luminosity is contained in five light values, we shall arrive in many cases at a satisfactory exposure with average subjects.

Calibration of Your Photographic System

Shutter precision, the calibration of the exposure meter, sensitivity of the film, and finally processing treatment can each have fluctuations which when added up render the exposure either systematically or intermittently inaccurate. It is advisable, therefore, periodically to check the precision of exposure, calibrating one's own photographic system oneself by means of a range of exposures made on normal reversal material.

The Choice of Shutter Speeds

The choice of shutter speeds is closely connected with the species one intends to photograph, with

the brightness of the lens, and with the sensitivity of the film.

Photographing a kingfisher in flight and photographing a herring gull in flight require different techniques. The first bird darts along at a considerable velocity, hovering for an instant before diving at lightning speed into the water. Usually it is in this moment of stall that the naturalist seeks to depict the creature. A bird which moves its wings without propelling itself swiftly can be "frozen" even with 1/250 second; at the most there will be a blur—the body will appear motionless while the wings appear moving. But why not try an extremely difficult photograph of a bird as it darts along in flight? If pictures of this kind are rare, it should be all the more encouragement to attempt them. Naturally a shutter speed of 1/1000 will be required or, if the camera is capable, a speed of 1/2000. Clearly the more aperture a telephoto lens has, the more one can combine fast shutter speeds with apertures not set at maximum, thus facilitating the focusing. Furthermore, to facilitate the combining of a very fast shutter speed with a stopped-down diaphragm, one should use high-sensitivity film and wait for bright sunshine.

In the case of a herring gull the situation is different: The bird flies slowly and rhythmically. To take it, a shutter speed of 1/250 second will suffice, giving preference to a stopped-down diaphragm to keep the subject in focus. Fast lenses and high-sensitivity film are not essential.

Usually toward evening, when the light is softer, it becomes impossible to capture the fast movements of birds, and one must fall back on shots of stationary animals. 1/125 second or, if appropriate, 1/60 or 1/30 second can be sufficient to take good pictures of the kingfisher perched on a tree trunk. On such an occasion maximum aperture in order to make use of all remaining light is the rule.

The chart sums up all possible conditions of shooting in terms of the two exposure parameters, shutter speed and diaphragm aperture. The diagonal lines connect all the equivalent points of exposure corresponding to the same EV number, and, moving from right to left, correspond with the increasing amount of light entering the camera.

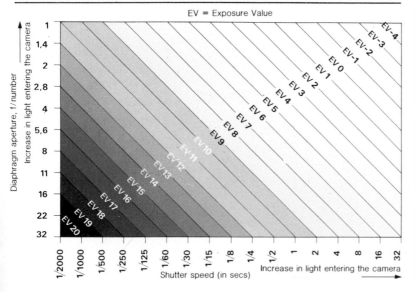

LIGHT CONDITIONS

Light conditions are many and varied, but two situations at the extremes of luminosity during the day are particularly common, abundant light and poor light. Abundant light offers the surest photographic conditions. Automatic exposure, properly controlled, can work over a wide range, selecting among diaphragm and shutter speeds in terms of the subject. Slow-speed film may be used to obtain the best quality of image. In the presence of strong light reflections, the possible effect of dazzle on the CdS cell of the exposure meter must be kept in mind.

As for poor light, everyone has encountered those typical and frequent conditions in which the light is barely sufficient to use the fast shutter speeds necessary to arrest movement. On these occasions wide-aperture lenses prove useful: where an active subject may cause blurring, the use of lenses at maximum aperture becomes the rule.

Automatic control of shutter speed is most useful, techniques for avoiding jolts become essential, and the choice of a fast film is often necessary. Only some compelling need in terms of depth of field may force one to stop down the diaphragm and risk blurring. If one wishes to take shots under such critical conditions, the following alternatives are advisable wherever possible:

(1) Change the lens to reduce the focal length. There are two advantages: The angle of view is enlarged, and the steady balance of the camera is less critical. Telephoto lenses of shorter focal length usually tend to have larger apertures, so when the subject permits, one should approach it using one of these lenses.

(2) Use high-sensitivity film or expose a film of medium sensitivity with a nominally higher value, requesting short development. One must be sure, however, that this can be

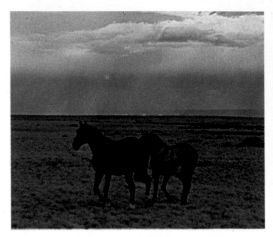

done to give satisfactory results.

(3) If depth of field becomes too short with maximum aperture dictated by a fast shutter speed, it is advisable to take an additional shot of the subject avoiding groups that would not be in sharp focus, that is, isolate the subject and frame it frontally in a flat position.

(4) Abandon ambient light in favor of flash, if this is technically possible.

Above: A very gray day, but light conditions are not difficult for shooting.

Below, left: A chamois on the edge of the woods, photographed with a 500 mm Takumar Asahi Pentax f/4.5; poor light and moving subject. These are typical conditions requiring maximum diaphragm aperture.

Below: A monkey, taken in full daylight with a 200 Canon f/4; no problem.

PHOTOGRAPHING MOVEMENT IN WILDLIFE PHOTOGRAPHY

The image of the subject will come out completely still if during exposure it does not have time to move. Blur, in fact, is the trail of the movement of the image projected onto the film during the period that the shutter is open. It is always due, therefore, to a movement of the camera or subject during exposure.

Of the two categories, camera movement and subject movement, even a simple shake of the camera produces, as a rule, a ruinous effect on the whole image. Many images which appear to be out of focus are in fact blurred by camera movement. The difference between the effects of shooting out of focus and moving the camera is the directional quality registered on the film by camera movement. Highlights in particular produce visible streaks that spoil the image. The direction of the streaks produced by the points of light show the direction of the vibration itself.

The hand-held camera can shake in any direction, but it is the horizontal or vertical oscillations parallel to the edges of the image in particular which spoil it, those which produce a movement on the plane of the film. Vertical vibrations are easier to cushion by using a simple support or makeshift rest or, better still, a monopod.

With a suitable tripod all camera movements can be cushioned. As the focal length increases, it becomes more and more difficult to eliminate the effect of vibrations, which are amplified by the narrow angle of view. With lenses above 1000 mm, the camera mounted on a medium-sized tripod tends to vibrate easily with each little puff of wind. The importance of using the right tripod for a given lens is obvious.

It is important to hold the camera properly, to practice reducing the vibrations of the body when taking a shot, and to take advantage of each support provided. Equally important is the proper use of the tripod, after making a choice of the kind suitable for your equipment and your sort of photography.

Automatic Shutter Release

Using the automatic shutter release is a simple method of minimizing vibration, first, because the movement which can be inadvertently transmitted to the camera in pressing the release button is neutralized during the delay; and second, because the raising of the mirror normally comes at the moment of pressing the button and the consequent vibrations caused by mirror movement are neutralized by the delay.

The Cable Release

The cable release is essential in many cases. It must be long enough not to transmit vibrations, that is, it must measure at least 20 centimeters (8 inches), and have a lock to keep it depressed during exposure time.

The Subject in Movement

The main problem in many wildlife photography situations is to stop subject movement. If camera vibration must always be avoided, the effects of subject movement, within certain limits, can have some positive aspects. Between a movement which is completely frozen and an undecipherable blur there exists a whole range of graphic effects. In certain cases the most effective images are those which combine both aspects in the right balance.

It is worth remembering that pictures of fast subjects completely frozen in movement possess an uncommon attraction, the fascination of the unusual, the unknown, because it is impossible to observe those images directly as they move too swiftly for our visual system. It may be said that movements which exceed a certain degree of velocity can only be seen as a blur by us. At the same time, however, these frozen images take on an unnatural and motionless appearance.

The right combination of blur and clarity becomes a matter therefore of great importance, combining both the capacity to inform, to describe fully, which belongs to frozen movement, with the capacity to communicate dynamism and life, which is the contribution of blur.

How to Control Blur

The first problem is to anticipate the effect of movement, that is, to hold in mind criteria to guide us in a practical choice of shutter speed in relation to the following elements:
- Kind of subject movement
- Type of lens being used
- Subject-to-camera distance

Blur is produced when the image projected on the film has sufficient time to change during the exposure. It is essential, therefore, to see how the effective movement of the subject reproduces itself on the film. This can be done by becoming accustomed to careful observation on the focusing screen of the image which will impress itself on the film. One must train oneself to assess the movement of the subject as seen in the viewfinder. Notice that with a 500 mm telephoto lens, the image in the viewfinder vibrates to such an extent as to create difficulties in keeping it framed with hand-held shots, while with a 24 mm lens, a slowing down of the movements and a kind of ballasting of camera vibrations will be noticed. Our eyes are capable of following rapid movement up to a certain limit, beyond which they can no longer make out the image clearly, and see only a blur; that is, they superimpose a series of successive images as if they were all one.

We shall now try and clarify the principles to follow in assessing movement in order to capture and hold it in photography. The actual movement of the image on the film is what concerns the photographer. The conclusion follows that the movement of the subject has a significance which depends on the distance, the angulation, and the focal length of the lens. These factors determine the projection of subject movement on the focal plane. As regards the plane of the film, subject movement may be:

- *Transversal*, that is, parallel with the focal plane. This is the usual motion of subjects passing tangentially to the position of the photographer. It is the most important one to freeze because it is not modified in projection on the film.
- *Diagonal*, when the subject approaches the photographer with a certain angulation. The movement is partially slowed down in projection on the plane of the film through the effect of angulation. This direction of movement in general is the most helpful to a photograph, because its effect is less severe and because it provides a three-dimensional effect to the composition, which conveys more of the feeling of space and dynamism.
- *Frontal*, when the subject approaches or moves away from the photographer. The image does not move on the film, but increases or diminishes. It is this movement that requires longer exposure time to capture, but it is less frequent and often produces pictures which are flat and static.

The shutter speed capable of freezing a given movement is established by the speed of the image projected onto the film. If the same subject is taken with different focal-length lenses, but at different distances so as to obtain pictures of the same dimensions, the same shutter speed will freeze the movement. Therefore, the factor that determines the way in which the real movement is transferred to the focal

plane is not the subject distance nor even the focal length of the lens, but the scale of reproduction. This is calculated by dividing the size of the image by the size of the subject.

The simplest method of determining the scale of reproduction is by dividing the focal length by the subject distance. For example, a subject taken at 20 meters with a 500 mm lens will be reproduced on the film with the scale $0.5/20 = 1/40$. The scale of reproduction shows by how many times the image is reduced in size compared to the real subject. Hence there will be a parallel reduction in the relative movement. The smaller the image is, the shorter the movement of the subject will be within the unit of time. The time needed to freeze the movement depends on the speed of the subject, the scale of reproduction, and the angle of movement in relation to the focal plane. These three variables give rise to numerous combinations, which are difficult to frame without introducing rather contrived and complex classifications.

A few general guidelines can be given to supplement practical experience, which everyone should acquire:

(1) Each time that the speed or scale of reproduction is doubled, shutter speed must be doubled.

(2) Cross movement requires a speed at least four to eight times faster compared to the same movement frontally.

(3) Long-focus lenses require fast shutter speeds for two separate reasons: first, because the longer the focal length, the higher the scale of reproduction, and so subject movement will be amplified; second, because camera shake becomes more and more noticeable as the focal length and the bulk of the lens increase, apart from any consideration of subject and scale of reproduction. This is the reason why fast speeds are always advisable with long telephoto lenses, quite apart from problems of subject movement.

HOW TO FREEZE MOVEMENT

Shooting a subject in motion in conditions of poor light or with very swift movement presents the problem of which techniques or devices to use to ensure the best chances of getting good results. In each case the problem may have to be tackled in a different way. The following solutions may be adopted:

• Follow the subject in movement through the viewfinder—a typical cinematographic technique, known as panning, to be used whenever possible.

• Wait for a pause in the movement. For example, in a leap there is often a moment in which the subject is almost stationary.

• Use a very fast film which can take accelerated development.

• Choose which movement must be frozen to get a readable image, select from among the three foregoing solutions the most suitable one, and make the fast movement deliberately blurred but of secondary importance for the image— the effective blur.

• Use flash instead of ambient light if technically possible and suitable.

Panning

When a moving subject has to be photographed, there may be one of two different situations:

(1) The subject moves along a fairly straight or at least predictable line, and at a regular speed.

(2) The subject moves in an irregular way, difficult to follow or anticipate. We shall speak about this on page 94.

In the first case the panning technique, or following the subject, will prove most effective. Let us see what this involves and how it is done. The most common kind of movement will generally have these characteristics: An animal runs or flies following a straight line, which never gets very close to the position of the photographer, who will be able to follow the animal in the viewfinder as it approaches and then moves away. This kind of movement is ideal for getting extremely dynamic pictures. To capture it, the camera is kept constantly trained on the subject while it is still at a distance, and carefully swung to follow its movement, pivoting on hips and legs to avoid shake and hesitation. The shutter speed must be chosen to freeze the main movement of the subject so that in the viewfinder and on film it appears to be moving, but always in the center of the picture, against a fleeting and indistinct background. This graphic effect creates an extremely vivid sensa-

tion of speed and dynamism. A suitable composition that enhances and matches the movement will result in an obviously striking image.

The ability to coordinate movements is acquired through practice, which will even give you the knack of knowing the right shutter speed to freeze an individual subject while leaving the background blurred. For panning, waist-level viewfinders (such as that of the Hasselblad, with only one mirror) are of no use whatsoever, because the direction in which the camera must be swung is the opposite of that appearing in the viewfinder. Here are a few practical hints:

(1) Only the approach

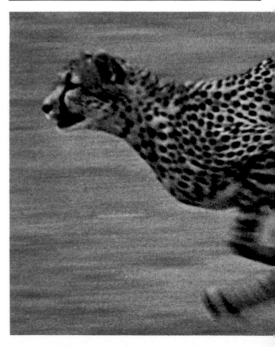

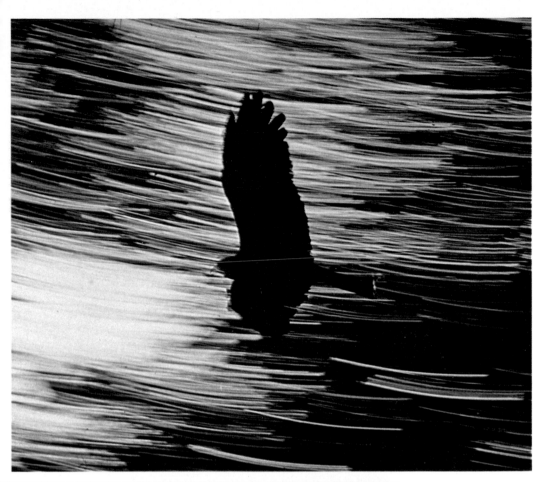

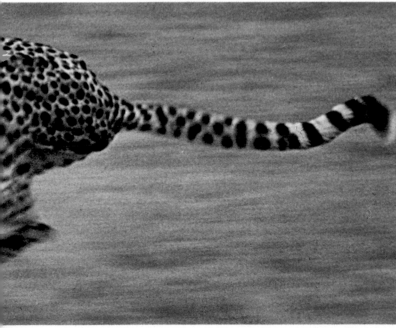

Above: Example of panning done under extreme conditions. The silhouette of the flying bird against a blurred and luminous background succeeds in conveying the sense of silent and fleeting movement.

Left: A classic example of panning, in which the strength and suppleness of the cheetah are conveyed in perfect fashion. In both photographs the strongly streaked background shows the great speed of the animals.

In the diagram: Camera movement in the shot using panning technique. The lens must follow the moving subject.

line-up to the point of least distance can be used for the shot. Fleeing animals are lost opportunities.

(2) It is advisable to plan the most effective movement for the shot so as to avoid angles which present obstacles such as trees or clumps of shrubs.

(3) The focus must be present over a middle distance, making use of all the available depth of field. Given the speed and brevity of the action, it is often impossible to adjust the focus.

(4) The flexibility and convenience of automatic exposure and zoom lenses turn out to be very useful on these occasions.

(5) A uniform background like the sky is inadvisable for panning. A tangle of vegetation produces a confused and intricate graphic pattern which accentuates the movement.

(6) Motor drive allows one to make better use of the infrequent opportunity, shooting more pictures and increasing the likelihood of striking the really big moment both from a graphic as well as a nature point of view.

THE CLIMACTIC MOMENT

The second case of shooting movement concerns erratic and unpredictable subjects. The technique to be adopted consists in waiting for the slowest phase of the movement or the easiest and most obvious position for shooting. For example, in a leap there is always a moment in which the animal, while continuing its movement, appears stationary for a fraction of a second and adopts a different attitude of flight, more relaxed, having spent the energy needed to rise. Examples can be found in the flight of birds, which has an instant of rest or near immobility. Using this instant, one can take photographs that are technically satisfying and genuinely interesting which would not otherwise be possible. Following the movement in these cases would be a formidable if not impossible task. Here the problem lies entirely in hitting on the exact moment in which to shoot: a sense of timing and knowledge of the path of the kind of movement are needed.

Pressing the release button must happen a few fractions of a second before the real climactic moment. One must take into account the interval of time which elapses between the command and the action which follows, which is not less than 1/20 second, besides the delay in human response. This technique may be combined with panning to capture the climactic moment, for example, during the obstacle race which characterizes the gazelle on the savannah. In this case the movement of the photographer must follow the course, slackening speed at the right moment, which cannot be feasibly done unless it has been anticipated and tried out beforehand.

Gazelle shot during a leap, at the moment of highest elevation. This is a perfect example of what is meant by photographing movement climax. The drawing shows diagrammatically how this technique is implemented. The camera is held still and this obviously implies the need for accurate timing and precision.

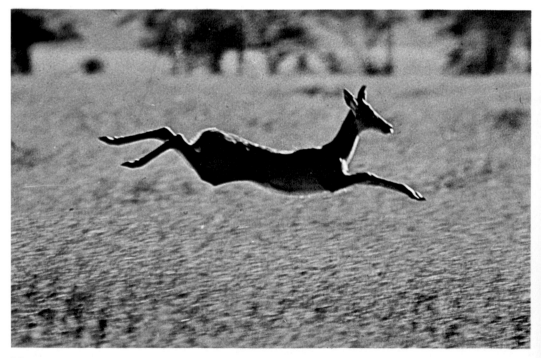

BLUR EFFECT

After having examined a number of methods of taking shots to avoid blur, we shall now see when and in what way blur is acceptable or even advisable.

It may be said that the presence of blur contributes to improving the image when the main subject is recognizable, that is, sufficiently well-defined as a whole, while blur is confined to that area which has a faster movement of its own, such as the wings or legs. Since even our eyes cannot freeze movements which are too fast, like those produced by the wings of many birds, pictures with a measured blur appear more natural to us.

This effective blur conveys the impression of movement as it normally appears to us. A static but not sharply defined background helps to focus the attention on a partially blurred subject which already suggests the feeling of movement. For example, the kestrel, in order to catch insects and rodents, enacts a special predatory ritual. It hovers in the air like a helicopter by lightly flapping its wings, and scans the underlying terrain. A picture of the bird of prey with wings moving and body motionless in perfect focus conveys beautifully this hunting ritual of the kestrel. If one were to use a faster shutter speed, showing the whole kestrel as motionless, this special wildlife photographic effect might be misunderstood, as there are hundreds of pictures in existence of this species of falcon taken in flight.

The effective-blur technique is connected with the technique for freezing movements. The choice of speed is even more critical here because one is at the limits between two adjacent areas of exposure, that of shutter speeds which are too slow and give an unacceptable blur, and that of speeds which are sufficiently fast but give completely static images. The shutter speeds required to obtain the desired effect are more varied and therefore easier as the action gets faster, for example, the speed of the wings compared with the speed of propulsion of the whole bird. On many occasions this effect is not sought but simply discovered in the course of photographing. The exposure time, necessarily short for the frequently bright conditions of light, together with the panning technique, also a necessity under these conditions, enable the subject to be taken motionless but with its claws or wings at least partially blurred.

To obtain this effect, direct experience is needed above all and the ability to concentrate during exposure. The time given in which to seize these precious moments is extremely short; timing and swift action are required, which can only be achieved through perfect coordination between photographer and equipment.

Flash and Blur

The effective blur can also be obtained with flash, adopting the technique known as "daylight effect." Exposing so that the two kinds of light are added together, as already described, will freeze the subject with the flash while some parts are blurred due to exposure from surrounding light. Because the entire field will be clearly visible, the background should be dark.

It is also possible to obtain blurred images with the light of the flash alone. If the speed of discharge is slow enough, for example, 1/300 second, the same effect will be produced as with that shutter speed. In fact, to freeze very fast movements, flash time less than below 1/5000 second is needed.

Egret: a static picture rendered more vivid and dynamic by the blur of the wings. Exposure time used: 1/250 second with 600 mm Nikon f/5.6 telephoto lens.

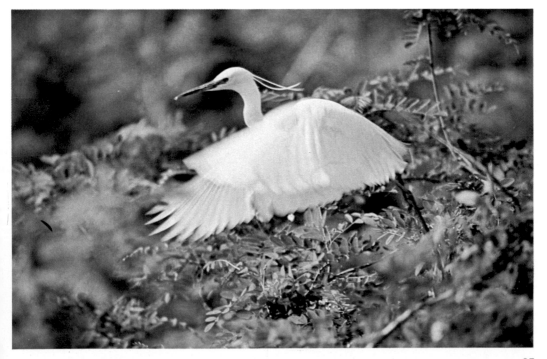

HIGH-SENSITIVITY FILM

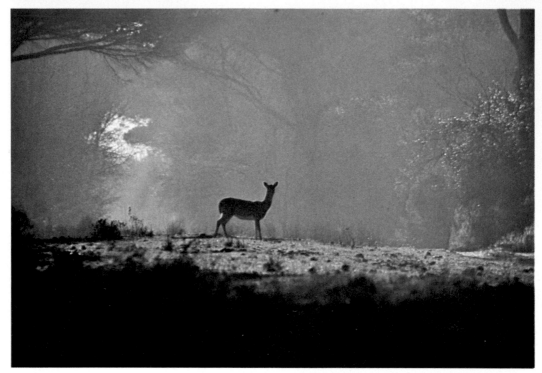

Recently the field of sensitized materials was enlarged by a new generation of very fast color film, filling a gap which had confined practically all ambient-light photography which required fast shutter speeds to black-and-white. The already high nominal sensitivity of ASA 400 for reversal film such as Ektachrome 400 and Fujichrome 400 can be "stretched" up to ASA 1600, with results which are still acceptable. Gaining two more exposure values means that formerly prohibitive limitations imposed by lighting conditions on photography have now been effectively overcome.

These slide films are similar to ASA 400 color negative films. The quality of the image is maintained and by using the larger formats one can get quite remarkable results which retain the sharp definition belonging to film possessing normal characteristics.

The use of these high-speed films is best with the 120 format for short and medium distance shots, where the lack of sufficient-ly wide-aperture telephoto lenses for cameras with formats larger than 35 mm is no limitation. One can thus get the advantages of both high-quality image and high sensitivity, which cannot be obtained to the same degree with the smaller format.

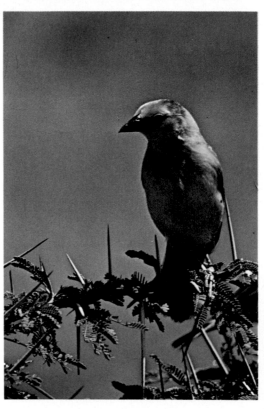

Two examples of the use of high-sensitivity film (ASA 200). To film the fallow deer in the photograph above a 200 mm Canon was used with diaphragm at f/4 and shutter speed of 1/125 second.

At right: African weaver.

BACKLIGHTING

The conditions for backlighting are present when the light is coming from the same direction as the subject being photographed. The problems that arise in such lighting conditions concern various important aspects:

(1) The image gives strong contrasts between the areas in light and those in shadow, which makes it difficult to reproduce the color spectrum.

(2) Measuring the exposure becomes a problem because of the necessity of isolating the actual subject from the light coming from the same direction.

(3) Some luminous rays may strike the camera lens and create reflections or spots of light or an image of the diaphragm.

A lens hood is indispensable. Summing up, backlighting conditions may be divided into two well-defined sorts:

(1) *Hard backlighting,* when the subject stands out against a luminous background which is the only source or main source of light. In these conditions the choice of exposure depends on the kind of picture one wants to obtain. Calculating the exposure normally, one will get a simple graphic effect, a silhouette; the subject will remain underexposed, without detail or modeling. If the outline does not reveal the subject immediately, the picture becomes a puzzle to be interpreted. To make an attractive and interesting picture, the composition must include essential elements easy to read, almost like a sign. Birdwatchers put images of this sort to practical use. Dark silhouettes against a white background will identify birds even at a great distance. If in choosing the exposure the light reflected from the subject is measured with an exposure meter or with a reading of the incident light, the background of the sky will become white, transparent, and the subject will show more detail in the areas in shadow: this is generally equivalent to overexposing by a few diaphragm stops.

(2) *Soft backlighting,* when the light falls on the subject more or less at an angle, but from behind the subject in relation to the position of the camera, and the light source does not enter the camera directly.

The background can be bright or dark, but without strong contrasts; the subject is clothed in a radiant light which emphasizes its contour and surface structure. The result is an image in relief with three-dimensional quality and volume. This kind of illumination requires care to avoid any ray of light entering the lens and spoiling the picture, and for this reason the use of a lens hood is always advisable. If the luminous intensity on the subject is sufficiently balanced, very striking photographs can be obtained. This is an ideal condition which should be frequently sought to increase the three-dimensional quality without losing detail.

Determining the exposure presents some problems. Depending on the light contrast on the subject, as a rule one measures the light reflected from the subject in shadow by means of a spot exposure meter, or by a close approach to the subject wherever possible. Alternatively, one can calculate the exposure on an area of the picture which has a similar degree of luminosity and use this. If the camera has the capability of reading and locking on an exposure or can correct it to two exposure values, it will prove very useful indeed on these occasions. If no measurement other than the normal kind is possible, you might try, with some chance of success, overexposing by one to three diaphragm stops. The greater the contrast between the areas in highlight and those in shadow, the greater the exposure must be.

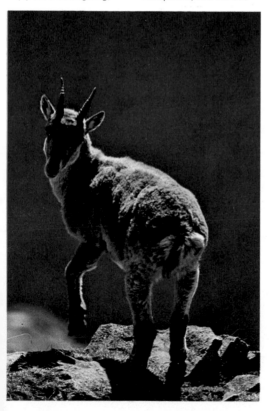

On the left: An example of soft backlighting. Observe the modeling in the image of the small ibex, enhanced by the graceful movement of its paw and above all by the soft side light and the correct exposure (600 mm Nikon f/5.6 with shutter speed of 1/250 second).

Above: Example of hard backlighting. The luminous background is the only real source of light. The tone scale is reduced to bright areas or almost dark ones and the image takes on the essence of a graphic effect. The griffon vultures seem to merge with the rocks, giving an impression of the strength needed for their harsh existence (Asahi Pentax 300 f/5.6 with shutter speed of 1/125 second).

STALKING WILDLIFE PHOTOGRAPHY

Stalking wildlife photography is the active search for animals in their natural surroundings by the nature photographer, in contrast to wildlife photography from a blind, in which the photographer remains concealed and waits for the animals to approach him. Practicing this kind of photography means being prepared for walking, and for the nature lover it is probably the most stimulating form of animal photography. This roving with the telephoto-equipped camera may immediately follow on the photographer's discovery of nature, or be itself a continuing discovery. The desire to track down animals that vanish as fast as they appear is compulsive and goes on increasing. The battle of skill between wildlife photographer and wild fauna becomes intense as the photographer must seize the moment between the appearance of the creature and its subsequent and immediate flight. At times it is a question of split seconds which must not be missed at any cost: a pheasant darting out of a thicket must not catch the wildlife photographer unprepared, when the telephoto lens has to be focused and the shutter operated almost instinctively with the shot properly framed. The parallel with real hunting springs to mind, but the skill demanded in nature photography is somewhat greater. Quick the noise and inevitable distractions would spoil everything. Stalking wildlife photography, however, does not mean all walking and no stopping. This may be so in the case of subjects known to be hidden which one wants to drive out while walking. Sometimes the photographer's interest may focus on certain species which flee at first but then return to their territory, or upon others that come and go from one area. The wildlife photographer then becomes stationary, that is, he stays in one place where he has found something to occupy himself. For example, on reefs laden with seabirds one can stop at a suitable point to try and capture pictures of passing birds without the need for camouflage or blinds. Even if this does not give very impressive results like photographs of animals from permanent blinds, stalking wildlife photography for many is more intriguing.

Normally beginners are so pleased to have taken a few shots of wild animals for the first time that they do not bother to check the photographic results in a strict sense. In a number of cases it is possible that any photograph is a record of nature observations. Even a small, out-of-focus picture may allow one to recognize, for example, the silhouette and white spots on the wings of a young golden eagle whose presence in a certain region has hitherto escaped notice.

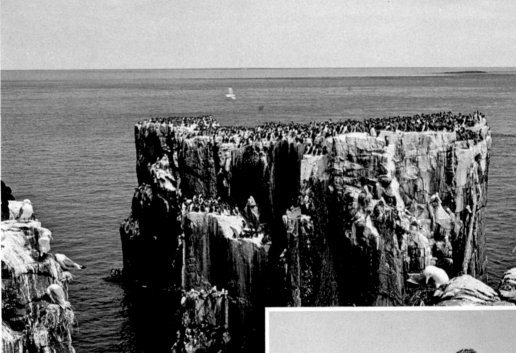

The wandering nature photographer can choose places and subjects to photograph with greater freedom, not being obliged to keep within the limits imposed by stationary blinds.

reflexes, accurate centering on the subject, rapid focusing and releasing are much harder than firing a gun at the prey.

Because of the need for swift responses and steady concentration, it is advisable to go out on one's own or at the most with two or three persons widely separated. With too many,

The difficulties found in stalking wildlife photography vary from country to country, and also can be measured in relation to the degree of fear experienced by a wildlife species in the presence of man. Each species keeps its own distance in flight from potential foes, which increases considerably, for example, when hunters are beating the fields. During the shooting season, in fact, wildlife photographers are at a considerable disadvantage because animals flee much more quickly than they do at other times of the year. A photographer will be sad to see subjects, patiently sought for days on end in order to obtain a few good pictures of their natural life, being terrified and killed with such indifference. In this sense the two activities really cannot coexist.

Where to Practice Stalking Wildlife Photography

Stalking wildlife photography may be practiced wherever there are animals, but especially in open surroundings where the wild creatures can be framed before rapidly concealing themselves behind a tree or in the thick of a wood. Places frequented by species that tend to camouflage themselves in low-lying grass or shrubs are suitable, because these animals wait to the last before attempting flight. Hares, pheasants, and partridges, for example, crouch down in hiding, motionless, or crawl along the ground, and only when the photographer gets too close will they raise themselves and run away. Thus it may happen that the wildlife photographer sees a partridge fleeing from him a few feet away and is unable to frame it because of its very proximity.

Equipment

For this kind of animal photography reflex cameras which are small and easy to handle should be used, in preference to the 6 X 6. Mounted on the camera can be a 300 mm normal lens which is light and lumi-

nous in aperture, like f/4 or f/5.6, or a 500 mm catadioptric lens, usually with a diaphragm of f/8. Moving animals can be securely frozen using shutter speeds of 1/500 or 1/1000, which are possible with high-speed film. A cloud in front of the sun or a dark thicket should not discourage the photographer, who can use film of ASA 200 or more.

Even with slower shutter speeds, good stalking wildlife pictures can be obtained by leaning on some fixed support such as a tree, a rock, or the ground. The rifle grip, which has already been mentioned, is an absolutely essential piece of equipment in stalking wildlife photography. Motor drive is undoubtedly of great assistance but should not be regarded as indispensable for the beginner. Usually with shots of wild animals in flight, what counts is the picture taken at the start. Clearly, with a volley of shots something will always be obtained, but first it is a good idea to get used to looking and learn to shoot at the right moment without the aid of the motor.

A waterproof sports jacket in camouflage colors with plenty of pockets is useful for holding spare film and even the wide-angle lens to document the habitat of the animals photographed. Some jackets are also fitted with a hood suited to meet every atmospheric situation. It is better to choose a wide cut so as not to have your movements cramped and also to be able to cover cameras and lenses in case of rain, wind, and snow. Another detail not to be underestimated is that the fabric should be soft and not rustle when one is walking. The synthetic material of a jacket may make a noise that apart from being irksome could become a warning signal for many kinds of animals.

A knapsack can be useful for carrying extra lenses, a second camera body, film, a small, portable guide to the animals being shot, food, and water. Naturally during weekend stalking wildlife photogra-

phy or when one does not move very far from the starting point or the car, a great deal of equipment need not be carried, not even the knapsack; in fact, the less weight one has to carry around, the easier it is to practice stalking wildlife photography. Film, however, should always be carried in a larger quantity than that deemed necessary, because unforeseeable opportunities may present themselves at any time and it would be a pity to miss being able to use them because of a shortage of film. In the summer, in preparation for long walks, one should never forget to take a canteen and some food to refresh oneself. A pair of hiking or field boots is essential. To

three choices ready: hiking shoes, high rubber boots, short boots.

Binoculars should never be forgotten, as the preliminary observations to understand the movements of animals and where they are hidden must be made from a good distance. A flight of heron descending on a bend of the river behind a copse of willow trees can be sighted by the wildlife photographer from a distance; then the decision as to the best way of arriving within lens range can be made. A necessary prerequisite to nature photography is the simple art of observation. The binocular model chosen should be the least cumbersome possible, such as an 8 X 30 with internal focusing.

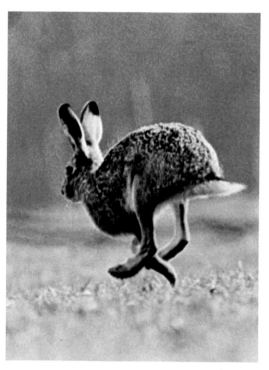

cross marshy ground, swamps, or springs, one needs rubber hip boots, that is, full-legged ones, to negotiate water hazards, even trivial ones like small ditches. They may be folded over during the walk. Coming out right after a thunderstorm, one can wear short rubber boots against wet and mud. In your car you should have

Above: Animal in flight (a hare, in this case), a picture typical of those taken while stalking wildlife.

RAPID-FOCUSING TELEPHOTO LENSES

Since automatic exposure has removed the need to adjust shutter speed and diaphragm aperture on many cameras, the only operation that the wildlife photographer must constantly carry out is focusing. With medium and long telephoto lenses, depth of field is often barely sufficient to cover from front to back the animal framed in the viewfinder, but there is always enough time to avoid blur. Under these conditions, every method and instrument which helps and simplifies the operation of focusing can give that advantage which will make possible shots otherwise lost or unattainable. Today the nature photographer has available an optical system and specialized equipment for telephoto photography designed to improve the effectiveness of focusing. One system,

ments. These grips are deliberately made with a short mount so that they can be connected to the rapid-focusing handle. Lenses available are a 280 mm f/5.6, a 400 mm f/5.6, and a 600 mm f/8. Optical characteristics are good, while luminosity is somewhat reduced in the shorter lenses. This equipment for wildlife photography is light, handy, and easily adapted to the different requirements of shooting by means of a simple replacement of the optical part. If the very practical and light bellows is used as a link between trigger and camera, one can move rapidly from long-distance shots to photography of detail. With the 400 mm, for example, a scale of reproduction of 1:3 may be obtained simply by altering the built-in bellows extension. All 35 mm reflex cameras can be

simplify the focusing operation is the one recently introduced by Nikon in the Nikkor IF-ED telephoto lenses of 300 mm (f/2.8), 400 mm (f/3.5), and 600 mm (f/5.6). The initials IF stand for internal focusing. In lenses made in the traditional way, during the focusing operation the helixes move and carry the front part of the lens. This part is also the heaviest because of the large size of the component lens, especially in long focal lengths, hence the increased weight of the mechanism, which must resist continual stress and expansion. With the IF system, only a few center lenses of reduced diameter are required to move, while the lens barrel itself remains rigid at a fixed length, and the mechanisms are protected and hence more reliable. Fo-

glass (extra-low dispersion) of which the lenses are made. The advantages lie in the improved transmission of contrast and hence in more clearly defined images and in the greater degree of hardness which ensures high mechanical resistance and a more compact structure. The only disadvantage at present, which cannot be ignored, is the price, which is high.

Automatic Focusing

Attempts to automate focusing are not of recent manufacture. In the past various appliances were devised which had in common considerable unwieldiness. It is only recently that electronic technology has miniaturized systems which are starting to appear on fixed-focal-lens cameras and are available to a wide public. Certain small cameras at modest prices now offer a further degree of

the Novoflex, provides an accessory of added interest, a special pistol handgrip which controls the focusing by means of a piston movement with a return spring. The smoothness and maneuverability of the mechanism renders manipulation simple and does not tire the hand. In this way, following a moving subject becomes much more spontaneous than with the traditional system of turning a ring. This pistol handgrip can be combined with a complete system of interchangeable accessories, comprising a ring or bellows which acts as a coupling device with the camera, and with a set of lenses with bayonet attach-

used by means of suitable connection rings.

Other systems also exist to facilitate focusing. With Leitz Telyt telephoto lenses of 400 mm (f/6.8) and 560 mm (f/6.8), focusing is achieved by means of a slider which is easy to grip because of its wide surface. Its movement is easy and spontaneous but not so rapid as the previous system. The optical quality of these telephoto lenses is considered to be among the best because of the high resolution and modeling of the images produced. Hence they are frequently used by professional nature photographers.

Another technological solution also designed to

cusing is softer and faster; the minimum distance is considerably reduced, as extensions of the camera lens requiring weighty and bulky frames are no longer needed. In practice these lenses gain in compactness, lightness, solidity, and even in luminosity. The large maximum aperture possible with these lenses increases the chances of being able to operate under difficult lighting conditions, considerably improves the vision of the image in the viewfinder, and widens the field of action of the exposure-meter cells.

The initials ED, on the other hand, indicate the kind of low-dispersion optic

automation which removes the need for the last remaining manual adjustment. Devices of this kind will soon be able to serve the needs of the wildlife photographer, who can sometimes miss, by a fraction of a second, the prey that he has been laboriously seeking for a long time.

Left: Telephoto lens with rapid-focusing Leitz Telyt R 560 mm f/6.3.
Above: The Novoflex system with rapid-focusing 600 mm f/2, handgrip, chest pod, and bellows extension.

On facing page: Puffin returning from fishing with a large catch.

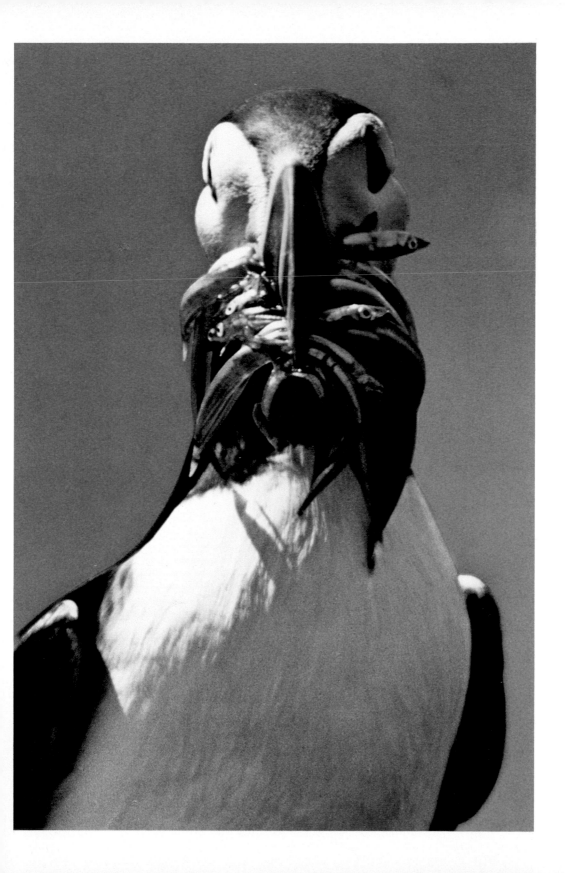

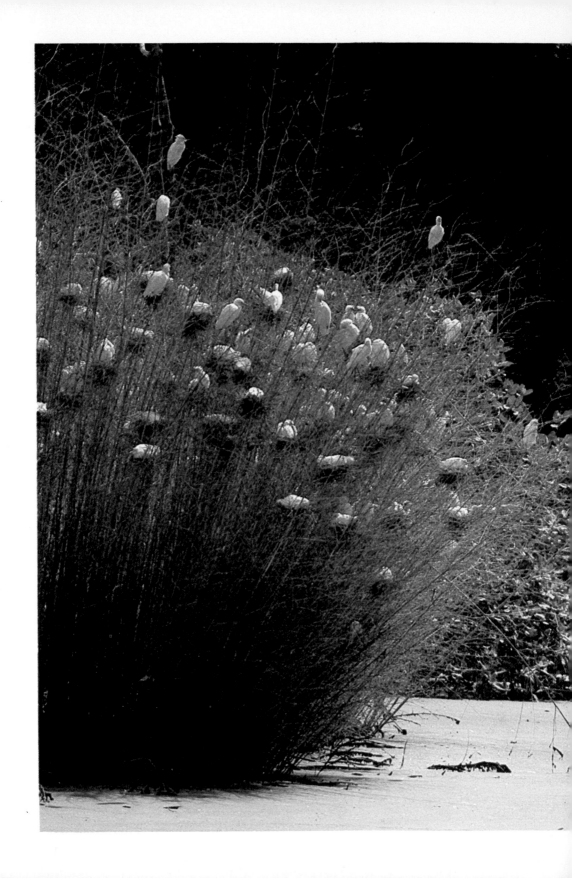

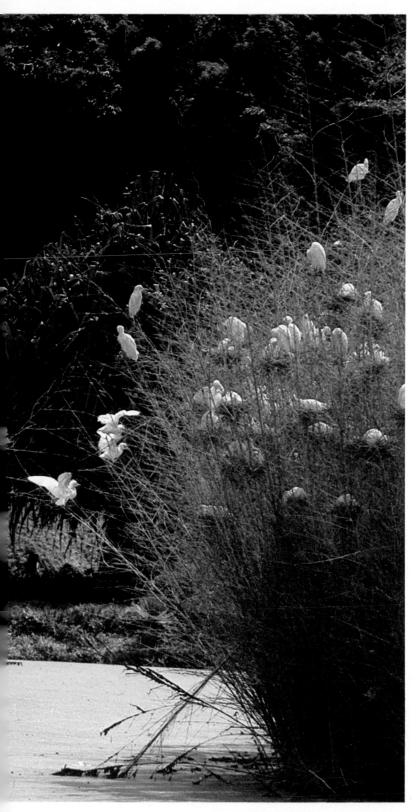

APPROACHING ANIMALS

Different factors, such as noises or the presence of strangers in the habitat, contribute to frightening wild animals, but almost always the upright figure of a human provokes their immediate flight. There are areas in which wild animals have had only rare contact with man and are therefore not afraid of him, but even among the most common species substantial differences exist. For example, storks, small birds, many wading birds, and various waterfowl show great willingness in allowing themselves to be approached.

To frighten animals as little as possible while approaching them, it is useful to observe certain basic rules.

Locating Subjects and Observing How They Behave

One should always observe exactly where subjects are located and what their behavior is. For example, if animals stretch their necks in an attitude of alarm, if they have stopped feeding and remain motionless, that means that they are tensed before taking to flight. In these cases it is useless to try and get any closer, but one should remain still and wait for a better moment.

Choosing the Right Method of Approach

It is necessary to examine the surrounding environment carefully. There is never merely one approach to a subject. You should avoid the most direct approach and choose the right one, noting hiding places and natural shelters behind which you can pause out of sight. Especially as regards mammals and birds, careful attention must be paid to the direction of the wind, which can carry human smell or sounds made while walking. An approach route must therefore be chosen which is downwind or with the wind coming from one side. The sun shining on the photographer, camera,

and lens can produce reflections of light which scare subjects. It is worth shielding the photographic equipment with antireflection material, but above all, focus on the animals with the sun behind you.

Camouflage

Beginners who think it is sufficient to dress in camouflage colors to be able to approach animals are deeply disappointed by their swift flight. In fact, what frightens mammals and birds is the upright figure of a man and his gait. If the traditional scarecrow is sufficiently human to terrify animals, imagine how much more a man in flesh and blood does even when camouflaged. Camouflage is quite useful but it simply cannot switch off the defense mechanisms and flight instinct of creatures that are much more sensitive than we think. In short, in stalking wildlife photography, to get close to the animals, a great deal of ingenuity and patience are needed which can only be gained in practice. The photographer who loses his patience at the sight of subjects fleeing at a great distance after believing his disguise was foolproof is certainly not well suited to practice this activity. Disappointment over the flight of animals should have a salutary effect instead and teach something about one's mistakes.

Camouflage Poncho

A very useful form of camouflage for stalking wildlife photography is a patterned, waterproof poncho. This cape, besides providing effective protection from the rain and the cold, proves very handy since it can be transformed into a mobile camouflage. Having sighted the subject, the photographer seals himself up in his poncho and advances, stopping from time to time to take pictures through the opening at face level.

The shape which the photographer presents when clothed in a poncho is more spherical and less like the figure that so scares animals. Perfectionists can attach cord and a thick mesh to the outside of the poncho on which to hang vegetation found on the ground, like twigs and leaves. It then begins to take on the appearance of a real "mobile shrub," edging itself little by little toward the subject. This is perhaps easier said than done. Indeed, on-the-spot experience is needed. Furthermore, in certain cases where an excellent position exists for shooting the subject, the poncho can be removed and hung by rope between two trees or bushes to form a kind of improvised blind. The concealment so obtained is the lightest and least bulky kind available, and as simple to carry as a raincoat.

Pretending to Be a Part of the Surroundings

Another useful piece of advice in getting near animals, especially certain species of mammals, is ap-

The stag has been taken by surprise and his image frozen seconds before he fled, thanks to the use of an Asahi Pentax 500 f/8 at 1/250 second.

Marshland birds can be approached with camouflaged boats and photographed before they fly away, as is the case with this goliath heron seen in the midst of papyrus vegetation (below), and the cattle egrets shown on pages 102–3.

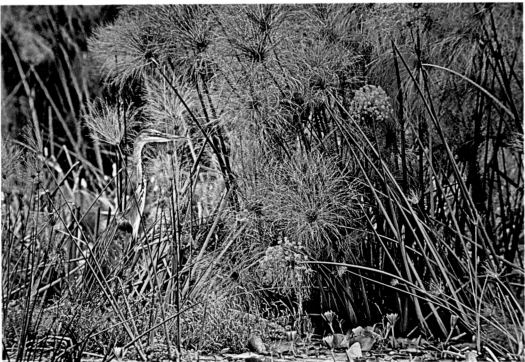

pearing to be part of the environment, like a farmer or a normal visitor to the area. For example, the chamois immediately recognizes the intruder stealthily approaching and takes flight. One must walk slowly and stop frequently. And never look straight at wild animals like a beast of prey would. Better to glance out of the corner of one's eyes to check from time to tirhe. Obviously the usefulness of this advice depends on differing circumstances and conditions as well as personal preference. An extremely individualized example, not within everyone's means, is that which Ray Gordon, the naturalist

THE SEASONS AND WILDLIFE PHOTOGRAPHY

Stalking wildlife photography can be practiced in any season. Indeed, in bad weather animals are less prone to move and hence they are easier to approach once spotted. Waterproof jackets and ponchos are indispensable in such conditions, not only to protect the photographer but also and above all to shelter precious equipment. Simple plastic bags to cover camera and lenses may also be used, leaving an opening in the bag for the telephoto lens.

When it rains, birds remain with heads lowered beneath wings; generally

even beasts of prey are less active in the rain than usual. The nature photographer may take advantage of these moments of inactivity in nature. Further opportunities to get good photographs, even if they are not easy, come with snow. Snow tracks allow tracking and photographing even the most evasive species, such as ermine, wolf, stone marten, even larger mammals, and birds hunting for food. On these occasions one must carefully avoid the easy mistake of underexposing subjects due to the reflecting surfaces of fields covered in

snow, which affect the exposure meter inordinately; and the intense white may obliterate detail on the film.

Wildlife photography can be practiced in any season and in any atmospheric condition. The red-footed falcon on the left was taken in the rain with a 500 mm Nikon mirror-lens f/8, ASA 160 film, and the clever expedient shown in the drawing.

Bottom: The golden eagle, which has successfully preyed on a fox, a rare shot made during the winter season.

and photographer, devised to get near wild white sheep in Alaska; he camouflaged himself with a sheepskin and approached the wild sheep between two tame ones yoked together.

In a different habitat the same animal species can behave quite differently. In a national park, where they are not disturbed, animals will allow people to approach closer to them, while in an open area the situation is quite different. In Italy's Gran Paradiso national park it is easier to approach wild goat, to within a few feet, in fact, than chamois, which might give the false impression that the first species was less shy. In other areas of the Alps, where it is less difficult to approach chamois, the exact opposite is true.

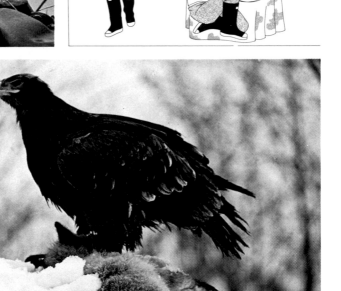

HOW TO JUDGE WILDLIFE PHOTOGRAPHS

To render a judgment on a shot taken of wildlife, one must assess the degree of difficulty which had to be overcome in taking it. For example, the picture of a hare (a common animal but very fast moving and sensitive to external stimuli) framed at a short distance, with the right light, at animal height, is a fairly difficult achievement. Whoever practices wildlife photography recognizes the complexity of such a shot and knows how to distinguish it from an equally sound picture of, for example, colorful tropical birds unafraid of approaching people.

Some basic rules can be enumerated for judging and classifying wildlife pictures.

(1) Animals should always be shot in their natural environment.

(2) The pictures must be acceptable from a naturalist's point of view and must therefore show certain fundamental characteristics. Among these, of undoubted importance, is their technical and aesthetic validity. However, all details in such photographs need not be shown in a strictly naturalist setting.

(3) Some photographs, even if they are not technically perfect, are nevertheless of considerable importance since they document a particular moment in the life of animals, such as the existence of a certain species in a particular habitat.

(4) Finally we should note the kinds of photographs produced for scientific purposes. Here the objective guiding the author may be to obtain visual material to support some scientific thesis, or the documenting of some previous research.

The Horizon in Wildlife Photography

One useful piece of advice, which may seem obvious but if neglected can spoil many transparencies, is to make sure that the horizon is well aligned and parallel with the lower side of the photograph. We have already mentioned this requirement elsewhere, but it is worth repeating again here. However, the wildlife photographer, intent on the animal subject and perhaps not in perfect equilibrium himself, can sometimes ignore the horizon, which may come out slanting one way or the other. With black-and-white the error is easy to rectify at the printing stage, but with transparencies this is impossible without drastically reducing the size of the photograph.

Correct exposure and perfect framing make the picture of this albatross especially fine and rich in detail.

On the facing page: Even if the birds in the background are out of focus, the framing of the curlew in the foreground is so dominant as to make this effective picture highly successful.

EXPOSURE FOR BIRDS IN FLIGHT

Proper exposure of flying birds presents one additional problem compared to the photography of animals in other situations. With an exposure meter system of the spot kind, it will be possible to expose the subject perfectly, centering it if it is fairly close. But usually birds considered to be approachable by the nature photographer fly at a distance which is neither too far nor too near, for which the photocell calculates an average between subject and background. We will now examine the visible differences on the basis of the color of subjects and background.

Dark Birds

Usually dark birds come out underexposed if taken against the sky. This happens because the automatic camera exposes by setting itself more by the light of the sky than by the subject. The same happens when regulating the diaphragm by hand while aiming the telephoto lens in the sky to frame the subject. To avoid this drawback when photographing dark birds, switch off the automatic and overexpose by one diaphragm stop or one shutter speed slower than that shown by the exposure meter. Modern camera diaphragms equipped with half stops are even more useful as it is not always necessary to overexpose by one diaphragm stop: sometimes half a stop, sometimes one and a half will be right. Similarly with shutter speed, one has to overexpose by a whole notch or not at all. With nonautomatic cameras one can prepare the proper exposure beforehand for birds in flight and adjust aperture and shutter speed, measuring the light by pointing the telephoto lens on a section of the ground normally illuminated. Bushes will do perfectly well, as they can be compared in exposure to dark birds in flight. It must be borne in mind, however, that if sunlight does not directly illuminate dark birds, although glaring errors of underexposure will be avoided, one will never succeed in obtaining results of the best quality but only acceptable pictures.

White Birds

With white birds in flight, the situation is different. The exposure meter on the automatic reflex is self-regulating and gives good re-

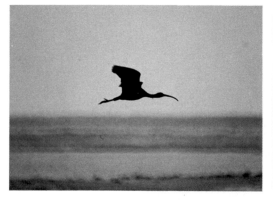

Above: Dark bird against a bright background. This glossy ibis, taken in flight over the Danube delta, has come out slightly underexposed because the exposure meter was set on a bright sky. The subject's position in relation to the horizon and the animal's environment make the picture an effective and interesting one.
Above, right: The alpine chough, although taken against a solid background, is underexposed by the "snow effect."
Right: Bright bird against a bright background. The automation of the exposure meter has set the exposure on an average stop between the sky and the white bird in flight, giving a correct exposure for this white-winged black tern.

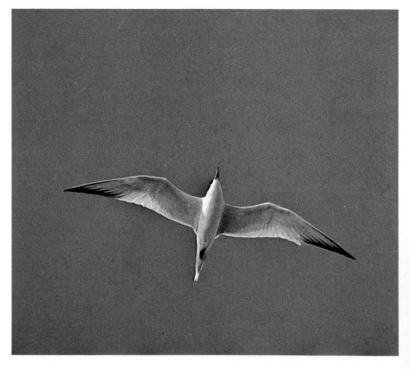

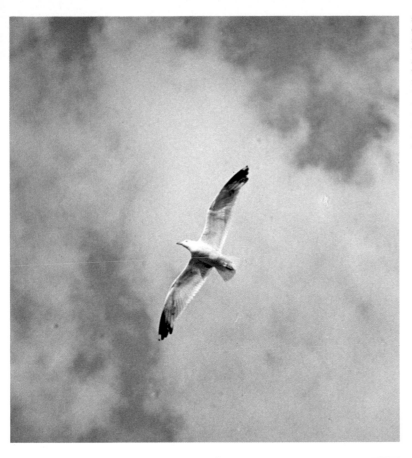

sults, as there is not a great difference between sky and subject. Usually, therefore, sea gulls, egrets, and terns come out fairly well exposed when taken in flight. In certain instances, which do not occur very often, there may be a risk of overexposing them. Here, however, correction should not exceed half a diaphragm stop.

Solid Background

One of the most useful techniques in photographing birds of any color in flight involves the use of a solid background. This consists in waiting for the birds in flight to pass in front of something which is blended well for the exposure meter, a mountain, for example. One can then shoot in a more assured frame of mind, knowing that the resulting average exposure will usually give satisfactory results.

Background with Clouds

Clouds have this "blending" function for the exposure. That is, the light coming from the subject is softened by the cloudy background, and this also serves to emphasize certain details of the plumage.

Background with Snow

An enhanced effect of underexposure is caused by the snow, especially if dark subjects are photographed. If the background is solid, it acts like a mirror, reflecting the light fiercely onto the exposure meter, which is thus fooled. The result is a narrowing of the aperture by one or two stops more than neccessary, with a consequent underexposure of the main subject.

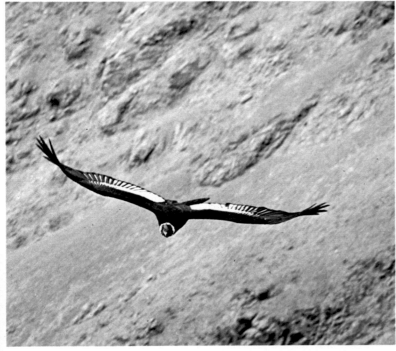

Two further examples of subject exposure against different backgrounds. The herring gull taken against the clouds (above) comes out nicely exposed even in the gray and black parts. The exposure of the Andes condor (on the left), photographed to advantage against a solid background, is perfect.

CONDITIONS FOR PHOTOGRAPHING WILDLIFE

In wildlife photography the quality of the image depends on three principal factors, in brief:

- Type of lens and optical characteristics.
- Shooting distance and transparency of the air.
- Kind of light and direction.

On the first point, remember that it is always advisable to use the telephoto lens with the shortest focal length possible, which is normally clearer and more manageable, and also more luminous. Furthermore, the risk of blur due to camera shake is reduced.

The second point is partly connected with the first. If one gets as close as possible to the subject, two advantages are gained: a lens of shorter focal length can be used, and the effect of the layer of air which comes between lens and subject is reduced to a minimum, a factor often ignored. In certain cases this haze can spoil the image by weakening definition and contrast. This factor becomes important with medium and long telephoto lenses (as has already been stated on page 83 in speaking of advanced equipment) when the distance to the subject exceeds 20 or 30 meters, as often happens. The transparency of the air changes noticeably with the presence of atmospheric dust and layers of different temperatures.

The presence of wind not only affects the steadiness of equipment but, by stirring up sand, organic particles, and spores, considerably reduces the transparency of the air. In these instances it is best to reduce the distance of the shot, or wait for better atmospheric conditions. Heavy and prolonged rainfall washes and purifies the air, to such an extent that it is often visible to the naked eye, allowing for pictures of astonishing brilliance to be taken.

The improved definition and contrast obtainable under these conditions is often greater than any possible improvement in optical quality which the most renowned, expensive lenses can give. Rain, which rapidly reduces soil temperature, also eliminates the other effect that modifies the transparency of the air—warm layers which form in contact with the earth because of solar radiation. In the warm season, especially in the middle of the day, rocks and barren ground get very hot; the warm air near them expands, becomes lighter, and tends to rise gradually.

These warmer layers of air have a different degree of refraction and hence modify the transmission of light causing a mirage effect. One can easily check the loss of image quality caused by this phenomenon by taking some photographs with a medium telephoto lens of a subject situated at a distance of 20 meters at least, in a barren and sunlit area. A few pictures should be taken, varying the height of the camera from the ground, from only a few centimeters to a meter and a half or more if possible (from a couple of inches to about 5 feet). The image at ground height shows poor definition and a certain indistinctness, because the light rays traverse a layer of air with more temperature variations. Such defects are considerably reduced in photographs taken from a greater height.

In practice it is advisable to choose an area for telephoto shooting where the surfaces are not strongly lit by the sun, and, if this is not possible, the camera

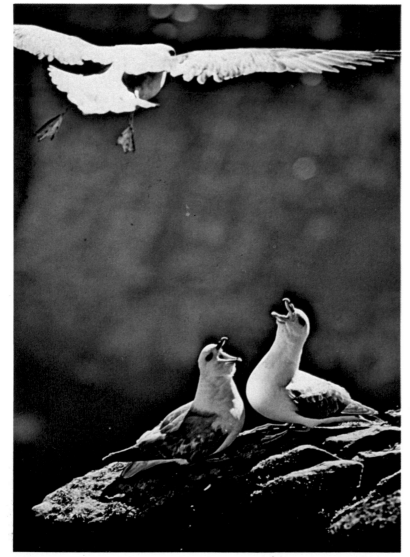

In this photograph, the lateral incidence of the light, besides enhancing the contours, lends a three-dimensional effect.

should be positioned in such a way as to avoid shooting through layers of air under half a meter (one foot). Instead, it is better to change the position of the camera so as to shoot over areas rich in vegetation or rivers or ponds, which absorb solar heat to a greater degree.

The best time to photograph is in the early hours of the morning, not only on account of the reawakening of wildlife, which makes it easier to discover subjects, but also because of the more favorable atmospheric conditions—fresh and clear, and light which is softer and more at an angle.

The kind of light and direction make up the third point, no less important than the preceding ones for assessing the quality of the image. The general subject of illumination has already been fully discussed, and the same rules apply to bird photography. Given the extreme mobility of these subjects in flight, it is impossible in practice to choose a more suitable angle if they are not properly posed for shooting.

It does happen, however, that one can take pictures of subjects whose behavior is known, and hence the best position for the shot and the time can be chosen. Normally, vertical illumination is inadvisable as this makes hard shadows without depth. The most spectacular effects are produced with soft backlighting, as shown in the photograph on the facing page: blurred but close background, cleverly angled light, but not too harsh, endow the subject with sharp outlines and three-dimensionality, while the plain, balanced composition effectively conveys the dynamic quality of the action. In the picture of the petrel, at the right, the side lighting accentuates the subject caught in the moment of uttering a cry and detaches the bird from the light background of the sky.

Choice of Exposure Time

Choice of shutter speed is strictly related to the spe-

cies one intends to photograph, lens aperture, and film sensitivity. Photographing a kingfisher and a herring gull in flight requires different techniques. The first bird actually darts along at a very considerable speed, then hovers for a moment in the air, beating its wings, before diving quick as lightning into the sea. It is usually in the moment of hovering that the nature photographer seeks to capture it. Considering that a bird which is only moving its wings can be frozen even with a speed of 1/250 second, at that exposure the photo will

show an effective blur of the wings. But why not try to take a very tricky picture of the bird darting along in flight? A speed of 1/1000 or, on cameras which are so equipped, a speed of 1/2000 second will be necessary. The more luminous the telephoto lens is, of course, the more one can combine fast shutter speeds and diaphragms stopped down below maximum aperture, so making the focusing easier. Furthermore, to facilitate the

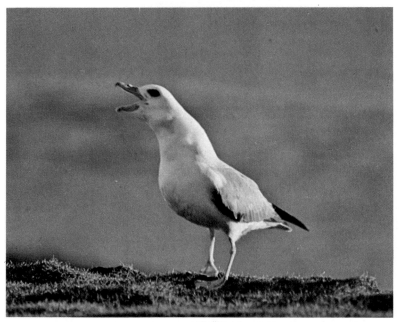

Above: A booted eagle frozen in flight with an exposure of 1/500 second.
Below: A fulmar, taken with the soft sidelight of the early morning; examples of perfect exposure.

task of coupling a fast shutter speed with a diaphragm stopped down, high-sensitivity film must be used and the photograph shot in bright sunshine.

In the case of a gull, the situation is different; the bird flies slowly and rhythmically, and to freeze it a speed of 1/250 second is adequate, keeping the diaphragm stopped down to get it entirely in focus. The use of very luminous lenses and extremely sensitive film is not indispensable.

Usually toward evening, when the intensity of the light diminishes, it becomes impossible to photograph swift movements of birds, and one must resort to photographing stationary animals. 1/125 second, or if required, even 1/60 or 1/30 second may be sufficient to get a very good shot of the kingfisher now perched on a tree trunk. On these occasions the rule is to open up to maximum aperture in order to make full use of the remaining light. This gives a blurred background, which brings out the contours of the subject.

HOW TO FRAME BIRDS IN FLIGHT

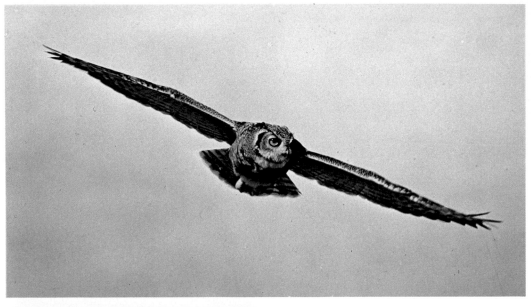

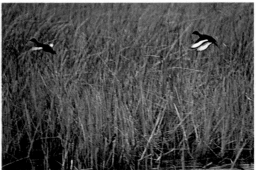

Most photographs of birds in flight show them framed from the rear. This usually happens because, from the moment of becoming aware of their presence to that of taking the shot, a few seconds pass in which the photographer tries to frame them closer, in proper light, and in focus—admirable aims, but the birds quickly fly over and past the position of the photographer, who ends up photographing them from behind.

Pictures which show a frontal view of birds are more effective because they convey both movement and the pattern of flight. One who appreciates wildlife photography will be enthralled by these difficult photographs, models to be

imitated at the first opportunity. This spectacular effect will seem almost like the work of a photographer who has preceded the birds in flight. Pictures taken from a full frontal view can be obtained if the wildlife photographer is on a mountain, for example, which the birds are approaching from below, rising to the height of the camera. A typical framing from a height may be done from the cliffs where colonies of nest-building seabirds are found. Shearwaters, puffins, gannets, and cormorants can be taken by positioning the camera on a high cliff and photographing downward at the birds flying over the sea. For this type of shot one normally uses a 300

mm telephoto lens, or a shorter one, as it is helpful to include the habitat. When you see birds flying below, wait until they gain altitude and approach your position. In the mountains it is possible to photograph birds from a height, and this is especially useful for documenting differences in plumage between young birds and adults. In the case of the golden eagle, such shots capture the white spots on the wings and tail feathers which show the age of the subject.

Interesting results can be obtained photographing birds from the side. Ducks especially are good subjects for this kind of picture, presenting the wildlife photographer with details of the upper and lower parts of the wings. Procedures for flank shooting are the traditional methods used in panning.

Shots of birds taken from below are perhaps the most common type of framing, but it is not as easy as it might seem. To get this kind of picture it takes repeated practice in framing birds and following them in flight, adjusting the focus as they move and tripping the shutter exactly as they reach the point di-

rectly above you—a moment's delay could spoil the result.

For such pictures, the longer the focal length, the harder it is to carry out the movement for vertical alignment of the camera and the object to be photographed, which is required to photograph birds flying exactly overhead. The best photographs of this kind are made with lenses which are easy to handle and not too long.

After referring to these four different positions for framing, it is worth mentioning the intermediate positions, which can produce acceptable results.

In all cases, the enormous advantage of a lens that can be focused rapidly becomes obvious.

Above: Great horned owl, a good example of a frontal picture.
Left: The side shot of these white-eyed ducks in their natural setting shows clearly the characteristic pattern on the wings.

Opposite page: An impressive picture of a parrot in flight, taken from below in a perfect framing.

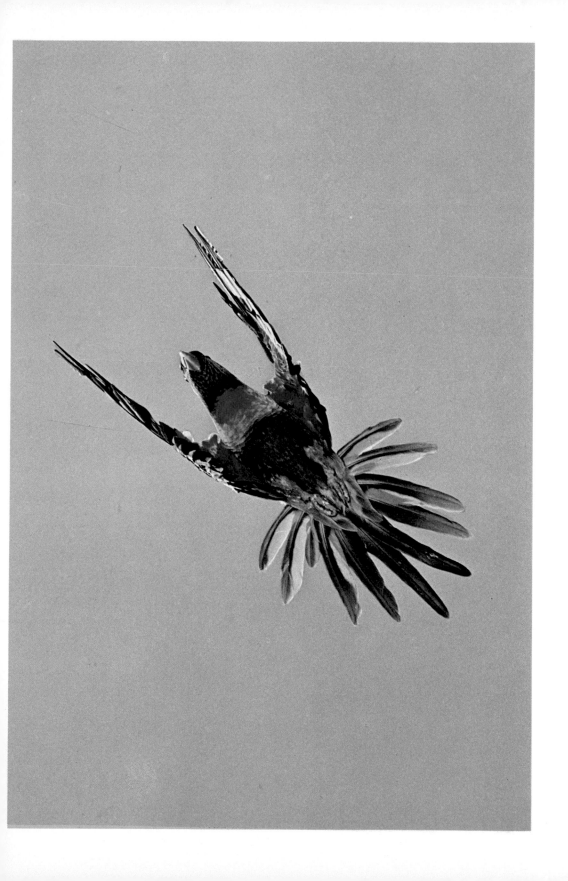

SHOOTING AT ANIMAL HEIGHT

Photographs of animals from their level give a better idea of the physical condition and of the natural ambience of the wild animal. The nearer the ground the camera is held, the more delineated and well-defined will the subject on the ground appear in relation to the background. Photographing an animal in this way means taking it about its eye level. Grass which appears uniform and superficially green from the height of a person takes on a completely different appearance at animal height and reveals numerous details, framing subjects in their habitat as they see it.

In stalking wildlife photography, small mammals in flight can be taken at a more suitable angle by kneeling, sitting, or lying down and covering oneself with the poncho or the camouflage net and foliage. When using a rifle grip with optional base support, remember that the ground is a first-class stabilizer for photographic equipment. Long telephoto pictures shot with one's body resting on the ground are often more "still" than those taken with a stand. A sandbag—a sack filled with sand or soil on the spot— is useful for supporting and stabilizing even the longest and heaviest telephoto lenses.

On the left: Hare taken at animal height by the photographer who was seated on the ground. The camera used was a Nikon FE with a 500 mm catadioptric f/8 lens and ASA 200 film.

Below: African weaver taken at the height of its perch and at not more than 2 meters (6½ feet) from the camera, with a Vivitar 70–210 zoom in macro position.

SEIZING THE MOMENT

Stalking wildlife photography is certainly the best method of seizing opportunities as they present themselves to the nature photographer roaming around the natural environment.

Luck and Readiness

One needs a good deal of luck to have an extraordinary encounter, but rest assured, sooner or later they happen to everyone. When the lucky moment comes, it must not be allowed to slip by. It can happen that the roe buck hunted without success for days, at suitable times along tracks where he usually passes, unbelievably appears all of a sudden behind the nearest thicket without being aware of the photographer's presence. It would be unpardonable to let unique moments such as this be missed. However, emotions in these sudden encounters can sometimes play nasty tricks on one. The photographer must overcome his instincts as a naturalist because a moment lost in fascinated contemplation of the animal can be sufficient time to prevent him from being quick enough to view, focus, and expose the shot. Successful photographs in situations where the photographer is completely surprised can almost always be put down to instinct, such is the degree of speed and automatic control required. These shots are the happiest memories of each wildlife photographer since they represent a real technical and personal triumph.

Framing the Area in Front of the Animal

One useful piece of advice to follow if you catch a stationary or camouflaged animal on the verge of flight is to frame an area situated slightly in front of the subject, exactly where it will be a moment later. Naturally you must shoot as soon as it starts to flee. In this way you anticipate the direction of flight, prepared

The Most Telling Movements and Different Positions

If the animal has not become aware of a human presence, it will be possible to take several shots and choose among the most telling movements to convey the characteristics of the species. It is also useful to take shots of a number of positions, as in the case of the titmouse who, head first, performs acrobatics, clinging to slender twigs and lending itself most effectively to animated pictures, typifying the behavior of the creature.

Knowing the Animal and Grasping the Opportunity

Know the animal and grasp the opportunity is a maxim that bears repeating. Squirrels (not the city or park kind, of course) tend to hide themselves from the photographer immediately, moving in a flash to the other side of the tree trunk. All over? By no means. If you are familiar with the behavior of these little creatures, you will know that they are full of curiosity and that if you hide and wait, throwing your jacket or some tidbit to one side of the tree, it will not be long before the squirrel will pop out again.

Motor Drive and Lenses with Rapid Focusing

To really take advantage of the lucky opportunities in wildlife photography, motor drive is unbeatable. Instead of one or, at the most, two records, the use of the motor gives us five or six good pictures. Rapid-focusing lenses add those few seconds or fractions of a second so precious in these instances.

to catch the first movements of the wild animal. Since in such a case panning is not used, but you wait motionless for the subject to come into the viewfinder, fairly fast shutter speeds are needed—1/500 second, for example. A slight effective blur of some parts of the body might justify the use of slower speeds (naturally a great deal depends on the animal's speed of flight).

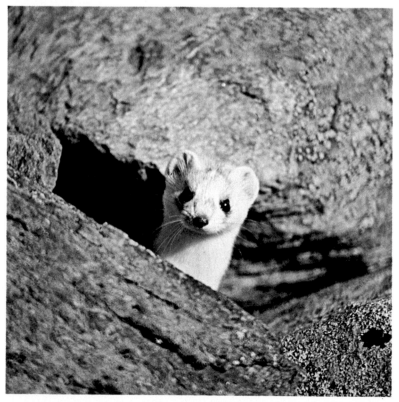

Two examples of skill and quickness of response which the wildlife photographer needs to have. Neither the otter (above) nor the stoat (right) had time to flee—the photographer managed to be faster.

AMBUSH WILDLIFE PHOTOGRAPHY

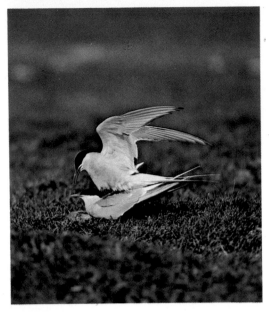

Wildlife photography from ambush consists in staying hidden and waiting for the animals to approach. The most traditional concealment and the one most often used is the hut. A simple device for hunters, the hut finds a more worthy field of application in animal photography. The best pictures in wildlife photography are often those taken from huts. In fact, it is not easy to be approached by wild animals unless one is most cunningly camouflaged. Remember, however, that the further away the subject is, the longer the focal length of the lens will need to be, to the detriment of the quality of the image.

Comparing three photographs of a wild animal, enlarged to the same dimension and taken with

telephoto lenses of 800, 300, and 200 mm, there is no doubt that a careful examination will show that the pictures taken with shorter focal lengths are better. The blind also offers the advantage of permitting the use of low-sensitivity film, which is wholly beneficial to color rendering. With the camera conveniently positioned on the stand, different apertures can be used and depth of field can be extended to bring other animals further back or the surrounding environment into focus. One can also wait for the right movement of the subject to capture spontaneous or unusual postures or actions illustrating the characteristics of the species. If stalking wildlife photography is readiness and quickness of response so as not to miss the few moments available for shooting, ambush wildlife photography is calm reflection and patience.

The Structure of the Blind

The classical shape of the blind is that of a block 1.70 meters (6 feet) high and about 1 meter (3 feet) on each side. The framework, as with a tent, may be composed of a light metal structure with a telescopic extension tubing system or solid joints. The structure of the roof is usually composed of thinner and more flexible metal pieces, which are fixed into the end joints of the four support poles, giving steadiness to the whole. The weight must not exceed 5 kilos (12 pounds); a comfortable

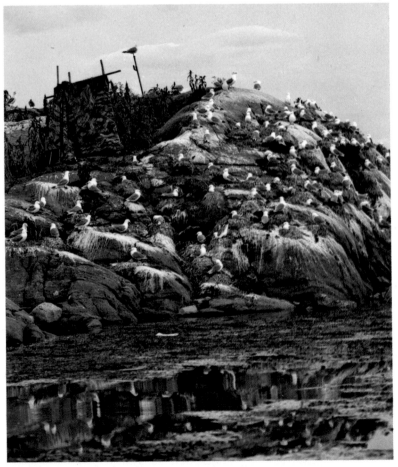

The terns (above, left) were taken from a blind some distance away so as not to disturb their mating. At other times (on the left) the blind can be placed nearer to the subject if it shows it is willing to accept this.

On the facing page: Feeding time for a cuckoo from the mouth of a reed warbler. Taken by a wildlife photographer from a blind camouflaged among the marsh vegetation.

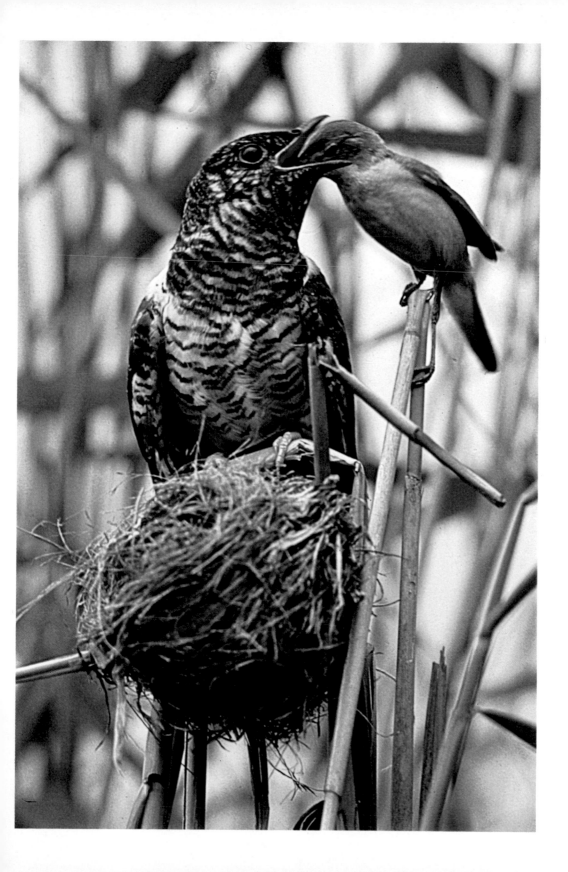

camping tent would weigh not much more. Remember that the blind cannot always be unloaded from a vehicle in the vicinity of the place where it is to be erected, but sometimes has to be carried perhaps for hours along uphill paths. In this event it is a good thing to pack the blind in a carrier bag or tie it to the knapsack.

Photographs are taken by pointing the telephoto lens through apertures in the sides of the blind. These apertures should be on every side to allow "unexpected" subjects that approach the blind to be observed and photographed. The ideal shape of these small windows is round, with elastic collars to enclose the barrel of the telephoto lens and fix it firmly to the blind's structure. Rectangular apertures (designed for hunting blinds) may be used, allowing the photographer to watch and aim the lens through the same hole. Some windows can be closed, and have graduated openings of several

sizes. There should be windows in the lower part of the blind to take pictures at "animal height." The canvas covering the structure must be properly weather resistant, and not too thin, to protect one from the winter cold and to be firm in gusts of wind. There is no better way to frighten wild animals than to erect a blind which the wind shakes noisily.

In some models, pull straps to steady the structure are provided for each corner, stretched to four tent pegs. Heavy canvas, on the other hand, traps summer heat, so that a long stay in the blind can become intolerable. Ventilation can be obtained by lifting the roof flap a few inches or inserting rectangular strips of cloth or wire screen on all four sides of the blind.

Camouflaging the outside of the blind with branches or other vegetation is not important except in special cases, and should be avoided if it involves cutting trees or using material which has not fallen on the

ground naturally. If the hut is positioned well and does not move, this kind of camouflage is superfluous.

The side of the blind behind you should be kept closed because the reaction of frightened animals may alarm the ones in front that you wish to photograph; furthermore, light entering the hut may reveal your movements inside by making them visible through the slits or by casting shadows against the canvas. The inside of the blind should therefore be as dark as possible.

How to Equip the Blind

In the blind there should be a substantial tripod and if necessary also a second, lighter one for support. Models with a double grip are best—the head of the tripod can be maneuvered like a steering wheel, allowing the camera apparatus and telephoto lens to be moved vertically and from side to side. The lighter tripod may be used for a second camera with telephoto lens aimed through

another slit, without shifting the first tripod away from the main subject. The second camera might be loaded with film of different sensitivity, or black-and-white or color negative film instead of slide film. Of course, with 6 × 6, one can use interchangeable camera backs on the same camera body, but it is always useful to have a second camera body (even a 35 mm with corresponding telephoto lens) for any eventuality.

The dream of every wildlife photographer is the large zoom lens with focal-length range from 300 to 1200 mm, which allows adjustment in magnification with a quick and simple movement, making it possible to photograph the black-tailed godwit in full length, then a group of wading birds together, then only the top of the head, and then just eyes and beak. Unfortunately the price of these huge zoom lenses discourages their purchase by large numbers of enthusiasts. However, with 300 and 600 mm focal

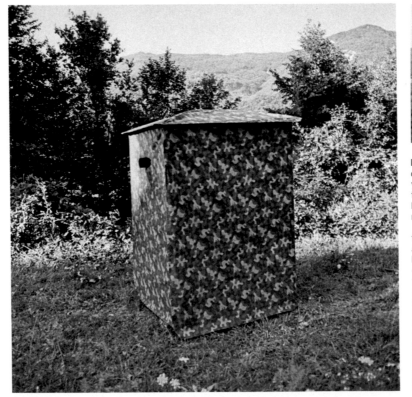

lengths, first-rate results can be obtained, though you have to move carefully to change the lens without being seen or making a noise.

A camp stool on which to rest while waiting for the animals is essential. Handbooks for identifying different species are invaluable to help record observations and photographs; and the characteristics of an animal species will be impressed on the memory down to the smallest detail when it is seen simultaneously in a book and in the field.

Naturally binoculars are indispensable. Besides being useful for photography,

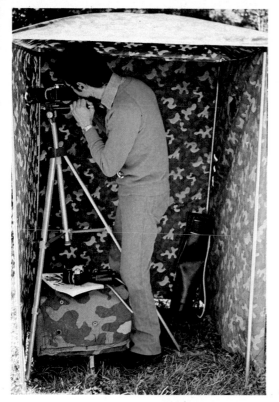

Where and How to Set Up the Blind

The place chosen in which to erect the blind should be in an area frequented by animals and untrafficked by human beings. Some hints on setting up the blind may be helpful. The hardness of the ground is a detail which should not be underestimated: a small crowbar is often required as well as a hammer to make holes into which the support poles are firmly driven. In such cases there is no need of braces to support the hut (as on soft or sandy earth), since poles which are firmly fixed into the ground more than suffice to sustain the structure. The firmness of the ground should be carefully assessed especially when erecting blinds on sloping ground.

After inserting the first pole, lay out precisely the distance to the other three and check the angles to avoid setting up a slanting structure. The speed of the setting-up operation depends on the model and also on practical experi-ence, and it is fundamental to work quickly so as not to unduly frighten the animals in the area. Hence blinds which are easy to erect are clearly preferable to more complex structures.

The direction of the sun must be carefully considered in positioning the blind. The area in which the animals will appear must have photographically suitable light. It would be absurd to position the blind with the principal aperture facing east knowing that the animals were going to be photographed mainly in the morning—the camera would face the sun. It is better to place the opening facing southwest and have the light coming from the side and from behind. Finally, don't forget to choose a spot in the shade if possible to avoid unnecessary overheating.

On this and the facing page examples of blinds set up with photographic equipment are shown.

the blind is the best place to observe the behavior of animals in their environment. Even if subjects are beyond the range of the telephoto lens, you will not tire of watching them through the binoculars and learning new things about them. And after having photographed animals in various activities and postures, you will be able to reexamine them at leisure through the greater clarity of the binoculars.

Water and some food should be taken into the blind, especially in summer; hunger and thirst often may be an irritant or slow down reflexes. It is a mistake to leave the blind too soon, as the best pictures are obtained after some time has passed since the photographer began his vigil and any humans have withdrawn from the external surroundings, leaving the wild animals undisturbed. A flashlight should be included to guide one among the equipment when the blind is dark inside.

The distance at which the blind should be placed from the subjects varies considerably from species to species and from moment to moment in their life. On average one can say that 10 to 15 meters (or 9 to 13 yards) is a good distance for most shots of birds. For mammals the question is more complicated, considering that their sense of smell easily detects the presence of human beings and provokes them to flight.

Some Advice When Photographing from Concealment

• A useful rule is to erect the blind in the right area and then leave it for a few days until the animals have accustomed themselves to its presence.

• Another possibility is to erect the blind in the dark on the previous evening and enter it before the first light of dawn.

• A standard piece of advice is to enter the blind with a companion and then make him leave so as to give the impression that human beings have entered and then departed. Don't think that entering the blind has passed unnoticed outside; underestimating animal intelligence is one of the most common errors, as is overrating their intelligence. If two or more persons enter the blind and then all leave except the photographer, the animals will be deceived, since they cannot count.

• Once the subject is framed and in focus, avoid as much as possible scaring the birds into flight with noise made by the release of the mirror, thus making it impossible to take any further pictures. This drawback can sometimes be avoided by raising the mirror before each shot; even if you can't see the subject framed at the moment of release, you can check it by sight. The noise of the shutter and the motor rewind cannot easily be eliminated. To muffle them, the camera must be dressed with a "blimp" or a soundproof cover consisting of

canvas and sound-absorbent material placed round it.

• When the subject enters the field of view, in contrast to stalking wildlife photography, one should not shoot immediately but give the animal time to settle in and become confident. This applies above all to bird photographs taken near the nest.

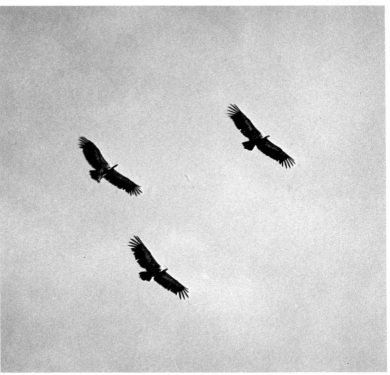

SHOOTING FROM A VEHICLE

The car is a mobile blind on four wheels, from which many pictures of animals are regularly taken. With the car, in fact, apart from being able to reach many places which are suitable for wildlife photography, one can also modify the ambush position, difficult or impossible to do with the traditional blind. In the car photographic equipment can be arranged in the most convenient way without running the risk of losing or damaging it. A large choice of lenses offers un-

deniable advantages, but the difficulty of carrying them or the fear of being overloaded imposes a limitation, problems which the car completely overcomes. In a car it is a matter of seconds to change lenses. Thus very heavy telephoto lenses like the 600 or 800 mm can be used with ease. The back seat is normally reserved for bags or containers for lenses and other camera bodies. If one is alone, the seat next to the driver can be conveniently used to hold the camera,

the telephoto lens, and the rifle grip mounted and ready for instant use.

Two kinds of wildlife photography can be practiced from the car—actively approaching the animal in its territory, and stopping the car in an area where animals have been previously sighted.

Approaching Animals with the Car

As we have already mentioned in the discussion of birdwatching, animals are not afraid of the silhouette

The car may be regarded as a blind on four wheels, because many animal species remain undisturbed by its presence. Using the rifle grip and telephoto-equipped camera through the car window (right), one can take close-ups of animals even at a distance, like the partridge below.

On the opposite page: Another example of a photograph taken from a car. Once the subject has been sighted, in this case, three griffon vultures, the nature photographer goes into action, assisted by the sun-roof.

of a car, since they are accustomed to seeing it in motion.

Normally good pictures cannot be obtained from a moving car. One can try, if moving in the same direction as the subject (for example, in the case of large mammals), using very fast shutter speeds. Usually, however, vibrations in the moving vehicle prevent satisfactory results from being obtained. Once the subject has been sighted, therefore, get as close to it as possible, but not close enough to make it flee immediately (with practice you can perfect the technique), switch off the motor, and go forward a little in neutral. Then stop the car, remaining motionless for a few seconds. The animal is already alerted on account of the car stopping. If you then make a sudden movement, it would certainly provoke the animal to flight.

The window must always be lowered before an encounter. Now you can raise the telephoto rifle-grip system slowly and extremely cautiously and aim it through the window, without leaning against the door. After shooting the first picture, if the animal has not yet fled, you can try leaning against the door to steady yourself, making as little noise as possible. Some like to lean the telephoto lens on a sandbag resting on the window frame; this can be done with subjects at a distance, but not with wary creatures near at hand.

In cases where the vehicle can be positioned near a marsh, for example, strong 800 and 1000 mm telephoto lenses can be used to photograph herons, ducks, and wading birds in search of food.

It is possible to set up a tripod with one leg resting on the seat and the other two on the floor of the car. A monopod secured to the door with a clamp which has been welded or bolted on can prove useful. Certain brace supports for telephoto lenses which are fixed to the windows with strong suction cups are also available.

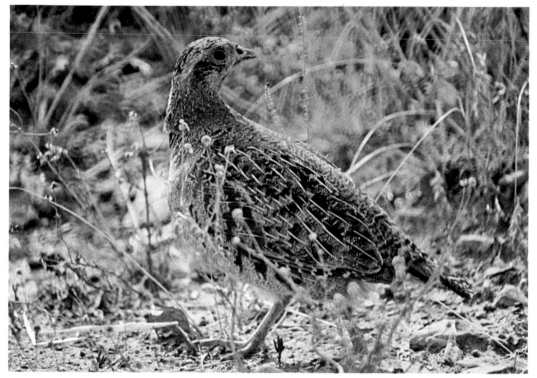

Ambush Photography from the Car

Another way to practice wildlife photography from a vehicle is to choose a place known to be frequented by wild animals and wait. It may seem strange, but often animals approach the car. Gamekeepers who survey wildlife preserves know this very well; some of the most interesting observations and shots of animals, made at a distance of a few feet, have been done in this way, that is, waiting quietly in a car. A fundamental rule

to observe is never get out of the car for any reason whatsoever. Furthermore, it is unwise to carry more than one other person. During a sighting passengers move inside the car or get out to have a better view, provoking disastrous stampedes. With only two in a car, one's companion can stay behind the driving wheel, allowing the photographer every available moment to prepare for the shot. In this way the rifle-grip camera can be aimed before approaching the subject and turning off the engine, and focusing can also be done while nearing the subject. On the other hand, there is the handicap with pairs of finding a sub-

ject on the driver's side, and then the two have to climb over one another; in the ensuing turmoil the subject often runs off.

If you are alone, keep camera and telephoto lens with rifle grip on the seat next to you to have them conveniently at hand.

Interesting modifications to make the car even more like a blind include camouflaging the windows with roller blinds that have peepholes for the telephoto lens. Car doors can also be removed. A sunroof lends itself ideally to photographing birds in flight. Birds of prey especially, that rise up swiftly as soon as they catch sight of the photographer, can be pho-

tographed if the car roof is opened fully. At times kites, buzzards, and kestrels fly low over the road in search of rodents killed by traffic. These are the right moments to bring the car to a sudden halt, put one's head through the roof, and fire a volley of shots. If the birds of prey are flying in the same direction as the car, one can photograph them from underneath during the movement (naturally one has to have a driver). This is perhaps one of the few ways of taking pictures of birds of prey in flight without waiting by a nest.

The type of car can be chosen on the basis of the requirements of the nature photographer. Certainly

sports cars with low suspension are no good; instead, the most suitable vehicles are spacious ones with generous luggage capacity and ample vision on all sides. The height of the chassis from the ground must be the maximum possible to avoid breaking the structural parts on unpaved roads. It is best if the roof can be opened and the body is not a flashy color nor chromium trimmed. This is not only to escape the notice of the animals, but more so human beings who are prompted by curiosity to approach when they see a stationary car with strange gadgets inside, thus provoking the usual stampede of animals.

IMPROVISED BLINDS

A blind can be improvised with camouflaged canvas material and suitably adapted umbrella. A simple and practical way of practicing wildlife photography.

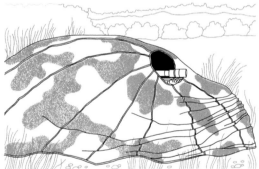

The traditional blind is not always necessary to provide concealment. Other effective solutions can be found. Ordinary camouflage material offers the wildlife photographer many possibilities. Stretched out on the ground, the photographer may conceal himself under this material, transforming it into a simple but effective improvised blind. The texture of the material should be fairly heavy so as not to be moved easily in the wind and to remain fairly rigid as it is arranged. The photographer should avoid movement under his shelter in order not to scare the wild animals, but this discomfort is compensated by the ease with which the material can be

transported and placed in position. For the same kind of use on the ground in summer, a closely woven camouflage net is cooler, and branches and leaves may be attached to it. Netting is lighter than canvas but also more delicate, and it may easily be affixed to tree branches.

To make oneself comfortable, a small rubber mattress may be placed on the ground.

If the position is well chosen as regards the animals, the improvised blind can be given a more permanent character by constructing a supporting framework over the mattress from dry branches or posts and crossbars. The top can be covered with

the canvas material or camouflaged netting. All photographs obtained under these conditions will be at animal height, or lower still, so that great care must be taken not to unbalance the horizontal line.

An interesting mobile blind, which can only be used however in good weather, consists of a cube about a meter and a half (four-and-a-half feet) high with supporting structure made of light sticks and covered on sides and top with thin pieces of cane woven together. This structure is very light and can be moved by the photographer inside and transformed into a "walking hut." It is a compromise between the method of ap-

proaching animals by stalking and the most traditional ambush photography. Naturally, because of its fragility and the fact that it is not fixed to the ground, this small blind can only be used on a fine day.

Another hiding place which can be set up swiftly is made with an open umbrella resting on its side with an aperture for the telephoto lens. The material should not be garish, as in most beach umbrellas, but camouflaged or in a neutral color. To enclose the photographer completely, a piece of canvas may be suspended from the edge of the umbrella which is not resting on the ground, so that one is completely hidden when seated.

THE BOAT BLIND

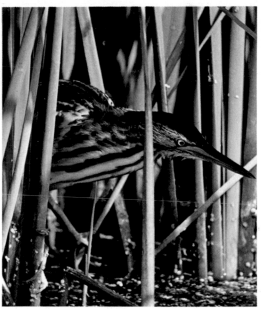

A floating blind is necessary to photograph the animal life of a marsh or a lake. A small blind is erected on a boat or the boat itself is modified with a large piece of properly shaped canvas cloth spread over it. The size of the floating blind, especially the support structure, that is, the boat, should be chosen for the watery environment to be visited. If it is a real swamp with shallow, muddy water, a flat-bottomed boat should be chosen (a punt); a square metal frame of tubing can be slipped into the posts fixed to the sides of the boat.

Naturally the motor cannot be used; a propeller would get caught in the shallow-water vegetation of the marshland. So the boat is propelled by poling or rowing. It is best to have a partner: while one is rowing or poling from the rear of

the boat (trying not to be too conspicuous to the animals), the other person remains hidden in the bow to take pictures. Once the picture-taking area has been reached, it is no longer necessary to row, but the boat can be made fast to a stake or anchored or secured to branches overhanging the water.

In deeper water, larger, better built boats should be

used, camouflaging them completely and moving them by means of the motor, which is turned off in the final phases of approach and replaced by oars protruding from the camouflaged structure. Some wildlife photographers use ultra-silent electric motors, which represent the last word in technology for photography of this kind. Others use a simple rowboat or dinghy suitably camouflaged; the rubber dinghy has the advantage of comfort and portability but the disadvantage of being difficult to row.

In any case, it is advisable to use luminous lenses and high-sensitivity film when moving on the water, to permit the use of fast shutter speeds as much as possible. The pitching and rolling movement of the boat, even if minimal, is fatal to a clear image,

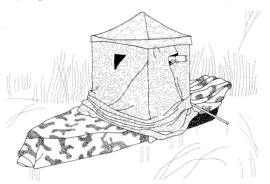

which seemed very easy to take at the moment of shooting. Another frequent error is the ease with which the horizon is thrown off balance; so one should either eliminate it, concentrating exclusively on the subject, or pay very careful attention to any rolling or pitching of the craft to see not only that the subject is in sharp focus but also that the shot is taken with the horizon exactly parallel to the bottom of the frame.

It is strongly advised not to set foot in the boat blind on windy days when the water is rough. Besides being unable to achieve any photographic objective, there is the risk of ruining the lenses with water spray.

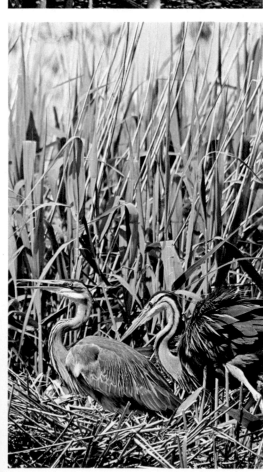

From the camouflaged blind and skiff (in the drawing), one can capture pictures of marsh-dwelling birds in their habitat even very close. The little bittern in the picture above and the purple herons below were photographed in this way.

TREE AND TOWER BLINDS

We have already mentioned that the wildlife photographer must often lower himself and stretch out on the ground to frame many animals in the best possible way, placing himself at their height. In a similar way it is essential to raise oneself up to a height above the ground to photograph subjects in trees or on rocks. The blind must be erected in a raised position especially to take shots of birds in their nest, but also to take better pictures of them in their habitat. The photograph of an imperial eagle taken against a background of treetops, beside sand dunes and sea, is of more value than showing the foreground since it succeeds in rendering perfectly the characteristics of the life of this bird of prey in its own habitat.

Blinds above ground level can be built mainly in two ways: either by climbing up to a position near the one occupied by the subject (in a tree, for example) to erect a platform there and build a blind, or to put up a self-contained

blind supported by tubular framework up to the height desired. These are the so-called "pylon blinds" made of metal tubing like the scaffolding used by builders or a lighter framework like the one used by filmmakers. The pylons are frequently raised to such impressive heights by wildlife photographers as to raise doubts concerning their stability. A warning to be prudent and to seek the advice of experts in this field is not inappropriate. One must be very careful before climbing up if the structure has not been tested for stability in the wind. In any case, when raised beyond a certain height, the pylon should be properly secured at several different levels of its own height to adjacent tree trunks or rocks. Furthermore, it is important to check that the bolts holding the different parts to one another are tightly screwed, and if necessary add metal cross braces to make the structure even more steady.

The erection of the

structure must be gradual for the sake of the birds in their nests; the additions should be revealed little by little. A section of pylon is erected and left unaltered for a day or two; then, taking advantage of the temporary absence of the creatures, an additional section is put up. After the adult birds have returned and you are sure that they have not been disturbed by the new erection, another pause and more sections, and so on until the pylon and blind are completed. However, the actual erecting itself must be carried out fairly quickly.

The fundamental rule to observe in building the pylon is not to endanger the wild birds or animals to be photographed. At the least sign that the birds are about to abandon their nest, one should stop.

The erection of a treetop blind should be preceded by careful observation to judge the best place for positioning it. One should search for strong branches suited for the purpose, always choosing a place near the trunk. The walls and roof of the structure of

the blind must be as light as possible but there should be a solid wooden platform for the floor. A ladder made of rope or even of wood or metal is needed to climb and descend, since it is not worth the risk of having expensive lenses broken while trusting to one's own athletic abilities.

Another system, developed by Swedish wildlife photographers, consists in placing a kind of box blind on the tree. With wooden floors and walls made of wire netting covered with canvas and supported by a dozen pieces of tubing, it can be fixed to the trunk directly, with a strong iron chain tied around it to steady it and make it secure. The advantage of this system is that the blind can be erected easily and rapidly, raising the box with a rope and a winch.

Powerful and heavy telephoto lenses can be used from these pylon blinds to photograph subjects at significant moments, for example, feeding and mating behavior, etc.

Difficulties in shooting from a treetop or pylon

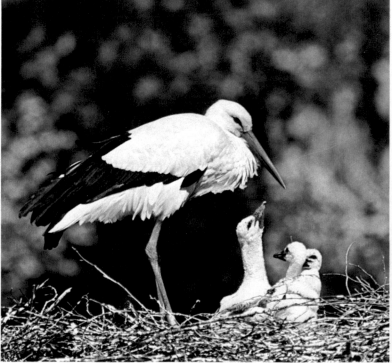

To photograph certain animals at their own height, it is sometimes necessary to place the blind high up among tree branches, as shown on the opposite page. The stork with its young was shot from a tree blind with a 500 mm 1/5.6 telephoto and shutter speed of 1/250 second.

Below: Positioned in the tree-top blind, the photographer gets ready to act at the right moment. Pictures like that of the osprey returning to the nest amply reward a long wait.

blind are related to the individual species. Storks, for example, are fairly easy to take shots of; in fact, these birds, who build their nests on the rooftops of houses in many countries, are used to visiting the human environment. When, however, they see themselves surrounded by so much attention, in contrast to the indifferent attitude of the inhabitants in regions where they build their nests, they may get suspicious. However, they soon get used to the presence of the blind. The relative ease with which pictures of storks on their nest can be obtained does not make them any less interesting. On the contrary, such pictures always give great satisfaction to the wildlife photographer, who can get shots of these birds in the most varied postures.

Taking pictures of the nests of birds of prey presents a different set of problems. Among other things, the rarity of some species, such as the os-

prey, may make it necessary for the photographer to obtain a special license to take pictures in protected areas. However, one can resort to less "critical" subjects, always taking due precautions. For example, so as not to harm the small number of nest-building ospreys while photographing them on the rocks of the Mediterranean, one can set up a treetop blind in the vicinity of an old nest used by inmature birds so as not to endanger the precious brood of hatchlings.

Photographing the nests of sparrow hawks and buzzards presents less of a problem, as they are fairly common birds. The reason for their relative abundance can be seen by observing how easily they accustom themselves to photographic setups. Many species escape extinction through this very adaptability. On the other hand, the rarity of a species shows us that it is less capable of adapting to new situations, more sensitive and fastidious. So it is unthinkable, for example, to run the risk of damaging the nest in order to get a good photograph of a lammergeier for any reason, whether for pleasure or scientific advancement.

The blind for photographing the golden eagle is usually set up by climbing a very steep mountain, lowering oneself with ropes, and building a camouflaged shelter in some hollow in the vicinity of the nest. Similar movements, besides exposing the nest-building to serious danger,

may provoke threatening behavior from the adult birds of prey. The eagle, like other birds, nose-dives to scare intruders away from its territory, and a nose-diving eagle on the edge of a precipice can create great difficulties and risks for the wildlife photographer.

Another way of getting "high" pictures is provided by observation towers in the wooded retreats of herons. One method consists in forecasting on the basis of observations made the previous year where the colony will choose to build its nests, and erecting the tower before the nesting season. But since herons easily change their nest-building locality, there may be some disappointments, but one cannot act otherwise; building the blind when the nests are already in use inevitably causes eggs and young ones to fall and damages many broods. The situation is different if one builds a pylon or treetop blind to photograph a single family of birds and finds instead a colony. Here one cannot

count on the absence of the occupants of the nest during the work of setting up the blind, because there will always be some individual present to give the alarm.

The tower blind gives interesting results in mammal photography too. Apart from the obvious need of being above the ground to photograph apes in their habitat, many species can be photographed from high up, taking advantage of the fact that animals do not expect anyone to be above their heads and hence usually do not look up. By choosing a position at the edge of a clearing known to be frequented by deer, for example, one can be sure that at sunrise or sunset sightings and pictures of these animals will be possible. The same method applies to the wild boar, which hunters armed with cartridges instead of film know only too well.

To avoid an excessive flattening of the images, the blind should not be raised too high, but instead should be camouflaged in the best possible way.

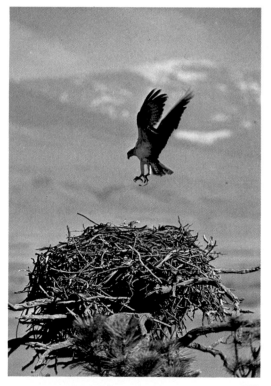

PERMANENT BLINDS

Blinds in nature reserves left in a permanent location are ideal positions for observation and wildlife photography. Animals are used to these structures and regard them as being an integral part of the environment, accepting as normal the inevitable noises made by visitors inside them. They can be made of a variety of materials, like the sturdy wooden blinds of the Royal Society for the Protection of Birds (in Britain) or more simply in cane or partial brickwork (like those of the Italian League for the Protection of Birds or the World Wildlife Fund in Italy). Naturally the more solid and sheltered the structures, the more one can work in peace and utilize super-telephoto lenses.

With the certainty of being sheltered from the weather, one can focus at leisure or try out different exposures, with plenty of space available to change lenses and film. Permanent blinds allow you to work at dawn, as soon as you are awake, without having to spend time placing and erecting the traditional blind.

One thing to remember is that often the openings of these permanent blinds are large enough to allow binoculars to fit through but not large enough for the big telephoto. This drawback sometimes renders a permanent blind completely useless and makes it necessary to erect an ordinary canvas blind in the vicinity, with all the inconvenience which this involves. It is worthwhile, therefore, to get information on these details beforehand from those in charge of the nature reserve.

If time is short, perhaps a colleague can inspect other permanent blinds to see what rare and interesting species populate their vicinity. Even if many wildlife photographers advise choosing a position and remaining there, the truth is that some of the best photographs of marshland birds have been shot by taking advantage of the fact that birds, at different hours of the day, move from one part of the habitat to another.

Always bear in mind that for blinds facing in a westerly direction, the direction of the sunlight allows shots only in the morning, while in the afternoon one must move to blinds which are positioned differently. There are blinds where, because of the favorable environment and available food, the animals can be photographed at close range, but normally the practical distance is judged equal to the magnifying power of binoculars of medium range. So, although every kind of telephoto lens for

nities which may present themselves when you are outside the blind, for example, walking along the access paths.

How to Build a Blind

To practice ambush wildlife photography you can build a blind yourself or with the help of a good craftsman. The simplest blind is in the shape of a teepee and is made of a framework of light steel or aluminum tubing 16 or 19 mm (.60 or .75 inches) in diameter. The ten pieces of which it is comprised screw into one another or are pressed together using tee joints. The structure may also be

wildlife photography, from the 300 mm up, can be used, in order to photograph the animals in such a way that they come out sufficiently large in the image, generally a 600 mm telephoto lens is advisable.

It is worth noting that, although photographers eagerly await the chance to capture a subject in the distance, small birds may happen to alight very close and in perfect illumination; a medium telephoto lens mounted on a second camera body in this case becomes an important piece of equipment, rather than an extra accessory.

Furthermore, don't neglect unexpected opportu-

Above: A small, light triangular-shaped blind can be swiftly set up without assistance.
On the left: Permanent blinds are commonly used on nature reserves where birds are known to feed regularly.

made of wooden stakes held together by long bolts and lock units. The ends of the tubing or stakes that are to be driven into the ground may be sharpened. The canvas should be of the camouflaged waterproof kind, but in summer it is good to have a spare nonwaterproof, lighter canvas to avoid overheating inside the blind. To provide access for the lenses and to observe the surrounding environment, there should be a few spy holes or openings that can be zippered.

The sections of canvas can be sewed together to make one piece which can be rapidly slipped on to the support structure, or sections may be joined by snaps or zippers, which can be used for the entrance as well.

With the same materials and greater patience, a larger and more comfortable model in the block shape of the traditional blind may be constructed.

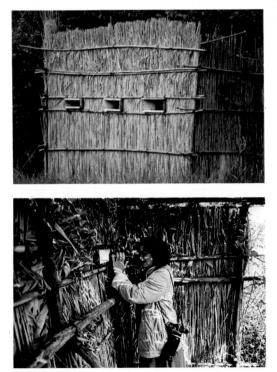

LOCATING THE BLIND

Near the Nest: The Most Spectacular Photographs but the Most Hazardous Ones for Nature

When birds are nesting, a very strong impulse drives them to reorganize all other habitual activities so that their energies are concentrated on reproducing the species. They pursue this aim with all their strength and will not leave the nest unless forced to by some serious disturbance or outside danger. Taking advantage of the moment, when the birds regularly return to a fixed point, the wildlife photographer conceals himself to take pictures of them. This kind of photography enables one to obtain closeups of subjects such as could not be obtained in any other way; pictures of adults or young individually or together, or intent on feeding one another, are possible. But the photographic goal should not allow one to forget the great risks which nesting can be exposed to. The naturalist interest of the wildlife photographer

should keep the understandable passion for photography under control to avoid useless mistakes. Those who take pictures close to the nest should adhere to a set of rules, a code of honor that all wildlife photographers should respect:

(1) Remember that photographing birds in the nest is an unnatural intrusion which always disturbs the creatures to a greater or lesser degree.

(2) If the photographer sees that the subject is

The best results in photographing nesting birds are usually obtained by using a blind. Never forget, however, that one runs the risk of disturbing these creatures, inducing them to abandon the brood, and all possible precautions should therefore be taken. Nests are sometimes placed in unsheltered places, like that of the albatross (right), or hidden in the vegetation, like that of the short-toed eagle in the picture below, taken with a 560 mm Leitz long-focus lens.

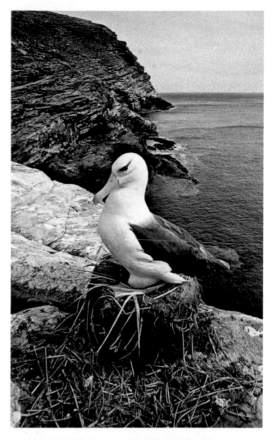

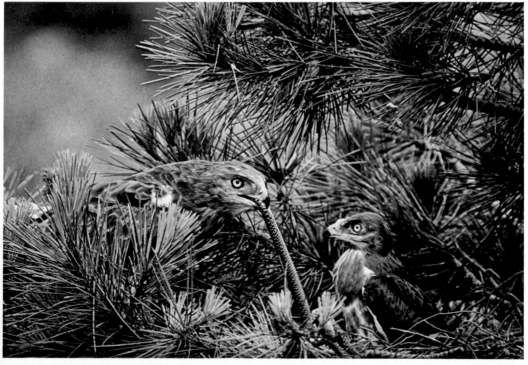

disturbed by the presence of the blind, he should immediately desist from erecting it and depart. This is easier for one who is more of a naturalist than a photographer, but it must be understood that to persist in remaining when the animals have not accepted your presence can only do damage, and at the same time satisfactory pictures cannot be shot.

(3) In positioning the blind, make sure that the nest is not visible to other human beings or beasts of prey. For the same reason, never clear around the nest by cutting away branches which obstruct the line of vision. The nesting place is hidden to protect it from predators. Crows, for example, wait for other nesting adult birds to leave the nest before plundering it. So if the nest is so hidden as to render the taking of photographs impossible, it is only right that it should be left that way and any photography abandoned. Also bear in mind that if the birds stray too far from the nest through fear of intruders, the eggs may get cold or, later, the young can succumb to the heat.

(4) Don't excuse a shot which could injure the birds being photographed by trying to convince yourself that that picture might provide knowledge about the species and hence help to protect it in some way.

(5) Never mark the place where the nest is located with stones, sticks, etc., in order to find it again to take further pictures.

(6). Always strictly observe the regulations in certain nature preserves which limit or prohibit the taking of photographs during the breeding season.

Where to Find Nests

To find nests one must know the habitat of the different species, and know whether the birds build their nests on the ground, in the open, among reeds, or in trees; when the breeding season for different species begins; and so on. But the only really effective way of finding nests is to be in the right place at the right time to observe where the birds alight to feed their young.

The illumination of the nest presents no problem for species that build their nests on the ground, like wading birds and varieties of terns. It is a matter of waiting for the right angle of the sun.

The situation is different for species of birds that make their nests in the thick of vegetation, where exposure requires the assistance of flash, as we shall see later on.

Where Animals Gather to Eat and Drink

A very good method for taking shots of animals from the blind is to wait for them in areas they frequent for eating and drinking. In Africa some water holes are equipped with permanent blinds from where observations or shots of large ungulates, predators, and elephants can be made. Often the help of someone who knows the places well is needed. To photograph the European bison in Poland, it makes little sense to roam about at random, but one must position the blind near clearings indicated by the gamekeepers to be favorite grazing ground. For this kind of picture, subject distance is usually fairly far, and telephoto lenses which are less powerful than 500 mm should not be used.

Where Animals Stop

During migration many bird species have fixed places where they stop to rest each year around the same period. Once these places, usually situated along the banks of rivers, are known, you can choose which birds to photograph and take up a position. It is worth remembering that after long migrations, weary birds can be photographed fairly easily and allow themselves to be taken at a shorter range. However, one should not take advantage of this tameness of the exhausted migrants to frighten them at the wrong moment.

How to Draw the Animals to the Blind

Many animals can be induced to approach the blind from which you intend to take pictures if some food is left in appropriately chosen spots. For this method to have some chance of success, you must know whether the area chosen is regularly visited by the species

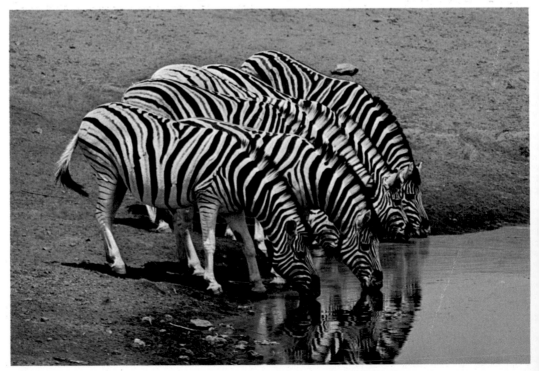

A good portable recorder and a directional microphone (below) or a parabolic reflector make it possible to capture bird song to be used later to attract other subjects into camera range. Similar results may be obtained with portable feeders (right).

On the opposite page: An interesting location for the nature photographer—the animal watering hole.

sought. Furthermore, a preliminary assessment is necessary to know whether the sunlight is sufficient for the shot one wants or if flash is required.

Bird Feeders

To photograph small birds, nothing is more helpful than a bird feeder. One can be made by taking a small wooden shelf about 30 by 30 cm (12 by 12 inches) with edges and nailing it atop a post about 1½ meters (5 feet) from the ground.

The food to draw birds is varied: sunflower seeds, peanuts, and lard for great titmice, blue titmice, and coal titmice; sunflower seeds and millet for green finches; millet and linseed for the little serin; grubworms for robins. Blackbirds like bran and meal and also apples and other fruits.

A great advantage of feeders is that they can be placed near home, in the garden, or on a balcony. It

is important to keep them regularly supplied with food to accustom the birds to come to the feeder each day. At first birds will be shy of the new structure, and it will take some time for them to get used to it; only then should one try and photograph them, using a 300 mm lens as a rule. Zoom lenses are very useful for centering a single subject or several species together, documenting their behavior as well. The robin, for example, often behaves like a bully, driving other birds away, while sparrows vie even with collared doves. Don't forget to put a small basin of water, wide but not too deep, by the side of the feeder, to which the birds will be irresistibly drawn to drink or to bathe in. Golden opportunities will occur for interesting and unusual pictures. Processed foods should not be offered to the birds so as not to harm them. While very useful in winter, the feeder is inadvisable in

spring, in the breeding season, because the parents might feed their young exclusively with the same unnatural food, or with a food which the adults could digest but not the chicks. It is better, therefore, to forgo the chance of a few extra shots and leave things to nature.

Artificial Nests

Another method of photographing and protecting birds is to provide an artificial nest, either a bird house or a small hollow log with a hole for the entrance. Such artificial nests should be placed in gardens, public parks, or wherever there is an absence of large trees and natural nesting places.

One can get excellent photographs of many of the more unusual species, like the flycatcher, the nuthatch, and the tree-creeper, entering or coming out of their nests, as well as documenting photographically what they feed on, the

number of young they rear, and so on. A technique used to photograph birds during the breeding of young consists in replacing one side of the birdhouse with glass, through which the entire development of the brood can be filmed. After each series of photographic shots, the glass wall should be covered again, and at the end of nesting, provision should be made to replace it with the original wall.

The shots can be obtained either by placing the lens and flash very close to the transparent walls of the nest, letting them protrude from a blind, or by putting a remote-controlled camera with flash in the same position. It is well to remember that these methods can only be applied with artificial nests, and never in other cases. It is completely unacceptable to shoot pictures of this kind by cutting out and hence destroying nests built in the natural cavities of old trees.

Wildlife in Sound: Bird Song Used as Bait

In spring another method of attracting birds is to play their songs recorded on tape. In the mating season the males sing at the top of their voices to make clear where their own territory is. If they hear a similar noise in their vicinity they approach the source of the sound to single out the intruder and firmly assert their territorial rights. It is then that the wildlife photographer using recorded bird song as a lure can get excellent pictures.

One can also use whistling and other mechanical calls, but the best method is to record the bird songs from nature and then use them to attract the same subjects. For this purpose the photographer should be equipped with a good portable tape recorder fitted with a directional microphone or parabolic reflector. This will also provide wildlife sound, which is particularly useful to accompany the projection of transparencies. An ideal combination is to show a photograph of the species in its habitat, then present the subject isolated in

close-up through the telephoto lens, allowing the song of the bird to be heard at the same time. This faithfully represents the natural environment and shows how the different bird species may be identified from their appearance and their song.

While the recorded bird song is being broadcast, the telephoto lens should be aimed at the point where the bird will presumably alight. Remember that normally, flying creatures alight on the highest and most isolated point, which could be a deadwood branch surrounded by not too many leafy branches.

Carrion for Birds of Prey and Mammals

A very useful procedure for photographing large birds of prey is to attract them by placing pieces of meat or the entire carcass of a dead animal on the ground. Vultures, who are powerful gliders, fly for hours in search of carrion, which they can sight from high up, probably by the movement of crows, who first come down where food is to be found. While preparing the bait, see that the blind is well camouflaged.

As a test, one can check the behavior of crows. If these shrewd and cunning birds fail to approach the carrion, this probably means that the blind is not well camouflaged and it needs to be completely redone. However, even if crows and magpies do approach, this does not mean that birds of prey will follow automatically.

One must be very patient and wait for many hours. The appearance of the first vulture over the meat bait is an unforgettable experience. The large size of the subject and the lengthy wait finally rewarded really tests the cool temperament of any lover of nature. Yet this is the moment when calm control is needed to carry out the necessary operations. The less noise one makes the better, hence the advice already given on raising the mirror and soundproofing the camera should be followed to the letter.

As one may naturally have to leave the carcass during the night, the following morning often provides the nasty surprise of finding nothing left. Nocturnal predators, such as the fox or dogs and wild cats,

waste little time in polishing off the remains. Hence there are two methods: either firmly tie the carcass to the ground so that it cannot be dragged away, also keeping a kind of night watch, or place the bait inside a net enclosure. This last method is used with meat baits, which Italian naturalist groups set out in Sardinia to feed the last surviving griffon vultures and protect them from poisonous carcasses. The dead animals are taken regularly from local stock farms to these enclosures, where birds of prey have become accustomed to alighting. Placing a blind near these feeding places allowed photographer Helmar Schenk to shoot some splendid photographs of griffon vultures, besides

Below: Setting out carrion is a good method of luring and filming large birds of prey, like the griffon vultures portrayed in this fine picture taken by the nature photographer and naturalist Helmar Schenk.

On the right: A red deer lured by hay placed on the snow.

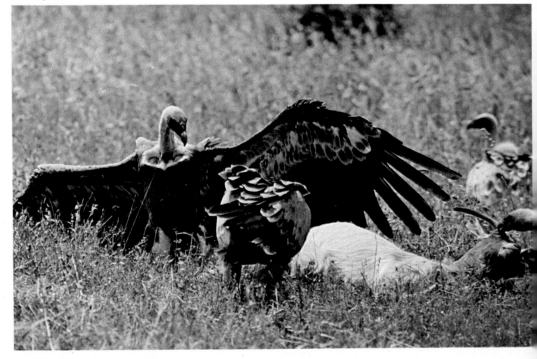

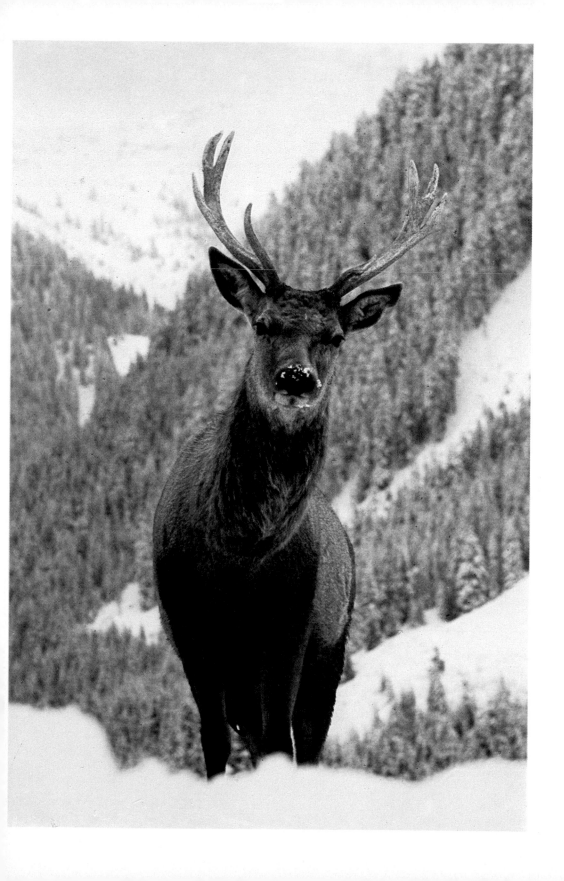

making important studies of their behavior toward the carcass. It seems that the weakest and most hungry subject gains the right of precedence from the group to feed itself. In these instances the nature photograph acquires the significance of a scientific document.

Naturally the ability to fly down onto the carrion varies with each species, and within a given species from place to place. In Africa it is easy to photograph many species of birds of prey, attracting them with bait, while in Europe it is not so easy to attract a justifiably shy bird, like the adult golden eagle.

The same method of food baiting is valid for predatory mammals, but bear in mind that in the case of the big cats it is not advisable simply to remain inside a canvas blind, but position yourself inside a vehicle. The use of live prey, such as bound kids, etc., can be definitely ruled out and left to the bad taste of certain adventure films. To film large beasts of prey, such as the tiger, it is best to put aside the desire to do it yourself, and join an organized party of visitors to the national parks, using properly equipped routes. Only under the expert guidance of local guides can one hope for the exciting encounter. In fact, even the greatest nature photographer can act like an amateur in a place with which he is not familiar.

Placing hay on snow is an almost infallible method for providing shots of deer in winter. One must ascertain, however, whether zoologists and naturalists believe environmental conditions in a certain place and period permit this artificial aid without indirectly harming the animals. In any event, these operations should be carried out only occasionally in order not to make animals that should naturally flee from man more domestic instead, at least until he stops killing them.

REMOTE-CONTROLLED REFLEX CAMERAS

The simplest and most economic way of operating a camera by remote control is to use the traditional pneumatic cable release, which normally reaches a length of 3 to 5 meters (10 to 15 feet). The distance is limited but should be enough to control the reflex camera from the blind. With this basic remote control, you will very soon feel the need for automatic film transport in the camera. Approaching the camera each time to wind to the next frame nullifies in practice the usefulness of remote control. Hence the remote-controlled camera is only really useful if it is motor-driven.

The growing popularity of reflex cameras with medium-powered motors, moderate price, and above-average performance makes possible a wide choice of equipment, which fully satisfies the need for remote-controlled units. Motors controlled by electromagnetic release make it possible to use handy electric wires for signals from a distance.

Devices for remote control of reflex camera motors are now of three kinds: electric cable, radio waves, and infrared rays.

Remote Control by Electric Cable and by Radio

Practical, economical, and with quick response, electric and radio remote-control function for medium distances (up to 20 meters, or 65 feet). Some problems may arise through having to lay wires. Different cameras adopt technical solutions which vary in the sensitivity of the release mechanism. By using circuits which amplify the electric signal, effective distances even beyond 100 meters (100 yards) are feasible.

Radio remote control apparatus available on the market, apart from its high cost, is not very reliable, and its radius of response even under ideal conditions rarely exceeds 100 meters (100 yards). It should be

Some shy animals who live in burrows like the badgers and the marten in the pictures below can be taken using a remote-controlled camera. Top illustration, opposite page: A camera that used infrared rays; on the right is the transmitter.

Center: Reflex camera remote-controlled to take a close-up of a ringed plover. Below: Hasselblad with soundproofing device, remote-controlled by electric cables; the small flash on the lens is visible.

said that perhaps the biggest problem is the large number of radio signals emitted continually in inhabited areas. In practice it is not unusual for the remote-control camera to be set in motion automatically, emptying the entire magazine and frustrating our expectations.

Preparations and checks to ensure that equipment is functioning properly take up a certain amount of time, to which must be added on-the-spot checks to see how things are behaving every so often. If, as usually happens, the wait for the subject is lengthy, with the circuit turned on, of course, an external signal can frustrate all the preparations. It is possible for manufacturers to design more reliable and less expensive equipment to widen the scope of use of the many automatic and motor-powered reflex cameras already available on the market.

Remote Control by Infrared Rays or by Intermittent Light

Remote-controlled cameras of considerable interest have been available for some time with functional features, low cost, and greatly reduced dimensions—these are cameras with remote control by infrared rays or by intermittent, or modulated, light—for example, Modulite remote control system ML-1, made by Nikon. These systems have also become popular as a means of remote operation of domestic appliances and television

sets without the encumbrance of electric wiring. The same technology applied to the camera removes the disadvantages of remote control by radio because external signals are not effective owing to the directional nature of the signal itself.

The remote control can be transmitted up to a distance of 50 to 60 meters (170 to 200 feet), more than enough on most occasions. The maximum distance depends on the sensitivity of the receiving cell and the intensity of the

transmitting cell. Infrared light behaves like visible light and can be reflected and concentrated in the same way. This allows a certain degree of control and flexibility in operation, which is useful, but requires some experience with the appliance. For example, by using mirrors and testing the reflection with a flashlight, one can get a path which avoids trees or other obstacles along the line between the camera position and that of the photographer. If the camera release is electromagnetic, as with

Contax, the receiving and transmitting system becomes extremely compact and can operate the reflex camera even without a motor, since a unit which transforms the electric controls into a mechanical one is not required. Normally, however, an electrically controlled motor is needed to make full use of this accessory gear.

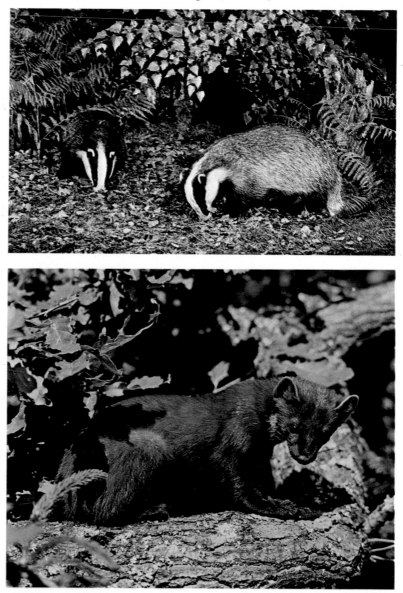

CONCEALMENT AND FLASH

In order to practice ambush photography from a blind, the use of flash is often necessary.

When to Use Flash Near the Blind

Flash units should be used in the following instances:

(1) When the light is not sufficient to photograph the subject and its environment, which frequently happens in woods even in full daylight.

(2) When one has to work at night to take shots of nocturnal animals.

(3) When the light is sufficient to take the subject but not enough to accentuate it, for example, details of plumage and color or movement in flight.

dismantled immediately. Furthermore, a considerable setback both for animals and photographer is created by persons who see all that strange gear and approach to nose about.

Which Flash to Use

In wildlife photography automatic electronic flash exposure on direct reading with preset aperture has a limited use. Two or more flash units should be available: a powerful one with a high voltage battery pack, and a second, lighter unit equipped with slave flash unit which can be swiveled in any direction.

the camera. The other one placed further away on the side is triggered by a beam thrown from the first flash, for which purpose the sensor of the slave unit must be turned to face the main flash. Both flash units and blind are placed at some distance from the subject, which varies depending on the shyness of the subject, in some cases approaching to within a few meters of the subject.

Within the blind the photographer can mount a 300 mm telephoto lens on the camera, supported by a stand, clicking the shutter by means of a cable release at the moment when the subject slows down its flight or performs movements at the entrance to the nest or shelter.

Hoopoes and woodpeckers and also nocturnal

predators stop for a moment at the entrance to their nest before entering. This is the ideal moment to shoot, but naturally one can vary this by choosing the moment when the bird alights on a perch nearby.

Some nature photographers advise the use of a third flash unit to light up the background. The night effect of a dark background may be inappropriate especially with pictures taken in the daytime. Remember, however, that subjects are often taken without background at the nest entrance.

Good example of flash photography from the blind. The green woodpecker has come out perfectly lit and exposed.

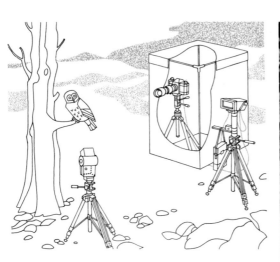

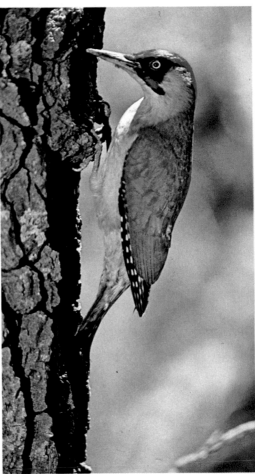

Risks for Nature

Even this kind of nature photography is not free of risk for the animals: besides the alien body of the blind, other alien bodies are present, the stands and the flash units. One should therefore proceed with caution in setting up, positioning two false wooden stands on site some time in advance to see if the subject shows any signs of being disturbed by this new presence. It cannot be repeated too often that if the animal will not accept the presence of the new structure, it must be

Where and How to Position Them

In ambush photography, the blind and the flash are positioned where there are animals coming out of or returning to the nest or shelter, or where they feed or drink—even if photography at a distance is suited to these extremely shy creatures. The blind should be positioned with care that the animals grow accustomed to it. Two stands are placed outside the blind to support two flash units. The more powerful main flash is placed almost next to the blind, linked to

134

Diaphragm Aperture and Focusing

It is very important to work with diaphragms stopped down and sufficiently sensitive film. The two flash units must be placed and the diaphragm aperture chosen to make sure that all parts of the subject will be in focus. For accurate focusing daylight is normally sufficient, even in the dim light of the woods, without having recourse to ancillary lighting. At night one of two possible solutions can be adopted: either the night is so clear as to permit focusing by making use of the luminosity of the clear sky and full moon, or a small flashlight should be used, perhaps with a red light, attached to the camera or rifle grip or held in the hand that holds the cable release.

The Use of Medium-Power Flash

To photograph many small animals, like frogs, small birds, snakes, tortoises, and so on, lighter flash gear should be used, suitable for carrying and easy handling. In spring, hedges and thickets swarm with small nest-building birds. Some nature photographers are expert in finding and shooting several species and nests in the same day.

The flash should therefore be small in size and of medium power. The detachable pivot type of sensor is invaluable, considering that close-ups of subjects often have to be taken and it therefore becomes necessary to aim the flash unit as accurately as possible. A 135 mm telephoto is often adequate

with this kind of photograph, for which an 80–200 mm zoom or 105 mm macro is also recommended. Not infrequently the flash must be held with one hand at a minimum distance while the camera is operated with the other. Some wildlife photographers affix to the camera and lens a kind of double-arm bracket with hinged parts with flash units at each end, adjusting the hinged parts so as to get the right angle for the lamp unit. The system is ready to use as soon as interesting subjects are sighted.

A spiral lead, which can be lengthened if necessary but is normally securely fixed to the camera and flash, is a useful attachment to avoid trailing wires, which can easily get caught in foliage.

A Useful Accessory: The Teleflash

A tele attachment on an electronic flash is basically a plastic lens which concentrates the beam of light in a limited radius, or onto a mirror which reflects and magnifies it. Accessories of this kind are available from various manufacturers. The Vivitar 283, for example, can be fitted with lenses or diffusers which vary the angle of emission so as to cover the field of a lens from 24 mm up to 135 mm. At the same time, the guide number is altered to take into account the actual quantity of light striking the subject. By enlarging the beam of light, it is spread over a wider surface, diminishing in intensity, and a larger diaphragm aperture is required. The opposite

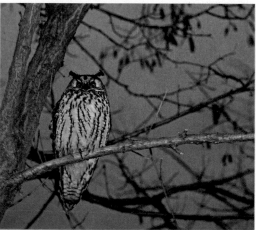

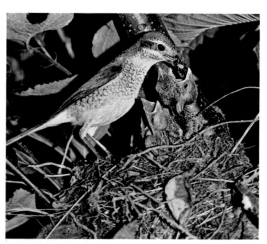

On the left, above: A teleflash consists of a slightly concave mirror which reflects and enlarges the light of a normal flash unit; a device of this kind was used for the picture of the owl.
Above: A shrike shot with a 250 mm Hasselblad. A battery-operated portable flash solves the problem of taking shots of small birds at the nest.

happens with tele attachments.

A similar device, but with a narrower angle, is provided by Metz for the 45 CT1 model; this is the 45-22, which can be used with lenses up to 200 mm. The guide number rises from 40 to 75, allowing shots at f/4 at 40 meters (43 yards) with high-sensitivity film (ASA 400). The main problem with these devices is aligning the beam so that it is parallel with the line from camera to subject. The correct angle is calculated by testing and observing in the viewfinder whether the lamp unit illuminates the framed area.

ELECTRONIC TRIP DEVICES

A camera with automatic exposure or linked to a flash unit with computer (automatic transmission) and motor drive is an independent, remote-controlled photographic unit. When placed in an advantageous position, camouflaged and soundproofed with absorbent material, it becomes an indispensable instrument whenever the subject to be photographed does not tolerate the proximity of man within the range necessary for taking the shot. The photographer, hidden at a certain distance, must be able to follow the approaching animal to shoot at the right moment by means of remote control with a cable or luminous beam. The wait may be protracted owing to the many factors that control animal behavior. In some cases regularity in the behavior pattern facilitates photography, allowing repeated pictures within the same waiting period. A great deal also depends on the ability of the photogra-

pher to keep his presence concealed at all stages of the ambush.

Direct remote control has many advantages: simplicity of equipment, functional reliability, ability to repeat the same shots, with adaptability to new and unforeseen circumstances.

We shall describe the elements which make up the electronic trip device and when it can be useful. It consists of devices placed in strategic points which automatically activate the firing mechanism of the flash unit when the subject cuts across the light beam. It is useful when the animal's movements are infrequent and there is very little time in which to take the shot; after lengthy waits the chances of catching the subject become remote. In these cases an automatic mechanism is necessary to operate the release directly.

Many photographic trip devices have been created, but only the one that uses a beam of light to detect

the presence of the animal offers real advantages, thanks to its high degree of sensitivity, its precise targeting of the area being framed, and its noninterference with the subject.

All trip devices work in accordance with the same system regardless of the kind of detector. As a rule, only when it is really essential should these photographic devices be among your equipment, as they often have to be specially adapted in practice to suit specific requirements. An automatic release system consists of the unit for taking shots and the electric trip device. The shots are made by an automatic reflex with motor drive. If the ambient light is not enough, the unit will have to be connected to a flash, also automatic.

If the exposure meter circuit is activated for a long time, the battery runs down quickly on many cameras. This is a considerable drawback, which has been overcome in some reflex cameras by using silicon cells which cut in only a

few moments before the shot is made, setting the exposure in a fraction of a second, while during the wait they do not consume any power.

A similar problem presents itself with flash: the power source loses voltage even without releasing the flash lamps if the waiting time is prolonged. Small and medium flash units which use dry batteries are less useful in these cases; professional flash units which use lead accumulators or high-voltage batteries are more suitable,

Below: African hoopoe feeding its young. When the right moment for the shot is unpredictable and fleeting, electric trip devices become essential.

On the facing page: A photograph which is the result of careful preparation. The characteristic environment, the effective and well-measured lighting, the shot taken at exactly the right moment are all elements which make this an exceptionally impressive picture.

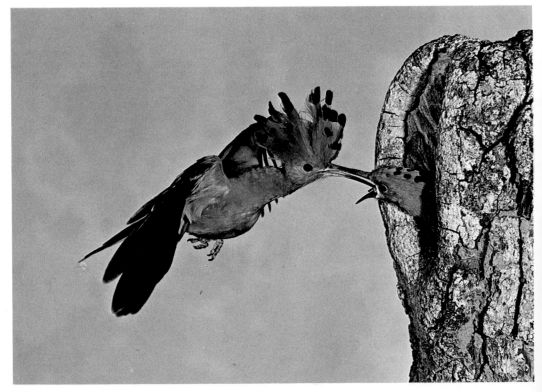

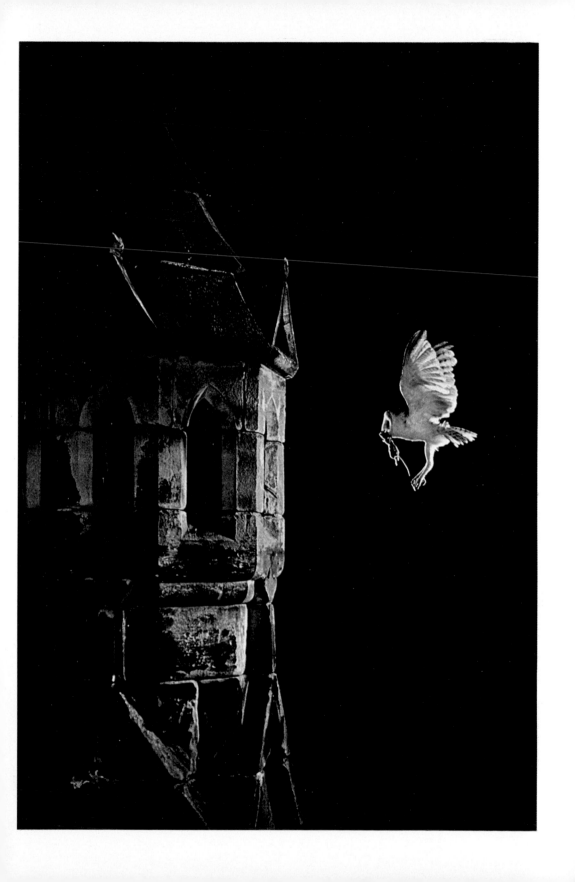

avoiding the misfortune of being without a charge at the very moment when it is needed.

The main factor which has to be taken into account for this kind of use is the time lapse between the pulse and the opening of the shutter. It varies with the type of camera, but on average is 1/20 second, and includes the time required to perform the complex operations of release, raising the mirror, shutting the diaphragm, opening the shutter, etc. If the camera permits it, one should preset the mirror in a raised position to reduce both the time lapse and the noise of the release. The time needed just for the release of

the focal-plane shutter is around 1/100 second. The time lapse can be ascertained by making some tests, photographing with the trip device an object in normal movement that cuts the beam of light. In this way the total time lapse due to the camera and the trip device can be calculated. Why is this element important? If, for example, we take a bird flying at a speed of 30 km per hour (18 miles per hour), corresponding to 10 meters (32 feet) a second, it will travel about half a meter (1½ feet) during that twentieth of a second which elapses from the moment when it crossed the trip-device beam of light and the actu-

al shutter opening. In practice there is enough time for the bird to quit the frame at least partly. The shorter the time lapse, therefore, the more precise and reliable will the framing of the subject be.

A camera which offers a favorable performance for this kind of shot is the electronic Hasselblad. Its normal time lapse is around 1/14 second, less than most 35 mm reflexes, but as it can be preset so that only the central shutter mounted in the lens need be operated, the time lapse is reduced to a value around 1/1000 second. After each shot the camera returns to the same initial position, with mirror raised

and diaphragm stopped down at the set value, ready for the next shot.

When natural light is used, automatic exposure becomes indispensable; but almost all reflex cameras measure light in the pentaprism with the mirror lowered. It is, therefore, not possible to raise the mirror, as would be advisable, and then have automatic exposure. Some reflex cameras, however, are exceptions to this rule, such as the Olympus OM-2 and the Hasselblad, again, which use special exposure meter systems that still operate even when the mirror is raised to automatically control the diaphragm.

Now we shall look at the electric trip device. This consists of a light transmitter (an ordinary low-voltage lamp fed by a suitable battery) and a receiver, consisting of a photoelectric cell linked to a signal-amplifier circuit. The light from the lamp is concentrated by means of a lens into a uniform beam which shines on the photoelectric cell. The cell receives a continuous signal until the moment when the animal cuts across the beam of light. This triggers off the transmission of the release signal by cable to the camera motor. If one masks the light of the transmitter with a dark red filter for infrared, the beam of light is rendered invisible, while the photoelectric cell will continue to register it. To reduce to a minimum the delay in sending the release signal, diodes which give an immediate response should be used.

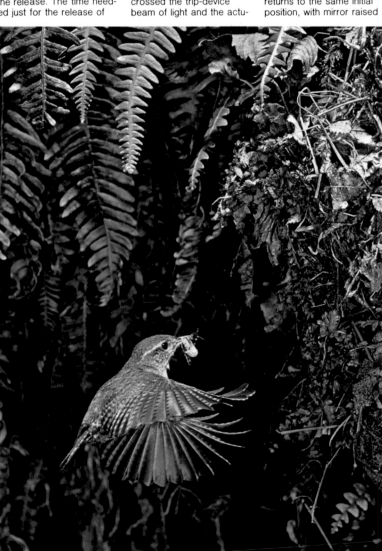

When the subject is small like this wren, the usefulness of the trip device is increased because the time available to center the bird is critical and the bird's movements are magnified due to the closeness of the shot. The background has come out so effectively on account of the soft lighting.

How to Arrange the Trip Device

The cell sensitivity and the power of the light given off by the lamp determine the maximum range of action, that is, the distance between light receiver and transmitter within which the circuit can function reliably. As a rule this distance should be sufficiently short to localize precisely the area to be covered by the lens. The system will only release when the subject is properly framed. To get the best position for the beam, repeated tests and trials will be needed to eliminate any chance of the animal slipping through the net.

One method to widen the area covered by the beam of light, which must be narrow to focus on the photo cell, consists in routing the beam by means of small mirrors arranged so as to form a zigzag path, terminating in the receiver. The total run should not exceed the limits allowed by the system's sensitivity. Transmitter and receiver are shielded by tubing so as to reduce light interference and not dissipate the beam. The focusing of the light on the photo cell is fixed by the lens of the transmitter, taking into account that a more powerful signal is also more reliable. The receiver should be

pointing slightly downward so as to reduce the light from the sky, while the transmitter should be pointing slightly upward.

Lighting

Trip devices of this kind are almost always used in conjuction with flash, which ensures correct lighting and above all the freezing of movement. Automatic flash units with detachable sensors are very useful as they ensure correct exposure with very fast shutter speeds and allow the photographer to position the flash lamp as required. A second flash unit synchronized by means of a slave unit will help to get softer,

more evenly diffused lighting. If sufficient natural light is available, exposure should be calculated to give a daytime effect, which can reproduce something of the environment in the background.

Note: As an important example of time lapse, look at the photograph of the robin on page 45 shot with a Hasselblad without raising the mirror in advance. In the lapse of 1/14 second the robin has had time to spin round before any impression has been made on the film.

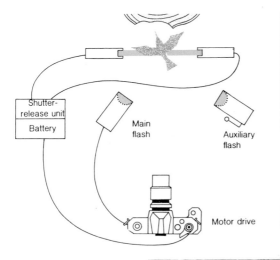

Above: Layout for an electronic trip device. By means of beams of infrared light, an invisible barrier is created which, when broken, triggers the release signal through an electric circuit. The camera, equipped with motor drive, can also be fitted with synchronized electronic flash units.
Above, right: The frontal shot brings out the shape of the bat in flight.
On the right: Kingfisher. Flash is almost always necessary when subjects are extremely mobile, as are birds.

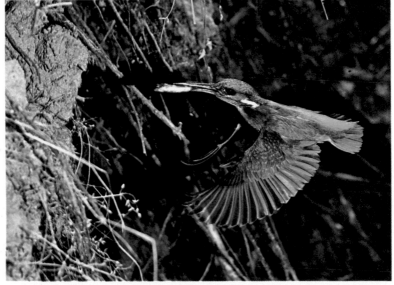

TELLING A NATURE STORY WITH PICTURE SEQUENCES

Sequences of photographs serve well to relate a nature story. A logical succession of photographic images draws the attention of the observer, above all because it shows the different stages of action frozen at the most crucial and significant moments. In an age of audiovisuals it is no longer conceivable that descriptions of events in nature should be entrusted to the written page alone. If there were not the deterrent of high costs for color reproduction, everything which gets described in writing would be accompanied by explanatory pictures. To take shots in sequence, motor drive is indispensable for rapid and automatic film feed, and so are special camera backs capable of holding a large number of frames (250 to 300 shots).

Sequences for Events Happening in Rapid Succession

Sequence can be used to describe the movement of an animal, with frames shot in succession, spaced out by a few fractions of a second, as when photographing running giraffes or the precise movements of a monkey swinging from one tree to another. To freeze and describe the different stages of the flight of an animal during extremely critical movements (for example, gazelles swerving rapidly to right and left when fleeing from a pursuing predator), motor-drive cameras are very useful since they are capable of shooting volleys of frames. On these occasions the release button is held down, while the motor does the rest. A typical example would be the use of a volley of shots of the departure and arrival of birds at the nest or perch.

Other opportunities for exciting and instructive sequences in succession are provided by geese and swans, who run forcibly along the surface of the water for a stretch in order to gain sufficient momentum for a takeoff.

Sequences to Document Prolonged Wildlife Events

The sequence can also be used to describe events which unfold slowly over a stretch of time. Some classic examples are the blossoming of a flower, the growth of a plant, the emergence of a butterfly from its chrysalis, and the hatching of an egg. After setting up the camera, focusing, and judging the exposure, the release is set by means of a timer which can control a series of flashes. This method is used more frequently in the laboratory, where one normally works at a more leisurely pace, positioning the equipment carefully and methodically. Nature shots that document, for example, the growth of a snowdrop in a field covered in snow possess a quite different kind of charm. In these outdoor shots the lack of electric current is overcome by using large portable batteries or long cables which can be connected to some neighboring source.

Sequences to Document Scientific Research

In nature and in the laboratory, sequences can be useful for purposes of research and scientific documentation. A series of images can document the different activities of animals, whether taken in a wild state or in a controlled environment like a zoo.

The sequences of photographs can then be evaluated from an ethological point of view, perhaps with the help of professional zoologists. The same ethological interest applies to sequences of fish shot in the aquarium (resting the camera carefully on the glass and assisting the operation with electronic flash), underlining their interesting behavior patterns, illustrated, for example, in their search for food, in mating, and in their ability to camouflage themselves.

The sequence of the unfolding of the split-leaf philodendron (Monstera deliciosa), shown in the five photographs below, was made in the studio and serves to document the manner and period of time in which the plant unfolds its leaves when subjected to different stimuli of light and heat.

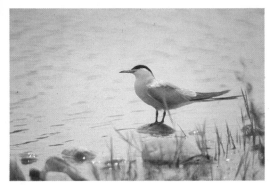
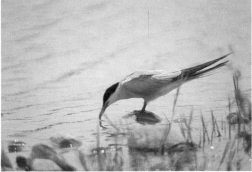
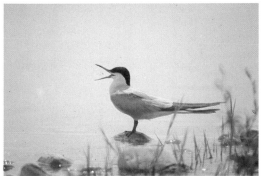
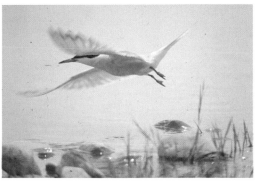

Shooting successive moments in the life of the same species and connecting them together in a logical succession may tell a nature story. For example, the tern which appears in the photographs above first looks toward its companions in flight, searching for possible clues as to what to do, then it drinks some water, feigning indifference, then it utters a loud cry to warn the group of its intention of approaching them, and then it launches itself into flight. It is clear that a single photograph could not have interpreted the bird's behavior.

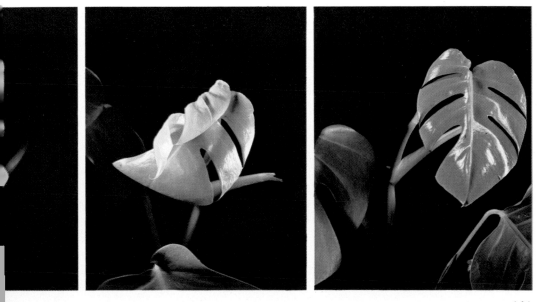

ANIMALS IN CAPTIVITY

Animals may also be photographed in conditions of captivity, bringing out details of their physical structure and character. Advice to photograph animals at the zoo to acquire practice in wildlife photography is not to be wholly endorsed, inasmuch as animals in captivity are immobile or partly immobile, and deprived of their habitat, they only vaguely resemble their counterparts living in the wilds. Can the antelope which approaches to within 2 meters (6 feet) of the bars of his cage be compared to the silhouette fleeing into the savannah?

Photographs of children are much nearer to wildlife photography than those taken of zoo animals. Hu-

cause it accustoms the reader to picture to himself a creature that could never be seen in nature. Almost all animals photographed in captivity show characteristics which reveal their condition and distinguish them from the same species in the wild state. Mammals, for example, never have such a perfect shiny coat as when in a wild state. The whiskers of felines in captivity are almost always spoilt at the tip, broken or curved. With birds of prey in the wild, it is interesting to observe the cleanliness of the plumage and the untarnished condition of the tail feathers, which in the case of birds of prey in captivity are always eroded on the edges.

pher. The practitioners of such tricks justify their behavior by claiming that it is almost impossible to find similar opportunities in nature. Taking pictures of trained animals attacking people and showing them to the public without explaining the contrivance is a distortion of naturalist information. With birds of prey who have been accustomed to man from an early age, the excessive tranquility of the subjects (puffy wings, placid expression) contrasts with the normal degree of tension which these birds of prey need to survive in a wild state. What many people cannot understand is that conditions for a couple of wild animals living in a particular habitat must be perfect to allow them to sur-

the background as well, since it is often made up of ugly cement enclosures. At other times it is useful to include the bars in the shot to stress the conditions of imprisonment and estrangement in which these animals are placed.

Framing the head alone is effective when taking shots of animals in the foreground. In this way one can cut out surroundings and any distracting details, and expressions which characterize the species and the individual are shown up better.

To give greater emphasis to the subject, the background can sometimes be rendered dark. This effect is achieved by waiting for the sun's rays to fall on the subject while the background remains in shad-

man infants, like those of wild animals, do not pose for the camera, and one must therefore get used to seizing the right moment. Pictures of children have more spontaneity than those of unfortunate animals in human captivity. Furthermore, it is important to learn how to take photographs, giving the right exposure, finding the correct light and suitable degree of sharpness.

The Real Difference Between Photographs of Animals in Captivity and Those in a Wild State

In many nature books one can see photographs of animals in captivity which are used to describe the characteristics of that species in a wild state. This is a disservice to the reader's understanding of nature be-

A timeworn trick used frequently is placing a bird of prey in a natural environment, tying it with a jess (a leather leash used by falconers on the feet of the bird) and hiding the leash and feet behind some natural obstacle like a rock or a tuft of grass. In the photograph the animal appears without feet, and this should arouse suspicion. Another feature to watch carefully is the expression of the falcon. The frightened expression in the eyes of the captive bird of prey is easy to detect by one who is familiar with these animals, but even the nonexpert can note the difference in individuals of the same species photographed in a wild state. Another expedient consists in using trained falcons while they hunt live prey released by the photogra-

vive natural selection. This is the great fascination regarding wild animals and this is their real integrity which the naturalist seeks to convey in pictures.

How to Photograph Animals in Captivity

To say that photographs of animals in captivity should not be passed off as being taken in nature does not mean attaching no value to pictures taken under contrived conditions. Many people take photographs in zoos so as to have pictures of certain species in their own collections. Bars and wire nets are made to disappear photographically by taking the shot with a telephoto lens with diaphragm at full aperture in order to blur them, or by resting the camera right on the wire. In many instances it is a good idea to blur out

ows. Under these conditions, exposing with diaphragm aperture at maximum, the contrast in light is increased to produce a night effect in the background.

Two photographs of animals in captivity made at the Recovery Center for Birds of Prey in Parma, Italy. These animals are waiting to be released. Close up they express the scowling pride of adult birds of prey. The golden eagle (on the left) has been taken with a light that underlines the firm structure of the head and the resilient movement of the wings. The short-toed eagle (on the right), photographed with a technique designed to render the background dark, shows its decisive personality.

In these two pictures of tigers it is easy to see the difference between animals photographed in the wild state and those photographed in captivity. The tiger shot in its natural habitat (lower picture) shows to the full its wildness and self-assurance, and camouflage. The placid resignation of the other tigers (on the right), even when kept in enclosures which seek to reproduce their natural environment, shows in contrast the absence of the tension which is typical of the wild animal in its habitat.

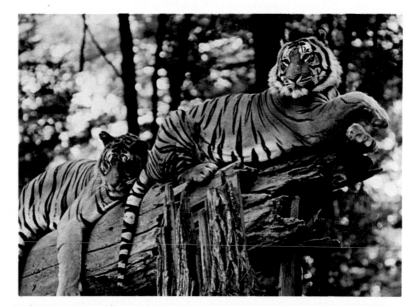

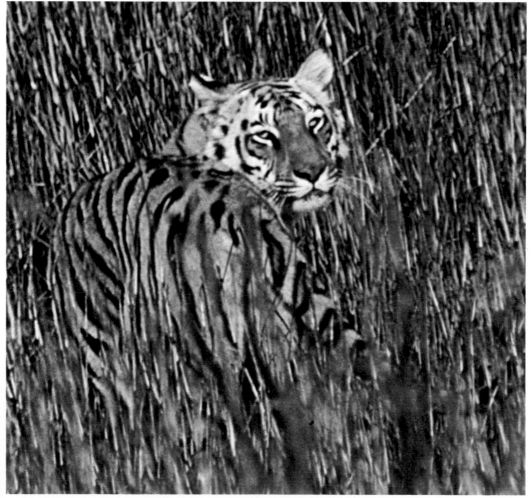

CLOSE-UP PHOTOGRAPHY

In close-up photography the reflex camera has effectively revolutionized the technique of taking shots, creating new and interesting fields of application with a simple method of operation unthinkable up to a few years ago. A fascinating field has been opened up to the nature photographer who, equipped with apparatus which is not excessively costly, can document a world teeming with subjects possessing the strangest and most fantastic shapes and colors, found easily in all places and seasons. This method of taking shots is based on a few relatively simple ideas which may be applied to any kind of camera; however, for simplicity's sake we shall be referring to the 35 mm format in all the examples.

Each choice of equipment or method of shooting should be guided by basic ideas following logical reasons. Details of minor importance have been omitted for the sake of brevity, and so as not to create doubts or confusion regarding the subject.

All reflex cameras fitted with a 50 mm lens can focus down to a distance of about half a meter (19 inches); at this distance objects 5 to 10 centimeters (2 to 4 inches) reproduce photographically too small. To calculate the ratio between the actual size of an object and that of its image reproduced by the camera, one uses a fixed unit of measure—the scale of reproduction (or scale of magnification), which is calculated thus: S = size of image on the film divided by the actual size of the subject.

Why is it important to learn the formula of this parameter? Because all close-up photography makes continual reference to this number to determine the choice of method and equipment to use in each case.

How is the S value obtained? Let us take an example using as our reference the 50 mm lens. Every object placed at 50 cm (20 inches) will give an image with S = lens-to-film distance divided by the lens-to-object distance = 50 mm/500 mm = 0.1. The image will be one-tenth the actual size of the real object.

Let us look at the diagrams on the facing page. When the lens-to-object distance is decidedly greater than the lens-to-film distance, the image will be proportionally smaller. As the flower approaches the lens, its image grows correspondingly until it becomes equal to the original.

Beyond this point, as the flower approaches, the image in focus on the film recedes from the lens and hence becomes ever larger. In the third figure on page 145, the optic system appears inverted compared to the first figure; in this illustration and the following one the principles of optics

which govern the different methods of taking shots in close-up, macrophotography, and photomicrography, are shown. This particular kind of shot is made easier by the use of a reflex camera, but appropriate equipment is still required and there are various problems which will be examined later.

According to the geometry of optics, when the value of S = 1, that is, at the point at which the image has the same size as the real object, the distance between the lens and the image or between the lens and the object is equal to double its focal length. Remember that the focal length of a lens is always calculated with the subject at infinity. These two concepts are the reference points for calculating which lenses to use in any specific case. Techniques for close-up photography are

The astonishing picture of a butterfly (Agraulis vanillae) taken in flight by means of the special technique described on pages 166 to 169.

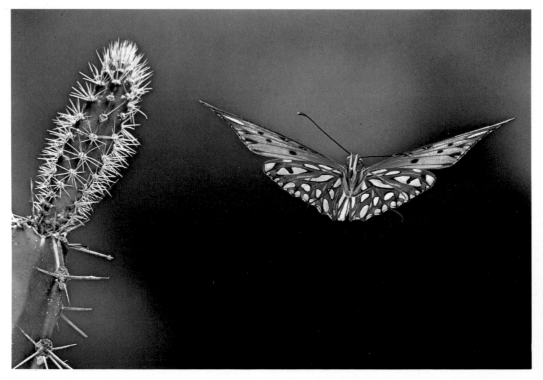

not distinctly separate from one another, but one passes by stages from one to the other as the scale of reproduction is varied. However, there are valid reasons why this field of photography can be subdivided into different parts. Close-up photography, so called, is simply that in which the scale of reproduction is less than one. Macrophotography is where the scale of reproduction is equal to or more than one, up to a value around 10. Photomicrography begins with a scale exceeding 10, using the microscope as its basic instrument. However, limits and terminology are often a subject of controversy among various authorities. What really counts is the difference in practice between one field and another. Thus shots up to $S = 0.3$ can be carried out with very simple equipment, like the reflex and supplementary lenses. There is no difference from normal shots here.

Once this value is exceeded, more special and fairly complex techniques have to be adopted; the distance between lens and film increases, which compels one to adopt different criteria concerning the choice of focusing and exposure time. Therefore it seems fairly logical to include within the field of macrophotography all techniques of shooting which start from a value of $S = 0.3$ up to the maximum of 10 magnifications, beyond which the microscope must be used. Photomicrography uses a specialized instrument which is based on the third diagram, a distance of a few millimeters from subject to lens, a much greater distance between lens and magnified image.

In current usage, to speak of macrophotography with $S = 1$ means, in the case which we are considering, taking photographs of objects smaller in size than those of the 35 mm frame.

It is obvious, therefore, that if large-format studio ' cameras are used, the matter is different. With a camera of a format of 30

\times 40 cm, the portrait of a face is really a macrophotograph, insofar as the scale of reproduction is equal to around 1. In fact the parameter S is independent of the format. If we change the size of the image to a significant extent, that is, the format of the film used, the techniques can undergo equally significant changes. But we are concerned with the 35 mm format.

As a rule, one can say that shots of small objects are easier using a small format, because of the lower value of the S required to get the same size of image. Technically, there are two methods which allow close-up shots to be taken with normal cameras. The first is the optical method, consisting of the use of magnifying lenses which, when placed in front of the camera lens, shorten the focal distance. The second is the mechanical method, where one increases the distance between lens and film, usually beyond the limits allowed by helical focusing, with extension tubes or bellows. The first method can be used with any camera, even a nonreflex one and one with fixed focus, inasmuch as the supplementary lens is added to the outside of the optical system. The second may only be used on cameras with interchangeable lenses, as the device must be inserted between the lens and the film.

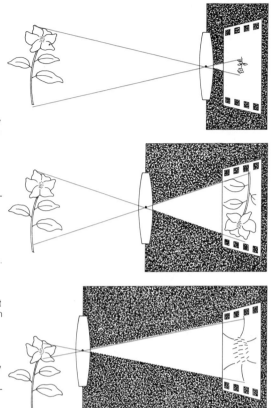

Distance and enlargement: How one moves to reduce the subject-to-lens distance, from close-up photography to macrophotography. In the first diagram the image of the flower on the film comes out smaller than the original, in the second it is the same, and in the third it is much larger. In the same way the film-to-lens distance increases and this brings correspondingly greater difficulties in shooting.

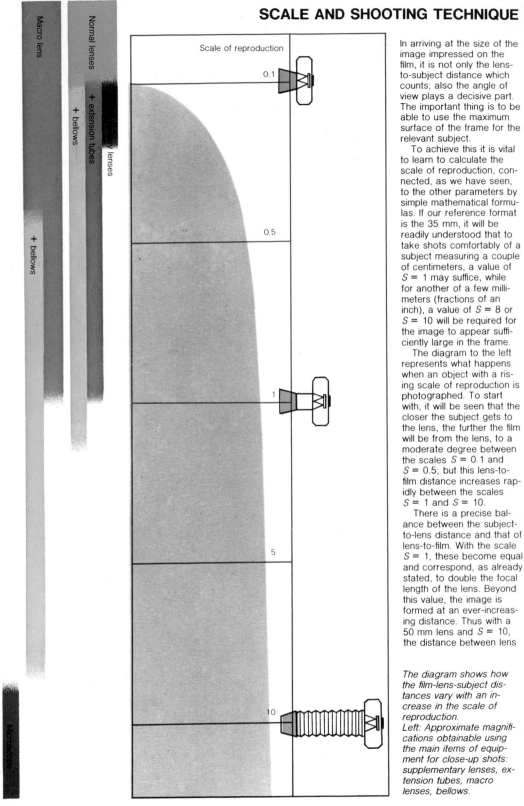

Macro lens

+ bellows

Microscope

Normal lenses

+ extension tubes

+ bellows

...y lenses

Scale of reproduction

0.1

0.5

1

5

10

In arriving at the size of the image impressed on the film, it is not only the lens-to-subject distance which counts; also the angle of view plays a decisive part. The important thing is to be able to use the maximum surface of the frame for the relevant subject.

To achieve this it is vital to learn to calculate the scale of reproduction, connected, as we have seen, to the other parameters by simple mathematical formulas. If our reference format is the 35 mm, it will be readily understood that to take shots comfortably of a subject measuring a couple of centimeters, a value of $S = 1$ may suffice, while for another of a few millimeters (fractions of an inch), a value of $S = 8$ or $S = 10$ will be required for the image to appear sufficiently large in the frame.

The diagram to the left represents what happens when an object with a rising scale of reproduction is photographed. To start with, it will be seen that the closer the subject gets to the lens, the further the film will be from the lens, to a moderate degree between the scales $S = 0.1$ and $S = 0.5$; but this lens-to-film distance increases rapidly between the scales $S = 1$ and $S = 10$.

There is a precise balance between the subject-to-lens distance and that of lens-to-film. With the scale $S = 1$, these become equal and correspond, as already stated, to double the focal length of the lens. Beyond this value, the image is formed at an ever-increasing distance. Thus with a 50 mm lens and $S = 10$, the distance between lens

The diagram shows how the film-lens-subject distances vary with an increase in the scale of reproduction.
Left: Approximate magnifications obtainable using the main items of equipment for close-up shots: supplementary lenses, extension tubes, macro lenses, bellows.

and film becomes 500 mm. Another important thing to remember is that by increasing the S value, the whole technique of shooting is completely altered and one can no longer refer to the diaphragm values marked on the lenses. On the left-hand side of the diagram are shown the optical instruments to be used with the 35 mm and in which interval of S they are suitably applicable. The method of using these accessories and their characteristics are described in the following pages.

The diagram sums up and illustrates only the most common conditions of use, ignoring the many possible ways of combining the various instruments. These are mainly of four kinds: supplementary lenses, extension tubes or rings, macro lenses, and bellows.

Supplementary lenses are practical and economical but only give good results up to a value below $S = 0.3$.

Extension tubes or rings offer a wide scope in use with first-class image quality. But they are less practical than normal lenses because they interfere with the automatic diaphragm mechanism and reduce the luminosity of the image.

Macro lenses are ones designed specifically for close-up shots. They incorporate a helical focusing system which allows focusing up to $S = 0.5$. Their excellent optical quality and flexibility make them instruments suitable for all-around photographic use as well. Their only drawback is their maximum aperture is less than that of normal lenses, so that they are not so useful in poor light.

Bellows enable one to get variable focal length; they are an essential instrument in powerful macrophotography. However, their use requires a more complex technique, particularly when all the automation of the reflex system is lost.

The choice of one or another of these instruments is determined by the scale of reproduction de-sired. Thus when the subject size is three or four times that of the frame, the use of supplementary lenses will suffice. If it is the same size, more or less, extension tubes or macro lenses should be used. If, on the other hand, it is considerably smaller, bellows will be needed, best used with a lens of fairly short focal length.

Exposure

In close-up photography calculating the correct exposure can present a number of problems. In fact, with supplementary lenses it is possible to operate normally, but when the S value exceeds one, things become more complicated. An increase in the lens-to-film distance reduces the light transmitted, hence the diaphragm value shown on the camera is no longer accurate. For example, a 50 mm lens set at $f/8$ has an effective aperture of $50/8 = 6.25$ mm; this diaphragm relationship has been calculated to be effective when the lens is focused in the range between one meter and infinity. When the same lens is focused at 100 mm, the S value becomes one and the lens-to-film distance becomes 100 mm, as mentioned previously, and the same diaphragm $f/8$ (having a diameter of 6.25 mm) will correspond to a different diaphragm value: 100 mm/6.25 mm = 16. This value is two times smaller; therefore the amount of light allowed to pass

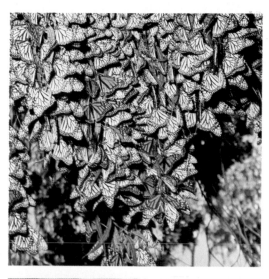

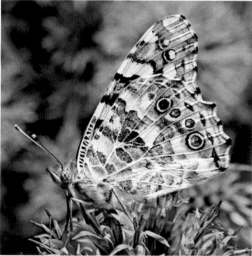

Top: Example of close-up photography using a supplementary lens (monarch butterflies). A similar result may be obtained with a macro lens.
Center: Painted lady butterfly (Vanessa cardui). *When the image on the film is the same size as the actual object, real macrophotography begins, a world full of the colors of insects and flowers which presents itself to our lens.*
Bottom: Butterfly wing (Clossiana titania). *With microphotography a world invisible to the naked eye can be explored.*

through the lens will be one-fourth as much.

The same calculation may be made in accordance with the well-known law by which illumination is inversely proportional to the square of the distance from a source of light to the illuminated subject. If we regard the lens as the light source, it is apparent that the intensity with which this strikes the film is reduced to a quarter each time the distance is doubled. In photography this is equal to the loss of two diaphragm values. The reduction in luminosity can be clearly verified through the reflex viewfinder. In a reflex with a through-the-lens exposure meter, the photocell will continue to measure the effective amount of light falling on the film and will thus correct the error. The problem appears with flash, unless one uses direct flash control, which at present is fitted to only a few cameras.

The graph shown below shows on the vertical axis the factor of extension of shutter speed needed to correct the exposure. Diverse factors contribute in determining the effective diminution of light on the focal plane, especially the kind of lens, its focal length, and whether it is used in a normal or reverse position. (See page 159) The result is analogous to and increases with the increase of the S value according to the equation $F = (S + 1)^2$, in which F is the factor of extension of the exposure time. Normally each lens is accompanied by precise tables provided by the manufacturers which give its characteristics for a specific use.

Depth of Field

Depth of field is the most crucial problem of macrophotography. By looking at the image on the ground-glass screen with maximum aperture, it is clear that focusing can be difficult.

In practice one cannot use diaphragm apertures larger than 8; in other words, it is not possible to take advantage of fast lenses. A wide aperture is useful for facilitating the measuring of exposure and for image vision in bad lighting conditions. However, very often the need to have the longest possible depth of field prevails. The macrophotograph is above all a photographic documentation, which might be incomplete if the plane of focus were drastically reduced.

In the graph on the opposite page, curves are shown similar to those already given on page 87, which show how depth of field can vary within short distances in terms of the effective aperture of the diaphragm in millimeters. The planes of focus obtained by calculation are for distances of .4, .2, and .1 meter (16, 8, and 4 inches). By comparing these with the preceding graph, one can see how the sharp area is drastically reduced as the distance diminishes. The field of sharp definition becomes narrower and more symmetrical compared to the plane of focus. From this one can see that it is best to focus at the center and not at a third of the desired depth, as is done with medium-distance shots.

With wide apertures it is not possible to obtain a sufficiently sharp plane. Remember that the depth of field depends solely on the size of the diaphragm aperture and on distance.

The smaller the diameter and the farther removed the subject, the greater the sharp area will be. If on the one hand we must shut the diaphragm to increase depth, on the other we cannot exceed certain limits beyond which, on account of the greatly reduced size of the aperture, diffraction occurs which further weakens the image definition. Diameters below 1 or 2 mm are inadvisable. The advantage of using lenses of short focal length is that, at equal diaphragm value, the aperture is correspondingly smaller and thus allows greater depth. In practice, each kind of lens has some diaphragm apertures which are preferable because they give the best results as regards definition, contrast, and depth of field.

With short distances, working conditions for telephoto lenses become even more critical. The greater extension in fact produces a considerable increase in exposure, the narrow angle makes blur easier, and with equal diaphragm value, the effective aperture is greater so that depth is diminished.

The graph below shows the increase of exposure time corresponding to an increase in the scale of reproduction: the factor of the extension of the exposure time rises rapidly when the point S = 1 is exceeded. This curve describes an ideal performance with a normal lens.

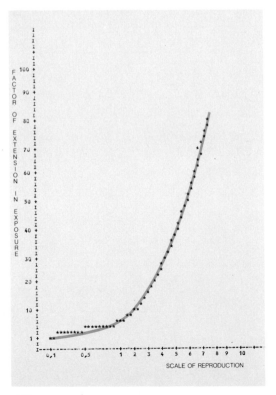

SCALE OF REPRODUCTION

The butterfly in the photograph on the right was skillfully taken with slight depth of field; the wings are in a parallel position to the plane of focus, and the background effectively contributes to the color-tone composition. The silver-studded blue seen below on the right was taken with considerable depth of field, taking in the entire flower, which plays an important part in the balance of the picture.

The graph on the right shows the extension of depth of field in macrophotography. Similar to the one shown on page 87, this graph shows in brief how depth of field varies in relation to the actual aperture of the diaphragm in millimeters at three focusing distances: 0.1, 0.2, and 0.4 meters.

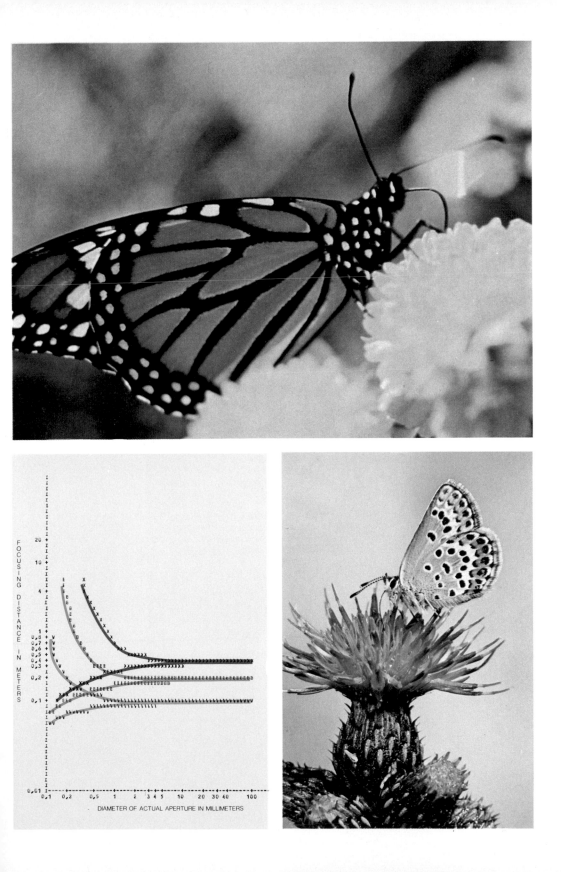

FOCUSING DISTANCE IN METERS

DIAMETER OF ACTUAL APERTURE IN MILLIMETERS

NATURAL LIGHT

To sum up, the technique of shooting at short distances requires the use of the following: small diaphragm apertures to give sufficient depth of field; fast shutter speeds to reduce the danger of blur when shooting fast-moving subjects; precise focusing (often hindered by poor luminosity); and increased exposure time by the diminution in intensity of light, due to the greater lens-to-film distance.

Shots taken in ambient light have a chance of succeeding only if the scale of reproduction does not exceed one. For higher values the light is rarely sufficient, and high-sensitivity film can therefore prove very useful.

In medium-distance macrophotography, shots taken in natural light offer some advantages. In fact, the exposure can be easily calcu-

natural light, very careful attention must be paid to the background. Although it may be blurred, a confused and unsuitable background disqualifies even the best picture. Hence, as soon as the subject has been selected, a background which best suits it must be chosen. The angle and height of the shot will depend on what is behind the subject. The easiest subject to photograph is the world of plants because it does not require very fast shutter speeds and allows the effective use of wide-angle lenses for taking pictures of details in the environment. The broad angle of shot and characteristic perspective of the wide-angle can create pictures which are very satisfying and more "modern" in appearance than ones of a single isolated flower.

Shots of small animals or

and giving softness of tones; the presence of the sun, besides the positive luminous intensity it brings, also confers brightness on colors and a three-dimensional effect on subjects. The direction of the light constitutes an extremely important variable. If the subjects are in abundance, like flowers in a meadow, we can select those that are lit by the best angle.

The effect of radiant light is particularly effective in highlighting structures and surfaces. Looking through the viewfinder, we will be able to visualize the best angle, the one which gives the strongest relief to the subject, detaching it from the background. Backlighting, on the other hand, gives a transparent effect to thin, fine subjects such as leaves, flowers, and small insects. In certain cases it is useful to correct

can also act as a shelter against the light breezes which keep flowers and leaves in constant movement. With this piece of cardboard, backlighting can easily be toned down and striking pictures obtained.

In this photograph of a brimstone butterfly, the soft light emphasizes the camouflage, and the composition is effectively balanced.

lated by using the internal measure, which takes into account all the variations of luminosity due to accessories. In this case the equipment will consist of a reflex fitted with supplementary lenses or an extension ring. With a macro lens, one will be able to take shots up to $S = 0.5$ without difficulty getting subjects in focus.

When taking pictures in

insects in ambient light give first-class results, rich in color and naturalness, but they require much patience, a good knowledge of the habits of the subject in order to surprise it at the right moment, and, it must be said, some good luck as well.

Natural light possesses the great advantage of placing pictures in a setting

sunlight by means of white screens. A practical accessory which has many uses is a simple piece of cardboard measuring 20 × 20 cm (8 × 8 inches), white on one side, and covered in matte metal foil on the other side. One can use it on either side, depending on the strength of the effect desired, to reflect light toward the subject, and it

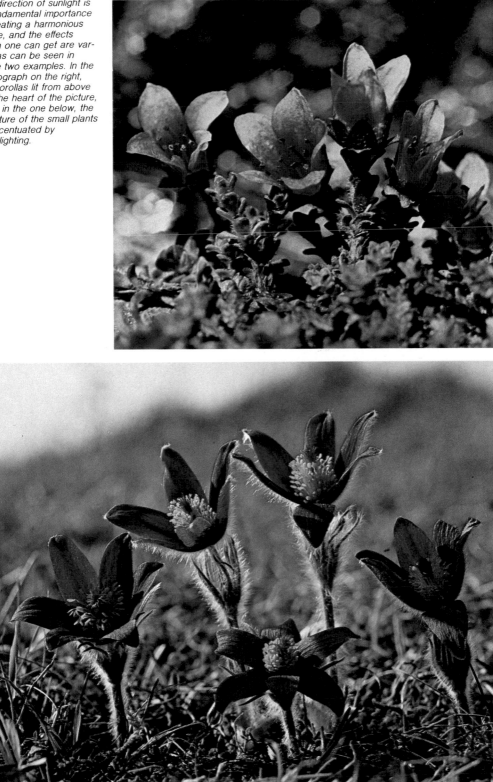

The direction of sunlight is of fundamental importance in creating a harmonious image, and the effects which one can get are varied, as can be seen in these two examples. In the photograph on the right, the corollas lit from above are the heart of the picture, while in the one below, the structure of the small plants is accentuated by backlighting.

151

ARTIFICIAL LIGHT

Flash is the ideal illumination for every sort of close-up shot, because it is better at resolving the various problems than other light sources. A compact, light electronic flash coupled to the reflex is the most adaptable and practical piece of equipment to photograph small objects with consistent quality without the use of a tripod. The advantages offered by compact flash units for this kind of shot are obvious in the very fast flash speeds, which arrest the harmful shake of the camera, exacerbated by the enlarged scale of reproduction; in the relatively high intensity of illumination, which permits the diaphragm to be stopped down for ample depth of field; in the kind of cold light easily adjustable through direction and intensity; and finally by the modest purchase price and negligible operating costs. The latest flash models, which are small and powerful enough, with intensity which can be adjusted at will, simplify still further their use in macrophotography.

However, compared with natural lighting, the use of flash also has its disadvantages, such as the impossibility of viewing the image as it will appear; the singular direction of the light, which sometimes gives very contrasty and unnatural images, with somber backgrounds that may be unsuitable; and an element of uncertainty in calculating the exposure, insofar as the intervening factors are many and not always easy to assess. Only the direct measurement of light on the focal plane solves this problem completely.

Flash units suited to close-up nature photography are the small, simple ones without accessory parts. On account of their lightness and low power, they are easy to handle, they can always be carried about, and they can be used at very short distances without difficulty.

Equally useful are the compact medium-powered flash systems that include a complete set of accessory parts and give a sophisticated performance. The detached sensor provides the chance to use automatic exposure, since it is more easily turned toward the subject when not too small. The most useful device, however, is the variable transformer, by which one can impose luminous discharge graded in whole diaphragm stops, as required.

Other flash heads giving satisfactory results are ring flash tubes, for shots at very close distance. The size of the ring flash allows it to be mounted around the lens. This flash gives illumination without shadows, well suited to scientific photography and shots where lighting is a problem on account of the proximity of the subject to the lens. A less monotonous kind of illumination can be obtained by partly shielding the ring flash with dark tape.

Lastly we should mention the automatic-exposure through-the-lens flash, which must be used, however, on automatic with the camera specially preset. With this system macrophotography becomes very easy with the light of a flash. The cells measure

The two diagrams below show how to obtain soft illumination with flash. When a single flash is used, the shadows may be lightened with a panel of white cardboard placed outside the field of view at a suitable angle. With two flash units, however, the two light sources must shine with different degrees of intensity on the subject; this is achieved by suitably adjusting the distances of the lights from the subject, or the amount of light discharged by each unit. Below, left: Caterpillar (Stilpnotia salicis). In insect macrophotography, soft illumination is particularly appropriate because the object is not merely a pleasing picture but one possessing some naturalist values.

On the opposite page: Flash makes it easier to take shots of difficult subjects, clearly highlighting their colors. In this photograph of an Australian frog, the diagonal composition has succeeded in creating a sense of vitality which is reinforced by the absence of any background distraction.

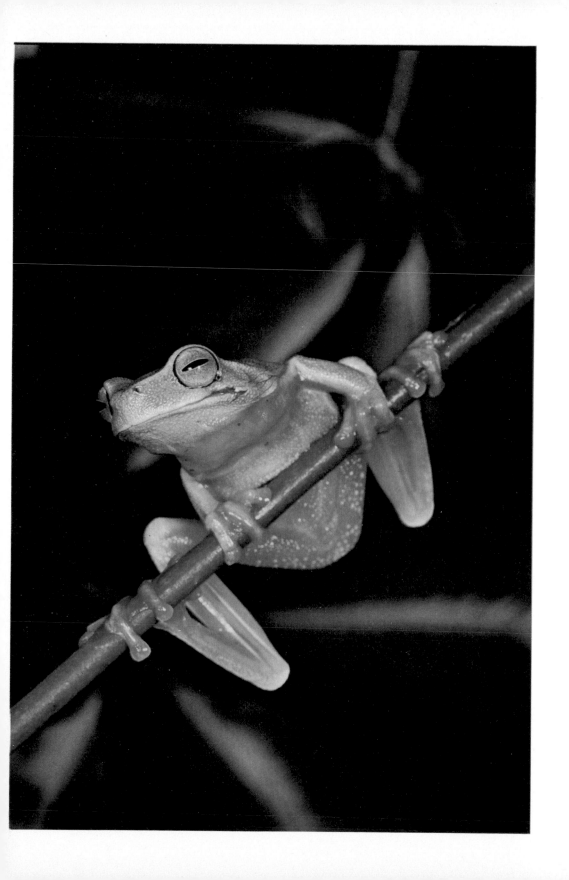

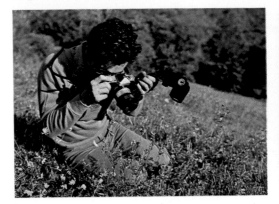

Handy attachments for macrophotography with flash. The arm bracket supporting the flash unit must be easy to turn. A dark background, rather underexposed, as in the right-hand photograph, gives a greater three-dimensional quality to the subject.

Below: Olympus OM-2 equipped with a Quick Auto 310 flash.

the actual light striking the film and therefore respond to any variation notwithstanding the lens, diaphragm aperture, or acces-

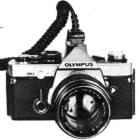

sories. This technology is probably destined to influence the development of flash units themselves, which acquire increased reliability and versatility in the field of close-up photography, where their usefulness is unquestionable.

How to Set the Exposure

There are two ways to set the exposure for close-ups. The first is by adjusting the diaphragm aperture, keeping unchanged the distance between flash and subject. The choice of aperture must take into account the need to have the greatest possible depth of field and variation in the effective aperture of the diaphragm be-

cause of the increase in the lens-to-film distance. In practice it is best to use the smallest aperture possible, bearing in mind its actual value so as to relate it to the distance from the flash. For example, if the scale of reproduction is equal to one, the effective aperture is no longer the one marked on the lens but a smaller one by at least two stops. It can be calculated using this simple formula: effective aperture = nominal aperture \times $(S + 1)$.

So if one sets the diaphragm at $f = 16$, the effective aperture with $S = 1$ will be $16 \times (1 + 1) = 32$. Exposure values are higher than those normally used. Some are given here which should cover all normal requirements: $f/32, 45, 64, 90, 128$. Intermediate values correspond with fractions, proportionate to the interval itself.

The second method of setting the exposure is to vary the distance of the flash, keeping the diaphragm aperture constant. Remember that the flash guide number is simply a reference which does not take into account the special conditions in which the flash is effective on the

close-up. One must therefore determine with some tests the effective guide number for equipment and film normally used in order to calculate the correct exposure at distances of one meter (3 feet), half a meter (1½ feet), 25 cm (10 inches), 12 cm (5 inches), and 6 cm (2½ inches) from the flash lamp to a subject of medium density. Normally the effectiveness of flash is slightly reduced over short distances. We know that the guide number corresponds to the aperture one would use to photograph a subject at a distance of one meter (3 feet). In close-up photography the relation between the distance in meters and the effective guide number is the same as the one used for medium distances, but take care to substitute the effective aperture for the nominal aperture, which, as we have seen, is no longer valid. It can be calculated in this way: effective guide number = effective guide number divided by the flash-to-subject distance in meters.

In practice this is much simpler than it might seem. Only three or four apertures are used, and subject distance is kept about equal both for the flash and the lens. Under these conditions, small flash units do not normally give overexposure, and they are very practical to use. More powerful flash units can be used to equal effect if they are fitted with a variable transformer. This accessory will prove most useful, since it allows the intensity of the flash light to be

graded in whole aperture stops and hence the same shot with different levels of illumination can be made without varying either the aperture or the position of the flash.

When the subject is worth it and it is feasible, it is best always to repeat the shot with a shorter and a longer exposure to ensure the right density.

To recap, shooting with flash requires the following sequence of operations: Establish the scale of reproduction and choose suitable attachments; set the aperture as small as possible if the greatest depth is desired, bearing in mind that if you want to keep the background blurred, you can judge the image through the viewfinder, shutting the diaphragm with the appropriate button; calculate, on the basis of the S value and diaphragm stop, the effective aperture; from the effective guide number, you can determine the distance at which to place the flash, which can be hand-held or mounted on an arm bracket which permits easy angling; choose the framing and focus accurately, moving the entire assembly systematically backward and forward to center the subject.

The flash should be placed at a certain angle in relation to the direction of the shot, as shown in the drawings on page 152, and pointing downward to obtain a more natural effect in the ambience. A lens hood will protect the lens from direct rays of light. After testing this method a few

times, it will become simple.

Exposure is much simpler with Quick 310 flash and the Olympus OM-2 camera. It is sufficient in fact to set the aperture fairly small and shoot. The indicator light for correct exposure will show whether the light received was sufficient based on the film sensitivity. In this way the position of the flash or the aperture can be altered, while the interval of luminous discharge is adjusted when the flash is on automatic.

Soft Lighting

Flash, with its strong directional light, tends to give images with hard shadows. In macrophotography the problem is diminished because the area of the flash lamp is comparable to or greater than the subjects themselves, and therefore it behaves, at the short distances used, like a powerful source of light which gives a softer and more encompassing illumination. If the subjects are very small, this effect is suffi-

cient. With subjects measuring a few centimeters on the surface and lit from a relative distance, however, the shadows again tend to be sharp, especially when there is nothing in close proximity to reflect the light. To get a softer light giving more color and relief to the image, there are two possible answers. The first is to position a piece of white cardboard so that it will reflect the light and lighten the shadows. In many cases this simple expedient will suffice. There is the advantage that reflected light is always less strong than the main source. The second consists in employing two flash units, one linked to the camera and the other synchronized, preferably by means of a slave unit. In this way the second flash is independent and can be positioned at any distance as desired to control the intensity of the flash. Instead of altering the distance, one can use the variable transformer if available.

One important warning:

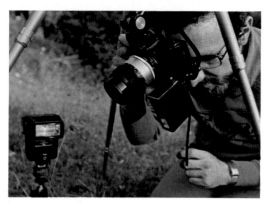

the two sources of light must not be allowed to give equal intensity of illumination. There must always be one principal light and one fill-in light, to avoid double shadows. While in medium-distance photography it is possible to get the so-called daylight effect, combining in the same picture ambient light and flash light, in macro this is not possible because very slow shutter speeds would be required, with the consequent danger of getting

double images. The simplest solution is therefore to calibrate the illumination with two flash units.

Soft lighting or special effects can be obtained by using two flash units, one mounted independently and synchronized by means of a slave photocell.
Below: Lighting from above always gives a natural and pleasing effect in high-power macrophotography and is often the easiest to arrange.

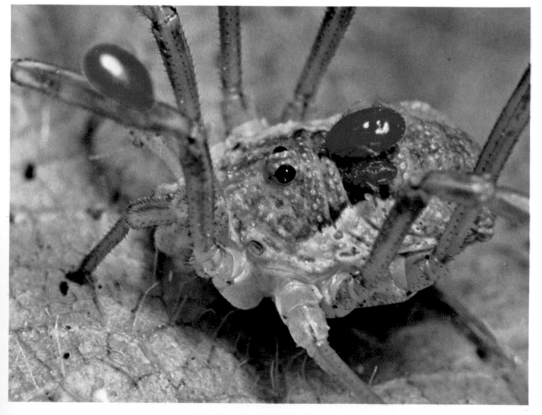

MACRO INSTRUMENTS

A supplementary lens (on the left) and extension rings (center). High-quality pictures can be obtained with supplementary lenses. With a straightforward shot, insects may be taken by surprise more effectively, as happened with the two mating butterflies in the color photograph.

Supplementary Lenses

Supplementary lenses are the most practical and simple instruments for taking close-up photographs. They are of positive power, made of optical glass and mounted in metal rings, suitably designed to be placed in front of the normal camera lens.

They can be easily purchased in handy sets of three of different dioptric powers. Their principal characteristics are their power and type of mounting. Power is expressed in diopters; the number of diopters corresponds to the reciprocal number of its focal distance, expressed in meters. So a lens of one diopter possesses a focal length of one meter and one of two diopters has a focal length of 0.5 meter.

The type of mechanical fitting to the lens can be pressure, bayonet, or screw kind. The last is by far the most popular and practical one. The gauge of the screw thread is the same for all modern reflex cameras. The diameter, measured in millimeters, determines its degree of applicability for different lenses. Each manufacturer has adopted different diameters to suit its own design requirements.

How Supplementary Lenses Work

The supplementary lens shifts the plane of focus of the camera lens on which it is mounted from infinity to the distance corresponding to its focal length, independent of the focal length of the camera lens itself. For example, if we place a lens of one diopter in front of a camera lens set at infinity, the focus will be shifted to one meter, whether a wide-angle or a telephoto lens is being used. However, the magnification obtained will be different due to the smaller area framed by a telephoto lens compared to the wide-angle lens, focused at the same distance of one meter; the supplementary lenses are therefore more useful with a telephoto lens. So the magnification obtained with a supplementary lens depends on two factors, its power and the focal length of the camera lens on which it is used; the greater the focal length, the greater will be the magnification

Diopters	Focal Length	Maximum and Minimum Focusing Distance	S
1	1000 mm	1000–333 mm (40–13 in.)	0.05–0.17
2	500 mm	500–250 mm (20–10 in.)	0.10–0.22
3	333 mm	333–200 mm (13–8 in.)	0.15–0.28
3+1	250 mm	250–167 mm (10–6½ in.)	0.20–0.33
3+2	200 mm	200–143 mm (8–5¾ in.)	0.25–0.39

obtained. However, it is not advisable to use supplementary lenses with medium and long telephoto lenses because both the quality of the image and the viability of the camera are adversely affected.

More than one lens can be used at the same time; then the more powerful one should be mounted first. Supplementary lenses always produce a certain deterioration in the quality of the image; only a very careful use can render these effects on the optical performance quite negligible. In practice one should limit oneself to lenses of not more than three diopters, use not more than two lenses at once, choose small apertures, and use the lens hood to avoid reflection. Three lenses are normally obtainable, and they can be used singly or in combination, according to the following table, which applies in the case of a normal 50 mm camera lens.

As the exposure is not affected, shooting is simple whether ambient light or flash is used. The only disadvantage arises from the limited area of focusing, which may necessitate a change in the type of lens with a change of subject. One advantage of these lenses is that they can be used on any camera lens with the same diameter, that is, they are not limited to a particular camera even if they often have the drawback of being mountable only on a few lenses of the same family.

Extension Tubes

For shots with a scale of reproduction less than 1, supplementary lenses or macro lenses can be used; from an S value around unity up to high-power macro, with $S = 9$ or 10, accessories must be used which permit the lens-to-film distance to be increased. Suitable devices are of two kinds: fixed extension devices, made of rings or tubes of increasing length, fitted with joints to attach them to the camera body and the camera lens; and flexible extension devices, including a cloth bellows which does not let in light, in which the lens-to-film distance can be set on all intermediate positions.

In contrast to lenses, these accessories are made specifically for each kind of camera, or better, for each kind of fitting. They enjoy the advantage of not affecting the quality of the image, which depends on the camera lens. Extension tubes are the simplest and most economic means of achieving a high scale of reproduction. Tubes suited to different fittings are available in sets of four or five different lengths, which can be used individually or in combination. The total length usually corresponds to the normal focal length. Individual characteristics are the kind of fitting, distinctive for each specific type of reflex camera; the length of each ring in millimeters; and the presence or absence of the mechanism which transmits diaphragm automation. This is an important feature that appreciably affects the price; some makers supply extension tubes with and without automatic diaphragm linkage.

The choice of a suitable extension tube must take into account frequency of use and cost. If it is to be used only occasionally, a nonautomatic tube will suffice; the optical quality is the same and the cost is one third that of an automatic. But if it is to be used frequently, an automatic tube which allows normal operation at full aperture will be required. Since at maximum distance the luminosity in the viewfinder drops considerably, one can only just see the image

Below: Mammillaria microcarpa. *With a close-up shot new symmetries and unusual color combinations are revealed, which often elude direct observation.*

at full aperture; with simple rings and a stopped-down diaphragm, which is usual in macrophotography, nothing can be seen. However, a ring with a pushbutton is available which allows an adequate aperture for vision in the viewfinder; the diaphragm is stopped down by releasing the button. This avoids forgetting to close it at the moment of the shot.

A normal set of rings provides the scale $S = 1$. There is no standard size, and each manufacturer divides the normal focal length (50–55 mm) into different parts. The automatic rings, coupled with the delicate mechanism controlling the diaphragm, must be mechanically reliable.

One advantage of tubes is that they can be used with all the lenses of the same production line and in combination with other kinds of macrophotographic accessories, as they have no adverse effect on the image. In contrast to lenses, their effect on focusing and therefore on the S value depends on the focal length of the camera lens.

How to Calculate the Effect of Rings

The S scale obtained by using a ring of predetermined length is calculated with the following formula: S = length of tube in millimeters divided by the focal

length of the camera lens. Thus a tube measuring 27.5 mm mounted on a 55 mm camera lens could give an S value = $27.5/55$ = 0.5.

If the rings are used with short focal length lenses, which have a short focusing range, there may be some S values which are not covered because the focusing range does not cover the difference in thickness between one ring and another. The shooting technique and the effect of the rings on the exposure are substantially the same for a bellows.

Extension Bellows

The bellows is basically an extension tube the size of which can be adjusted. It is characterized by the type of mechanical coupling; by the maximum and minimum length of extension in millimeters and the range of the S values, applicable to a 50 mm camera lens; by the presence or absence of automatic diaphragm linkage; by the presence of a monorail which permits only the length of extension to be varied, or of a double rail by which the focusing can be adjusted independently; and by the presence of perspective control and scales. These are the features which classify the type of bellows and the performance it can give.

Accessories must be made with mechanical precision if they are to be

reliable in use. The camera lens and the body are fixed to the two panels equipped with fittings, which slide along a rail controlled by a tensioning mechanism with a locking knob. The second rail is very useful for focusing; the first determines the S value, while the one underneath, integrated with the tripod, permits the

micrometric and uniform transfer of the whole reflex camera assembly. The bellows, without the second rail, can be mounted on a second separate one, available as a component of the accessory part. As with tubes, automatic diaphragm is a great amenity but appreciably affects the price. Automatic universal

Above: Large-scale reproduction requires the greatest care to reduce "shake." A stand and cable release are always necessary.

On the left: Bellows with double rail: the lens reversing ring is attached to the front part of the bellows.

bellows can be obtained for most standard kinds of attachments, however, which are reasonably priced, with an efficient mechanism; the availability of scales and perspective control is of no relevance to nature photography.

The Use of the Bellows

The bellows is a necessary instrument in macrophotography for a high scale of reproduction. Conditions of use are particularly critical due to the drastic diminution in luminosity and the nonexistent depth of field at full aperture; focusing is difficult. So the bellows should only be used mounted on a stand, even if only a makeshift one, to reduce shake and hold the subject in focus.

As with tubes, once the scale of reproduction has been selected, one must calculate roughly what length of extension is required. After adjusting and locking the relevant knob, one can proceed to frame the subject, moving the whole assembly backward and forward. To center the focus the second knob is used, which can also be locked. In the rare case of shots taken with ambient light, the internal photocell will measure the correct exposure.

To calculate the extension factor, the formula already given, which is easy to remember, should be used: extension factor of exposure time = $(S + 1)^2$. Here is an example: with a 50 mm lens and a value of $S = 2$, one gets $(2 + 1)^2 = 9$. If the normal exposure time had been 1/125 second, with the bellows at that value of S, it would become $1/125 \times 9 = 1/13$ second.

With considerable extensions it will always be necessary to use flash. To determine the aperture, calculate the effective value under shooting conditions with the following formula: effective aperture = nominal aperture $\times (S + 1)$. The use of the bellows requires a calibration test of the system to establish the best conditions for exposure, with the camera lens

used either the right way around or reversed. In the second case, even the automatic bellows loses its advantage, as we shall explain in the following pages.

Lens Reversing Rings

Look once again at the diagrams on page 145. In the first diagram note that with a normal shot at medium distance the subject is far removed and the image is near the lens; in the third one the position is reversed. Normal lenses are designed to function at maximum performance as shown in the first diagram.

In high-power macrophotography, the lens functions as shown in the third drawing, that is, under different conditions from those it was made for. And in fact if we reverse the camera lens, we shall find that the quality of the image improves considerably.

For this reason, when a scale of reproduction above 1 is used, it is best to invert the lens. To do this a special ring is used known as a reversing ring, which has a mechanical attachment on one side to insert into the bellows and a screw thread on the other to hold the front of the camera lens. When the camera lens is mounted in this way, the rear part becomes the front and no further mechanical fitting is possible between camera and camera lens for transmitting automatic control.

Since lens reversing makes the whole technique of the shot more complicated, it should only be used when it really does improve the optical quality.

Every type of lens, depending on its constructional features, may be more or less suited for reversing. Generally, wide-angle and normal ones are most suitable for this sort of use. When the inverted camera lens is used, full aperture may be affected; since the rear lens becomes the front lens, full aperture will now be determined by this diameter. Camera lenses with a normal optical system have front and rear lenses of equal diameter and hence there is no need for correction. For retrofocal lenses or telephoto optical systems, certain modifications must be introduced.

With the inverted lens, a semiautomatic functioning of the diaphragm can be regained by using suitable accessories. A few will be mentioned as examples, using the terminology of the Nikon system.

With a BR 3 ring, inserted on the bayonet of the camera lens, which is now the front part, filters and other accessory parts can be mounted, because this ring has a screw thread which attaches in the normal way. With the BR 4 automatic ring, which has two bayonet attachments, male and female, automatic functioning of the diaphragm is maintained when it is used in conjunction with the special AR 4 double cable release. This accessory part is particularly useful because it greatly simplifies the process of shooting. It can also be used with nonautomatic bellows, with direct or inverted lenses. With an E 2 type ring, which is connected to the diaphragm mechanism, one can operate the diaphragm aperture itself with the cable release to see the image and focus it. Every device which simplifies the process of shooting is to be recommended as it leaves the photographer more freedom to concentrate on the picture.

Ladybugs mating. For subjects whose size is only a few millimeters at the most, as here, focusing becomes a real problem. Only when they are motionless is there time to frame them with ease.

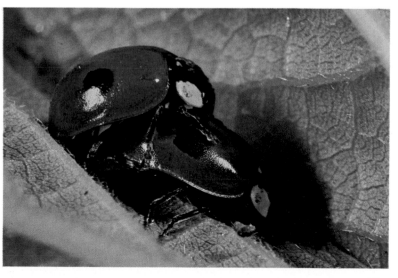

MACRO LENSES

Lenses made specially for close-up photography possess special optical and mechanical characteristics designed to give good resolution right up to the edges of the photograph. With a high scale of reproduction, lens aberrations must be corrected; it is particularly important to avoid image distortion. These features make macro lenses suitable for any other kind of reproduction. The range of focusing is greater and, by means of the full extension of the helicoid, the scale 0.5 is normally reached. The sub-

Diagrammatically macro lenses can be divided into four categories: normal, telephoto, wide angle, and zoom. The normal macro lens, with a focal length around 50 mm, is the standard one used, both for general photographic purposes and as lenses for reproduction, when used with rings and bellows. The 90–200 mm telephoto lenses are more specialized, and rather cumbersome on account of the considerable extension they have to reach. They are particularly useful when it is not easy to approach the

close-up shot and are a basic accessory to be used in combination with bellows for reproduction work or powerful magnification. One advantage which is readily appreciated is the continuity of focusing that permits the desired dimensions of the subject to be easily seen in the viewfinder, without the need for calculations or tiresome replacement of one ring with another. A wise choice would be the purchase of a macro in place of the normal 50 mm lens, which has the sole advantage of giving better luminosity.

The alternative is the macro telephoto lens, which is a more specialized

use, as in the case of a morphological survey of medical or nature subjects, special macro lenses are available such as the Medical-Nikkor 200 mm f/5.6, which has ring flash incorporated to give shadow-free illumination. A model which appeared recently, the Micro-Nikkor 200 mm f/4.5, has an internal focusing feature.

Shooting Technique

Up to the scale of 0.5 the shooting technique is quite normal. Continuous focusing avoids any complication and the dimensions of the image can be determined through the viewfinder. One

sequent range, from 0.5 to 1, is covered by using an extension ring, suitably selected, which is half that of the focal length.

The term *macro* or *micro* is usually given with the focal length. Traditionally, macro lenses have a focal length equivalent to that of normal lenses or short telephoto ones. At equal focal length, aperture is reduced for definite technical reasons. However, for macro shots small apertures are called for, so this is not a serious disadvantage. In certain cases, the reduced luminosity of the image in the viewfinder can create a problem. Usually the front lens is set back in the lens barrel so as to create an incorporated lens hood, which proves useful even when the lens is used in a reverse position, giving a more convenient lens-to-film distance. To allow ample depth of field, the minimum diaphragm aperture reaches f/32.

subject, either in scientific and technical work or in the wildlife photography of insects and other shy and fast creatures. The wide-angle lenses from 20 to 35 mm are lenses to be used with bellows to obtain large scales of reproduction beyond the value of 2; the shorter focal lengths enable one to get powerful magnifications even with normal bellows, which on average do not exceed 15 centimeters (6 inches) in length. Zoom lenses with macro positions are called macro lenses but rather inappropriately, as they do not have the same features as other macro lenses, but can be used to take the occasional close-up picture. The internal lens is positioned by means of a screw. Shots can be taken at a scale normally not above 0.3.

Which Macro Lens?

Macro lenses are ideal instruments for every kind of

choice, designed for uses like the wildlife photography of insects. These are instruments with very selective features, more cumbersome and costly but fairly light. On account of its long range, the macro telephoto should not be used above scale 1. In the photograph on the left, two macro lenses are shown: the Micro-Nikkor 55 mm f/3.5 and the 105 mm f/4. The length of the 105 mm is half that of the 55 mm; likewise, the subject-to-lens distance will be half to get the same scale of reproduction. This can be a decisive disadvantage in some cases as the working distance should always facilitate both the illumination and the shot. One solution is to use a good lens converter on the normal macro lens for occasional macro shots, which will increase subject magnification and retain the same minimum focusing distance.

For detailed and frequent

Above, at left: Comparing macro lenses of 55 mm and 105 mm. At a magnification of 1:1, the subject-to-lens distance varies with the length of the lens.

Above: With the macro lens it is easy and quick to take pictures under any conditions, finding the right dimension of the subject with the viewfinder.

can work flexibly and free-handed even with ambient light, if this is sufficient for shots with fairly small apertures. The difficulty is accommodating the high shutter speeds with depth of field. In many cases it may be of help to use high-sensitivity film, but if one is relying on definition obtained only with low-sensitivity film, it is essential to shoot in sunlight or with flash.

Automated exposure is even more useful here because small subjects give a much more variable tonality than larger ones. Once the right image scale is found, one will discover that it is easier to focus by moving the camera backward and forward. In practice this op-eration must be continually repeated to keep the right distance or to follow a subject. If the enlargement obtained is not enough, one can always add an extension ring, which must be automatic to maintain normal camera functioning. Aperture is reduced, as is shooting potential, in proportion to the length of the ring if a flash is not used or a tripod for static shots. Here it is helpful to make use of the classic methods for minimizing the danger of blur due to camera shake: cable release, lifting the mirror, or using an automatic shutter release.

Focusing will have to be done through the camera lens unless one has a rail device to insert between the tripod and camera. When using telephoto lenses or bellows, one should take extra care in handling and supporting the equipment because the unbalanced weight can easily damage the lens mount.

The most practical and flexible equipment for macro is shown on page 164: reflex with macro lens, adjustable arm bracket, small detachable flash easy to swivel.

Flash frees one from the problem of blur and depth of field: the maneuverability of the apparatus makes it possible to follow subjects in movement, varying the enlargement by means of the setting on the camera lens and regulating the focus by shifting the whole assembly. If subjects do not allow a close approach and one is not equipped with a spare macro telephoto lens, a lens converter can be used. With the small apertures needed with flash, quality results can be obtained in a practical and convenient way.

Ease of shooting not only allows concentration on the picture but also permits the most suitable position for getting the best results. If necessary, one must lower oneself, lie down on the ground, or climb a height to obtain a picture from the most natural and effective angle possible.

In insect macrophotography it is vitally important not only to judge the shooting distance with maximum precision, but also to avoid approaching so close to the subjects as to scare them away. The problem is solved by using a 100 mm macro lens, with which one can take shots at a 1:1 scale from a distance of 20 cm (8 inches), far enough not to frighten the insects. The bee in the picture below was taken from this distance.

THE WORLD OF PLANTS: FLOWERS

Flowers are the first subject for the beginner in macrophotography. They are found in all seasons, in gardens, fields, and woods. They do not avoid the photographer, and they offer an inexhaustible variety of shapes and colors. They seem to be the simplest of subjects because they already possess a harmony and beauty which instinctively draws attention. But often the pictures taken are rather disappointing and give only a faint idea of the original subject. This should not discourage the beginner. Photography is deceptive; its relative technical simplicity gives the impression that it is easy to take good photographs, especially when the subject is rich in color and in harmony. In truth, beautiful pictures are rare and are the fruits of a creative effort needed to convey the feeling of harmony experienced by the photographer by means of the elements of the language of photography. The photographer must become accustomed to looking at things in a photographic way; the image will be built up in such a way as to communicate something and not simply taken as it appears in the viewfinder. It is just like taking a portrait of a flower. Look at it carefully, see how the three-dimensional shape is transformed by varying the angle, how the structure of the leaves is rendered. The patch of color that catches one's attention will remain flat and discordant if there is no ordered and pleasing composition in the framing.

The eye selects and eliminates whatever jars by an automatic mental process; the camera, on the other hand, must be controlled by someone. In the picture, the colored areas should be harmoniously balanced and the background adapted so as not to distract attention. As soon as the subject has been chosen, it is vital to select a background. For complex and many-colored subjects like flowers, a simple background with a few blurred or shaded features accentuates the image and completes it. The most suitable natural backgrounds are a blue sky and the dark green of the underbrush dimly illuminated and kept distinctly blurred. If it appears that the background is not suitable, try changing the angle of the shot or look for another, similar subject in a better position.

Flowers and plants which grow wild in woods and valleys should not be picked for any reason. They are a natural heritage to be protected along with the rest of nature, which is there for us to photograph. In certain cases the photographer will have to use an artificial background, such as sheets of cardboard placed behind the subject. We recommend

Above: Tiny flowers of the grasslands, spontaneous, delicate, and almost unknown subjects. Large-scale reproduction is employed in order to photograph them, so the exposure is critical. Naturally, an indispensable condition here is the complete absence of wind.

Right: Example of a correct shot with effective illumination. Photographed from below, selective focusing is easier, the subject looks natural, the background does not interfere, and furthermore the plant appears placed in its own vegetational environment.

When the composition of a picture is considered, the number and nature of the elements which constitute it must be kept in mind. In the photograph above (Anemone sulfurea), the three flowers are perfectly focused and well framed; the background, which is sufficiently blurred and of varied color tonality, contributes positively to the picture.

that these be neutral and made to appear as natural as possible. Colored backgrounds almost always completely destroy the atmosphere of a picture, depriving it of any value for the nature photographer.

The most important means of controlling the background is focusing. As a rule, the subject should be completely in focus while all extraneous elements should be blurred. Colored masses of flowers in the background arranged in a certain harmony and blurred are often helpful for suggesting the natural setting of a meadow in bloom without being distracting. With a completely clear background, the subject becomes just one of the many elements present in the same picture.

Contrary to what has

been generally recommended, in flower macrophotography the use of the smallest possible aperture is not advisable. By means of the depth of field control button, which many cameras have, one selects the aperture which brings the whole subject into focus while blurring the background.

Shrubs and leaves which are too close, upsetting the composition, are moved out of the way by being folded back as required. First one must have a clear idea as to what the real subject is—one or more flowers or a whole group. Uncertainty on this point often leads to muddled pictures.

The Shot

It is advisable to have a low tripod in order to work

comfortably on a level with the subject. A pivot head mounted directly on a square wooden plank may be useful. With this very simple arrangement, the camera can be positioned at ground level, which is ideal for many small subjects. Some tripods allow the center post to be reversed; others have screw mounts on each end. By mounting the reflex camera as shown on page 155, one has a very firm system relatively easy to maneuver.

The availability of a solid support with adjustable height but not higher than half a meter (18 inches) from the ground makes it possible to take shots of flowers and small plants at the right and natural angle. In fact, when taken from above, a flower appears squashed on the ground and becomes confused with the background, which is too close to be blurred. Furthermore, with this accessory we can expose at fairly slow speeds without the risk of shake, at least

within the limits permitted by continual movement caused by light breezes, which are present even on calm days.

By means of pieces of cardboard or strips of plastic material the subject can be masked to photograph it with greater ease; sometimes it helps to hold the stem with wire covered in green plastic, which is easy to camouflage and bend.

Sunlight is preferable not only on account of the setting and the natural effect but also to afford control over the subject. With white cardboard strips it is even possible to change the illumination and soften contrasts caused by the direct rays of the sun. When the subject is very small, measuring only a few millimeters, flash will replace ambient light. Flash used with skill can give first-class pictures which are soft and natural, with masked resolution due to the extremely short exposure time, which eliminates any risk of movement.

Tiny Flowers

In any place where there is grass one can find very tiny, almost invisible flowers which because of their size are little known even though they are photographically interesting. Taking shots of them requires more preparation, as one has to work with a large scale of reproduction. In this field the most varied forms and colors can be discovered, which may be favorably compared to those of larger flowers that are usually much better known and well documented.

Rain

It is not very encouraging to have to go into the country in search of pictures in the rain, but the period immediately following rain is favorable. Nature appears as if reborn, vegetation takes on a resplendent quality, sparkling with reflections. Images of flowers with water drops have become inflated publicity symbols; yet, it is still possible to discover new and beautiful pictures which are strikingly effective.

THE WORLD OF TINY ANIMALS

To photograph animals of small dimensions a number of problems have to be overcome apart from the technical ones of shooting; one must know how to track them down and get sufficiently close.

The world of tiny animals is much more populated and more colorful and fantastic than the world of medium and large animals. Their numbers on earth are incalculable. Interest in these tiny inhabitants of the globe, scattered throughout every region, is richly rewarded by the breathtaking nature of the pictures which can be obtained. This is real wildlife photography, which can also be divided into the ambush and the stalking kinds. Generally speaking, the great abundance of insects and other small creatures, found above all in spring and summer in every wood and meadow, creates no real problem as regards subject matter. Insects are found everywhere in all seasons, and constitute an inexhaustible world with endless possibilities for interesting shots. A basic familiarity with the species can be very useful: an interest in the subject one is photographing broadens one's knowledge, which in turn increases the likelihood of tracking down the chosen prey.

Related to the problems of shooting, different categories of subjects can be distinguished. To begin with, there are slow creatures such as caterpillars, snails, and all creeping insects. These are the inhabitants of grass and low bushes, plant vermin or camouflaged insects waiting motionless for their

Above: Example of simple, efficient photographic equipment for stalking insects.

Below: Insects that don't evade the photographer are obviously the easiest to shoot but sometimes difficult to single out, as in the case of these mimetic creatures. At left: A caterpillar. Below: A leaf insect.

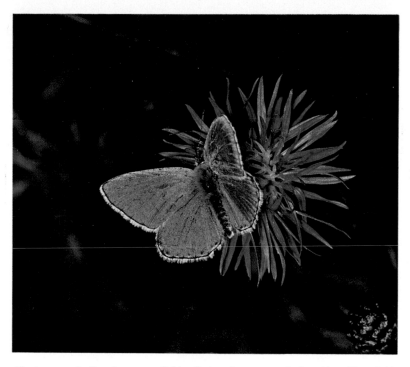

Butterflies are widely studied for the beauty of their ornamentation by nature photographers, who often succeed in obtaining splendid pictures rich in color. On page 170 the subject is treated in detail.

prey. To find them one must have some ingenuity and patience, because nature has given them a coat which takes on the color of their environment to perfection. The pictures of insects on the facing page effectively document this camouflage, as the surrounding environment is also visible.

Some of these mimetic insects are much sought after as photographic prey. The praying mantis is a remarkable subject on account of its highly expressive and unique mode of behavior. Then there are creatures fairly easy to follow such as ants, spiders, scorpions, etc. They are found without much difficulty, but elude the camera lens very swiftly. They can also be photographed in their lairs and hiding places.

Winged insects give the biggest problem due to their extreme mobility, but they are the most sought after on account of their beauty and gracefulness of form. Butterflies and dragonflies are typical subjects.

Shooting Technique

The techniques of taking macro shots of the plant and of the animal worlds

differ in some significant details. The world of plants gives the photographer all the time he needs for studying the subject and getting a picture which documents the harmony of form and color. The animal world, on the other hand, is movement, seizing the right moment, more a documentary than a search for form, but a comprehensive and interesting document. For this reason the equipment for macro wildlife photography is based on the use of electronic flash.

Insects which are not too mobile can be taken even without flash, but only when not too large a scale of image is required. The ideal equipment for this kind of shot is that shown in the illustration on the opposite page. It consists of a reflex with macro lens, an adjustable arm bracket, and a small flash unit. It can be safely hand-held or used on a tripod in ambush positions. For insects that are definitely unapproachable, a macro telephoto lens is very useful. As an alternative, as we have already mentioned earlier, a lens converter may be used which in conjunction with a small aperture has only a

negligible effect on the optical quality and it maintains the minimum focusing distance unchanged.

The shooting technique is satisfactory with equipment like that described up to a scale of reproduction below 1, but the shot becomes problematic with a larger image scale because then subject dimensions get small, luminosity drops considerably and it is difficult to follow the subject and see it. For this kind of insect, taking shots under controlled conditions is unavoidable, with the use of artificial light to make focusing easier.

Useful accessories to keep in reserve are a viewfinder with angle view for shots on the ground; tripod and clamps for ambush photography; and a cable release. Motor drive is an extra which is only rarely useful, as the electronic flash unit needs some time for recharging. A white strip of cardboard may help to brighten the shadows in the case of motionless subjects. Once the camera is ready to take the shot, one must show one's ability at locating the prey, approaching it slowly and focusing rapidly. Diaphragm

adjustment is set by a table of distances. As usual, when the subject is worth the extra effort, one should take a few additional pictures, varying the aperture.

SHOTS OF INSECTS IN FLIGHT

By means of the techniques illustrated in the preceding pages, one can take shots of winged insects while they are resting on flowers, branches, or leaves, capturing them in a moment of repose during their continuous search for food. In flight insects become extremely mobile. Even following them with the eyes is difficult on account of their greatly reduced size and speed of movement. The acrobatics of the common fly in flight are unpredictable and amazing.

Trying to photograph insects in flight with normal equipment, as one soon discovers, is a vain endeavor, such are the practical and technical difficulties to overcome. An En-glish naturalist, Stephen Dalton, with a deep interest in the insect world and a persistent enthusiasm for photography, tackled this problem and resolved it through years of study and trial and error. The photographs shown on these pages bear eloquent testimony to his achievement.

Let us see how he worked. As a first step he solved the problem of the direction of flight, which is wholly unpredictable. Then he had to have sufficient depth of field. In practice a corridor had to be created within which the insect might steer itself by preference and at which the camera lens was to be kept pointed. This can be a 100 mm lens. Shooting with aperture stopped down gives sufficient depth of field and a distance from the area of shooting suitable for the equipment. Another serious difficulty to overcome was that of the high velocity of flight, further emphasized by the scale of reproduction, which must always be kept around 1. Under these conditions normal measures are ineffective.

Even the fastest speeds of mechanical shutters are insufficient to freeze such rapid movements. With the scale $S = 1$, the image on the film moves at the same speed as the subject. A subject that flies, say, at 5 meters (16 feet) per second will have covered 5 millimeters (2/10 inch) in a thousandth of a second. To have a well-defined image, during exposure the subject must not move on the film more than a quar-ter of a millimeter. So the real exposure time needed to freeze these movements is around 1/20,000 second. Only flash can reach such fast speeds; in fact, the normal computer flash duration may approach 1/50,000 second but the intensity is proportionally less and is inadequate when small diaphragm apertures have to be used. So it has been necessary to design high-intensity flash units with a discharage speed of 1/20,000 second.

A further difficulty Is that the small dimensions, the speed, and the unforeseeable nature of the path render useless all attempts to manually control the release. A highly sophisticated electronic trip device system is required, because the time lapse of the shot must be well below the time taken by the insect to leave the framed field, and more so because it must be sensitive to a very minute body such as that of an insect. It has been necessary, therefore, to develop two novel instruments. The first is a special additional shutter which can open with a time lapse around 1/500 second. Normal focal-plane shutters have a lag of 1/20 second in a reflex 35.

The second is a highly sensitive detector which can react to the passage of a hair. This device operates with a ray of light, which is reflected through mirrors to form a fairly impenetrable barrier. The whole assembly, which was complicated and cumbersome at first, has been simplified on the basis of actual experience, and has now become portable for use on location; in practice the insects are captured, placed in a dark area of the apparatus, and allowed to find the exit toward the light, passing through the electronic trip device. Be-

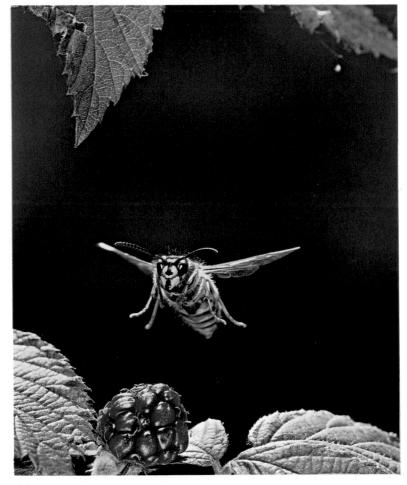

Photographs taken by Stephen Dalton with his trip devices. A wasp (on the left), and a lacewing taken with the multiflash method (opposite page).

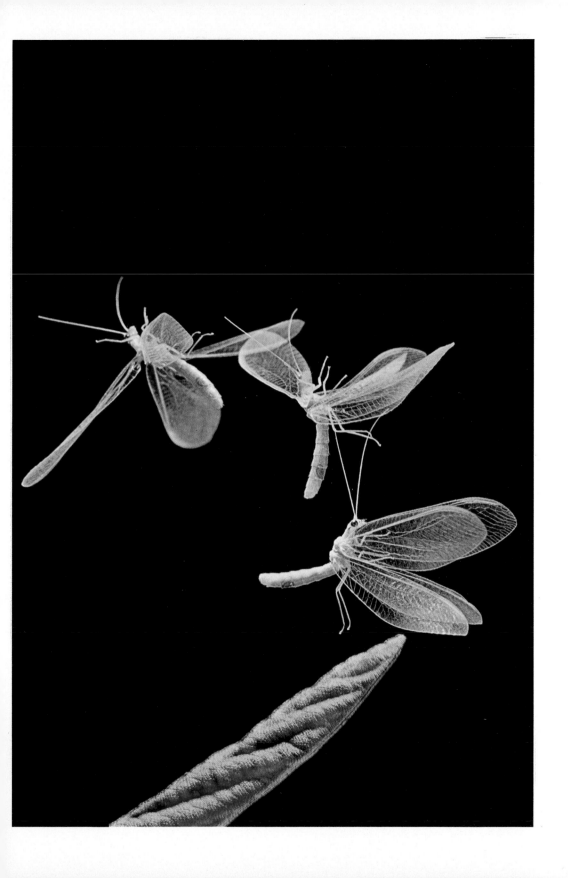

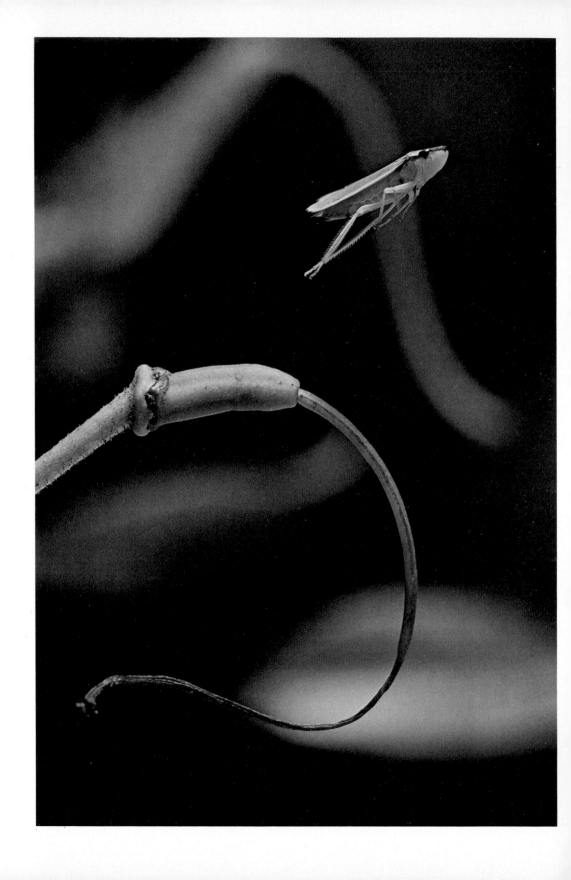

Leafhopper Graphocephala coccinea *(opposite page)* and damselfly Lestes sponsa *(below)*. As can be seen, the insects reveal an astounding harmony and grace in flight.
In all the photographs by Stephen Dalton on these pages, the illumination is soft, background clean, and there is real depth of field. These are pictures that take one's breath away, not only on account of their beauty but also because they reveal novel and fascinating aspects of nature which could not be seen by the naked eye. On the right: A simplified diagram of an electronic trip device used for taking pictures of insects in flight.

fore returning to their own world they will leave behind a remarkable and astonishing image of themselves.

The photograph on page 167 was taken with an extremely fast sequence of flash while the shutter was open. In this way it is possible to follow and study the movement of the wings and the dynamics of flight. This extraordinary achievement has opened up new possibilities of documenting hitherto unknown aspects of the world of nature, through images of breathtaking beauty. It seems that insects acquire in flight their true identity and grace of carriage, which is also true of birds.

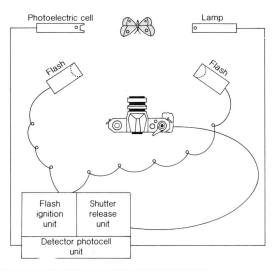

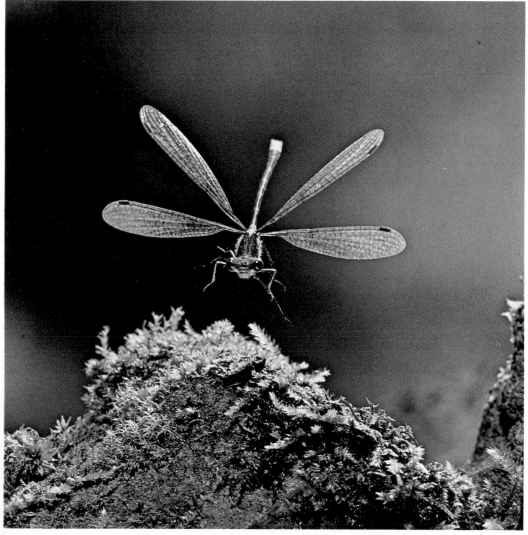

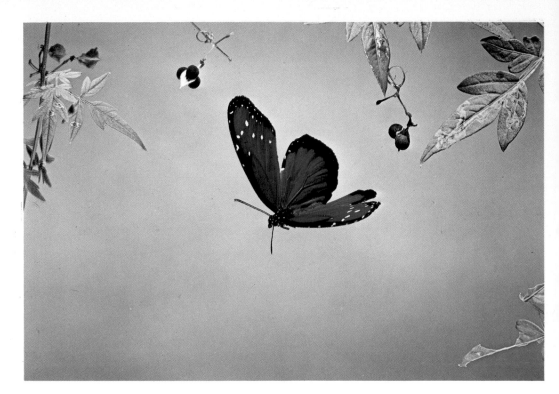

BUTTERFLIES, FIRST LOVE

Among the many kinds of insects which can be found in a field or garden, perhaps only the butterfly does not disappoint the expectations of the naturalist starting out as a photographer; the brilliant colors and harmony of the wings are enormously enhanced in the enlargement obtained by projecting the transparency. The classic picture of the butterfly on a flower with outstretched wings is very effective; variations on the theme are inexhaustible and always fascinating and pleasing. The shooting technique is fairly simple and is similar to flower photography. Flowers and butterflies are symbols of gracefulness and charm, and their portrayal must be matched by our own ideas in new combinations.

Butterflies, like all flying nectar-collecting insects, should not be followed but awaited by placing the camera near the flowers that customarily capture their attention and which can provide suitable backgrounds for photography. The camera is fixed on the tripod at a suitable distance, and focusing is set, checking also the background behind the flower. The pictures are shot at the right moment by means of a cable control, taking care to move slowly and avoiding casting any shadows on the insect, even for a moment, which would make it inevitably take flight. One must also pay attention to the movements of the flower, which can take the subject out of focus.

A simple and practical expedient to keep the butterfly on the flower consists in placing a drop of water mixed with honey on it. The most propitious time of day is the morning, because butterflies tend to keep their wings wide open then to capture the little sun available, and they are slower in their movements. By observing their habits and peculiarities over a period of time, one will be able to learn their behavior pattern and position oneself near the right flower to take shots in complete comfort.

The lens with a focal length around 100 mm is ideal because it allows sufficient distance to avoid disturbing the subjects.

The large spectacular nocturnal moths may be photographed with flash and with the help of a light source used as a decoy. A lamp placed in the garden will attract moths and other insects of all kinds. On humid, warm moonlit nights the activity of these insects increases, and it is easier to catch them on flowers; with the help of a flashlight, focusing is adjusted and the pictures are taken with the ordinary flash outfit.

Shooting in the dark of night requires accustoming oneself to the inconvenience of having to use the flashlight to achieve the best framing, and always under conditions of poor visibility, but it isn't difficult to obtain striking images once the favorite flowers have been identified, usually the strongly scented ones. Butterflies of woods and tropical and humid zones are sometimes difficult to approach because of the very nature of the terrain and the height on trees or marsh reeds at which they normally rest. In this case one can use real telephoto lenses up to 300 mm, or lens converters on an ordinary macro lens. The large dimensions of these magnificent insects makes shooting fairly easy. Above all, a good knowledge of their habits and the patience to wait to catch them in their magic moments is required.

Danaus gilippus: *A very delicate picture of a butterfly in flight, taken with the help of the electronic trip device described previously.*

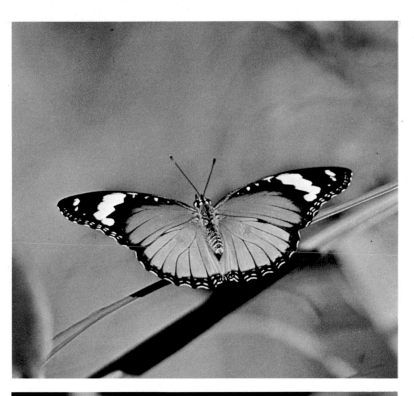

The mimic butterfly (Hypolimnas misippus): A fine example of an effective photograph of a butterfly. The insect with spread wings is entirely in focus; the background, sufficiently blurred so as not to disturb the composition, allows some elements of the natural environment to be visible.

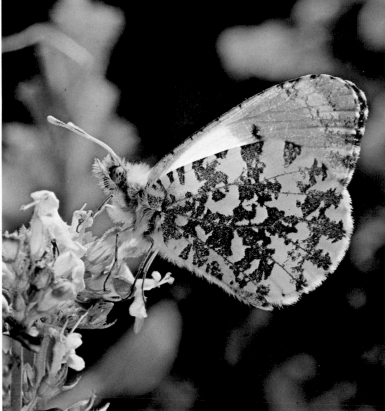

Orange-tip butterfly in profile, a good picture from a compositional point of view, further enhanced by the modeling which results from effective illumination and exact focusing.

PHOTOMICROGRAPHY

Photomicrography is by definition photography through the microscope. The term photomacrography strictly means all shots of medium-size subjects which are too small to be observed and studied by the naked eye and are still too large to be really observed under the microscope.

Characteristics of the Microscope

Basically the microscope consists of an objective lens; an ocular lens, or eyepiece; and an extension tube with a mechanism for adjusting the distance between the object, or specimen, and the objective lens. The length of the tube depends on the optical characteristics, that is, on the desired power of magnification; the diameter must be sufficient to avoid internal reflections, which spoil the quality of the image.

The objective is the optical element which, when placed near the specimen, forms the enlarged image conveyed to the eyepiece, which further magnifies it. The feature which is always given is the power expressed in magnifications, for example, 40X. Other specifications given on good-quality apparatus are the aperture number, the estimated length of the microscope tube, and the name of the optical system. If a mark P or PLAN is shown, this means that the most important aberration has been corrected, the one which causes the formation of curved images that make it impossible to get reproduction with clear definition on the surface of the film. Since the objective and eyepiece together make up one single optical system, it is extremely important that they should both be made by the same firm so that the best possible optical performance can be obtained.

From the magnification number on the eyepiece, one can calculate the enlargements obtainable by multiplying this number by the power of the objective. Thus an eyepiece of 10X used with a lens of 30X will give a total magnification of 300X. The viability and versatility of the instrument depends on the kind of performance given by the system comprising the stage (which holds the slides), the condenser lenses, and the mirror. If the condenser lenses are equipped with a diaphragm and adjustable focusing, a much more accurate illumination is possible, with improvement in the quality of the image.

Types of Microscopes

The microscope is an instrument with an enormous field of application, available with a very wide range of features at a great variety of prices. The models which will interest the naturalist are basically the student's microscope and the research microscope.

Microscopes for students are of medium quality, generally more than sufficient to meet the needs of amateur photomicrography. They are fitted with a single eyepiece, a turret lens holder for three objectives, and a simple mirror condenser for adjusting the illumination. This is the ideal instrument to begin with, because lower quality microscopes can give disappointing results. If the optical quality is good, the purchase of a separate accessory for illumination will improve performance and facilitate shooting.

Research microscopes are complex and versatile instruments, expensively priced, usually already preset for photographic work. For this purpose they are normally equipped with three eyepieces, two for convenient direct vision and the third for permanent connection to the camera. The sophisticated instrument system which they are fitted with allows for a very accurate and extensive control of the most important parameter, illumination, which is left to the photographer. Some types are even fitted with zoom lenses for arriving at the optimum magnification in the lower scale of values.

Equipment for Shooting

The technique of microscope photography is different from the ones we have looked at up till now for a whole series of reasons, which are listed here. It is basically laboratory photography, which requires special equipment and a specialized though not difficult technique. The camera becomes an accessory part of the microscope, with the main function being a useful container for the film. Since with reflex cameras one can use the viewfinder to see the image, even simple microscopes can be used for photography without difficulty. The through-the-lens exposure meter plays a less important part because the luminosity of the shots often diminishes to such an extent as to fall outside the range of measurement. The illumination is entirely artificial, obtained with tungsten lamps or flash.

On the left: Apparatus for photomicrography. The camera body becomes an attachment of the microscope.

Essential instruments for photomicrography are: a reflex camera, a microscope, an attachment to join them together, an illumination system.

Attachment of Reflex to Microscope

With the normal camera lens detached from the reflex, the camera must be fitted to the eyepiece at a height which allows the film (and viewfinder) to receive the rays coming from the eyepiece beyond the point of intersection. Before doing this, focus the microscope until a sharp image is obtained, and turn the lamp until the whole field is uniformly lit.

Methods for firmly connecting the camera are of two kinds. The first is a special nonflexible attachment, one end of which plugs into the camera body mount and the other end of which is secured to the eyepiece. This is the simplest and most economical system; but as the weight of the camera rests on the microscope, the apparatus will only work properly if the microscope is sufficiently strong and steady.

Furthermore, the focusing mechanism of the microscope can be adversely affected and every vibration of the camera due to release or winding will be transmitted to the optical part. In research microscopes the attachment is built on a very solid structure which does not produce these drawbacks. The second solution is to use an adjustable bellows attachment or an attachment of lightproof canvas and a separate stand to hold the camera. A reproduction stand will do or even a tripod, but this is less practical. To avoid reciprocal jolting of the two units, the microscope must be firmly secured. The film plane must be set exactly perpendicular to the direction of the luminous rays.

The Illuminator

This is a lamp designed especially to provide illumination in the field of microscopy. The simplest kind utilizes normal opalescent lamps, while the better ones use low-voltage lamps, which are much more efficient and compact and can be focused with

greater ease and precision. The lamp must be capable of being effectively centered and hence should be fitted with a condenser lens with adjustable diaphragm and focusing control. The effective usefulness of this fairly expensive accessory is well worth the price.

Besides this special instrument, other light sources can be used. Occasionally it may be possible to use the powerful beam of a slide projector, which has the advantage of being automatically cooled and of having a color temperature suitable for films in artificial light. The flash is placed to one side, as it does not replace the illuminator but is added to it for shots of subjects which have a tendency to move.

In the diagram: How the camera body is fixed to the microscope by means of a rigid coupling. Bellows attachments are also available which are less simple but in many cases safer.

In the photographs below, on the left: Macrophotography of the compound eyes of a horsefly, a picture typical of large-scale reproduction which requires a photographic technique similar to photomicrography but without using a microscope. On the right: A similar subject, taken with a microscope, reveals the hexagonal structure of the compound eye of an insect.

THE TECHNIQUE OF SHOOTING THROUGH A MICROSCOPE

The quality of the image does not depend on the camera, which only plays the passive role of receiving the image, but on the lens of the microscope and on the illumination. The following operations are carried out through the camera body.

Loading of Film

Black-and-white film can be used to distinguish and highlight areas of differing color by means of colored filters. Generally speaking, color slide film is the most suitable. If tungsten light is used, the film must be chosen so as not to alter the color balance of the light used, or the appropriate conversion filters should be used, which are inserted underneath the microscope stage and not in front of the camera. If flash is also used, it is best to remove the filters.

eras with interchangeable viewing screens can use a suitable one such as the Nikon M type, which has a crossed grid on a clear field. If the split-image focusing screen gets completely clouded over, it renders the vision of the subject itself difficult. The simple ground-glass screen is very good. Cameras with interchangeable viewfinders can use viewfinder lenses which magnify up to six times the size of the image on the focusing screen. Focusing is greatly simplified.

View on the Ground-Glass Focusing Screen

The lack of light makes the use of normal focusing methods impossible. Cam-

Measuring the Light with the Stop-Down Method

By switching on the electric circuit of the through-the-lens meter of the reflex camera, the light actually falling on the film is measured. There is no camera lens and no diaphragm aperture when shooting through the microscope, of course. Cameras with automatic exposure with aperture priority can also work in automatic. Those with spot-measuring exposure meters enjoy a considerable advantage because they can fix on the real subject, normally surrounded by bright or dark fields, which falsify the mean measure.

Other Operations

Shutter speeds normally used are in seconds, and hence all possible care must be taken to avoid vibrations caused by, for example, lifting the mirror or repeated use of the cable release. Shutter speed is the only available means of varying the exposure with normal equipment and illumination.

The following operations are carried out with the microscope:

(1) Selecting the objective and hence the magnification; the less this is, the better will be the image and with a higher degree of contrast; the resolution of details remains constant within certain limits.

(2) Focusing. This is effected with two kinds of control knobs, one for gross adjustments and the other for fine ones. Refocusing has to be done frequently and repeatedly to find the most suitable point; the presence of viewfinder lenses on the reflex facilitates the operation.

(3) Adjusting the mirror and the condenser lens under the microscope stage. In this way image contrast, light diffraction, and depth of field are controlled. It is an important operation for the quality of the image, but requires a minimum of experience; the viewfinder will reveal the effects of the various adjustments.

The following are controlled on the illuminator:

(1) Distance and angle. Normally one endeavors to make the distance needed to get a well-focused illuminating light as little as possible, in practice about 15 to 20 cm (6 to 8 inches); thus the exposure time is reduced to a minimum.

(2) Focus and diaphragm aperture of the condenser lens, which give uniform illumination of the microscopic field.

Illumination

Illumination has a decisive importance not only for clarity of vision but also to obtain good resolution in the image. With equal optical equipment, very different results can be obtained by simply varying the parameters of the system of illumination. There are different systems that make use of highly specialized apparatus, but the kinds suited to the amateur nature photographer can basically be reduced to three: bright-field illumination, dark-field illumination, and polarized light.

Bright-field illumination. The light coming from the mirror is suitably focused so as to give uniform illumination over the field area; the subject remains immersed in the beam of light and is rendered visible by transparency. This is the most commonly used meth-

Volvox algae, *which form typical spherically shaped gelatinous colonies.*

174

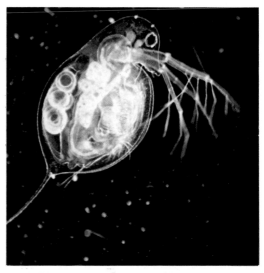

Above, on the left: Bright-field illumination is achieved, as shown, by concentrating the luminous beam on the mirror so that the subject is illuminated by transparency. This is the method normally used for transparent subjects (like the skeleton shapes of radiolarians in the photomicrograph above) suitable for reproduction at high magnification.

On the right: Dark-field illumination, and photomicrograph of daphnia (water flea). Opaque subjects and living, transparent ones are accentuated more by this kind of illumination, which is achieved by directing the luminous beam onto the subject, as shown in the diagram.

od because it lends itself to the study of fine structures at a high degree of magnification, to laminar substances such as the wings of mosquitoes, and above all to sections of animal and vegetable tissues. These are often artificially stained to highlight their structure, which in infinitesimal thicknesses become transparent. In this way it is easily possible to observe the inner structures. First, one adjusts the light of the illuminator and the angle of the mirror to obtain uniformity over the field area; then one regulates the diaphragm aperture and the focus of the condenser lens under the stage so as to get optimum resolution and contrast. This is the most commonly used meth-

od with very small subjects because of the high degree of luminosity which it gives.

Dark-field illumination. Transparent illumination is not applicable to opaque and three-dimensional subjects, such as insects. These must be illuminated by reflection, directing the beam of light onto the specimen from above. The subject will appear illuminated against a dark field with a more accentuated contrast, rendering the colors more brilliant. Even transparent subjects can be more visible on a dark field. Small animals, like the water flea shown in the photograph on page 175, for example, can easily be observed in reflected light, while in transparency they become too diaphanous

and flat, without detail.

Above 50 or 60× magnification, it is not advisable to use this method of illumination for low image luminosity. From a strictly photographic point of view, any transparent image will be rendered more effective when the background is dark; on the other hand, the reflection of light on the screen dazzles the sight and makes colors appear pale. Photomicrographs on a dark field in projection are extraordinary for their saturation and the contrast shown even by the softest tones.

This kind of illumination may be obtained by more elaborate methods than those enumerated. One of these consists in placing a suitable screen in the lumi-

nous beam, which blocks out the center part and allows only the outer rays to focus on the subject. Only some of the rays refracted by the specimen can then enter the objective.

Double and asymmetric illumination. Photomicrography depends almost entirely on techniques of illumination. As one acquires more and more confidence in handling the instruments, it is easier to find the conditions that best suit microscopic subjects.

With two independent light sources, the specimen is lit simultaneously from above and below. By varying intensity and direction, one can find conditions in which the lights play on the surface of the subject so as to restore its depth and solidity, keeping the colors full and brilliant, and giving the subject a delicate transparency. Another way is to introduce asymmetry into the field area, partially masking the luminous beam. The subject will thus

be shown up more effectively.

The Electronic Flash

The nature photographer will be able to discover the unexpected fascination of the microscopic world by observing the life which stirs unceasingly in a drop of water lifted from a pond. Hundreds of microscopic creatures run frantically across the circular field in a jungle of scum, hiding themselves in the tiny vegetation, fighting and repro-

ducing under our eyes. To observe these transparent creatures, which do not require magnifications beyond 50X, dark-field illumination is perfect, or, better still, balanced double illumination, which brings out the three-dimensionality and the pale colors.

Taking live shots of these subjects presents problems. Speeds normally used are over a second, especially with dark-field illumination, even if movements are fast; more in-

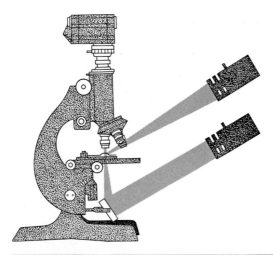

tense light tends to give off too much heat, evaporating the whole of our microcosm. The answer is to use flash, which poses the problem of how to adapt it for this specialized purpose. By using a small-size flash, one can easily build a support on which the illuminator or the flash can be used in the same position. It is even better to find a mobile mirror system which deflects the two lights alternately—that of the illuminator for vision and that of the flash for the shot. A third solution, even more practical, is to incorporate a lamp in the flash reflector; in this way a picture can be shot at any time while carrying out the observations on the subject.

The right exposure is found by experiment. To vary the intensity of the light, gray filters must be inserted over the luminous beam, as it is impractical to move the flash back and forth since it must normally occupy a precise position to give the desired effect. Here a variable transformer simplifies the operation, making it easily possible to work out exposure tables. The only system capable of giving the correct exposure even in a specialized case is through-the-lens automated flash.

Illumination with Polarized Light

Polarizing screens similar to those used in the polarizing filter have a particularly interesting use in microscopy. Many mineral substances, as, for example, certain rocks made up of crystalline agglomerates, possess the peculiarity of being optically active, that is, they produce unusual optical phenomena when placed in a field of polarized light.

The principle of the polarization of light is applied differently in each of two situations. When the polarizing filter is placed in front of a camera lens, the unpolarized light in the sub-

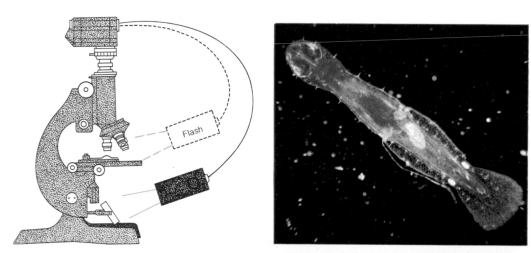

Above: With supplementary flash (dotted lines in the drawing) one can take photographs of subjects in movement, as these examples show. Above: An arrowworm. Right: Cyclops with eggs.

On the facing page: By using two sources of light as shown in the diagram, a more three-dimensional image is obtained, suited to shots of animated subjects. The two photographs obtained by this method show a larva of a bristle worm (above) and pluteus larvae of an echinoderm (below).

ject, a panorama or an environment, is filtered out. In microscopy, on the other hand, the subject, a thin specimen of rock, is placed between two polarizing screens. If the rock under examination possesses a special property known as double refraction, an extraordinary optical effect will be produced, which is continually changing as the two filters are rotated. Even with the simplest microscopes, polarized-light illumination can be obtained. For this purpose it is sufficient to adapt two Polaroid-type polarizing sheets. Insert one inside the eyepiece and the second under the stage. In this way the mineral sample, previously cut into a very fine section by means of a special technique of microtomy, will be inserted in the light polarized by the screen underneath, called the polarizer. If the substance is double refractive, slightly displaced rays of light will pass through the second screen, called the analyzer, producing breathtaking coloring, which is very bright and saturated.

By turning the eyepiece,

with the analyzer attached, one alters the polarization plane, and constant variations of tonality as in a kaleidoscope are obtained. Turning the eyepiece produces different effects from those produced when the sample itself is turned. By means of more complex optical devices, the contrasts in the image can be altered. For example, by inserting suitable prisms, special effects can be obtained which are useful in the scientific field to illustrate differences which cannot be shown in any other way. The possible uses of these techniques are numerous and specialized; but even with ordinary equipment, truly remarkable pictures can be obtained.

For microscopes of certain quality, polarizing prisms are available as an accessory. Normally, low magnifications are used, from 20 to 50X, which give more luminous images. As can be seen from the three examples illustrated, common garden rocks turn out to be much less gray and uniform for the microscopist than would appear to the naked eye.

THE UNDERWATER WORLD

Whoever dives into the sea discovers even at a depth of a few meters a different world of silence and dreamlike colors, of astonishing creatures, and of endless variety. This extraordinary natural environment brings man face to face with dangers and difficulties which can only be tackled and overcome with special preparation and suitable equipment.

Underwater photography has contributed enormously to the documenting and publicizing of scientific discoveries in the submarine world, but this is an activity which requires energy, time, and equipment such as no other kind of photography does.

"Aquacity"

"Aquacity" is a term that describes the ability to move in the water with natural spontaneity without making unnecessary efforts. To approach the discovery of the underwater world, this first level of skill must be acquired, which is easily and safely mastered under the attentive guidance of an expert who un-

derstands the difficulties. For this purpose it is advisable to entrust oneself to a qualified instructor.

Acquiring aquacity means learning to control the movements of one's body as well as to overcome the fear of water and depth. The former needs exercises to accustom the muscles to coordinate their movements for working in the water, reducing waste of energy to the minimum; the latter, on the other hand, demands a conditioning of the mind based on faith in one's abilities and the capacity to keep calm, in the deep conviction that the sea is not a hostile environment. All divers should dive only in the presence of someone able to offer immediate help. Underwater training courses are structured in such a way as to offer instruction in progressive stages of aquacity: the technique of snorkeling, then the technique of using aqualungs and scuba equipment in general, and finally how to cope with the unforeseen, how to function and work in the water. At

the first level, photographic activity is limited, insofar as the time available to search for the subject and take the picture is normally confined to one minute. It is a simple technique which anyone can master, by which one can take shots of subjects on shallow bottoms a few meters in depth.

At the second level one is trained in the use of air cylinder aqualungs, and freedom and scope of action are considerably widened. The necessary equipment requires investing a fair sum of money, as well as considerable personal involvement, which is justified, however, by the much greater potential for taking shots. The ability of the underwater photographer depends to a large extent on his underwater capabilities, hence only the third level of aquacity will give that practical safety needed to choose the right angle, change equipment, etc., without having to concern oneself with actual underwater technique.

The air-cylinder aqualung is a widely-used device, allowing prolonged immersion without any particular difficulty. The period of immer-

sion is calculated on the basis of tables derived to assure safety. This period diminishes as depth below the surface increases. For example, at 20 meters (65 feet) immersion can last 50 minutes, while at 40 meters (130 feet) it is reduced to 20 minutes. Depths below 15 or 20 meters (50 or 65 feet) in many areas are richer in photographically interesting subjects; to get pictures with a certain amount of photographic and naturalist interest, one must consider underwater equipment which will give the necessary freedom to reach the environment one intends to document.

Underwater Light

Light conditions underwater are very different from what they are on the surface, and this introduces a deci-

As can be seen from the two photographs on these pages, underwater life offers the camera lens a vast choice of subjects of the most varied forms and colors.

In the chart: Water acts on light like a blue filter and as depth increases, colors are absorbed and their intensity progressively reduced.

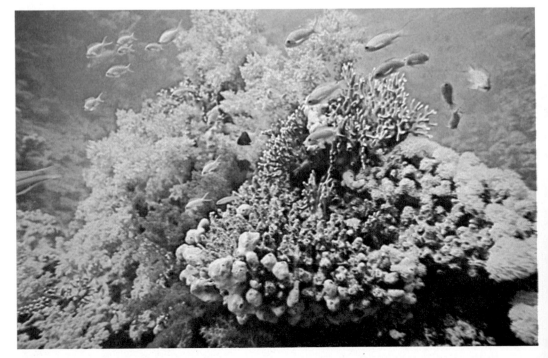

	f/16
m 5	f/11
	f/8
10	f/5.6
20	f/4
30	f/2.8

sive change in the criteria for taking pictures. The main reason for this difference is the progressive absorption of luminous radiation by the strata of water, which act like actual blue filters, increasing in density depending on depth, and which progressively block the red component and then the yellow and green ones of white light. Absorption varies considerably with effective conditions of the water, but some average guidelines can be given which are reliable in clear water.

Up to 3 meters (10 feet), the light is still fairly balanced, the red is only partly absorbed, and the still high degree of intensity facilitates shooting. From 3 to 12 meters (10 to 40 feet), the dominant blue becomes progressively more intense, red is totally absorbed, and the intensity of light decreases rapidly. The clearness of the water and favorable sunlight permit satisfactory shots with ambient light, but the flashgun often is useful and in many cases necessary. From 12 to 35 or 40 meters (40 to 120 or 130 feet), natural light becomes almost monochromatic, an intense blue, while the ex-

tremely low level of luminosity necessitates the use of flash for every kind of shot. This is photographically the most rewarding area for interesting subjects.

Beyond 40 or 50 meters (130 or 165 feet), immersion becomes progressively more difficult and dangerous for those who do not possess considerable experience and adequate equipment. Furthermore, periods of immersion are steadily reduced. Flash is always necessary, together with floodlights to light the way. Other phenomena modify the behavior of light in water: diffusion, produced both by the liquid itself and by particles in suspension, which depreciates the quality of the image, weakening the contrast; and refraction, which causes a light wavelength to be deflected when passing from air to water, due to a different degree of density. This phenomenon is the one responsible for most of the optical problems in underwater photography, such as the effect by which the photographic image appears larger by about one-third than it would be if taken on the surface.

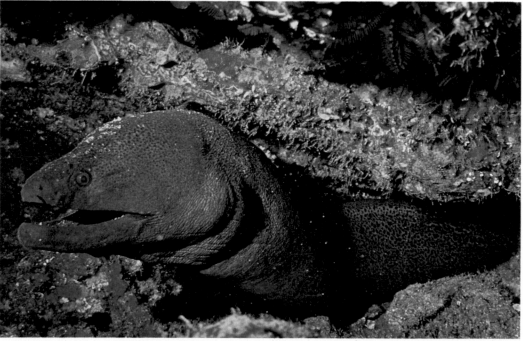

UNDERWATER PHOTOGRAPHIC EQUIPMENT

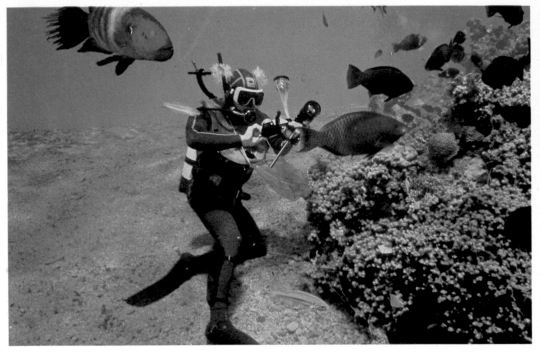

Above: Underwater shots require personal diving equipment and photographic equipment which is completely waterproof.

On the left: Nikonos III camera and Sekonic Auto Lumi L-86 underwater exposure meter in plastic housing.

On the facing page: The marine environment is unusual and fascinating and always provides an effective background for the subjects.

From what has been said already, it is obvious that the underwater photographer must be adept underwater, properly equipped, and have adequate experience.

The choice of photographic equipment depends on the kind of shot, on the depth at which one intends to operate, and on the quality of picture one is aiming for. If high quality together with sufficient maneuverability and reliability are required, the choice is not very wide:

• The Nikonos underwater camera.

• The traditional 35 mm reflex fitted with underwater housing.

• Larger-format 6 × 6 or 6 × 7 cameras with similar waterproof equipment.

The Nikonos System

The Nikonos system is the only equipment designed specifically for underwater photography which offers top-quality performance, maneuverability, and unsurpassed toughness. The camera first launched under the name of Calypsophot has been made by Nikon in three separate versions: Nikonos I, II, and III. A new model, IVA, will

be available which has new automatic exposure and a through-the-lens metering system. This model will use the same accessories and lenses as the widely used model III. The mechanical solutions adopted are specifically designed to secure ease of functioning and exceptional robustness for a camera, adequate waterproofing, and functional elements reduced to the essential. Model III shows certain improvements which ensure safer and more regular functioning; for example, the tiresome irregularity in the spacing of frames due to the type of film

transport has been eliminated. Nikonos is a nonreflex camera, with interchangeable lenses, in aluminum alloy, pressureproofed and tested down to a depth of 60 meters (200 feet). Waterproofing is secured through toroidal O-ring sealing.

The camera is made up of three parts: an internal body, in which the film is inserted; the outer structure, into which the camera is slipped; and the camera lens, with anticorrosive steel sockets. The camera, once closed, becomes waterproof and dirt- and dustproof; owing to these char-

acteristics, it is also used by explorers in the desert, in the mountains, and wherever environmental conditions would place other traditional cameras in difficulty.

Four lenses are supplied with the outfit, for which special viewfinders are provided to be inserted in the flash-carrying hot shoe. The 35 mm f/2.5 lens normally fitted to the camera is widely used, suitable for above-surface and underwater shots. The short 80 mm f/4 telephoto lens is only occasionally useful in the water, but can be useful above surface for environment shots and coastal subjects, for example, amphibians. The 28 mm f/3.5 wide-angle lens is the most suitable for underwater shots; in fact, its angle of view in the water corresponds to that of the 35 mm, on account of the refraction effect. The fourth lens is a 15 mm f/2.8 wide-angle, with a very high performance rating, but which is expensive and

rates as a more professional instrument. It is equipped with a special optical viewfinder with a dome lens port incorporated.

These last two wide-angle lenses can only be used underwater and require their own viewfinders. The built-in viewfinder has no range finder and is not suited to underwater sighting but is only useful above the surface with the 35 and 80 mm lenses. Each lens is fitted with knobs to adjust the focusing and diaphragm aperture; pointers indicate the depth of field. The shutter, with vertical movement along the focal plane, gives speeds of 1/30 to 1/500 second and exposure B; synchronization with flash is possible with speeds up to 1/60 second with two kinds of contacts, X for electronic and M for flashbulbs. Many accessories made by Nikon and other manufacturers are available for this camera; flashbulbs and electronic flash, extension tubes, supplementary

lenses, viewfinders, camera lenses. For ambient light shots, an exposure meter is useful: the Sekonic Auto Lumi L-86, in plastic housing, is practical and comes from Nikon. A model designed specifically for underwater use which is more sensitive is the Sekonic Marine II, which measures an angle of 10 degrees.

In close-up photography special frames must be used which, when attached to the camera, limit the field area. There are three kinds, to be connected to the corresponding supplementary lenses. This system operates fairly well with stationary subjects, but not with fish which do not allow themselves to be easily framed, and often flee in fear.

An attachment which helps one to see the image better than the direct-vision finder is the optical viewfinder. It is important that this frames a wider field than that exposed on the film to facilitate the choice of subject and composition.

The flashgun with electronic flash or flashbulbs is an accessory which widens the field of action so considerably as to be an essential part of any underwater outfit. This matter will be dealt with later; here we can usefully mention the connection between the camera and the flash unit.

There are different kinds of attachment plugs for fixing the flash lead to the camera. The Nikonos III is different from the previous model. Although most underwater flash units are adapted to take the Nikonos attachment, it is best to make sure when purchasing and equip oneself with appropriate adapter-reducers to pass from one system of attachment to another.

One last accessory worth mentioning is the arm bracket, which makes it possible to carry the camera, flash, and exposure meter with one arm, leaving the other free to operate adjustments and make the shot.

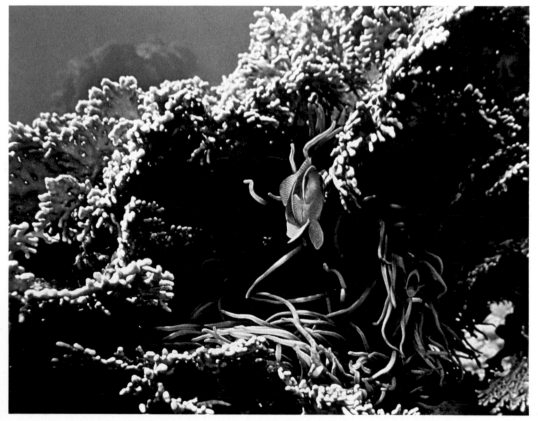

REFLEX CAMERAS IN WATERTIGHT HOUSING

As an alternative to using a special underwater camera, one can use an ordinary camera protected inside watertight housing. There are three main kinds of cameras which can be adapted for underwater use: the compact 35 mm nonreflex, like the Rollei 35, the normal 35 mm reflex, and the 6 × 6 and 6 × 7 large-format reflex. For occasional use one can make an economic choice with the compact 35 mm; but only a reflex camera can give that versatility and high-quality performance capable of satisfying every requirement. The 35 mm format is preferable to the larger ones on account of its lower cost and greatly reduced bulk: only for truly professional needs does the better quality given by the 6 × 6 and 6 × 7 formats become an advantage.

Addition of the waterproof housing renders the photographic equipment very cumbersome. Nevertheless the 35 mm reflex offers the availability of many camera lenses; direct-vision focusing through the ground-glass screen; the ready availability of accessories and servicing, such as automatic exposure and motor drive. The housing is less bulky on the more recent reflex cameras, which make them easier to handle.

Underwater Housing

Housing should possess the following requisites: It must be waterproof and resistant to pressure down to a depth of at least 60 meters (200 feet); resistant to atmospheric agents and salt; in good working order; and manageable. There are three categories:

(1) Housing made of an elastic structure. Suitable for simple, economical cameras, generally can only be used at a depth of not more than 10 meters (30 feet) below the surface. The camera is operated by means of a kind of internal glove.

(2) Housing in nonflexible plastic. This is the most widely used on account of reasonable price and good overall characteristics. High resistance to pressure enables plastic housing to be used down to a depth of 80 or 100 meters (270 or 340 feet), while total resistance to atmospheric agents and relative lightness makes it suitable for all purposes. Housing produced in many versions by Ikelite is also very popular.

(3) Housing in aluminum casting, which uses special alloys. These are the most resistant and practical, but also the most expensive.

We shall now examine the criteria which determine the usefulness of underwater housing.

• Resistance to pressure. The greater this is, the more reliable the equip-

Below, left: Canon F-1 in a plastic housing. On the right: Sports viewfinder mounted in place of the normal pentaprism. It allows for vision of the whole field even with the eye at a distance of 6 centimeters (2½ inches) from the eyepiece. Bottom, left: With the camera inserted in the housing, the framed image is easy to see and appears on the focusing screen as it does in the photograph on the right.

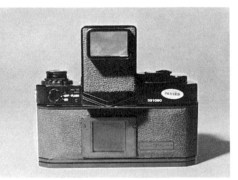

ment will be, and the more immune will the camera be from the danger of water infiltration and accidental knocks.

• Manageability in and out of water. Greater bulk is always a negative factor, while the weight is almost canceled out in the water; for example, a pressurized reflex which weighs 10 kilograms (22 pounds) out of water, may weigh only 100 grams (less than ¼ pound) in water. Another important aspect is maneuverability. The camera controls must be easily accessible to the hands, without necessitating cumbersome movements, and the operations needed to open and close the housing must be easy. The controls, transmitted by means of crank mechanisms, are those relating to focusing, diaphragm aperture, shutter speeds, wind, and release. The least frequent adjustment is that of shutter speed, normally preset in advance and kept constant, because one often uses either the flash or

Below: Refraction of light in water. The diagram shows how the image of a fish taken with a wide-angle lens is affected by the flat and the dome lens ports: with the dome lens port the refraction effect is neutralized and an undistorted image is obtained.

On the right: Interchangeable plexiglas lens ports.

the fastest speed, in line with shooting conditions and the sensitivity of the film.

• Interchangeability of the lens port. The best housing allows replacement of the single glass lens port, which is normally used, with spherical or double glass ones, which are necessary when using lenses with a wide angle of view.

An accessory which can facilitate the operation of shooting is motor drive; with this one can get sequence shots, without sudden movements.

The built-in exposure meter creates some problem as regards the legibility of the values shown on the indicator; even in quite favorable conditions, the light is low, and the moving index pointer is often hidden by the housing.

The Flat and Dome Glass Lens Ports

If a ray of light falls perpendicularly onto a strip of transparent material, it passes through it without suffering any deflection, while if it falls upon it at an angle, the more acute the angle of incidence is, the greater will be the deflection. Besides being deflected, the rays of light produce color diffraction fringes which spoil the quality of the image. This explains the difference in behavior between the flat and dome glass lens ports

in water; using a dome glass lens port, the ray of light at every point falls perpendicularly onto the surface and there is no diffraction and deflection. These optical effects are directly visible, since the camera behaves like our eyes. With a flat glass lens port, distances seem less by about 25 percent; the focal length of the lens is lengthened by one-third. For example, a 35 mm lens becomes equivalent to one of about 46 mm focal length. Furthermore, the quality of the image is weakened at the edges due to diffraction. With a dome glass lens port, the angle of the shot in water is the same as it would be above surface; consequently the image on the film will not be enlarged but will be the same as if taken out of water, and the quality of the image will remain normal even on the edges. With the dome glass lens

port, problems relating to the use of the wide-angle lens in water, which are greater the shorter the focal length—that is, the wider the angle of shot—are masterfully solved. The drawback is that each camera lens must be fitted with the right kind of lens port, insofar as the radius of curvature and position in relation to the camera lens must be calculated on the basis of the focal length. It is therefore advisable to purchase equipment which has been fully tested by the makers. The lens port is normally made with plexiglas, which has a good degree of transparency and pressure resistance; for a better distribution of the pressure on the spherical surface, a lesser degree of thickness for the single glass lens port is also required. Bear in mind that plexiglas must be handled with care because it is easily scratched.

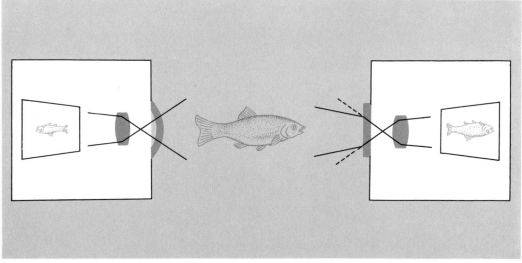

AMBIENT LIGHT

While it is easier and more usual to photograph with ambient light above surface, in the water the contrary is true. Sunlight, even at a medium depth, becomes too weak for taking shots of moving subjects and the dominant blue weakens or erases all other colors. The factors determining the technique of photography are the amount of sunlight available, the transparency of the water, and depth. The criteria for calculating the exposure are different from those used above the surface.

Water is an agent that absorbs and colors light, drastically narrowing the photographer's field of action. It can be said that most underwater pictures are taken at a distance from the subject of less than 3 meters (10 feet). To exceed this thickness of water, one needs a considerable degree of clarity and favorable sunlight. High-sensitivity film is useful because it allows shots to be taken even with low levels

of illumination, but does not solve the problem of distance, because with an increase in distance in water, the contrast and the three-dimensional quality of the image are reduced

Calculating the exposure underwater involves a degree of uncertainty. It depends not only on clearness of the water, diffusion of light, tonality of the seabed but also on depth and lens-to-subject distance.

With color film, the exposure must be calculated with great precision. For subjects at a distance of not more than half a meter (1½ feet), in water which is clear, the following guidelines can be given:

• Moving from an environment above surface to one underwater, one diaphragm stop is lost.

• A further diaphragm stop is lost at a depth of 1 meter (3 feet) and also after 5 meters (15 feet), 10 meters (30 feet), 20 meters (60 feet), and 30 meters (90 feet). Furthermore, if the subject is more than 2 meters (6½ feet) distant, the diaphragm aperture must be opened one stop.

The Exposure Meter

Light can be measured with an underwater exposure meter or by an internal exposure meter if a reflex camera is being used.

With the hand-held exposure meter, one must measure the light reflected by partly approaching the subject to center it better, preferably pointing the photocell downward to avoid the luminosity coming from the surface of the water. If the bottom is bright or very dark, the reading may be distorted. With the built-in exposure meter the reading is carried out in the same way, by approaching the subject to eliminate anything which might deceive the photocell, but without varying the distance greatly because otherwise the reading would be distorted owing to the reduced distance through water.

Sunlight

In the first depth range, down to 8 or 10 meters (25 or 30 feet), ambient-light shots are easy enough and the coloring is blue and quite acceptable. Ideal light conditions are present during the middle part of

the day in bright sunshine. The luminous rays which filter through the water can give good contrast and unusual three-dimensional effects if the water is very clear. In the presence of clouds, the diffusion of light maintains a fairly constant luminosity during the middle hours of the day. When the sun's angle of inclination drops below 30 degrees, the light in the water diminishes rapidly.

The Position of the Subject

As sunlight strikes the water from above, one can

*Diagrams show possible positions of the camera and subject in relation to sunlight, and relevant photographic examples. On the right: The slanting light near the surface provides three-dimensional, strongly contrasted images, as in the case of this shark (*Odontapsis taurus*).*

Below: Pictures taken from the direction the light is coming from have an effective setting with rich colors and soft, uniform light.

On the facing page: Shot taken in backlighting. The shadows have been toned down by a soft flash.

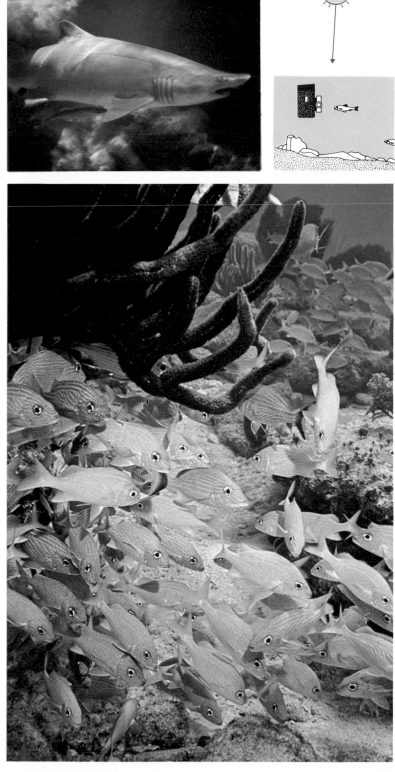

draw a plan of three positions for shooting in relation to the direction of light:

• The subject is taken from the side. Illumination is three-dimensional, and highlighted. If the bottom is bare or invisible, however, and dark on account of the water mass lying above, the subject will appear isolated, without any point of reference.

• The subject is taken in the same direction as the light, that is, from above. This is the condition in which the strongest and most brilliant colors are obtained.

• The subject is taken with backlighting. The problems encountered above surface are increased by the turbidity of the water and the constantly high contrast due to the direction of light underwater. A light flash is very handy to brighten the subject, which would otherwise remain completely in shadow.

ELECTRONIC FLASH

For many years the only equipment widely used underwater for artificial illumination has been the flashbulb, which can be useful when a particularly powerful flash is required. But flashbulbs are losing ground on account of the rapid growth of electronic flash, which has become practical, effective, and reliable at a much lower running cost. They are much more "ecological" than flashbulbs, and simpler and handier to use, especially in water, as one does not have to replace the bulb after every flash (burnt flashbulbs should never be left in the sea). The cost of the electronic flash unit is higher to begin with, but in a short time, with moderate use, it certainly is repaid. For these reasons it is advisable to think in terms of purchasing electronic flash, which is an almost essential accessory in the water but also very useful on land. Up to a few years ago its use in water was regarded as being dangerous and as having a very cold light, less suitable than the ordinary non-blue flashbulbs; the growing popularity of these accessories shows, however, that these drawbacks have been eliminated or substantially reduced. A warmer tone on the flash can be obtained simply by using a salmon-colored filter which some manufacturers supply for this purpose.

In underwater photography, flash reveals dazzling colors, astounding chromatic combinations which nature seems almost to want to keep jealously hidden; thus the pictures obtained often turn out to be extremely fascinating.

The electronic flash units used in water can be the normal kind, appropriately protected in watertight housing, similar to the ones used for cameras. Good power, rapid recharging, and sufficient range are all desirable characteristics for underwater use. Waterproof housing is available for flashguns of medium power like the Philips 38

CTB and the Braun 2000; other housings are designed for small flash units like the Metz 303.

Flash equipped with a computer to control the luminous discharge cannot be used in the water on automatic because the light reflected by the film onto the direct-reading sensor does not correspond to the effective illumination (this is a point we shall deal with a little later).

Two useful accessories are the variable transformer, which allows adjustment of the light discharge in accordance with the type of shot, and the slave flash, which eliminates the need for cables and leads, which are always awkward when using two flash units (the Philips 38 CTB, for example, has a photocell built in which acts as a slave flash). Housings for flash possess the same characteristics as those for cameras; they are smaller in size and simpler, however, and only have on/off controls.

It is very important that the movable arm bracket connecting the flash head to the camera should be maneuverable, but of sufficient length to allow for positioning nearer or farther away depending on the distance from the subject. Furthermore, it must be easy to unfasten underwater, whenever it proves desirable to deploy the camera and the flash in separate positions. Special care must be taken to keep the electric contacts

in a state of repair to minimize the risk of an electric failure and to prevent the electric battery from discharging itself too rapidly.

Underwater flash guns, designed specifically for this kind of work, are also available. They are an advisable choice for underwater photographers who frequently use flash. Robustness, compactness, and ease in use are the desirable characteristics, while they are of average price and medium capacity. Some models possess features which make them practical and handy for use in water. For example, the Marine Strobo Professional has a variable transformer of three levels to suit different kinds of shots, range, and macrophotography.

The Apollo Sea Master has a sensor which controls the luminous discharge with a light signal. The most interesting and practical solution, however, is that of the recent Nikon model SB101, which uses a system of keeping the remote sensor SU-101 separate from the flash, to measure the light reflected from the subject toward the camera with automatic control of the luminous

discharge. In macrophotography especially, this solution can greatly simplify the problem of exposure.

Flash Technique

When using flash, one must take into account how water affects the spreading of light. The radius of effective

Above: Philips 38 CTB electronic flash, in special plastic housing.
Below: Underwater electronic flash Nikon SB-101 with separate sensor SV-101 inserted on the hot shoe.

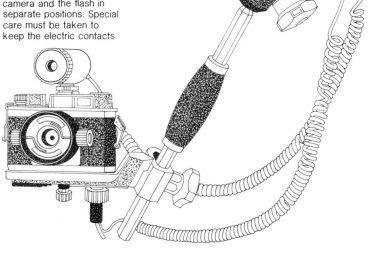

action of the underwater photographer remains limited, and the best way to get good quality pictures is to approach the subject and use a wide-angle lens. Even the most powerful flash does not normally penetrate farther than 3 meters (10 feet) underwater.

The method of illuminating the subject is very important: if the lamp is placed near the camera, small particles suspended

On the left: Underwater with artificial illumination, the lamp must be placed, as shown in the lower diagram, near the subject and at an angle so as to reduce to a minimum the diffusion of light.

In the photo below: Example of flash photography with dark, watery background.

Bottom: Example of a picture in the right setting with a light background, which enhances the darker subject. The side angle of the flash has produced a shadow in the background which lends a feeling of depth.

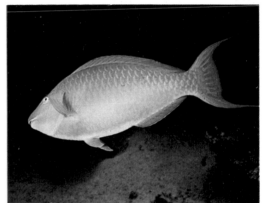

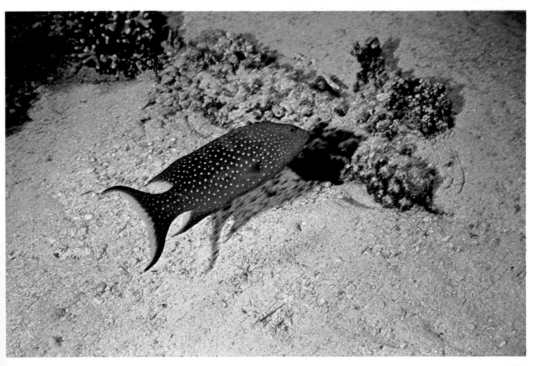

in the water in front of the camera lens will be strongly lit up, given their proximity to the source of light; a myriad of bright, sparkling dots will produce a fall in the color contrast, like a haze effect. If, on the other hand, one illuminates the subject holding the lamp near it but as far as possible from the camera lens, the cone of illuminated particles will remain substantially outside the field of the shot. Lamp positions which give the most natural effects are those which simulate sunlight from above, slightly at an angle, to give a relief effect. Different angles of inclination should be tried out, and the effect of flash can be simulated with the help of a flashlight.

Exposure with Flash

As a rule, the flash unit is held at a certain distance from the camera, so that the subject is illuminated from an angle. The light discharged by the flash diminishes in intensity along its path to the subject due to absorption, becoming progressively bluer. Hence, determining the diaphragm aperture on the basis of the guide number must be done by taking the overall distance from flash to subject to camera into account, in contrast to the method used above surface. The other two factors governing exposure are the clearness of the water and subject and background tones. The best solution is to arrive at some useful equivalents with one's own flash in average conditions of use; with a little experience you will be able to guess what diaphragm aperture to use in relation to the distance. However, experts advise taking shots with at least two different diaphragm stops whenever the subject merits it.

One factor to bear in mind is the effect of the angle of illumination on exposure. When using a wide-angle lens, it is sometimes necessary to have baffles mounted in front of the flash to increase the angle of radiation. The effect on exposure is calculated by a number multiplied by the guide number.

UNDERWATER TECHNIQUE

Color slide film undoubtedly gives the greatest satisfaction in underwater photography. Color is something immediate and spontaneously readable, the background blue instinctively calls the sea, the underwater environment, to mind, while the corresponding uniform gray of black-and-white prints communicates no definite image, but rather leaves the picture flat and confused. The use of negative color material does not give encouraging

results, because the dominant blue is not compensated for in the calibration of automatic printers, and filters throw all the other colors off balance.

The Choice of Photographic Equipment

The underwater photographer's gear consists of his personal diving outfit and, obviously, the photographic equipment. An important accessory is the underwat-

er flashlight, which is very useful for singling out subjects and facilitating focusing with the reflex camera. The choice of photographic equipment depends on how frequently one intends using it, and on the availability of traditional cameras of good quality. The third deciding factor is the overall cost. Underwater photography, on account of its special complexity, must be planned in detail. On the basis of past experience, one must choose the diving area, the length of time and depth to which

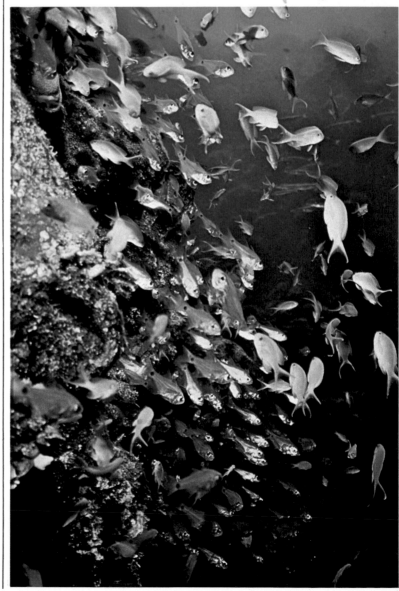

Pictures taken with artificial illumination.
In the photograph below of an octopus, note the balanced illumination of the flash on the subject and the natural lighting in the background; the picture is thus rendered pleasing and interesting.

one is prepared to go, and the equipment to be taken.

It cannot be over-stressed that one should never attempt diving unless one feels in good physical health; when tired or fatigued, the speed of one's reflexes and the concentration needed to shoot at the right moment will fall short and results will be disappointing.

Two endowments which the underwater photographer must certainly possess are patience and precision. For every dive the equipment needs a careful checking of the working parts, which must be kept lubricated with the right silicone grease; the camera must be preset for the kind of photography to be carried out; the exposure meter set at the right degree of sensitivity, shutter speed and aperture set at the normal stop; the flash should be equipped with a fresh battery or the power unit well charged.

The range depends on the number of frames in the magazine and on the number of flashes per charge. For the 35 mm, the magazine with 36 frames is always advisable, and for the 6 X 6 camera, the 220 format with 24 frames; and for flash, high-capacity batteries. From time to time the small batteries in the exposure meter also need to be checked.

When entering the water the camera must be ready to shoot. If the preparation procedure follows a consistent operational pattern, it will become spontaneous, precise, almost automatic. Entering the water, one will be able to assess conditions in the water and light conditions; if there is a fair degree of clarity, it will be possible to take some pictures with ambient light, while if it is turbid, macro-photography will be more suitable. It is best not to get too close to the bottom

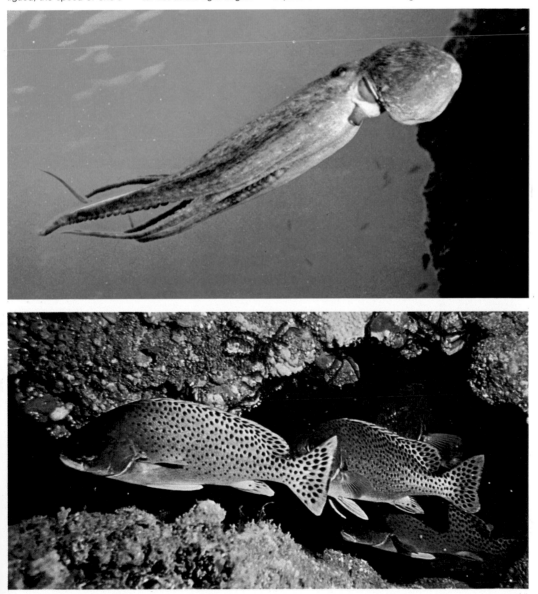

so as not to stir up fine particles, which take some time to settle again.

If one finds oneself in a current, it is best to try and approach the subject against the current; the water will be cleaner and approaching will be safer and quieter.

As soon as a subject is located, the picture must be thought out and programmed, so as to coordinate movements to reach the right distance and shoot with confidence. As with any other natural environment, often the first impression is that there is very little to photograph; as one gradually adjusts to the environment, an unexpected world is revealed, teeming with life. Each dive underwater becomes a discovery of a new environ-ment, a fascinating micro-cosm, which requires many such dives to know and document.

In the underwater world the photographer may be attracted by different subjects depending on the goal he has set himself; he might wish to document an environment and its life, or to study rare species or ones of special scientific interest. More frequently it is the extraordinary chromatic effect offered by marine life which is pursued. The coasts of tropical zones are a paradise for the underwater photographer on account of the enormous variety of subjects with astonishing colors that can be photographed without much difficulty. In the Mediterranean there are coastal areas rich in underwater life, but it is often necessary to dive to quite considerable depths to find interesting subjects.

The difficulties encountered in tracking down and approaching a photographic prey often provide a stimulus rather than a reason for discouragement, analogous with what happens in wildlife photography.

In this connection it should be mentioned that molluscs and static invertebrates such as starfish, gorgonia, sea anemone, and cerianthus give no photographic problems, while mobile and shy subjects, like almost all large prey or those found only at a great depth, are the coveted subjects. For photographing large prey, a short telephoto lens mount-ed on a reflex camera may prove useful; focusing through the ground glass screen is valuable because, working with ambient light, one has to use a fairly wide aperture, and a focal length of around 80 mm gives poor depth of field. While maintaining sufficient distance, one can shoot the prey at full exposure.

When flash is used, it is advisable to be careful of anything which may be illuminated excessively and produce tiresome "holes" of light in the transparency; hence, avoid aiming at potential flash highlights. It is useful, however, to carry out various tests to judge the effect of the flash in different positions and to learn how to control light and give the shapes relief and depth.

Even taking stationary subjects requires a certain know-how. Any sudden movement can frighten these strange creatures that close themselves up rapidly, losing their spectacular appeal. To enhance the colors, use lighting at an angle, uniformly spread over the entire subject, choosing if possible a dark background to accentuate the shapes.

On the right: Sedentary bristle worms (Spirobranchus giganteus).

Bottom: The cylinder anemone, Cerianthus membranaceus.

On the opposite page: Sea anemones (Anthozoa) and sponges.

UNDERWATER MACROPHOTOGRAPHY

Close-up photography can give a great deal of satisfaction to the underwater photographer and presents no special technical difficulties. Here the problem of dominant blue is absent, because the distances through water are small, and even the turbidity of the water, within certain limits, is of minor importance. Furthermore, the macrophotograph almost requires the use of electronic flash, both in water and on land. Small subjects are fairly numerous, are found easily, and are very photogenic on account of their rich coloring and variety of shapes. No nature photographer can fail to be impressed by the astonishing, almost abstract beauty of these tiny inhabitants of the temperate seacoasts.

Equipment

Two underwater photographic systems, Nikonos and reflex in waterproof housing, solve the problem of close-up shots in a different way. The non-reflex Nikonos camera uses bars fixed to the camera body to cover the frame area; the camera lens may also have supplementary lenses and extension tubes. The advantage of supplementary lenses lies in the fact that they can be mounted or removed in water, in contrast to tubes; in practical terms this leaves one free to change the type of photography without having to resurface. The outfit is comprised of three lenses and three field frames, which can be used with 28, 35, and 80 mm lenses. A 1:2 scale of reproduction is achieved with good results providing very small apertures are used. Extension tubes give a better quality image up to the edges, especially with larger scales, but they are less

Below: Nikonos camera fitted with accessories for close-up shots—supplementary lens and field frame.

A sea slug, Antiopella cristata, which has a structure that accentuates morphologic and chromatic characteristics to make it conspicuous. This phenomenon is very rare among marine invertebrates, since they tend to camouflage themselves rather than make themselves conspicuous.

Another sea slug with brilliant colors, a creature that inhabits the Red Sea, near Eilat, Israel.

practical than supplementary lenses because they require exposure compensation (not simple ones to calculate), as the greater lens-to-film distance must be taken into account. The drawbacks of this system are the difficulty of framing moving subjects with the field frames, as well as visualizing the image taken. In fact the technique is simple and works quite well with stationary subjects, but fish move off too rapidly.

In this field, reflex cameras display all their versatility and functional capacity; direct vision becomes indispensable in obtaining accurate focusing and choosing the framing with due care, bearing in mind that with transparencies errors in composition are not easy to rectify.

With the reflex the same accessories can be used as are employed above surface, apart from the bellows. The waterproof housing places no limitation on the use of supplementary lenses, although extension tubes, even with the reflex camera, cannot be removed in water. Housing with interchangeable lens ports provides an attachment in some cases for the use of supplementary lenses or tubes. Other kinds, on the other hand, enable one to control the insertion of supplementary lenses from the outside; this is a valuable feature because one often changes the subject or the scale of reproduction during the same dive.

An accessory which is useful and practical in wa-

ter is the macro lens; focusing from infinity down to a few centimeters with no break in continuity is a real advantage which leaves one free to choose the most suitable framing and scale of reproduction by simply turning the focusing ring. The focal length of these lenses, around 50 mm, is particularly suitable because it does not require excessive close-ups, facilitating illumination and shooting.

The Shot

With both systems already mentioned, the shooting technique adopts similar criteria: Flash is always used; the sensitive material used is color slide film; the diaphragm aperture must never exceed $f/8$. For this kind of close-up shot, compact flash units with limited capacity are more than sufficient. The advantages of electronic flash are fully exploited where it is fitted with a variable transformer, which ensures that only the light strictly necessary is used and increases the number of flashes, and hence its independence. The short distance from

light source to subject ensures a much softer, more embracing illumination, which makes the colors deep and brilliant. The speed of flash also eliminates the problem of blur; in fact, with ambient light and a fairly small aperture, it would be rare that a shutter speed sufficient to avoid blur would be possible, bearing in mind that in water one cannot keep motionless and finding a natural support is a problem.

The small diaphragm aperture is necessary for sufficient depth of field to compensate for a certain imprecision in focusing due to the uncomfortable working conditions. In close-up the focus is obtained more easily by moving the camera nearer to and farther away from the subject to find the most suitable position, rather than turning the focusing ring. In fact, with small scales of reproduction, the lens-to-film distance is similar to the lens-to-subject distance. Hence, by altering the focus, the scale of reproduction is altered, which, of course, may not be desired. Calcu-

lating the aperture is the only real problem; flash units in waterproof housing can only be operated manually. (This applies to the automated ones as well, as we have already seen.) Only the new Nikon underwater flash has a detached sensor, thus permitting automatic exposure. As a rule, determining the correct aperture is done by trial tests; in practice the apertures which may be used are three or four in number, from $f/8$ to $f/22$, and with a little experience one will find a personal method with reference to standard conditions of film speed, type of lens, distance, and color tones of the subject.

The distance of the lamp from the subject must be roughly equal to that of the camera lens; the flash must operate from an angle and from above, and the luminous beam must not strike the lens directly. With fairly powerful flash, it is useful to be able to adjust the luminous discharge with variable voltage; otherwise there is a risk of overexposure, even with the diaphragm stopped down.

Macrophotography is a technique which can give great satisfaction to the underwater photographer owing to the astonishing variety of flora and fauna found fairly easily even at moderate depths.
In these examples documentary interest is coupled with extraordinary forms that make fascinating images.
On the right: Stenopus hispidus.
Below: Macrophoto of the microscopic polyps of red coral.

On the facing page: A colonial anthozoan, typical of that multiform group of marine creatures which lead sedentary lives or creep slowly along the sea bed.

SIMULTANEOUS ABOVE- AND BELOW-WATER SHOTS

These pictures are the only ones which can be taken in water without the need of underwater cameras. They always look impressive, and unique, arousing the layman's interest, who will ask how they are done. In fact, if the line of separation between water and air is sharp and continuous, it might seem like a hoax.

The technique needed to produce them is fairly simple but requires a certain commitment and special equipment, which one has to make oneself. An ordinary reflex is placed in a watertight box, one side of which is glass, transparent and sufficiently strong. As can be seen from the drawing, this container is fixed and ballasted to make it stable and firm.

Mounted on a small solid tripod, the camera is placed on the bottom of the box. To compose the picture from above, one must have a viewfinder with angle view if the reflex is not equipped with a detachable pentaprism. The camera lens should be a wide-angle which gives ample depth of field, sufficient to keep the nearby surface of the water in focus and at the same time the natural environment outside. In this way framing is greatly simplified; each subject seen will be caught in the picture.

The trickiest problem is illumination. The two environments, above and below the water level, have different luminosity, so that the exposure calculation for one will be too dark or too bright for the other. In the photograph below the proximity of the otter to the glass has simplified taking the shot, whereas in the picture on the page opposite the lighting was balanced with an additional flash strategically stationed near the end of the stretch of water. In this way the author of this exceptional shot, George Silk, succeeded in simulating sunlight filtering into the stream and in illuminating another silent inhabitant of the same natural environment.

To take a picture like this one, the photographer has to plan it section by section, find the right conditions for shooting, and have the patience to wait as well as the good fortune to see different, concomitant events happening. One

also needs considerable environmental awareness to watch and anticipate the behavior of the animals so as to arrange the ambush positions with care. In this kind of situation, motor drive and remote control are extremely useful, as they allow one to remain hidden at a sufficient distance. The box must be camouflaged and sealed to muffle the noise of the camera release; one must also avoid distracting reflections on the inside of the glass.

Below: Fawn and trout, by George Silk, an exceptional photograph showing two different worlds in the same natural environment, almost magically in contact.

On the opposite page: Canadian otter photographed using the same technique.

In the diagram the watertight box with the glass front, which can be used to take photographs like those shown here. Note, on the left, the electronic flash mounted on a tripod.

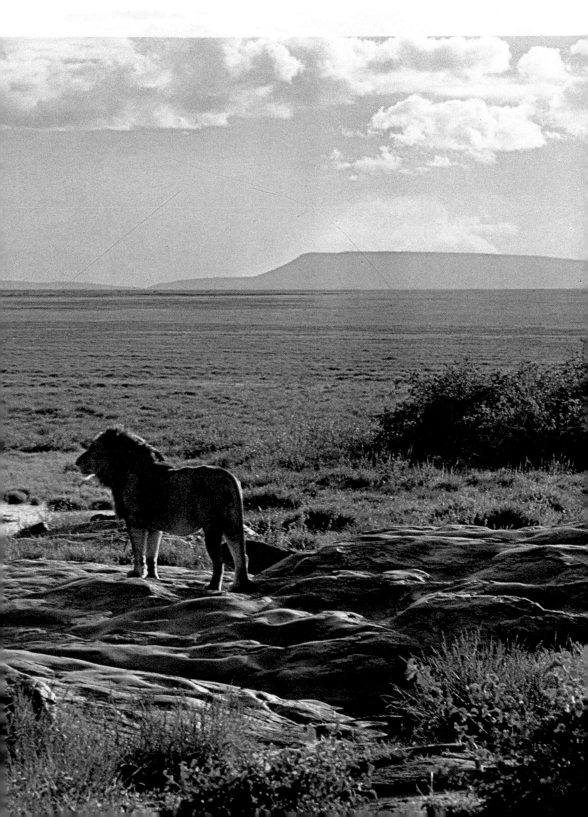

SAVANNAHS AND PRAIRIES

These natural environments will be treated together because the technical photographic problems which they pose for the nature photographer are similar.

Considered from strictly zoological, geographic, and climatic points of view, the prairies of North America and Australia and the South American pampas are characterized by warm summer seasons with fairly harsh winter periods. The scant rainfall brings about the spread of extensive stretches of low-lying grassland. In the savannahs, on the other hand, the climate is never too cold since there is no sudden change from summer to winter. Precipitation is abundant during the rainy seasons, alternating with

periods that can be extremely dry. Stretches of grassland are thus produced which are less even, with low-lying hardy vegetation and typical scattered trees, alternating with large open areas.

From the nature photographer's point of view, these biomes, or environmental organisms, have many characteristics in common. To start with, the uniform flatness of the terrain poses no real problem for getting the correct exposure. In the tree-planted savannah, however, the shadows are very dark compared with the illuminated areas, so that it is best to allow for longer exposure. Then the strong sunlight, common to both the prairie and the savan-

nah, compels one to use low-sensitivity film (ASA 25 or 64), reserving the high-sensitivity film for special occasions. Finally, the absence of natural shelters and the extensive stretches of the habitat make it necessary to use either a cross-country vehicle or a minibus, since wildlife photography on foot is only occasionally feasible.

Safari Photography

Safari photography consists in group traveling organized by specialized tour operators or nature groups for the purpose of visiting and photographing natural environments.

The African national safari parks are justly famous. On the modern safari, wildlife photography has now completely replaced the old-fashioned expedition which engaged in the

slaughter of large mammals. Today nature photography contributes enormously to supporting this ecological kind of tourism, which is a considerable source of income for many developing countries.

The choice of an organized tour is basically necessary for someone venturing into a new country. The alternative, going it alone, requires spending considerably more in terms of time and money searching for a

Below: A fine picture of animals in their habitat. The lioness seems to be in doubt whether to pursue the fast-moving ostriches or devote herself to easier prey.

On the opposite page: Frontal framing of a cheetah, showing characteristic features of its coat.

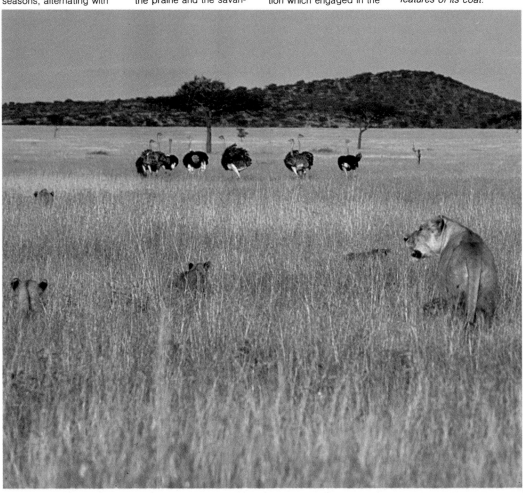

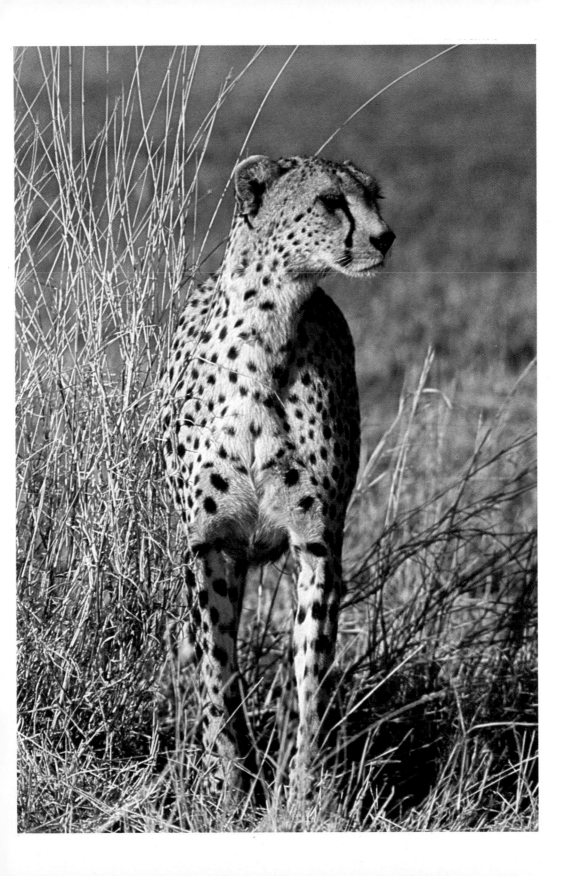

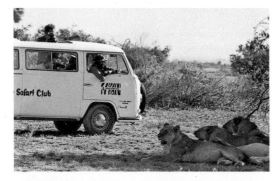

guide, hiring a bus, finding out about the best places in which to photograph animals, choosing the most suitable hotels. To satisfy the beginner, Africa, with its spectacular sights of wild animals at close range, is undoubtedly the best place.

The successful organization of a photographic expedition, with participants bringing a variety of naturalist and photographic skills, provides the great satisfaction of group participation in daily experiences and hardships, resulting in a better capacity to adapt oneself.

The Photographic Safari Minibus

Basic transportation for photographers shooting animals on a safari is the minibus, which the tour operators place at the clients' disposal to be used as a blind on four wheels. At the outset there should be mutual agreement with the travel firm on seat reserva-

tions in the vehicle for the whole length of the safari. One can thus practice using the window as a support for the telephoto lens, and decide how and where to place the bag containing the lenses, whether under the seat or at one's side, so that everything is always nearby and ready to hand. These little details of organization, which appear insignificant at first, are the ones which save time at a crucial moment if they are planned in advance. A cer-

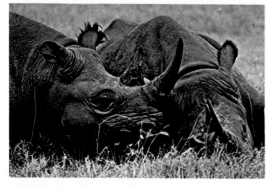

On the left: The minibus is a very practical conveyance for a photographic safari. The picture of two sleeping rhinoceroses was taken from a minibus.

Below: Baboons photographed in the savannah at the edge of an acacia grove.

Right: It is easy to photograph elephants by waiting for them near water holes where they drink or bathe.

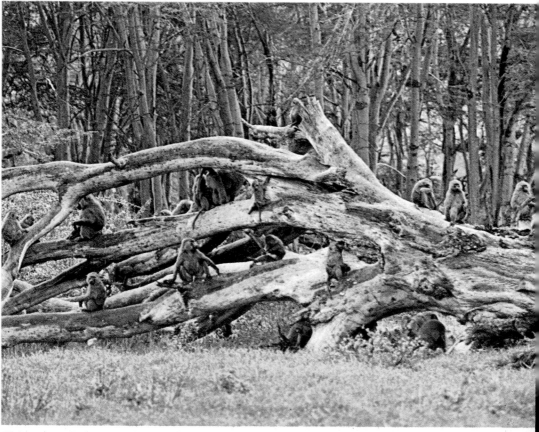

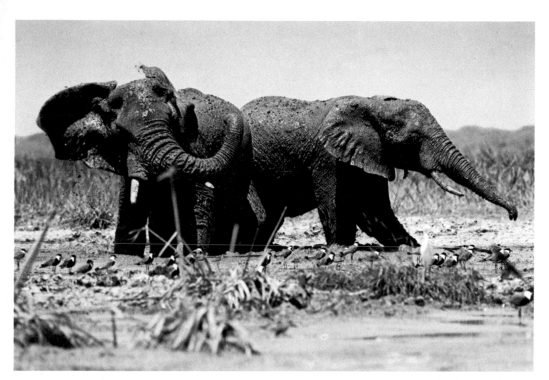

tain degree of comfort inside the minibus while shooting pictures of animals is fundamentally important for maintaining that lucidity of thought and precision of action needed for nature photography—which focal length to use for a herd of gazelles or when to shoot some gnus running in a diagonal direction to the vehicle. Another problem to be faced when traveling on a photographic safari is that of jolts and bumps, which unavoidably throw the passengers and equipment about when riding over the rough roads and tracks of the savannah. Again, precautions should be taken. Pieces of foam rubber should be placed in photographic equipment bags around the camera body and lenses so as to soften any impact during jolts. Bags which already contain insulating material will do, but they can be cumbersome when a great amount of equipment is being carried. Also it is impractical to keep the bag shut to stop the lenses from shaking and then reopen it each time to choose what is needed. In such cases a knapsack

filled with protective material may turn out to be more useful, inside which spaces are provided to hold different lenses and the cameras, while attachments of lesser importance can be kept in the side pockets.

Equipment

During a photographic safari it is not possible to have all the space and time desirable, hence very long focal length lenses cannot be easily used. An exception to this rule is the 1000 mm mirror lens, a super telephoto of unusual lightness, which is useful for taking shots of rare wildlife sighted with binoculars at a considerable distance. It should be noted that the body of the minibus is never entirely still because any movement inside the vehicle creates vibrations which render the use of long telephoto lenses difficult.

A second camera with wide-angle lens is essential for pictures of the environment to accompany ones of animals and plants. A wide-angle lens suited to the savannah and the prairie or grasslands is the 24 mm, but even a 28 mm will do providing it is luminous

and, therefore, maintains good depth of field even with little light. A 35 mm lens can be used to photograph isolated trees.

Environment photography can be effectively practiced in the savannah and on the prairie. The wide-angle lens can immortalize fantastic sunsets lighting up huge herds in movement or acacias teeming with birds, the classic but always moving picture of the Serengeti Plain with Mount Kilimanjaro in the background, the pink sweep of flamingos on Lake Nakuru in Kenya, or the dark silhouettes of bison on the immense green stretches of the American prairie.

On a safari one should not forget to bring a macro lens for flora and a medium telephoto to take shots of small animals that can be approached. A 500 mm mirror lens or even a 400 mm ordinary lens are the most widely used ones for savannah photography.

As regards film, remember that exposed film suffers the heat more than unexposed film. Film rolls for the day can be carried in the pockets of one's jacket, while spare film

should be left in a cool place, if possible where there is air conditioning or in a refrigerator. Remember, however, to remove film some hours before using it to allow it to adjust to the difference in temperature. Otherwise condensation can form on the emulsion and spoil the film. To change the film in the camera, always look for a shaded spot, creating this with your body if necessary. It is best to load the cameras the night before or early in the morning, avoiding useless exposure under strong sunlight. Exposed film should immediately be put back inside protective containers and stored as soon as possible in a climatically stable place with an even temperature. Never forget films left in the vehicle; the sun heats up the inside very quickly, producing a considerable rise in temperature, which would damage film irreparably.

Checking and Maintenance of Equipment

Cleaning cameras and camera lenses is a practice which must become habitual after every photographic safari excursion. Certain adjustments to the equipment and tidying up are required in the morning before departure and in the evening on returning. First, brush all the lenses and cameras with the bellows brush, then remove the finer particles of dust with special cleaning pads. Don't forget that one has to contend with colloidal clay dust, which is very sticky and penetrating. As a protective measure an ultraviolet filter can be placed over all the lenses. Before leaving on an outing, always check that one has everything: film, spare batteries, lenses, loaded cameras, etc.

When to Make a Photographic Safari

It is a good thing to leave on the day's journey before dawn. In fact, animals are more active at dawn, and photographers can work without the oppressive heat that develops later, and above all there is a soft, low sidelight, with greater clarity in the air. When the sun rises to perpendicular, the air temperature increases, and layers of haze are created. For sunset and evening it is useful to have high-sensitivity film ready. Once the rainy season is past, it is the ideal

The environment of the savannah often offers the sight of huge herds of herbivores in movement, as in the photograph on the facing page.

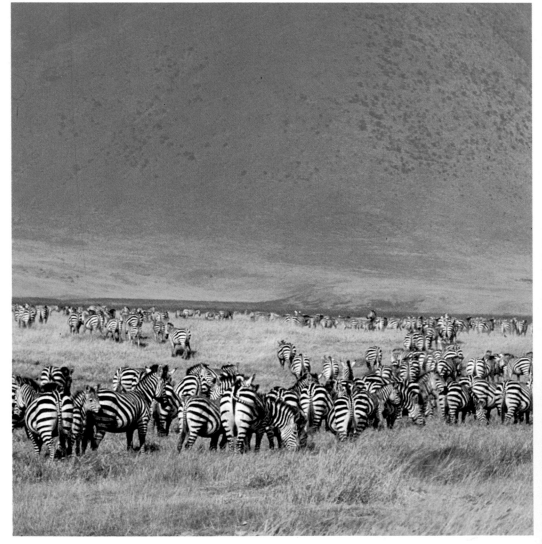

time for a photographic safari, when the savannah blossoms and has a green appearance, in contrast to its characteristic image of a dry environment.

Photo Subjects in Savannah and Grasslands

In the large African national parks animal subjects to photograph are so varied and abundant that most times one is bewildered by the choice, especially when

Below: Animals at rest during the hottest hours of the day, like the lions in this photograph, are easy to approach with the minibus.

several present themselves at once. A group of subjects, perhaps the easiest to shoot, consists of animals that doze in the daytime and devote themselves to hunting their prey in cooler hours of the day and at night.

The heat of the sun, especially around midday, drives many animals to seek refuge in the shade. Lions will allow vehicles to approach them, almost showing their indifference to man. In this case zoom lenses up to 600 mm are ideal.

One must not be deceived by the tame appearance of some animals and

forget that they may be dangerous. Elephants, buffalos, and rhinoceroses all come into the dangerous category. These species often react to the approach of man by hurling themselves at him, especially when they have their young with them to defend. Bear in mind the strict regulations which apply in all the national parks.

With the fierce African sun beating down the photographer faces the problem of very hard shadows. Furthermore, animals photographed under trees are not evenly illuminated but often come out marked by shaded lines, which cer-

tainly does not help their photographic appearance.

A category which is more difficult to approach, but no less photographed on this account, is animals in flight. Large herds of gazelles, gnus, zebras, and giraffes can be filmed by not getting closer than the minimum distance of flight, which is almost always a few dozen meters. In this case the long telephoto lenses of 600 and 800 mm are useful, providing one can overcome vibration in the minibus. With less powerful lenses one can take shots of the herds in large groups, allowing for shifting movement of the vehicle.

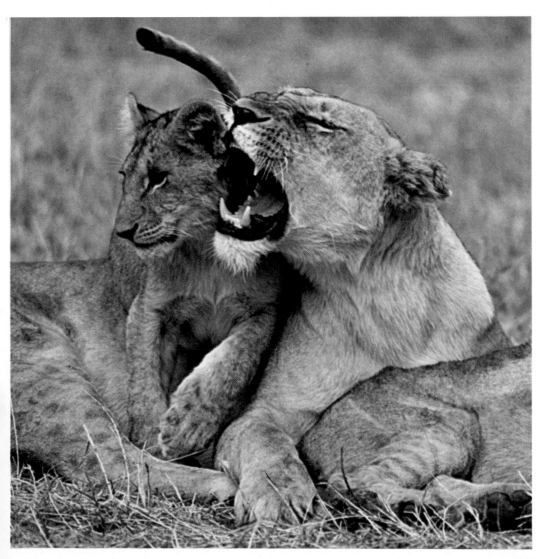

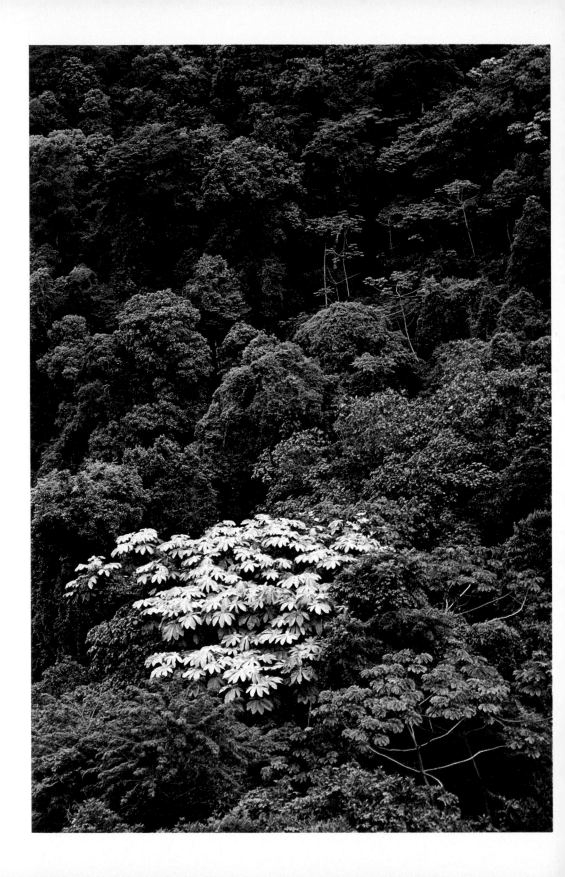

TROPICAL FORESTS

Tropical forests are distinguished by high levels of temperature and humidity, with a climate that remains fairly constant throughout the whole span of the year. The most famous tropical forest is the green expanse of the Amazon basin, which is also one of the last and most extensive virgin environments. In Africa the nature photographer who wishes to work in tropical forests must travel along the Zaire basin or to certain countries along the west coast, while in Asia one may choose the islands of Java, Sumatra, and Sri Lanka.

How to Face the Tropical Environment

The basic feature of these environments is the humidity, which sometimes rises to 80 or 90 percent, putting men and equipment to a severe test. Photographic expeditions in these surroundings should be undertaken with the help of a local guide. The itinerary is usually programmed to follow the course of waterways and tracks made by animals and the rare human visitors to the forest.

Clothing should be light, practical, and functional for an environment in which protection from water (both heavy downpours and standing water on the ground) and from numerous insects and parasites is necessary. It is important to bring an adequate supply of insect repellent, goggles (for gnats), and a first-aid kit.

One must take care not to overexert the body during the first few days so as not to weaken it and expose it unnecessarily to the action of tropical microorganisms. Instead, try to keep the normal bodily defenses intact, gradually adapting to the diversities of environment and climate.

On the opposite page: The difference in color of the Cecropia peltata (a tropical American tree) breaks the continuity in tones, which would otherwise have left the image flat.

Protecting Photographic Equipment

Equipment is protected from humidity principally by being placed inside sealed containers, in which small packets of desiccant and absorbent material have been included, which can be readily purchased and which can sometimes be reused by drying them out in the sun. Film should be protected from heat and humidity with every care, especially if exposed; but even unused film, in these particular climatic conditions, can give excessively strong color effects. Bear in mind that when inserting a roll of film into the camera, it is then being exposed to the possible action of harmful external factors. The temperature needs to drop only a few degrees in the presence of a high level of humidity for drops of condensation to form on the film, rendering it swollen and furrowed in the winding. Hence, if possible, rolls which have been begun should be used up within twelve hours. Once the image is registered on them, they should be replaced inside their own containers immediately and the containers in their turn put into thermal bags (special envelopes which can be purchased from dealers of sports and mountaineering equipment) and then covered with a thermal fabric composed of a layer of shiny aluminum, which reflects the sun's rays without absorbing them. Certain processors provide special anti-mold treatment for film used in tropical areas. In any event, as soon as one reaches the base camp, everything should be put in a ventilated place.

When on the move, if a watertight equipment case is found too cumbersome, thermal bags and fabric

In tropical forests there is no lack of subjects to photograph. Orchids and the python are common examples.

should be used. To protect cameras and telephoto lenses from sprays of water, they may be covered with plastic bags. The warm humidity fosters the growth of bacteria and mold on leather covers and rubberized material. These materials should be cleaned and dried every day. In case of emergency, recourse may be made to the rays of the sun, taking care, however, not to leave the camera exposed for too long, and under no circumstances turn the lenses directly toward the sun.

In contrast to the savannah, where a minibus carries all camera equipment, in the tropical forest every ounce of weight is felt on one's shoulders, since most excursions are made on foot. Equipment must therefore be light, and as luminous as possible considering the lack of light in the forest. For areas bordering waterways, where there is more light, preference should be given to catadioptric lenses, which combine long focal length with lightness. The impossibility of finding replacements makes it necessary to take along spares of parts essential to the functioning of the equipment.

Subjects to Photograph

The forest is the habitat of many birds, butterflies, reptiles, and monkeys. Many subjects, however, are difficult to photograph because they keep to the high branches of trees, where it is difficult to catch them with a straight shot. They can be taken from below, however, while they are moving from one tree to another. The best place for wildlife photography in these environments is along the rivers and streams, where the tree cover is broken; birds can

be taken on the banks of the river or perched on the branches of trees overhanging the water or in the swampy areas. The use of a polarizing filter to eliminate very strong reflections or to take direct shots of the typical fauna in the water does no harm.

The lens hood, which may often act as a rain umbrella, must be used. Ultraviolet filters should be kept constantly mounted on all the lenses.

In the forest, fine clearings can be found where numerous and sometimes rare species of monkeys may be photographed. Sloths, which move very slowly, are easy subjects. It is harder to photograph mammals like tapirs and peccaries, while it is impossible without a proper expedition and months of patient work to take pictures of the jaguar, but one can hear its stirring and full-mouthed hunting cry. As regards photographing the environment, heavy undergrowth and dense vegetation make it difficult to get good overhead pictures without performing acrobatics not to everyone's taste.

The tropical forest is also the domain of snakes. To take shots of them the medium telephoto lens alone is not enough: one must learn to flush them on the lower branches of trees or on the ground. Only an expert eye, however, succeeds in detecting at some distance a green mamba completely camouflaged amid vegetation.

Shooting a boa constrictor or the many-colored and dangerous coral snake so that it stands out against its background requires patience and skill. Assisted by the unchanging climate, insects reproduce themselves unceasingly throughout the year and reveal themselves to the nature photographer in thousands of different species, forms, and color combinations. Brilliantly colored butterflies of all sizes make these environments the paradise of macrophotography. Besides the indispensable flash, special macro lenses are very useful on account of the speed

On the right: A shutter speed of 1/1000 second was enough to freeze the extremely rapid flight of the hummingbird.

Below: The proper use of flash in the tropical forest greatly improves picture quality, as the photograph of these saimiri monkeys shows. Here the composition is also very good.

On the opposite page: Enthusiasts of macrophotography have no need of special tricks to attract their subjects. The tropical forest is the domain of myriads of insects of all species.

with which they can be used. It can happen that unusually large moths are sighted flying fairly fast, and it is not easy to take shots of them without adequate space and the ability to use one's equipment rapidly. In these cases macro overlaps into wildlife photography. Another very interesting subject are large beetles, reaching 15 cm (6 inches) in length, and a whole variety of spiders.

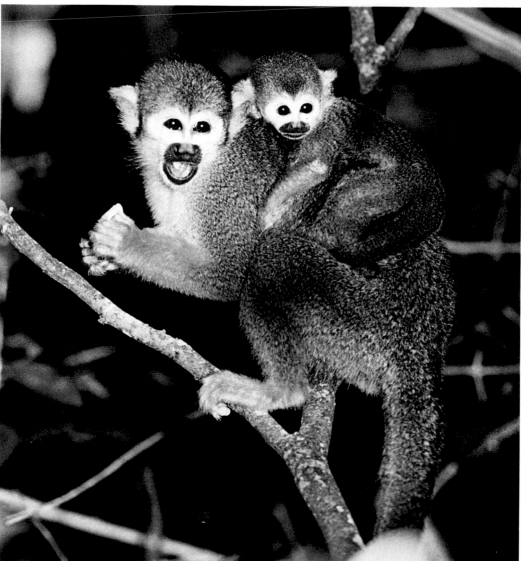

DESERTS

Deserts are regions characterized by meager precipitation and wide temperature ranges, as much between day and night in tropical deserts as between summer and winter in deserts of temperate zones. They can display very varied characteristics, from complete barrenness to wild, thinly scattered steppe-like vegetation. In these habitats many species of animal and vegetable life have developed remarkable powers of adaptation, and the combined action of wind and climate have molded vistas of exceptional beauty, often made even more picturesque by special conditions of light.

Desert Equipment

In recent years crossing the desert in a Land Rover has become more common. Routes mapped out in advance can be obtained, and with the help of a guide one can work out variations with suitably chosen stops to take pictures of the animal and vegetable life.

Usually the person wishing to cross desert stretches is making some kind of test of himself. The nature photographer has a different motive: his main object is to make contact with a particular environment to watch and learn about its characteristic features and to photograph the richness of life there.

Lightweight and pale-colored clothing, wide-brimmed hat, light shoes and ankle boots, an ample supply of fuel, radio, water and food in excess of one's needs, a small camping tent, and medicine kit are the basic gear.

How to Protect Photographic Equipment

Heat. Excessive heat is a dreadful enemy of all photographic equipment. The adhesive holding the lenses softens, and lenses can get misaligned, rendering the equipment useless. A solution can be found by placing cameras and lenses in heat-resistant polystyrene bags covered in light cloth or thermal material. At night the bag should be left open to change the air, and a thermometer may be placed inside to check the temperature. The absence of humidity poses problems which are the opposite of those encountered in tropical forests: film can crack or split. The excessive dryness of the air can be remedied by placing a damp cloth or blotting paper soaked in water inside the bag. A small refrigerator which works on a car battery is useful in preserving spare film rolls. Always remember to take the film out of the cold at least a few hours before use to allow it to adjust gradually to the change in temperature. In any event, the cases containing the photographic equipment and rolls of film should be placed in the most ventilated part of the vehicle.

Never leave equipment exposed to direct sunlight, especially lenses, because the shutter would almost certainly get damaged.

In the desert, cameras should be loaded in the shade early in the morning. Once the film has been placed inside the camera, it is protected from the light but is still completely exposed to the heat. The loaded roll ought to be used up fairly quickly. In the desert, as in other environments, exposed film is more subject to deterioration, with changes in color quality. Film therefore

Below: The molding of the sand dunes by the wind produces an endless variety of shapes in the desert, which the long shadows serve to enhance.
On the right: An example of how a great nature photographer, Kazuyoshi Nomachi, can make a photograph of the desert appear by using a wide-angle lens, filters, and appropriate exposure and composition.

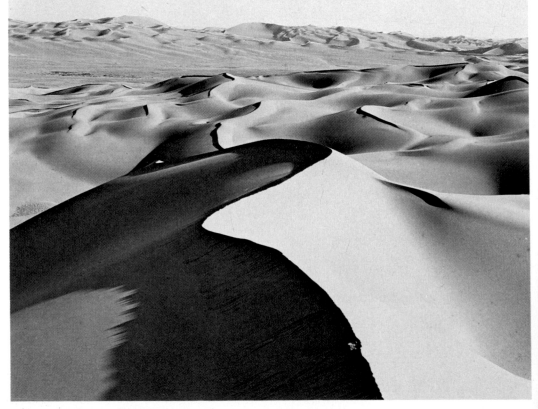

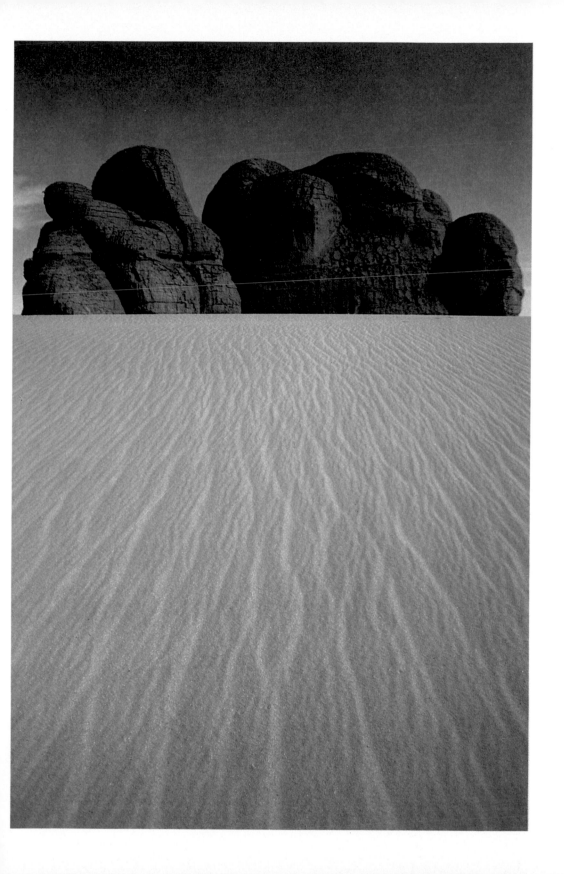

ments must be cleaned regularly a number of times each day with a light brush equipped with bellows. Soft cloths and treated paper for cleaning lenses are available, but they should be used very lightly because pressing on grains of sand and dust could scratch the lenses. Plastic lens caps should be removed and put back after each shot as a protective measure, even if this is awkward. A very useful ac-

of the desert, says that in the Sahara he used a simple polarizing filter on his wide-angle lens. By eliminating excessive reflection, focusing on a simple bush surrounded by a sea of sandy dunes, and waiting for the right light and long shadows suited to the subject, Nomachi has captured unique pictures of the Sahara desert. Another photographer might have made the same subject quite ordinary.

On the left: A secretary bird, a falcon-like African bird which specializes in capturing reptiles, taken on the edge of the desert.
Below: The small elf owl, which nests in holes made by woodpeckers in huge cacti, a subject frequently photographed in American deserts.

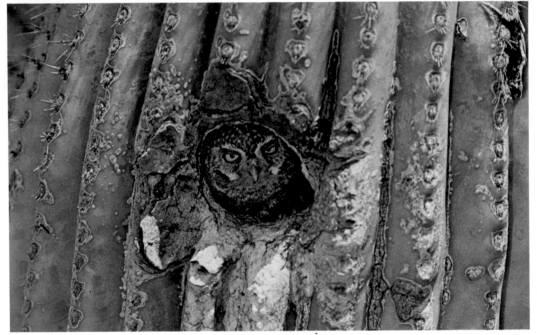

needs great care. In emergencies, film can be placed in a plastic bag and buried underground to maintain it at a more steady temperature. Most important is to send it as soon as possible to the laboratory to be developed.

Sand. In the desert, besides the heat, sand is the cause of trouble to the nature photographer. Driven by the wind, grains of sand penetrate everywhere and can jam the camera mechanism. They get into the film-winding mechanism and above all into the heli-

cal focusing, so that in focusing, the grating noise of particles of sand may be noticed. Every precaution must be taken against the intrusion of sand when film and lenses are being changed. If possible these operations should be carried out inside the car with the doors closed, after having cleaned hands and clothing, with the camera resting on a clean cloth. The airtight containers and the plastic waterproof bags also serve to protect cameras and lenses from the sand. Lenses and attach-

cessory to have in strongly illuminated environments is a hood on all lenses, as well as an ultraviolet filter, which possesses the double advantage of acting as a repellent against excessive ultraviolet rays and sand particles.

What to Photograph in the Desert

Desert environments offer scope for pictures of exceptional beauty and originality. The famous nature photographer Kazuyoshi Nomachi, creator of breathtaking photographs

Fine pictures can be obtained by taking shots of the changing shape of dunes in the African desert or the flowering of spring in American deserts. Even old rocks shaped by wind erosion provide excellent subjects for shots.

No special skills are required to photograph mirages, as long as one takes a series of shots with different exposures, because the exposure meter might be dazzled by the excessive light.

The ease of transport provided by a vehicle en-

ables you to have a long telephoto lens at your side with which to take shots of the small graceful gazelle, or the addax antelope, or the oryx, animals pursued for years by incredibly ignorant hunters. Animal species adapted to living in the desert use their capacity for survival to the maximum. However, they should not be molested by being followed in a vehicle for the purposes of photography. Close-ups of some birds can be taken with a medium telephoto, such as the charming elf owl, a small nocturnal bird of prey that nests in American deserts in holes made by woodpeckers in giant cactus plants. Other species are more difficult to photograph, such as the roadrunner, a very swift terrestrial bird of the American southwest. Among reptiles, one can photograph the dangerous sand viper, completely camouflaged in the yellow sandy desert, or colored boas. Some lizards and tortoises allow close shots to be taken of them. This is the case with the beaded lizard and the desert tortoise. Predators like the lynx or the jackal and rodents like the gerbil or the rat kangaroo are much more shy, and a super telephoto lens must be used to get good pictures.

Insects and other invertebrates might not seem common in the desert, but patient observation will reveal a surprising number of beetles, spiders, and other creatures, including scorpions.

The highly adapted vegetable world also offers interesting subjects, such as the giant saguaro, an enormous cactus which rises to a height of 20 meters (60 feet), and the different species of succulents covered with spines as a protection against herbivorous creatures.

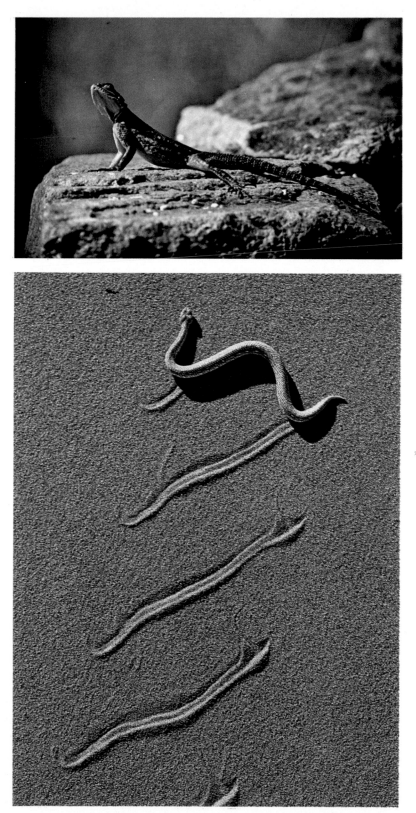

Above: Agama lizard shot with a medium 200 mm f/4 telephoto lens.
Below: By following the snake Bitis peringueyi *over the desert sand, interesting effects and pleasing compositions can be recorded.*

WOODLANDS

The term woodland refers to temperate, deciduous forests characterized by a sharply variable climate in different seasons and by frequent rainfall throughout the year. These great forests, which once extended over all the plains and hill country of Europe, and partly over those of America and Australia, have now been greatly reduced by intensive agriculture.

Woods of oak, elm, linden, ash, beech, and hazel, with undergrowth comprising elderberry, red currant, raspberry, and wild brambles, now make up the remains of what was once the huge woodland heritage of our planet. As altitude increases and the latitude approaches the arctic regions, broadleaf trees are replaced by conifers; the environment is still wooded but can be considered and better described by its climatic and photographic characteristics as a mountainous environment.

The Nature Photographer in a Woodland Environment

A wardrobe of country clothes plus a light raincoat and a pair of leather ankle boots are usually more than enough for photography in a woodland environment. Get to know the forest before penetrating it is a rule worth respecting: hence one must become informed on the subject and practice along the footpaths and glades, find out if the environment inside the woods is very extensive, and equip oneself with a small compass for direction-finding. A light knapsack is very useful for carrying some food and a canteen, apart from the photographic equipment. If you go out at night, heavier clothing is required, which should never be in bright colors because these are more easily seen by sharp-sighted nocturnal animals.

The best time to take pictures in a forest is in the morning, when the light of the sun, still low in the sky, filters through the trees, opening a path for itself between the trunks instead of through the denser branches. During the winter season the absence of foliage on the trees facilitates the photographing of mammals and birds in the forest.

Photographic Equipment in the Woods

What equipment should one take with one into the woods? The lack of light strongly indicates the use of very luminous medium-power telephoto lenses like a 300 or a 400 mm with a f/5.6 aperture, for example. A tripod is necessary, while the monopod is very useful for eliminating vertical shake. Horizontal shake can be avoided by resting the camera and monopod against a tree. Screw clamps are also handy when fixed to branches to hold the equipment firm. Not to be forgotten is the cable release and a supply of high-sensitivity film. One should never be without a wide-angle lens because the forest provides good material for environment photography: the morning light filtering through, lighting up an oak forest in spring, or the carpet of red leaves in an autumn beech forest creates images that illustrate the entire environment of the deciduous forest. Remember that when taking pictures in the woods, one is always working with sharp contrast and that shadows are deep, with a strong light penetrating through the branches. Macro equipment is essential to take shots of all the tiny living creatures connected to the life of the trees—insects, flowers, and fungi. A medium battery-operated flash for macro shots is also necessary. Some nature photographers claim to practice stalking wildlife photography without much difficulty with a telephoto lens and maxiflash. A great deal naturally depends on habit and personal taste.

What to Photograph in the Woods

Searching for footprints and tracks in the woods is

To photograph woodland like the beech forest on the left, use a monopod and lean against a tree to eliminate both vertical and horizontal vibrations. A long exposure is necessary to give the required depth of field.

Opposite page: Small birds and squirrels (below) are difficult to photograph in the woods because of the poor light.

the key to finding subjects to photograph. In fact, in the woods animals can be very close to the photographer, who is unable to see them. Thus by observing footprints or the bark of trees scratched by deer or following the path of droppings or the remains of food, cones, or nuts nibbled by squirrels or other rodents, one can reach the subjects to photograph. Some photographers practice the technique of following herbivorous creatures like roebuck and deer, following their tracks very early in the morning. Others wait for them instead, stationing themselves in a high blind, after discovering the glades where they emerge to graze at daybreak and in the evening.

The best seasons for photographing roebuck and deer are spring, when they leave the woods to feed on new shoots in the pastures, and autumn, when, during the mating season, their fear of man diminishes. Not infrequently a shot of deer during a fight between males is possible if you

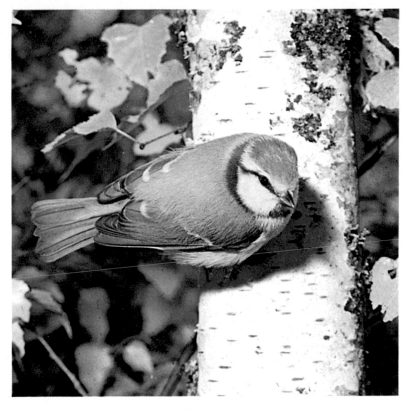

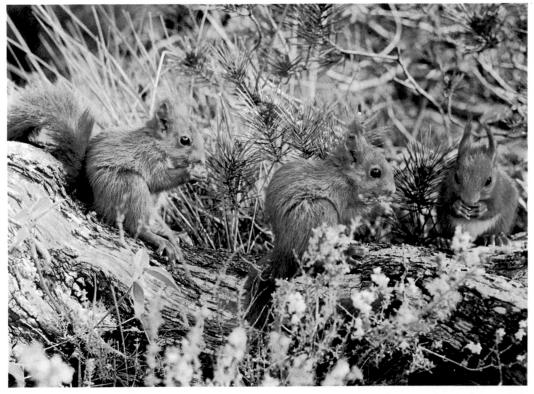

approach them from down-wind, moving silently under cover from tree to tree, waiting for the animals to look the other way or to be occupied in feeding.

The startled roebuck will normally flee in haste with great leaps. Then no time should be lost in compos-ing and shooting, putting into practice what was said earlier about panning and movement climax. Encoun-ters with roebuck are usu-ally unexpected for the na-ture photographer, and rapid-focusing lenses mounted on a motor-drive camera are useful.

In summer one may chance to come upon young deer left hidden in the undergrowth by their mother; in fact, she will spend some time away feeding, returning to suckle at intervals. The photogra-pher with no wildlife experi-ence mistakenly thinks the young deer have been abandoned, and he pets

them. He thus commits a vain, grievous mistake: alarmed by the scent of man on her young ones, the mother will desert them. A rule which is useful in photographing deer is to set out when it is still dark so as to take them at the first light of dawn. In addi-tion, late at night is the time to record the call of the roebuck and the bellow of the stag.

Photographing animals in their dens is another tech-nique to use in the woods. We have already discussed elsewhere in the book how to set up camera and flash outside a badger's lair. For a fox the technique is simi-lar, but remember that this cunning animal is more suspicious and shy, and to get good close-up shots is a real challenge. The blind which the nature photogra-pher chooses is usually sit-uated in a tree. Before po-sitioning the camera, first methodically observe the

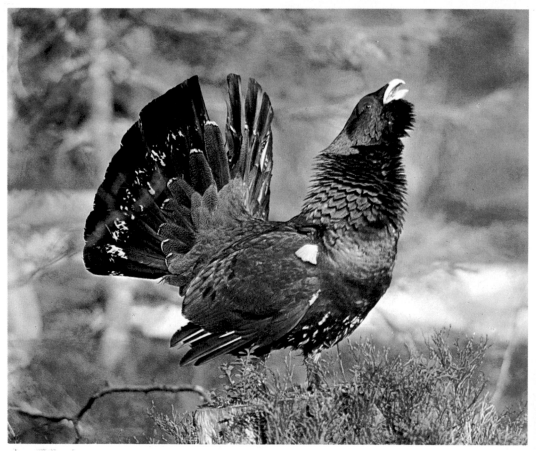

218

Light filtering through the branches is often used to bring out details of the life in the forest. The fungi (right) were taken with a 24 mm wide-angle f/3.5 lens.

Deer (bottom) can be photographed in clearings at sunrise or sunset when they come out from the depths of the forest to feed.

Opposite page, above: Tiny invertebrates can be taken in the woods; here we see a spider (Araneus diadematus).

Below: The finery of the wood grouse (capercaillie) may be photographed on the edge of the forest, when the male, intent on his love song, is less afraid of man.

enough to have their picture taken.

Other subjects to photograph in the woods are tree dwellers. Woodpeckers can be taken by waiting for them at their nest, while owls can often be surprised dozing, resting on a branch or in tree forks.

One good opportunity for photographs in a forest is at the nests of small birds in spring. To track them down one must have a scientific knowledge of the different species, but experience is important above all. Nesting birds can be taken in two ways:

(1) Place the blind at 2 to 3 meters (6 to 10 feet) from the nest and use a 200 or 300 mm telephoto lens plus flash. This method is used commonly by north European nature photographers.

(2) Position the blind farther away, about 15 meters (18 feet) from the nest, placing the camera 1 to 2

fixed tracks used by these creatures of habit. The electronic trip device can be used with the fox once his habitual path has been discovered. Other small mammals such as hedgehogs, rodents, shrews, and field mice all have their regular "trods." Some food may be left on their path to get them to stop long

meters (3 to 6 feet) from the subject operated by remote control, with cable and electric contact fixed to the motor drive. The camera lens to use in this second case should have a focal length of about 100 mm.

This second method disturbs the animals less than the first one. A flash unit, or better still, two, should

be positioned as explained in the section "The Blind and Flash."

Among possible shots of animals in the woods, one should not forget the squirrel; while in North America they are quite easy to find, in Europe taking shots of them without a blind is no easy matter, since they run rapidly around the trunk.

It is hard to photograph the bear without the assistance of a local expert guide. Once its nocturnal habits are known, you must wait for it at the right time and in the clearings which it normally frequents. Remember that in spite of its bulk, the bear is very agile and will be gone unless you shoot with all speed.

MOUNTAIN ENVIRONMENTS

When deciduous trees yield to conifers, around 1500 meters (5000 feet), the environment takes on characteristics similar to those of the northern regions, with a climate characterized by less abundant precipitation than in the lowland forests, and temperatures which prevent excessive evaporation and hence keep the mountain conifer growth sufficiently moist.

Mountain Equipment

To visit the mountains in summer once needs, besides good hiking boots or climbing boots, a knapsack with food, water, and photographic equipment, one additional thick pullover, and a lightweight parka for unexpected changes of weather. A waterproof poncho to cover the knapsack and oneself in case of rain and a compass are also handy. In winter gaiters should be added to boots to protect legs from the snow.

Some advise snowshoes for traversing snow-covered ground, but skis are generally better. With snowshoes movement is slow; they are cumbersome, and if the snow is very deep progress will be difficult. Cross-country and downhill skis permit turning in all directions more rapidly. For climbing, sealskins are attached to the bottoms of skis, which prevents them from slipping backward. Boots for cross-country skis are specially shaped, as is the ski binding, which allows movement of the feet.

Sunglasses are necessary to protect the eyes from the fierce ultraviolet rays encountered over expanses of snow. It is a good idea to take light foods with high calorie content such as chocolate and sugar cubes. A small inflatable rubber cushion allows one to remain seated while photographing.

Photographic Equipment in the Mountains

Photographic equipment in mountain country should be as light as possible. Especially in winter, when opportunities are fleeting and seconds count, heavy telephoto lenses which make it difficult to frame with sufficient speed should be left behind. The catadioptric lenses, that is, mirror lenses, supported by a rifle grip, are ideal on account of their lightness, as are rapid-focusing lenses on account of their handiness and large aperture—for example, a 560 mm telephoto with *f*/6.3 aperture. In the summer, when ambush photography is more feasible, one can attempt to carry lenses of long focal length, with a tripod strapped to the knapsack. The monopod, owing to its reduced size, can be taken everywhere. Ultraviolet filters must be kept on all the

Below: Rock ptarmigan taken with a Leitz long-focus 400 mm f/6.3 lens.

Opposite page: Yak in their natural habitat. The picture conveys the idea of hardiness and strength which characterizes animals adapted to cold climates.

lenses because of the intense ultraviolet radiation.

Macro equipment is essential in spring and summer. The astonishing beauty and variety of mountain flora provides even the less expert nature photographer with splendid material. The first warm days of spring see myriads of flowers sprouting forth, the color tones of which change and become more vivid as the season advances. Mountain meadows are a paradise for the macrophotographer at this time of the year.

Subjects to Photograph in the Mountains

Mountains lend themselves particularly well to environment photography, both on account of the variety and the changeableness of the setting: open valleys, snow-capped mountains, geological formations, frozen waterfalls, glaciers, forests covered in snow and illuminated by the sun.

When using the wide-angle lens, careful attention must be paid to the effects of distortion. One must avoid, as has already been seen with trees, a "collapsing mountain" effect. Furthermore, super wide-angle lenses "shrink" mountains, making them appear more distant than is desirable. In no place except a mountain do various kinds of sunlight illumination produce such different photographs of the same envi-ronment, as was shown on pages 62 and 63. For example, mountain silhouettes photographed when the shadows are long will appear more "molded." Conversely, when the sun has risen high in the sky, it tends to "flatten" pictures of mountains. The sharpness of such pictures is obvious. The purity of the air renders images well defined and colors more glowing.

Mountain country gives the nature photographer the chance to shoot splendid flowers like buttercups (left) and wood anemone (below).

Bottom: the woodchuck is not too hard to photograph if the camera is positioned close to its burrow.

Photographing the marmot demands patience. The first encounter with this animal may be disappointing, as it disappears so quickly, uttering a whistling cry of alarm. Place yourself near a marmot's den and, while remaining still, wait until it reemerges from its hiding place. The ambush can be carried out without a blind, and sometimes you can get within 4 or 5 meters (12 or 15 feet) of the subject.

Capercaillie, the large European grouse, should be sought on the edge of a forest with high trees. They are usually fairly shy. As happens with many animals, the mating period fully occupies birds' attention, reducing their instinctive fear of strangers. Hence the ideal season for taking shots of them is spring, when the courting males sing perched on a branch or a rock. One should go out at night, before dawn at any rate; listen to their song and follow their tracks and place oneself near the spot where they perform their mating display on the ground, taking rapid shots in sequence.

Hares, grouse, and stoats are usually taken with the usual stalking techniques, catching them when they stop for a fleeting second to look around in snow-covered surroundings, observing the sudden and unexpected appearance of the nature photographer.

To photograph large mountain mammals, like ibexes, chamois, and rocky mountain goats, one should approach cautiously and move only when the animals are feeding or distracted. It takes very little to frighten mountain mammals.

The dream of every nature photographer is to capture a shot of the bearded vulture in flight, the most legendary of vultures (right).

Below: Some mountain animals like the ibex, taken here in the Gran Paradiso national park in Italy with a 500 mm f/8 catadioptric Nikon, allow one to approach for close-up shots of them.

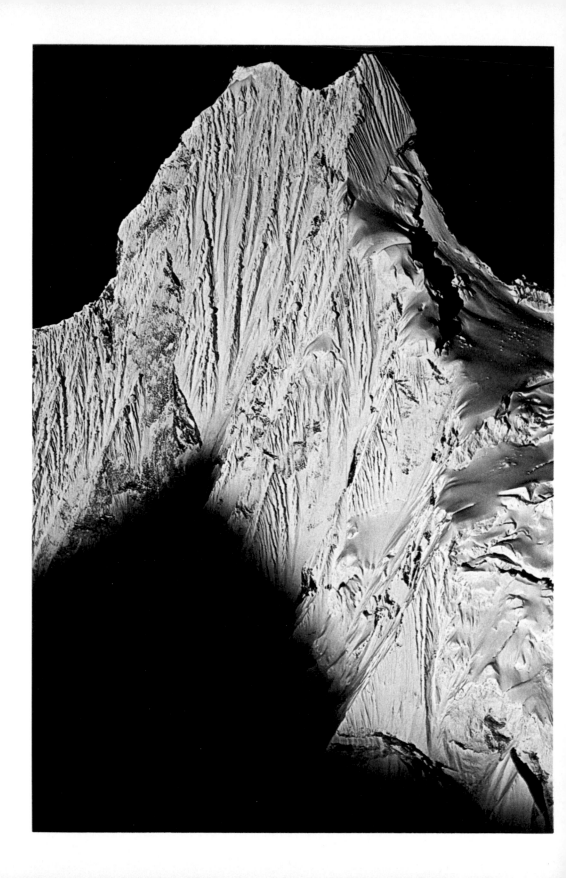

COLD REGIONS

Above a latitude of 60°, in the circumpolar regions, the ground is frozen or snow-covered for a great part of the year. Furthermore, in the Arctic and Antarctic regions there is perennial ice. In these environments the extremely cold temperatures put men and equipment to a severe test. The outfitting of a nature photographer who wants to penetrate these remote and fascinating frontiers of the globe should follow the recommendations of some center or institute specializing in polar expeditions; it should never be left to the initiative of individuals.

Before departure, cameras should undergo special antifreeze treatment, even though modern cameras are capable of standing up to the harshest climatic conditions. Equipment can be tested by placing it inside a refrigerator for a certain length of time, ascertaining afterward whether everything is still in working order. The camera

should not be left exposed to the cold longer than necessary for taking shots; the simplest way is to keep it covered inside the large pockets of the polar clothing.

Batteries are another problem. Bring an ample supply of them, because they tend to lose their strength even if they reactivate themselves on returning to a more normal temperature.

Cold, as we have noted, helps to preserve film, but below certain temperatures its sensitivity may be affected. Particular care must be taken when moving from excessively cold places to warmer ones. Condensation easily forms on lenses as well as on film. Cameras must be allowed to adjust to changes in temperature and gradually reduce condensation, or they should always be kept in a relatively cold place.

The powerful intensity of solar radiation in snow- and ice-covered areas requires the constant use of

protective sun cream and dark glasses by the photographer and ultraviolet and skylight filters for the lenses. The polarizing filter is effective as a means of darkening the sky and brightening colors. Because of the strong illumination, the film must be of low or normal sensitivity.

In cold environments it is not easy to move rapidly from one position to another to improve the composition. Lenses must be changed often, however. With intense cold and with hands covered by heavy gloves, this is no easy matter; difficulty will also be experienced in focusing. Some nature photographers advise wearing a lighter pair of gloves beneath the heavy ones, which can be useful in working with greater precision in such operations as changing the film roll. One should never work with bare hands because, apart from the danger of frostbite, at very low temperatures the skin tends to stick to metal surfaces.

Subjects to Photograph

In arctic regions nature photography is practicable during the long polar summer, when for six months the sun shines uninterruptedly on one of the poles. The Antarctic region lends itself to environment photography additionally on account of its high mountain ranges. Around the North Pole, on the other hand, the environment is extremely flat and barren. Because of this monotonous polar wilderness it is difficult to find any contrast.

A good telephoto lens allows one to take shots of the polar bear alone or

Below: The photograph of this Antarctic environment is sufficiently animated by the mountain in the background, by the bird in flight, and by the block of ice in the center of the picture.

On the opposite page: An outstanding picture of the Himalayas taken by the great Japanese nature photographer Yoshikazu Shirakawa.

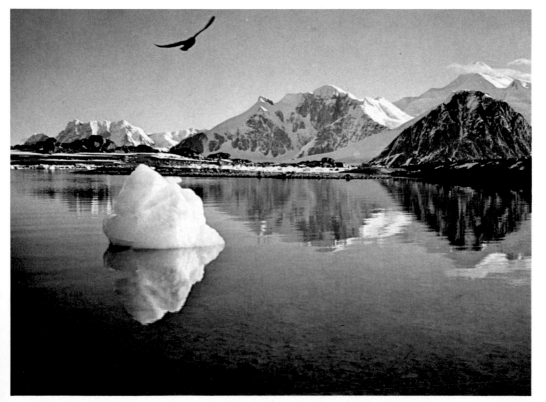

with its cubs on the ice pack or sheets of ice driven offshore by the sea current. Such photographs are usually taken from a vessel sailing around the pack. Further opportunities to take pictures from the boat may be provided by drifting ice formations.

Seals can be photographed while they lie resting in the sun, or with the old trick of cutting holes in the ice and waiting for them to come up to take a breath, as the Eskimos used to do to capture them.

The penguins of Antarctica and other sea birds are not really afraid of human beings, and allow all kinds of pictures to be taken of

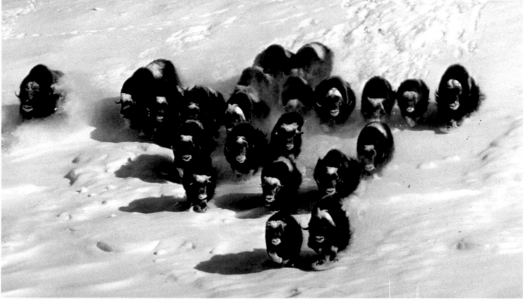

Photographs of the snowy owl (top) or the musk-oxen (center) are exciting opportunities which the tundra offers.

The seal (left) can usually be taken while it is basking in the sun or when it returns to the breathing hole in the ice after a swim.

Opposite page: The polar bear (top) is usually photographed from the boat on its own or in the company of its cubs on the ice pack. The penguins (bottom) allow pictures to be taken of them fairly easily because they are not afraid of man, unlike most other animals.

them. The elephant seal and the walrus are not too difficult to photograph, once one has succeeded in reaching their territory.

In the polar regions it is also possible to photograph extraordinary effects of light, mirages, and the famous aurora borealis and australis with their rare colors, among nature's most remarkable wonders. The northern lights extend south from the North Pole, covering the wooded taiga and the tundra.

In the brief period when the temperature is above freezing, even sometimes reaching quite high levels, the tundra can provide the lens with splendid pictures: lichen, moss, flowers with vivid colors. Musk-oxen, fairly tame, will allow the nature photographer to take pictures of them without too much difficulty.

Shots of the snowy owl brooding or diving on a lemming are always fascinating. Even the elk can be taken in summer on the tundra, and encountering this huge animal, 2 meters (7 feet) in height, is a memorable experience even for the expert nature photographer. Further impressive pictures of the tundra can be obtained by photographing caribou, the North American reindeer, migrating in late summer when, assembled in large herds, they move toward the south.

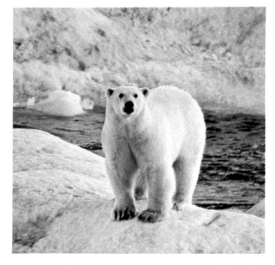

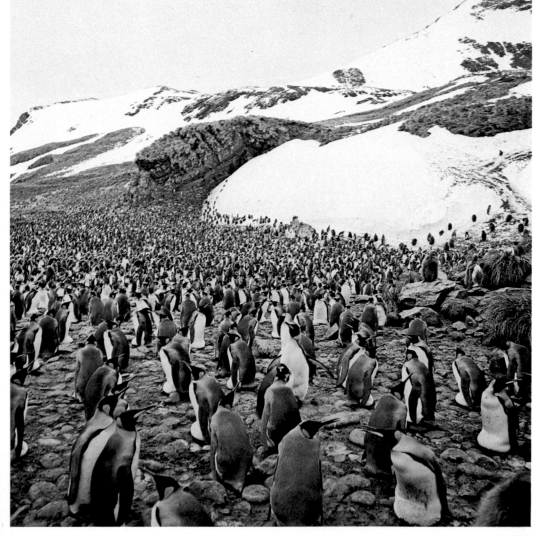

THE SEACOAST

Exposed for millions of years to the effect of waves and weather, the coast is the environment in which it is possible to photograph the meeting point between two different worlds, the marine and the terrestrial: rocky coastlines molded by the waves and composed of igneous and sedimentary rocks, coral reefs produced by the accumulation of huge concentrations of coral, shorelines, such as some stretches of the Irish coast, whose basaltic rocks derive from lava flow, sandstone or cha'k cliffs which were once submerged.

Photography on the Coast

The high level of salt present in sea air and spray can corrode and damage the metal parts of the camera. Each time after being used, the camera should be replaced immediately inside its protective housing or covered with cloth, and it ought to be carefully cleaned at the end of each day. One very good way to

protect photographic equipment is by means of suitable plastic bags, which serve to shield the apparatus from spray. If a wild wave wets the camera, it should be dried at once with the greatest care. If, on the other hand, the camera were to fall into the water, it should be immersed in fresh water immediately and then in alcohol: these are drastic remedies which must be adopted at once unless the camera is to be ruined.

Another problem frequently met with on the coast is that of contamination by sand. Extremely fine particles of sand found on certain beaches can infiltrate everywhere. As in the desert, the camera needs to be cleaned regularly with a bellows brush. Always change the film well away from wind and sand, in a sheltered place if possible.

When taking pictures the strong luminous intensity found on certain seashores should not be underrated. Only medium- and low-sensitivity film should be used. Along the coastline ultraviolet filters are very useful, and a lens

hood is essential. This also helps to eliminate reflection, which can so easily dazzle the meter along the seashore, producing errors in exposure. A polarizing filter should not be forgotten, which is also very useful for taking shots of small molluscs in shallow water. It has been calculated that the ideal angle of shot to avoid reflections is 37 degrees to the surface of the water.

The broad field of view of the wide-angle lens is useful for illustrating the environment in its entirety, as in these photographs of the rocky coastline of Corsica (left) and the sandy shores of Tahiti (bottom).
Right: On rocky coasts one can photograph large bird colonies without great difficulty and without using a blind. These gannets were taken on the coast of Scotland.

Subjects to Photograph

Along coasts environment photography offers numerous and excellent opportunities: the rocky coastline, the conformation of the sandy littoral, the shot of the coast with typical vegetation growing by the shore, pebbly beaches produced by the force of breakers.

The best days for photographing the surface of the sea are stormy ones, taking the waves with a sufficiently slow speed to give a slightly blurred effect. It is even possible to show the sea still and the waves blurred as they dash themselves against the coast.

Rocky Coasts

Rocky coasts rising steeply out of the sea are the habitat of numerous species of sea bird, sometimes found in colonies of thousands of individuals. To photograph gannets and many species of gulls, there is no need for a blind but it is enough to stay crouched and still, with a 300 mm lens mounted on the camera. On the other hand, it is harder to find the right composition, since sea birds usually build their nests on the most inaccessible parts of the rocks and usually facing the sea. Don't fail to take care and see where you put your feet, testing the firmness of the ground; some rocks which seem very solid prove to be brittle and will not support a person's weight. A pair of climbing shoes or ones with a good grip are needed.

As impressive as the thronging birdlife of the British coasts are the colonies of green cormorants and shearwaters that nest in the Mediterranean. On calm days they can be photographed from a boat, approaching them slowly and shooting in rapid sequence. Naturally this kind of shot always risks being blurred; hence the film must be high speed, the sea must be relatively calm, and the hour chosen should ensure good illumination from the cliff face. Shearwaters can also be taken on the sea, when they fly low over the surface of the water, and the same with cormorants when they are half im-mersed in the water, undecided whether to dive again. Among birds that can be photographed one should not forget birds of prey that build their nests on high cliffs rising steeply out of the sea. Shooting these birds does not always require an organized expedition; arrange your photography plans to coincide with a holiday period for the family, choosing a part of the coast known to be used by birds of prey. Peregrine falcons, griffon vultures, and Eleonora's falcon in Sardinia can be taken with little effort by waiting for them to return to their cliff while enjoying the climate and the exceptional natural environment at the same time.

To photograph molluscs where only the high tide will reach them, flash is needed since they try to attach themselves in an area of shadow to avoid rapid dehydration. At other times pictures can be taken of small creatures living in rock pools. Using a macro 105 mm lens with polarizer and flash, one can photograph at leisure small fish moving from one hiding place to another in the hole. In shallow water in a place sheltered by the rocks, with a little patience shots can be taken of interesting or unusual moments in the life of small marine creatures: the crab disputing over some food with the humpbacked octopus, a frequenter of the same underwater rocks, which waits to clutch its prey, camouflaged the color of the bottom and hiding its tentacles under its body; shrimps appearing and disappearing like lightning if food is thrown to them in the water; and sea urchins on the look-out for hostile starfish.

Sandy Shores

The greater part of the sandy seashores of the earth are heavily inhabited by man, who has leveled the dunes, turned the coastline into private property, and built directly on the sand. Few beaches, especially in industrialized countries, have escaped this senseless assault. On these remaining beaches, gulls and various wading birds flap their wings over the sandy shore searching,

Along the seacoast there are animals of great interest from a photographic and naturalist point of view.

Right: Jellyfish on the water's surface.

Below: Red crabs of the Galapagos Islands.

On the opposite page: A colony of puffins (Fratercula artica). These birds belong to the Alcidae family, good swimmers who inhabit the coasts of Europe, North America, and Greenland.

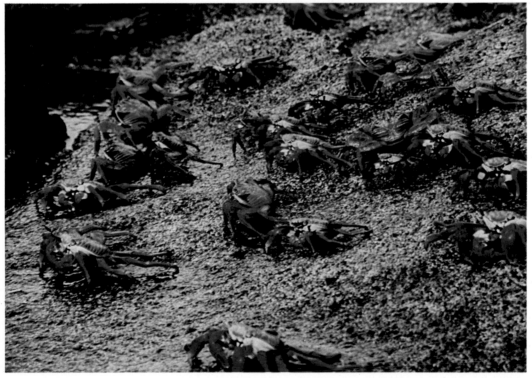

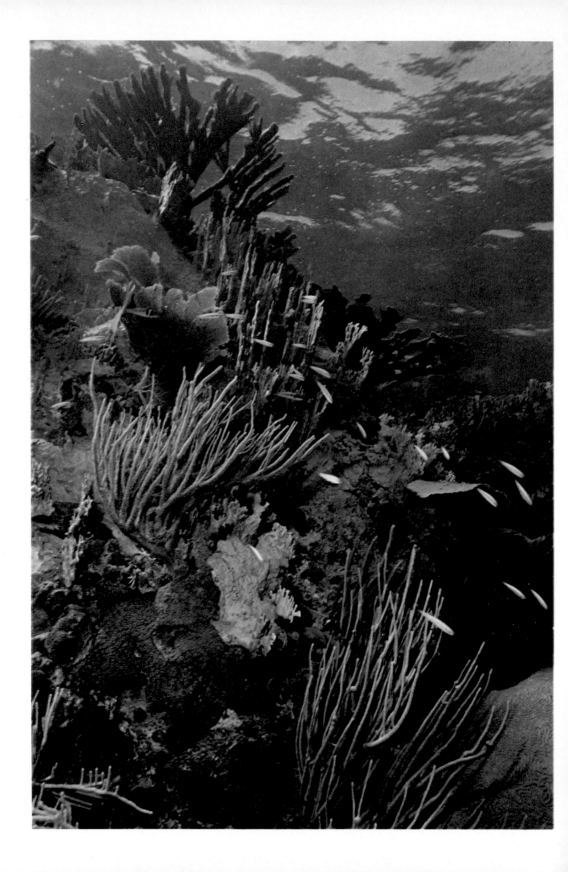

Pictures of the underwater environment shot near the coastline. The photograph on the opposite page was taken on the slope of a reef covered with corals in the Virgin Islands.

taking pictures of the thin, elongated razor clams that rapidly withdraw deep into the sand as soon as they detect the vibration of footsteps on the ground, or clams or small crayfish and crabs digging their holes. For these last creatures the camera should be placed on the ground perhaps with a plank underneath to avoid direct contact with the sand, using an angle viewfinder and macro lens. In this way impressive pic-

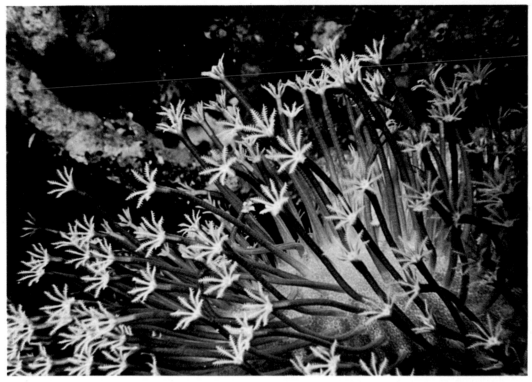

and foraging with their beaks for molluscs and other small animal food.

The beach is an open place where it is not easy to approach animals without being seen. It is advisable, therefore, once one has located the favorite haunts of oyster catchers, curlews, sandpipers, and other varieties, to build a blind, position oneself inside, await the return of the birds, and shoot. On the beach many bivalves can be photographed at low tide and these creatures seek shelter by digging small holes for themselves in the sand. Unusual shapes may be revealed by

tures of crabs can be obtained at a natural height, with sea and sky in the background. Other subjects for nature photography on beaches are the remains of sea creatures and shells washed ashore by the waves.

Coral Seashores

Coral beaches are only found in tropical zones. Here very strong illumination from the sky and reflection from water and sand render it necessary to use low-sensitivity film. Ultraviolet filters and polarizers are also essential. The danger of sand penetrating the camera is greater here

than on other sandy shores on account of the microscopic nature of coral sand, which is like powder.

In a boat, besides protecting the skin from the sun's rays, one should shield the equipment, as we have already noted in the case of other environments where similar problems of extreme illumination are encountered.

At coral shores, however, most photography is with underwater cameras. Myriads of fish of all shapes and colors in a fabulous underwater garden environment of coral can be taken even at a shallow depth. At this level

sunlight still penetrates in sufficient quantity to allow good pictures in ambient light. Once the outer ring of the barrier has been passed, photography of rays, sharks, and sea turtles at a greater depth requires underwater flash to avoid bluish pictures.

Above the surface, the telephoto lens can be used to shoot large colonies of nest-building terns on the coral reef. And one can take advantage of low tide to photograph birds, in search of crustaceans and molluscs, landing on the exposed bottom as soon as it emerges from the receding water.

WETLANDS

Swamps, pools, lagoons, peat bogs, marshes, lakes, floodplains, riverbeds, deltas, and estuaries, are classified according to a commonly accepted convention under the denomination of wetlands. The importance of these areas, assailed for years by hasty and destructive reclamation, is enormous: this mass of water influences climate, balances the hydraulic equilibrium of a territory between surface water and deep water, and generates a great variety and abundance of animal and vegetable life. Its value therefore, is at once economic, social, and scientific. To which can be added the potential of these environments for the practice of different recreations and sports, especially birdwatching and wildlife photography. The last great wetlands of Europe, at the mouths of the Guadalquivir, the Rhône, and the Danube, attract thousands of nature photographers each year as happens in America in the Everglades. The wetlands are the domain of birds, and during the nesting season or during the autumn and spring migration periods, the nature photographer has ample opportunity for photographing wildlife: herons in marshland, small birds nest-building among the reed beds, wild ducks in the open-water areas. Photography in the wetlands can be carried out from the bank or shore, positioned in the appropriate blind, or from the vehicle, driving along the lakes or roads which allow one to get near the birds. For such work the 1000 mm catadioptric or telephoto lenses can be used, from convenient blinds, if you can afford this expensive equipment. When shooting from the car, one should not approach too close to the birds. But remember that even if the photographer keeps at a reasonable distance, some species of the wetlands, such as the flamingo, while not flying away all of a sudden, slowly but resolutely paddle away from the photographer in shallow water. One needs considerable patience waiting for them to draw near again.

Another method is to wade into the marsh in tall rubber boots, with anti-mosquito spray and light photographic equipment (for example, a camera with an ordinary 300 or 400 mm lens or a 500 or 600 mm mirror lens, plus a good supply of film) to practice the traditional kind of stalking wildlife photography. During a walk many species, especially wild duck, will fly from the water, and these can be shot in flight using fast film. On other occasions, which occur quite frequently, moorhens are seen or small birds suddenly come into view, forcing the photographer into quick response. On these stalking outings it is advisable to bring a special 105 mm macro lens, allowing shots of insects and marsh flowers.

Penetrating into marshland vegetation among strange sounds, the sudden appearance of animals, and the smell of wild herbs provides the most vivid sensations of direct contact with nature. Wetlands in one sense may be regarded as the last areas left intact that have escaped the anthropomorphizing by western civilizations.

To photograph marshland birds close-up and in their habitat, one can use the technique of boat blinds, which has already been described. Herons, usually photographed at a considerable distance, can thus be taken in close-up and in their environment, which will result in far better pictures. When they rise up in flight, considering the

Below: Photographs taken at animal height often give striking results, as we have already explained. This fine picture of a hippopotamus brings out the environment in which it lives.

On the opposite page: Reed bed in the summer heat. Plants rooted to the bottom form an effective shelter for many animals (frogs, birds, rodents, insects, snakes, etc.).

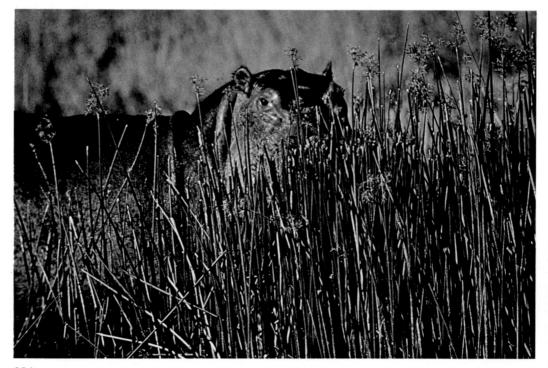

slow wing beat of these birds, a good number of shots will be obtained.

Dabchicks and grebes are not easy to photograph at close quarters, since at the slightest movement they dive underwater, to reemerge farther away. Photographing from the boat blind in the habitat of these diving birds, you may have to wait up to 5 or 6 hours for the right framing. Interesting photographs may be taken of subjects such as small birds that build their nests in the reeds. Nests of reed and sedge warblers, the delightful haversack nest of the

penduline titmouse, or close-ups of the "moustache" of the bearded tit are all opportunities within reach of the small boat blind.

Some photographers prefer blinds used for hunting waterfowl or other structures made specially for marshland photography instead of the small skiff. One can work with ease on these steady platforms, mounting heavier and more powerful lenses. But more patience is required if birds fail to approach immediately, and one does not experience the same exciting feeling as on entering the

animals' territory in the skiff.

As a rule it is not easy taking underwater pictures in the wetlands, owing to whirlpools in the currents of rivers and torrents and turbidity in stagnant water areas. One can, however, make use of a system like the one described on page 198, which allows pictures to be taken at the surface of the water or just beneath the surface. A box is used in which one side has been replaced by a wholly transparent sheet of glass fixed in such a way as to ensure that it is completely watertight. To take shots

one can get into the water if it is not very deep, wearing high rubber boots, or lie stretched on a skiff or raft. Framing can be done from above through a special angle viewfinder. A good flash should also be attached to the glass side. The container can be ballasted to make it float upright in the water or to rest on a shallow bottom. A medium telephoto lens can be mounted inside this structure, taking care that the front lens is aligned and secured to the glass side of the container. In this way shots can be taken of half-submerged frogs

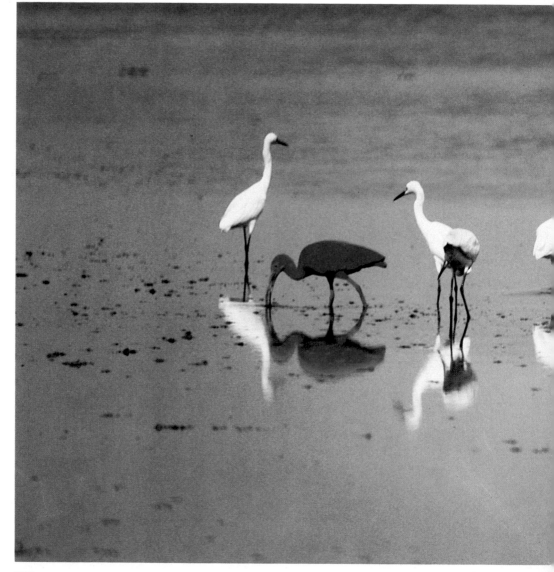

Marshland is the paradise of the nature photographer and the bird enthusiast. This is shown in these pictures of scarlet ibis and egret (below) and pelican (right), taken with a 600 mm Nikon telephoto lens at full aperture (f/5.6).

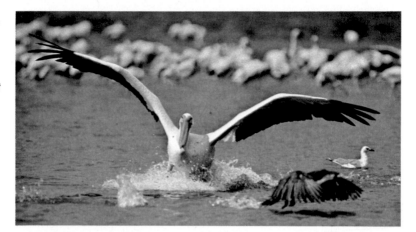

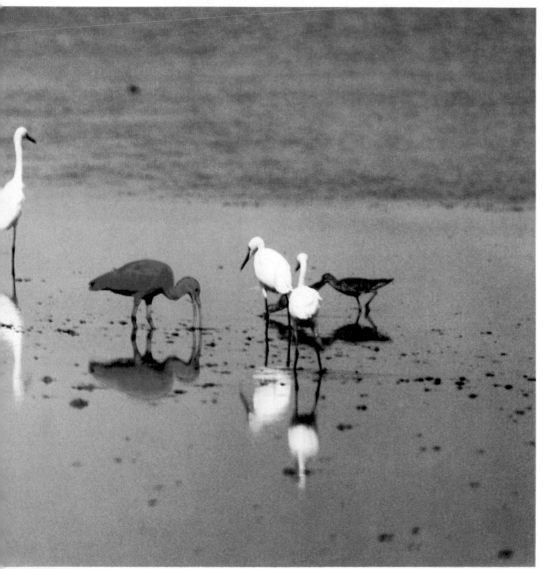

Grass snake (Natrix natrix) swimming on the surface, taken with a 200 mm tele-photo lens.

Swallowtail butterfly photo-graphed hanging from a stalk in the typical frontal position in which marshland insects are usually taken.

On the opposite page: The European frog. In spring these creatures fill ponds with spawn, a favorite food of many predators.

scanning the surface with their big' eyes, or water snakes and vipers swimming rapidly with a sinuous movement, keeping their heads out of the water to breathe. Even marshland vegetation (water lilies, gentians, broadleaf pond weeds, marsh crowfoots, different kinds of rushes, etc.) can be taken to advantage with this system. Furthermore, it is not difficult to photograph rushes and iris near clusters of water lilies, and frogs waiting to grab insects but ready to throw themselves into the water as soon as the photographer appears.

When photographing amphibians from above, a medium telephoto lens should be used with a polarizer. In mountain lakes, where the water is often clearer, one can even attempt difficult underwater shots of the gaudy coats of newts. Walking along the bank or standing still, and using a medium telephoto with supplementary lenses or special macro camera lenses, one will find many further opportunities for taking interesting pictures. Dragonflies are perhaps the insect most often photographed in marshes. The intense blue color of the *Agrion virgo* dragonfly cannot escape the notice of the nature photographer; to take shots of this insect, one merely has to locate the place where it repeatedly settles. Frequent opportunities to shoot dragonflies arise during the mating season, when individuals remain coupled.

Insects are often photo- graphed hanging from the stems of water plants, and they appear more conspicuous in semi-backlighting.

It is worth shooting film with the macro lens focused on large beetles such as the diving beetle and scavenger beetle or on small water larvae. Mammals who frequent the wetlands are not easy to take shots of, principally on account of their shy, nocturnal habits. Catadioptric telephoto lenses and rapid-focusing lenses are the best for such pictures.

The presence of otter can be recognized from the unmistakable trail that it leaves in fresh snow and droppings containing fish-bones. To photograph beavers, be prepared to endure long, patient waiting in blinds specially built near their dams. The help and permission of the park keepers is both useful and necessary. Other small mammals that can be photographed in marshes are the harvest mouse and the coypu. To take shots of them in the thick of reeds or other a vegetation, a flash is almost always necessary.

URBAN ENVIRONMENTS

Animals, trees, and plants can also be photographed in civilized environments. Indeed, in the last few years cities that are rich in green areas seem to have become the domicile for many animal species, above all, birds. Within the urban confines, in fact, no guns are fired, pesticides are not sprayed in quantity; furthermore, a great deal of food is left by man, and in some parks there are still great and ancient trees which have not been cut down for wood, as they have been in the suburbs. Perhaps partly for these and other reasons we are witnessing a numerical increase in

species nest-building in green areas of the urban environment.

To seize these opportunities you can use second-hand equipment or one of your older cameras, with appropriate telephoto lens ready for immediate use, kept for such occasions well hidden in the trunk of the car. In fact, golden opportunities hardly ever happen when one goes out deliberately to take pictures, but they take place unexpectedly; hence you may witness the sudden arrival of storks over the rooftops of a small town or the migratory flight of wild geese between the bridges

of an urban river or an invasion of hundreds of starlings at sunset.

Parks, Gardens, Tree-Lined Avenues

Tree-lined avenues, public parks, and private gardens are the places most frequented by urban birds. To photograph them, rise early in the morning and go to a green urban area, sitting quietly in some clearing or near a small lake or on a bench. With a telephoto lens of medium power, such as a 300 mm, many species of birds can be shot. Chaffinches, robins, great titmice are easy to photograph with a little patience and immobility. They will be the first to approach.

The blackbird, to mention one common example, is definitely on the increase in urban green areas. Pairs can be photographed in the mating season when they call to one another with their unmistakable cry. In many English parks, sparrows and pigeons eat food offered to them straight out of one's hands. The green woodpecker and great spotted woodpecker can also be photographed in parks. The hoopoe in its nest is often photographed with the help of an electronic trip device, and the adult may be caught passing insects to its chicks.

In private gardens opportunities are more frequent with birdfeeders and artificial nests. From a suitably concealed spot, one can take pictures of the animals at the feeder.

Pleasing pictures not too difficult to take are provided by squirrels who live in parks. In contrast to the wild variety, who hide themselves immediately, urban squirrels remain in view of the camera lens for some time, in good light.

Flora can also be photographed in an urban environment: bordering the side of avenues, limes, poplars, cypress, horse chestnuts, and plane trees; in parks, the oak; on lawns and walls, thousands of wild flowers and also in flowerbeds, magnificent flowers which seem to have been planted just to be photographed. Hedges provide shelter for many animals and for a variety of shrubs like blackthorn, hawthorn, and wild rose. Waiting near a hedge can sometimes be rewarded by pleasant surprises.

Historical and Old Places

Under the eaves of many old houses one can take

Hundreds of oyster catchers photographed near a small town in Holland.

On the opposite page above: A whooper swan landing on a stretch of water near an inhabited area. Below: Water plants taken in a large urban park.

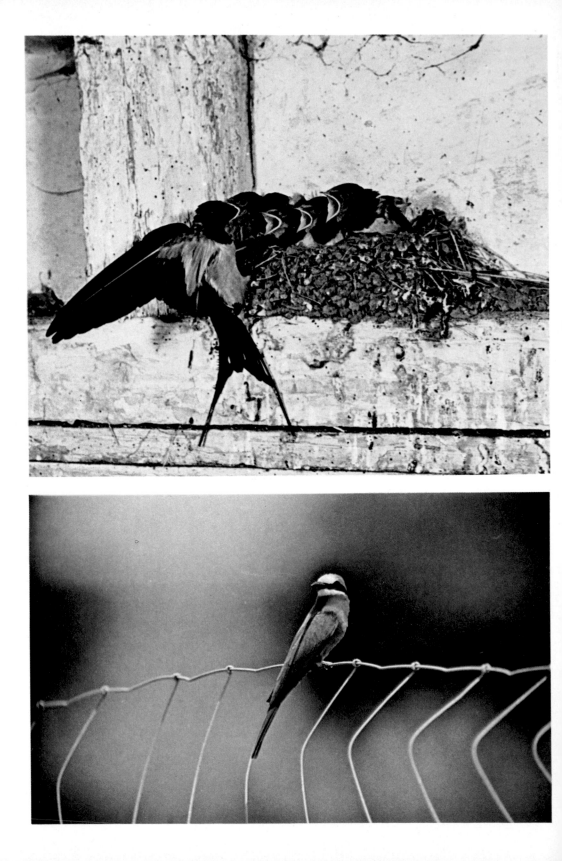

pictures of the nest-building of the house martin, a bird similar to the swallow, distinguished by the characteristic white patch on its back. In the same way, swallows can be photographed as they return to their nests, built in the hollows of the walls of old buildings, or even when in flight while they turn in their hundreds where the hot air drives insects upward. In the cavities of old walls, one may catch the redstart occupied in feeding its young. In old places there is no lack of nocturnal predators, such as the silent white barn owl, which can be shot after dark with teleflash.

Urban Waterways

Right in the center of many European cities it is not difficult to photograph flocks of gulls circling over the rivers that run through them, searching for fish and garbage. From the bank direct shots can be taken which could not have been obtained so easily in a natural environment. Coots, diving ducks such as pochards, and tufted ducks are easily taken paddling in the calmer waters of the river at a bend or inlet. Other kinds of animals, which would be ex-

tremely scared elsewhere, become quite tame in the city, knowing they are enjoying a kind of nonbelligerent pact with man. Even birds of prey, especially kites, are often photographed flying over rivers passing through towns. In certain urban centers of South America, the black vultures and swarms of crows have been taken right in the middle of a town. The kestrel is still found in many European cities, and it can be photographed from a position on the top of tall buildings where it builds its nest.

In the city birds are not so afraid of man and can be photographed by attracting them with food. Opportunities to take pictures of animals are provided at drinking fountains; this applies to birds and squirrels.

On the opposite page, above: Swallows can be taken while nest-building, usually in old cottages or barns, when they are not afraid of man's presence. Below: the African bee eater was taken in town from a car with a Nikon 600 f/5.6 resting on the car window.

ACKNOWLEDGMENTS

The authors wish to express their sincere gratitude for the advice they received during the preparation of this book from Gianfranco Bologna, Gigi and Alessandro Bozzi, Pierandrea Brichetti, Giuliano Cappelli, Paolo Fasce, Sergio Frugis, Angelo Gandolfi, Paolo Jaccod, Giorgio Lazzari, Lello Piazza, Vittorio Pigazzini, and Helmar Schenk. Special thanks are due to Paolo Fioratti for his advice concerning the section on electronic trip devices and to Silvio Foschi for his suggestions regarding underwater photography.

 The authors and the publisher would like to thank Larry Weisburg for his expert editing of the translation.

INDEX

Numbers in *italics* refer to pages with illustrations.

Photographic agencies: Ardea Photographics, London; Bruce Coleman, Uxbridge (Great Britain) Jacana, Paris; Time-Life, New York; Magnum Photos, New York; Natural History Photographic Agency (N.H.P.A.), Hythe (Great Britain).

To indicate photographic positions on the page, the following abbreviations are used: *t*, top; *b*, bottom; *c*, center; *l*, left; *r*, right.

p. 2	F. Mezzatesta, Parma	38	G. Izzi	72	E. Arnone
3	S. Dalton (N.H.P.A.)	39	G. Izzi	73	E. Arnone
6-7	F. Roiter, Venice	40	H. Chaumeton (Jacana)	74	*t*, C. Bevilacqua (L. Ricciarini)
8	*a*, G. Izzi, Ferrania (Savona)	42	G. Izzi		*b*, E. Arnone
	c, E. Arnone, Milan	43	G. Izzi	75	*t*, *c*, E. Arnone
10	G. Izzi	44	P. Fioratti, Milan		*b*, P. Minelli, Padua
11	G. Izzi	45	*l*,*r*, G. Izzi	76	*t*, E. Arnone
12	Studio Gramma, Verona		*c*, P. Fioratti		*b*, G. Izzi
13	*1*, *3*, F. Mezzatesta	46	*t*, P. Fasce, Genoa	77	S.T. Karisson (Tiofoto, Sweden)
	2, *4*, G. Izzi		*c*, *b*, P. Jaccod	78	E. Haas (Magnum)
14	*t*, G. Mazza, Monte-Carlo	47	*t*, J. Prevost (Jacana)	79	J. Simon (B. Coleman)
	b, G. Izzi	47	*b*, P. Jaccod	80	G. Izzi
15	G. Izzi	48-49	©Yoshikazu Shirakawa, Tokyo	81	*l*, G. Cappelli
16	Ansel Adams (Life)	50	F. Erize (B. Coleman)		*r*, G. Izzi
17	*t*, G. Cappelli, Florence	51	C. Haagner (Ardea)	82	*t*, G. Izzi
	b, I. Suffia, Savona	52	Schraml (Jacana)		*b*, F. Mezzatesta
18	*t*, A. Gandolfi, Genoa	52-53	P. Jaccor	83	F. Mezzatesta
	b, P. Jaccod, Aosta	54	*t*, F. Mezzatesta	84	A. Lindau (Ardea)
19	*t*, P. Jaccod		*b*, Boisson (Jacana)	85	*t*, R. Barbieri, Milan
	b, G. Cappelli	55	F. Mezzatesta		*b*, G. Izzi
20	G. Gualco (Union Press, Milan)	56	N. Cirani (L. Ricciarini)	86	P. Jaccod
21	*l*, E. Arnone	57	F. Roiter	87	P. Jaccod
	r, G. Mazza	58	*t*, A. Gandolfi	88	J.B. & S. Bottomley (Ardea)
22	M.D. England (Ardea)		*b*, S.E.F.	90	*t*, J. Valentin (Explorer, Paris)
23	G. Izzi	59	*l*, P. Jaccod		*bl*, A. Gandolfi
24	Studio Gramma		*r*, G. Izzi		*br*, P. Jaccod
25	*t*, Erca S.p.A., Milan	60	E. Arnone	92-93	J. Dominis (Life)
	b, Kodak S.p.A., Milan	61	E. Arnone	93	*t*, E. Haas (Magnum)
26	*t*, Studio Gramma	62-63	*b*, W. Mori (Mondadori Archives)	94	E. Haas (Magnum)
26-27	*b*, Camera Press, London	63	*t*, E. Arnone	95	P. Jaccod
27	*t*, G. Izzi	64	*t*, Photothèque Vautier, Paris	96	*t*, A. Gandolfi
28	G. Izzi		*b*, E. Haas (Magnum)		*b*, Varin (Jacana)
30	*t*, Polycolor S.p.A., Milan	65	F. Roiter	97	*l*, P. Jaccod
	b, J. Prevost (Jacana)	66	*t*, G. Nano, Savona		*r*, H. Shenk, Cagliari
32-33	F. Mezzatesta		*b*, G. Izzi	98	*t*, S. Dalton (N.H.P.A.)
34-35	F. Roiter	67	Pictor, Milan		*b*, F. Mezzatesta
37	*t*, R. Crespi, Milan	68	E. Haas (Magnum)	99	Ermié (Jacana)
	c, P. Jaccod	69	E. Haas (Magnum)	100	G. Izzi
	b, F. Greenaway (N.H.P.A.)	70	*t*, I. Berry (Magnum)	101	Bel e Vienne (Jacana)
		70-71	Gamma, Paris	102-103	Pictor, Milan
		71	*r*, M. De Biasi (Mondadori Archives)	104	*t*, A. Gandolfi
					b, E. Haas (Magnum)
				105	*t*, F. Mezzatesta
					b, A. Visage (Jacana)
				106	M. F. Soper (B. Coleman)
				107	Brosselin (Jacana)
				108	*t*, F. Mezzatesta
					b, H. Schenk
				109	*t*, F. Mezzatesta
					b, Ziesler (Jacana)
				110	Ermié (Jacana)
				111	*t*, L.R. Dawson

	(B. Coleman)
	b, B. Hawkes (N.H.P.A.)
112	*t*, Ziesler (Jacana)
	b, F. Mezzatesta
113	A.D. Trounson & M.C.Clampett (Ardea)
114	*t*, F. Mezzatesta
	b, P. Jaccod
115	*t*, Stouffer Productions (B. Coleman)
	b, V. Pigazzini, Monza (Milan)
116	*t*, Ziesler (Jacana)
	b, A. Fatras (Jacana)
117	Robert (Jacana)
118	*l*, F. Mezzatesta
	r, S. Gillsäter (Hasselblad, Sweden)
119	F. Mezzatesta
120	*t*, G. Izzi
	b, F. Mezzatesta
121	*t*, G. Izzi
	b, F. Mezzatesta
122	G. Izzi
123	*t*, P. Fioratti
	b, G. Cappelli
124	*l*, F. Mezzatesta
	r, A. Gandolfi
125	*t*, P. Fioratti
	b, J. Tallon (N.H.P.A.)
126	*t*, G. Izzi
	c, *b*, F. Mezzatesta
127	*t*, J. & D. Bartlett (B. Coleman)
	b, P. Fasce
128	Varin-Visage (Jacana)
129	*l*, G. Izzi
	r, J.A. Bailey (Ardea)
130	H. Schenk
131	T. Micek, Innsbruck
132	*t*, G. Izzi
	c, R. Volot (Jacana)
	b, P. Fioratti
133	*t*, J.A. Bailey (Ardea)
	b, H. Reinhard (B. Coleman)
134	R. Volot (Jacana)
135	*tl*, G. Izzi
	bl, *d*, P. Fioratti
136	P. Steyn (Ardea)
137	S. Dalton (N.H.P.A.)
138	S. Dalton (N.H.P.A.)
139	*t*, Mammifrance (Jacana)
	b, P. Fioratti

Line drawings by Flavio Ghiringhelli (Milan) and Flavio Segattini (Verona).